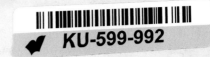

GINGER GEEZER
The Life of Vivian Stanshall

Chris Welch, former *Melody Maker* critic and ex-editor of *Metal Hammer* and *Rock World*, has written books on Jimi Hendrix, Tina Turner, Led Zeppelin, Yes, Peter Gabriel and David Bowie. He contributes to *Mojo*, *Record Collector*, *Rhythm* and the *Independent* and plays drums in his spare time. Lucian Randall is a music writer and researcher who lives in London. They have interviewed family, friends, band mates, producers and colleagues. Fans inspired by Vivian, including Stephen Fry and Fay Weldon, share their memories in this intimate biography of an artist whose life was as colourful as his work.

'You need never have heard a Bonzo Dog Doo Dah Band song to enjoy this terrific biography.' *The Times*

'Compelling portrait of troubled funnyman . . . [Stanshall's] death, in a booze-related house fire in 1995, is shocking only for its lateness. But this loving book shows why so many were still so sorry.' ***** *Uncut* magazine

'This excellent account follows the strange trajectory of Vivian Stanshall, frontman for the incomparable Bonzo Dog Band, who, despite twin addictions to alcohol and Valium, managed to keep his career afloat for the next 30 years through his verbal genius and passion for the absurd . . . The first section about the Bonzos, a group that won more affection than success, is often laugh-aloud funny.

Though wildly erratic, Stanshall's post-Bonzo output was far

from negligible. The authors single out his LP Teddy Boys Don't Knit (a reference to his youth as a crocheting Ted in Southend), the audio version of Sir Henry at Rawlinson End and the first production of his show Stinkfoot on a boat in Bristol (not to be confused with the houseboat-home that Stanshall sunk). Having scuppered two marriages, the ailment-plagued Stanshall died in 1995 at 51, apparently as a result of a fire caused by his own carelessness.

Substantial, sensitively written and often hilarious, his story is utterly unmissable.' *Independent*

'An excellent biography.' *Oxford Times*

'Hooked me.' Christopher Hirst, Books of the Year 2002, *Independent*

'A fantastic book' Gary Crowley, BBC London

'Brings the originality and the larks back into circulation.' *Time Out*

'Excellent.' *Daily Post*

'Lays bare an often horrible life . . . His comic gifts were never just funny, but savage and elegiac by turns, and the book evokes [Stanshall's] celebration of mad Englishness, with its Dada-surreal vision of Edwardiana and the 1920s . . . a hair-raising account of a man who was funnier from a safe distance.' *The Sunday Times*

'I've got that book, but I've not got round to reading it yet.' Jarvis Cocker

GINGER GEEZER
The Life of Vivian Stanshall

Lucian Randall and Chris Welch

FOURTH ESTATE • *London*

Lucian Randall: dedicated to Gloria and David Randall

Chris Welch dedicates this to Marilyne and Steven

This paperback edition first published in 2002
First published in Great Britain in 2001 by
Fourth Estate
A Division of HarperCollins*Publishers*
77–85 Fulham Palace Road,
London W6 8JB
www.4thestate.com

10 9 8 7 6 5 4 3 2

ISBN 1-84115-679-5

Typeset by Palimpsest Book Production Ltd, Polmont, Stirlingshire
Printed in Great Britain by Clays Ltd, St Ives plc

Contents

'He was one of those men in whom nature runs riot; she endows him with not one or two but twenty talents, all of them far beyond the average and then withholds the one ingredient that might have brought them to perfection – a sense of balance and direction'

– Alan Moorehead on Sir Richard Burton, in *The White Nile*

Illustrations

18. The 1969 *Keynsham* album. (courtesy of EMI Records Limited)

Plate Section 2

1. The Stanshall family on holiday in Kent, 1971. (family collection)
2. Vivian and Neil Innes, 1971. (courtesy of Barrie Wentzell/Repfoto)
3. Street darts: journalist Roy Hollingworth aims for Vivian in Soho, 1971 (courtesy of Barrie Wentzell/Repfoto)
4. Vivian with Silky, 1985. (courtsey of Ki Stanshall)
5. Vivian at the *Melody Maker* awards ceremony, 1971. (courtesy of Barrie Wentzell/Repfoto)
6. Vivian with Bones the bulldog, Chertsey, 1980. (courtesy of Andy Roberts)
7. Publicity shots for 'Teddy Boys Don't Knit', 1981. (courtesy of Barrie Wentzell/Repfoto)
8. Vivian on board *Searchlight*, 1984. (courtesy Andy Roberts)
9. Vivian on the *Thekla*. (courtesy *Bristol Evening Post*)
10. Vivian with Ki, Silky, Sydney and others. (courtesy *Bristol Evening Post*)
11. A note left one morning for Rupert, from Vivian, 1986. (family collection)
12. Vivian with Ian Dury in Spain for *The Changeling* shoot, 1994. (courtesy John Megginson)
13. Vivian in the 1990s. (courtesy of Barrie Wentzell/Repfoto)

Acknowledgements

The authors would like to thank all those who gave generously of their time and patience during their research, and provided both details of Vivian's life as well as views of his achievements and personality. Particular thanks go to family members, notably Monica, Pamela, Rupert and Mark. Friends and colleagues also made invaluable contributions towards gaining insight and understanding of Vivian's work and character, and the authors would like to thank them all.

Hi there! Nice to be with you. Happy you could stick around. Like to introduce: Keith Altham, Michael Bielby, Vernon Dudley Bohay-Nowell, Tony Bramwell, Gerry Bron, Pete Brown, Jack Bruce, Steve Buckley, Rob Burns, Roy Carr, Robert Chalmers, Mary Chater, Dave Clague, Philippa Clare, Alan Clayson, John Cleary, Gail Colson, Glen Colson, Mark Cooper, Rob Dickins, Gus Dudgeon, Roy Flynn, Stephen Fry, Richard Gilbert, 'Admiral' John Halsey, John Wesley Harding, David Harrison, Roy Hollingworth, Isle of Wight Rock Archives, Lee Jackson, Peter Jackson, Bill Kates, Bob Kerr, Neil Innes, Bruce Lacey, Sydney Longfellow, Gary Lucas, John Megginson, Keith Miller, Mark Millmore, Zoot Money, Pete Moss, Leslie Murray, Tom Newman, Tim Nicholls, Rocky Oldham, Jenny Peart, Mike Plumbley, Andy Roberts, Steve Roberts, Margaret Salter, Robert Short, Virginia Short, Rodney Slater, 'Legs' Larry Smith, Roger Ruskin Spear, Eileen Stanshall, Ki Longfellow Stanshall, Mark Stanshall, Monica Stanshall, Rupert Stanshall, Tony Staveacre, David G. Walley, John Walters, Bill Watkins, Roger Wilkes, Barrie Wentzell . . .

And also: Angel Sound London, Kate Balmforth, Danny Barbour, Dinah Drazin, Dan Duggan, Mick Fish, Jo Foster, Goldust Studios Bromley, Greenwich Maritime Museum Library, Dave Hallberry, the Maritime History Archive, Andy Miller, Madhu Prasad, Sarah White.

GINGER GEEZER
The Life of Vivian Stanshall

1
Teddy Boys Don't Knit

Early years

A journalist once asked Vivian Stanshall to feature in a newspaper article she was writing about a species known as the English eccentric. Sir John Betjeman was to be the senior representative and Vivian the younger example. Was he, she enquired, still 'doing it'?[1] Stanshall was astonished by the question. He didn't *do*, he was simply being himself. On or off stage, he explored his absurdist vision of the world without pretence. Wherever he was, his outfits were equally flamboyant, his improvised routines often intricate and his physical presence captivated whoever was to hand, band mates, audiences or bewildered passers-by on the street. Anyone, as long as he could make a connection. His was not a persona applied for a performance and removed at the end of the evening along with the gold lamé suit, those disturbing ping-pong-ball eyes or the pink rubber ears.

Whether playing the effete, sequinned showman with the Bonzo Dog Band or later reporting from the shadows of the stagnant countryside at Rawlinson End, Vivian's sharp observations on the inanities of life were as personal as they were funny and they came in an unending stream, he never switched off. In full flow, as he was on 'The Intro and the Outro', a favourite Bonzo Dog Band track, he delivered rapid-fire gags, here a seemingly never-ending roll call of increasingly unlikely musicians. 'And looking very relaxed, Adolf Hitler on vibes.' The image of the Fuhrer loosening up had an incongruity which was

1

true of Vivian. He never relaxed; constant activity and new ideas bubbled and burst out of him, driving him, and everyone around him, to distraction. The interviewer who suggested this was a studied image was fortunate to have phoned rather than met him at his home. Vivian often made troublesome visitors feel uncomfortable by pausing mid-conversation to pointedly feed his collection of piranhas with freshly killed mice or to hint that one of his larger snakes was loose on the premises.

The journalist might have done better not to hunt for hidden tricks or mirrors and instead simply looked a little deeper into how one person could be inventive in so many fields. Or asked how that person could simultaneously be the upper-class squire and a ripe Cockney geezer and how it was that the murkier fringes of English normality came to be unflinchingly illuminated by an artist whose own character was formed in a part of traditional England. It was in a Great British seaside resort that Vivian spent most of his childhood.

Southend-on-Sea is a cheeky, presumptuous sort of place. For a start, it is some thirty-five miles to the east of London, rather than south. It is situated on the Thames Estuary; not quite the sea. It does have a famous funfair called the Kursaal and a mile-and-a-quarter pier, the world's longest. Gaily festooning the seafront are the famous illuminations, signalling Southend's status as an alternative to the drab, city streets of the capital. It certainly performed this function for many deprived London families in the 1950s. After a slow and tedious journey by steam train, thousands of eager holiday-makers spilled out of the station and headed for the front in search of dodgem cars, slot machines, deckchairs, hot dogs, jellied eels, cockles, tea and a game of bingo. The highlight was a trip on the pier railway or a heart-stopping ride on the water chute at the Kursaal.

London kids thought of 'Sarfend' as a sort of paradise, a Never Never Land where time stood still and everyone lived on a diet of sweets, candy and hot doughnuts. It was difficult to imagine anyone actually living and working in such a pleasurable environment.

The small but busy town grew into an urban sprawl during the post-war years. In the process it merged with its older neighbours like Leigh-on-Sea. In this cluttered coastal conurbation Vivian

Stanshall grew up in the 1950s with his mother, father and younger brother. Leigh-on-Sea isn't quite the romantic artist's birthplace that Dublin, Paris or New York are, though actor Steven Berkoff was attracted to the area, featuring the mighty Kursaal amusement park in his early autobiographical play, *East*, as a place of escape and excitement. For a youngster who lived in the town all year round, it was the soulless 'Concreton' alluded to in Vivian's later tales of Sir Henry Rawlinson. If nothing else, the years there inculcated in Vivian a love of seafood, English seaside resorts and Cockney slang, habits and tastes.

Leigh-on-Sea was actually the remnants of an old fishing and smuggling village, which was well established when upstart Southend was still a hamlet. It was a place where you could still find cockle boats and sheds, sailors' inns and clapboard cottages, and where you might spot a lively red-haired child with a penchant for painting and drawing. He grew into a noisy tearaway teenager with a fondness for practical jokes. Throughout his childhood, Vivian later claimed, he was 'hopelessly, innocently burdened with the ineluctable conviction that I was destined to be an artist and I really couldn't help that'.[2] His early interest in art came from his mother's side of the family. His great-great-grandfather was what was then called a black-and-white artist. Much as the inescapable portrait painters crowd popular attractions like London's Leicester Square today, he would wander the streets drawing quick sketches or portraits. Eileen Stanshall, Vivian's mother, was dragged into art shops and plagued by her young son's requests for art materials and paintings.

Mrs Stanshall was born Eileen Monica Prudence Wadeson in Kilburn, London, on 5 February 1911, and lived at 65 Salisbury Road in nearby Willesden Green. Her father was John Thomas Wadeson: 'In my father's family every boy child was called John Thomas or Thomas John, which was a tradition which went back many years. There were no fancy names in those days!' she says. He was a fireman who served in the Royal Navy during World War One, following which he drove an ambulance during the great influenza epidemic that ravaged Europe in 1919. 'Everybody was down with the 'flu and dying of it,' recalls Eileen. 'They asked for volunteers to man the

ambulances. I was about eight years old, and at school, and you'd see the ambulances passing all day long.'

The family were accommodated in a fireman's house which seemed a place of comfort and security amid the crisis. Eileen recalls children and adults falling victim to the killer epidemic in every street in the neighbourhood, though her family was unscathed. She was the fourth child of Mary Beatrice (neé Douch), who had left a convent to be a nurse, just about the only work a girl could get in those days: 'My mother and all the children were Catholics and Dad wasn't. But if there were any dances on, he'd go with her to the church hall.'

Eileen went to school in Willesden Green and later went to work for the Address-O-Graph company, which made customized metal address plates for small businesses. She quickly grew tired of the endless clanking noise of the machinery. Aged eighteen she went for a job at a Catholic church furnishers called Burns, Oates and Washbourne, in the City, where she did office work. She remained single until her late twenties, when she went on a trip to a holiday camp at Caistor, near Great Yarmouth. Such holidays were very popular with young people as an alternative to staying in a staid old hotel; indeed, after World War One, the camps were built especially for teenage holiday-makers. The young man whose heart Eileen caught was born Vivian George Stanshall in 1911. By the time his future wife met him, he had a different name.

'His mother liked "Vivian",' explains Eileen. 'She had been reading a novel and the hero's name was Vivian, so that's what she called her baby. When he got older he thought it sounded sissy, so he wouldn't tell anybody his real name.' Vivian changed his name by deed poll to Victor and was known as Vic.

Vic chanced upon Eileen at one of the many dances at the camp and was immediately smitten. 'I had bright ginger hair and I was always dancing,' says Eileen. 'I passed him as I went into the dance hall and he was by the doorway. I didn't even look at him. When I sat down he came over for a dance. I wondered why he wanted me, because my friend Rose was a beautiful girl. But he never left me alone that whole evening. We had one dance after another. From then

on until the day he died he never took his eyes off me.' Vic was good-looking, six-foot-two and, although he wasn't a Catholic like Eileen, he had a commanding manner that immediately impressed his sweetheart. He was very sporty and fit, with a twenty-inch neck and huge biceps. His passion was playing football and he had faultless manners. 'He had a very nice voice. His mother made sure that all her family spoke nicely, because the old man didn't. I could quite see her point of view. But Vic could mix with anybody and he was very well liked. Some men will put it on, but I noticed he always spoke in exactly the same way as the men he was dealing with.'

The relationship blossomed and Vic took his girlfriend to meet the family. His father, Thomas Henry Stanshall, was a music dealer who sold sheet music and 78s in a Walthamstow shop. The Stanshall name goes back to the Crusades, and has a number of meanings: a stone hall, a wall of stones or, going back to Saxon times, St Ann's Hall. The Stanshalls are now a rare breed. Vic himself never looked into the history of the name, but his two sons – Vivian and Mark – took up the challenge and were bombarded with letters from Americans writing to say their name was Sandhill. They all wanted to know if they could be any relation and Vivian told his brother, 'You answer those in case they want to breed with us.'

Vic had two sisters and was spoiled as the youngest and the only boy in the family, growing up to be the traditional sort of man who expected his tea ready for him when he got home from work. His mother was 'a tall thin woman', remembers Eileen, 'who looked as though she needed a good meal.' Vic's dad made a less favourable impression on the girl: 'Vic's father was in the army and he was very strict. There was no love in that family, somehow.' Vic emulated his father in being unemotional: he was happiest out with the lads and messing about with cars. 'There are pictures of him with a souped-up Austin 7,' says Mark Stanshall, 'and he had a rather nice three-wheeler Morgan with pipes coming out of the side.'

Eileen and Vic were married, after a five-year courtship, at the Church of the Sacred Heart of Jesus in Kilburn on 19 June 1937. Vic was twenty-seven and his bride a year younger. The groom's family were then living in Walthamstow, on the north-east outskirts

of London. The newlyweds set up their home nearby; by this time Vic was a financial secretary, working his way up to become an office manager.

On the outbreak of war in September 1939, Vic Stanshall joined the RAF. He was too old to be a flyer and went into administration, where he rose to the rank of lieutenant. 'He was having a lovely war because he was teaching the guys self-defence and playing football,' says Mark Stanshall. 'When they found he had some sort of brain, they put him into ciphers and he worked on decoding. God knows what he actually did. He wasn't at Bletchley Park, but it was something similar.' The family moved from London to avoid the Blitz and their first child was born in Shillingford, Oxford, on 21 March 1943.

The birth was a difficult one. Eileen was in labour for seventy-two hours and, as she told her son years later, 'You nearly killed me, now that's enough of that! [The nurse] brought me three babies, two with tiny little heads and you with a great big whopping head and ginger hair. I said, "Ooh, no, I'll have one of those little ones." She said, "I'm afraid you're stuck with it."'[3]

They named the boy Victor Anthony Stanshall, Victor being the 'manly' name his father had wanted himself. Eileen always used the boy's second name, Anthony. When the child himself learned to speak, he found it difficult to say 'Anthony', which came out as 'Narnie'. The pet name stuck, at least until Anthony was old enough to reject both his parents' choices in favour of his father's original name, Vivian. His older friends called him 'Vic' throughout his life, as did his first wife and his own son. His second wife, and the daughter he had with her, both called him Vivian. The one name by which he disliked being addressed was 'Viv', and he corrected people if they tried it. But to fans of the Bonzo Dog Band, he was always Vivian. It was not an act of rebellion to take his father's rejected name, says Mark Stanshall, 'it was affectation. He didn't have another Vivian in mind. It just sounded good.'

It was not until September 1948 that the Stanshalls had another child, Mark. Perhaps because of the five-year age gap, the boys 'didn't mix and they were never really friendly', in Eileen's words. Mark Stanshall agrees. 'There was always that jealousy thing. He was the

first born and he and Ma had a fairly idyllic life during the war when they were living down in Shillingford.' They lived in a bungalow in the beautiful Oxfordshire countryside.

'The first two years of my childhood were wonderful,' Vivian recalled. 'Just me and Mum and me and my voices, evacuated from the East End.'[4] He remembered how the local cows would wander into the kitchen and his mum, broom in hand, would shoo them out. At the bottom of the long garden were the upper reaches of the River Thames. Paddleboats sailed past, filled with soldiers on leave, taking their girlfriends on bitter-sweet farewell cruises. Young people called to each other across the river.

The London Blitz was past its peak, but the country still faced danger from the Luftwaffe and Hitler's V1 and V2 revenge weapons. Shillingford did not escape the bombs, because it was between two air-force bases which were under fire, particularly at night. Young Anthony's Oxfordshire adventure ceased when the war ended. It was a mixed blessing to have Dad back. Anthony later said that he could remember almost nothing from the age of three until he went to art school, perhaps an attempt to block out parental criticism. Ominously, his father came back with ideas. He decided he was officer class. This attitude manifested itself in his belief that it was important to speak 'correctly' in order to get on in life, a trait Eileen had first noticed in Vic's mother. In turn, Anthony's dad instilled the same into his family.

'He was fearfully middle-middle-class,' says Mark Stanshall. 'We all spoke with this awfully posh accent.' Commendable, perhaps, but totally out of place when the family moved away from the tranquillity of Oxford and back to the urban sprawl of London's Walthamstow. For the rest of his life, Anthony would remember the incongruity of learning received pronunciation. 'I didn't even know any upper- or middle-class kids, but I was saddled with a posh accent that was totally unjustified by my background. I didn't really know which side I was on.'[5] If he was reticent in applying himself, he had the voice 'thrashed' into him by his father.[6] Vivian began to split his persona between the tough talker of the streets and the polite conversationalist at home.

For all that, Walthamstow was not too bad. They had a corner

house at 173 Grove Road. 'We used to grow sunflowers out in the back garden and keep tortoises,' says Mark Stanshall. In 1953, the family settled in Westcliffe, between Southend and Leigh-on-Sea. For a time they had a flat above a shoe shop in Westcliffe's broad shopping street, at that time the smartest area of the town. They moved into a house in Beech Avenue seven years later. Anthony became more streetwise in Southend, still veering at will between the tough talk of the local lads and the Home Service, BBC tones his father required. Immediately after the war, Vic's ambition was to become a chartered accountant. Eileen recalls that he worked near Fleet Street for a finance company involved in the South African diamond trade. As with so much else, he was never forthcoming to his family about his work.

'No one knew what he did exactly but it was something to do with unit trusts,' says Mark. He was not as grand a figure in the City as he made out, never inviting Eileen up to London to meet his partners. Ex-officer Stanshall (now balding, like all the male Stanshalls) was always smartly dressed when he went to work. He took plastic Pac-a-Macs for added protection, which Mark remembers 'we always thought were ridiculous'.

Anthony was both impressed and intimidated by the spectacle. 'He polished his shoes so shiny that when you looked down you could see all the way up to his suspenders – or up skirts, if you fancied it. And then he covered his shoes with protective rubber galoshes and with bowler hat rammed tight and brolly grasped, he would every morning roller-skate from Walthamstow to the City.'[7] A wonderful image, this Stanshallian flight of fancy has roots in reality, as his mother confirms: 'A lot of people did roller-skate during the bus strikes. He might have tried it once or twice. I remember there used to be loads of strikes even when I worked in London and I used to thumb a lift to the office. It was quite fun. Everybody was doing it.' Mr Stanshall, however was unaware of any humorous aspect to the ritual of work. Like many of his generation, he was not adept at handling emotions of any kind. Anthony was 'downright terrified' of his father and would continue to be so, even after the man's death almost forty years later. The boy keenly felt the lack of any conspicuous display of affection. Eileen is quite sure that his father loved him. 'A lot of men are like

that. They love the babies,' she said, 'but when they get to be boys and they see the wives giving all their time to them, they get a bit jealous. There's no denying; they just *do*. And then they lose interest in the children.'[8] Mark was more accepting of his father. 'I didn't have a conversation with him myself,' he says, 'but I suppose he was good because he always put the food on the table for us.' He shared one of his father's few interests, football. With father a season ticket holder at Arsenal, six-year-old Mark would be taken along to see the side play.

It was only years afterwards that Anthony began to understand his father a little better: 'He's quite remarkable in his respect for authority, which was good for me because I think that is lacking now. He is upright and righteous and has an inflexibility of behaviour which borders on the old Catholic Church . . . [and] a set of values with which, for the most part, I completely disagree, but it is something I can measure myself against and I think that it is a sad thing that most children don't have that sort of rigidity.'[9] Decency, though, meant little without affection, and the boy felt that everything he did was a disappointment to his father. Vic wanted his son to be a footballer, but Anthony showed no interest in the game. He relished other sporting challenges. Every year there was a seven-mile swim from the pier at Southend to the cockle sheds of Leigh-on-Sea. Sixty hopefuls set out to brave the waters and Anthony was among the dozen or so swimmers who finished. Two-thirds were knocked out by a severe underwater current. He was also rather fond of throwing the javelin, and would go on to have a lifelong interest in sharp, pointy weaponry, often to the alarm of his friends and colleagues.

Anthony's relationship with his mother was uncomplicated. Eileen adored him, providing support whenever he faced a crisis in his life: 'Mark was much more independent,' says Eileen, 'but Anthony had to have his mother on the end of the phone.' As a child, Anthony was, he admitted himself, 'freakishly precocious', speaking from the age of five months. In a sweet shop Eileen explained to the owner that her son always took a long time to choose what to have. 'I doesn't,' Anthony piped up. The man looked at mother and child and said, 'How old did you say he was?' By the age of ten months, Anthony

later claimed, he was able to hold a conversation. Such was his energy, baby Anthony was strapped into his pram, and such was his loathing of doing nothing that the very smell and feel of the leatherette pram would stay with him for the rest of his life. He hated restraint: 'We had a dining room and a lounge at Walthamstow and he'd get out of his playpen and walk into the hall, round to the kitchen then back in again,' adds Eileen. 'He just wanted me to see he could do it.'

On holiday in Hastings as a toddler, he caught the attention of a seafront clairvoyant, who told his mother that the child would either be an actor or an admiral. Eileen asked the psychic how on earth she could tell. 'I got the vibes,' she was informed. Anthony would later joke that the response was, 'Your pram is sinking and he's saluting as it goes down.'[10] Wherever these mystical portents came from, they identified part of his career with a fair degree of accuracy. As for the nautical part, he joined the Merchant Navy and later both owned a houseboat and settled on a converted ship.

Like most children, Anthony was first and foremost a rascal, and Eileen regularly fended off irate neighbours complaining that the boy was running wild in their gardens. 'He was always up to something and always thinking about something,' laughs Eileen. There was much opportunity for messing around on the seafront. 'I used to kick sandcastles over when I was a kid. Horrible boy,' he later said. 'On the other hand, I suppose that's the closest most people are going to come to sculpture in their lives. Apart from their haircuts.'[11]

Anthony was also creative, with a passion for music. 'Anthony just had music in him,' says his mother. 'He was always playing something and my father was like that. I had two brothers who were musical and just like Anthony they could pick up an instrument and get a tune out of it. My brother Tom could play the violin. My mother used to encourage music in the family and my father played an instrument as well.' Mischief and music coincided in young Anthony. The front room at Beech Avenue, a spacious, semi-detached house, was separated from the street by a forecourt and a hedge. The boy sat in the front room with the biggest trombone he could find. He lay in wait for passers-by and walloped them with the trombone's slide.

Art was another burgeoning talent in Anthony, one for which he

had a much stronger instinct. One reason the family made their move from London to Southend was to enable Anthony to attend the local art school. He was always keen on art: at the age of two he was 'mixing boxes of paint trying to make blue sky', says his mother. 'He could draw anything you asked him, even when he was little. He'd drag me into art shops and I'd buy him artists' materials.' Eileen encouraged her son's self-expression through his interests while agreeing with her husband on matters of family discipline. 'Anthony was well brought up and did as he was told. He had to. My mother brought us up rather strictly and if she said, "Go out and get me something" you went. There were no arguments. Nowadays you see kids of seven arguing with their parents. My mother wouldn't put up with that.' Eileen ensured the boys were brought up as Catholics, just as she had been. Between primary school and Southend High School, Anthony attended convent school, 'being taught a lot of perverted, one-sided rubbish by nuns who were otherwise quite OK, and I got by as the clever boy who built match-book galleons they could display on open days'.[12]

In church, Anthony could barely contain himself at Communion as the other church-goers, eyes closed and tongues hanging out, waited to receive the Host. The bishop, a firebrand Irishman, caught him giggling and sent him back to his pew with a slap round the face. He lost interest once Mass was translated into English. 'I didn't understand it any more. Really, I didn't,' he said. 'It had no cadences, there was no longer any chime in me. It had been demystified to a point where it had been made base and ordinary – and, certainly, spiritual life is not ordinary.'

His mother, with 'quite a deal of perspicacity', thought he should have been a priest. Later he said himself that artists and priests were similar, 'because – this is going to sound awfully pompous and silly – you are communicating to share a spiritual enjoyment of life . . . I mean priests in an ideal sense, what I understand is a shamanic priest, a guru, a spiritual leader, not necessarily someone who dishes out three Hail Marys and ten how's-your-fathers.'[13] His son Rupert says that he even flirted with the idea of converting to Judaism. Faith was always important to him, despite his reputation for irreverence. 'He

had a picture of Christ on the wall,' says Rupert. 'It was conditioning from when he was a kid. Somewhere in him there was some respect for religion, without question.'

Anthony passed the 11-plus examination and attended Southend High School. He became friends with a boy named Pete Wiltshire, who impressed him through knowing how long it took to dissolve mice in nitric, hydrochloric and sulphuric acids: 'Of course, I warmed to him.' Pete also met with Eileen's approval. Like her son, Pete was tall and both boys felt uncomfortable with the old-fashioned short trousers. The school strictly enforced a uniform of grey trousers, black shoes, white shirt, a house tie and green blazer. Pete's dislike of the uniform was shared by Anthony, who came in one morning wearing black-and-white check trousers, black-and-white shoes, a white coat and a bow tie. He was sent home. The school did not have him down as a real troublemaker; he was simply an intelligent, rather cherubic boy who did not fit in, and there was no room for individualism in the classroom.

'Even when I was at school I never looked normal,' he recalled. 'To avoid being beaten up I would have to devise gags and strokes and pranks, or behave in an outlandish manner, in order to be taken under the aegis of bullies. Perhaps I was therefore purchasing by my behaviour self-protection, so I suppose after a while that becomes natural.'[14] There was not the flexibility in teaching to cope with him. As one of his teachers said, 'We didn't have many eccentrics at school. The system wouldn't allow it.'[15] The boy thought of the system as constraining, reductive and empty. It produced 'Normals', he later explained to *Melody Maker*. 'Normals are all about you. They leave signs on the streets that give you clues. They are just people entirely formed by their environment. They are not necessarily middle-aged, middle-classed people. It's the clothes they choose to wear and the way they choose to speak. They imagine they are ordinary, yet they are really dreadful freaks – terrifying. They are people bound by convention, "Normal" is a paradoxical term.'

The poor relationship with the school brought out the prankster in Anthony. 'He was always in trouble,' says Mark. 'He was the one who always had a mouse in his pocket or organized some form of

anarchy.' Eileen went to the school in the end and convinced them to let him go to the art college instead. Anthony remembers he was just about to be expelled when she intervened. The constraints of the education system were too much for the inventive youngster. It left him with a 'hatred of the system which did its best to put me off Shakespeare and any poetry, painting . . . stuffed down my throat things that were obviously unsuitable and made things that were exciting to me unpalatable by making reverent, dead things out of them'.[16] Vic Stanshall went along with his wife's plans for Anthony to attend the art college. For all his insistence on speaking properly and behaving well, he did not have that much influence. 'Oh, Vic did as I'd tell him,' laughs Eileen. 'He wasn't daft, though. If he thought something wasn't right, he wouldn't have done it. I knew as soon as Anthony was born that he was going to be different. I didn't want him to have a job he wouldn't like or enjoy. If he didn't get his own way, people would dislike him, because I knew he'd play them up.'

Both Stanshall boys indulged a lifelong passion for accumulating rubbish and junk from sales. 'I collected glass and bits of silver and pictures,' says Mark. 'We were always bringing stuff back home.' By the age of fourteen, Anthony was amassing a collection of 78 r.p.m. records. He had bought a gramophone with the old-fashioned horn amplifier for 17s/6d on which he played a selection of numbers which formed the basis for the Bonzos' act. 'I remember he bought a record by the Alberts called "Sleepy Valley", which was played on the Phono-fiddle,' recalls Mark. Bonzo member Neil Innes also nurtured an affec-tion for this ghastly instrument: 'The solitary string was raised by something that resembled a violin bridge and only vigorous pressure from a violin bow could entice sounds that ranged from a low, thin, melancholic wail to an utterly unattractive high-pitched shriek.'[17] Needless to say, young Anthony loved it.

During the school holidays, Anthony was a part-time bingo caller in Southend, where he learned all the patter. The focus for carefree childhood memories was the beloved Kursaal funhouse. It had, he later said, an 'antique *fin de siècle* charm about it, with a grey-and-pig's-kidney-coloured colonnade. Then there's quite a lofty dome

atop that, with a kind of mosque-ish top. A pleasure dome.'[18] He started his fairground career collecting pennies from the slot machines. Inside the building he worked on the dodgems and eventually got to guard the celebrated water chute. It was an absorbing, year-round occupation. Out of season, Stanshall helped to maintain the attractions, painting the carousel horses and the ghost train.

Southend-on-Sea was an adventure playground outside work and school hours. It was where a youngster could roam the streets as a teddy boy. In the mid-1950s, British boys and girls thrilled to the new sounds from the States, together with the paraphernalia of being a teenager: B-movies, horror comics, pop records and trendy fashions. Where once they had jived to Ted Heath and his Orchestra, they now learned to rock'n'roll to Bill Haley and the Comets, Elvis Presley, Gene Vincent and Little Richard. Aged just eleven when rock'n'roll first broke, Anthony was too young to be in with the gangs. He bought his first pop records instead: 'Rock with the Caveman' by Tommy Steele and 'Giannina Mia' by Gracie Fields.

English kids adopted the clothes, slang and violent habits of teddy boys, taking their name from the Edwardian styles that became fashionable at the start of the decade: drape jackets with velvet collars and thick-soled shoes nicknamed brothel creepers. On the back cover of Stanshall's 1981 album *Teddy Boys Don't Knit*, there is a black-and-white snapshot of him as a youngster, sitting sprawled with his mates on a bench in the street. They loaf in the maliciously indolent way that only teenage boys can, under a Southend police noticeboard. A 'Keep Britain Tidy' poster depicts a huge finger pointing directly at Stanshall's head. Clad in blue suede shoes and drainpipe jeans and sporting a Tony Curtis hairstyle, he sits and grins, sporting the kind of expression that members of the officer class might have interpreted as dumb insolence.

Being a ted 'meant wearing second-hand clothes with collarless shirts and corduroy suits', remembers Mark Stanshall. 'Vivian always took it to the max and wore a complete frock coat and top hat. He always loved to be looked at and liked to be the centre of attention.' Twenty of them on motorbikes would tear around, waking up the neighbourhood. 'My father, being ultra-conservative, couldn't cope

with a son who was always wandering about looking like a Victorian doctor with all these musical instruments piling up.'

The teds were the toughest of all working-class lads, notorious for gang fights with bicycle chains, particularly at such south London flashpoints as the Elephant and Castle. The craze spread all over the country and was established in Southend just as a teenaged Stanshall headed for the streets in search of freedom. There he found a gang culture that appealed to a growing love of ritual, folklore and strange languages. There would be battles on the pier that was supposedly the preserve of pleasure-seeking families, between the Leigh gang, the Benfleet boys and the Southend mob. By the time he was sixteen, Anthony ran with the local Leigh boys. Inconveniently for his street cred, Eileen had taught him to crochet as a young child. This was anathema to his fellow-gang members, as he attested in the afore-mentioned album title, *Teddy Boys Don't Knit*. His posh accent surfaced occasionally, but this meant he was tolerated as an 'amusing mascot' by the gang. A rival team of interlopers might come down from Dagenham and from the pier entrance right up to the High Street there would be a reception committee.

It was a testosterone-fuelled time for Anthony and he later worked it into his music. 'When I feel particularly aggressive . . . I use the most aggressive part of my life which I suppose was the 1950s when I was a teddy boy.'[19] He was arrested with his gang, instilling in him a healthy disrespect for the law – or at least the law as practised in Southend.

'The police were notorious, and I was falsely accused of assaulting a policeman,' he later said. 'I was said to have hit a policeman with such force he had to be picked off the pavement. It was absolute rubbish, but I was found guilty. I had to spend a night in a cell with the light on all the time, and I wasn't allowed to use the lavatory. It was hateful. I think there should be more education for the police.'[20] Back home, he hid the drape jacket and drainpipe trousers behind the coal bunker to become well-behaved Narnie indoors.

Street culture met his artistic influences and laid the foundations for a serious drink problem. According to his second wife, Ki Longfellow: 'He believed all this shit about what a *real* artist goes

through,' she says. 'A *real* artist drinks red wine and smokes and lives in a garret. A really great artist dies young. So he began drinking when he was thirteen years old, but this was normal, hanging out with the guys he met on the streets.' He was beginning to find out who he was – and that was different: 'I didn't enjoy it,' he later told an interviewer. 'It's just that when I was thirteen and growing my first beard, I just went up to the top of my road in Leigh-on-Sea. I was pointed out by a little boy and his mother said, "Shh . . . He's a crank." So I thought, "That's it, that's what I am." I mean, it's very handy to know what you are.'[21]

The other important teenage business was love. His first love was a girl named Mary. They met when he was fifteen and he was 'insanely in love' with her for many years. She thought he looked like nothing on earth, with his colourful clothes and his newly acquired artist's beret. He rode to her school on his bone-shaker bicycle, waiting for her near the tennis courts. She too was taught by nuns, who instinctively disapproved of this strange young man and banned her from going out at lunchtime. Waving at Mary from the side of the tennis courts, Stanshall attracted the attention of the PE teacher, who became convinced there was a pervert near the grounds. The teacher strode over and told him to make himself scarce. Mary's attempts to explain that it was all right because she knew this particular 'pervert' fell on deaf ears.

Neither of the two young people had much money and were rarely on their own together. They went for long walks along the seafront by Old Leigh and out on the sands. Mary was invited to the Stanshall house where, to her astonishment, her boyfriend was called Anthony – by now he was Vivian to everyone outside the familial home. The atmosphere chilled when the boy's father returned, Eileen's personality changed and the house became quieter. After that, Mary did not visit when Stanshall Senior was at home.

Anthony was now Vivian, much to his mother's chagrin. He later made the change of name permanent. 'He did it properly by deed poll,' says Eileen. 'He did that because he wanted to be in show business and he thought it sounded better.' Vivian wanted another name change too: he asked Mary to marry him. Eileen did not approve. She

was certain the girl was too young to understand her true feelings. She also knew that she wanted her son to finish art school and so she took Mary into the kitchen one day to tell her that the wedding would not have her blessing or that of her husband.

'If you love him, you'll wait,' she told Mary. They might have waited until Vivian was twenty-two, but it was never to be. This was not because of Eileen: she was adamant that her Narnie would never go behind her back and Vivian was just as certain that he could have done so. It did not come to that. Crushingly, Mary turned him down. Vivian cried for a week and always believed that Mary came to her decision because she lacked faith in him. While he might have been colourful and great fun to be with, underneath it all he thought that in her eyes he would never amount to anything. Yet his career prospects were the last thing on her mind.

'I just didn't believe you, that's the bottom line,' Mary admitted to Vivian when they met years later. 'I just didn't take you seriously, ever, because you used to disappear out of my life and then suddenly turn up again.'[22] The relationship ended, but the couple would never forget the vivid memories of their first love. Vivian was even more determined to get his degree.

2
So the Boys Got Together and Formed a Band . . .
1961–65

In 1961 Vivian Stanshall went to sea. The plan was to earn enough money to fund study at Central School of Art. He was admitted without having any formal qualifications from his school days. Oddly enough, for someone whose success was to come largely from a dazzling use of vocabulary, his educational skills were relatively secondary compared with the tactile instincts of the artist.

'I remember smells, tastes and colours which I can recall at any time, but I couldn't quote you anything. I do engulf quite a lot of books, but it's not ordered – there's no structure,' he said. 'I freely admit to being in awe and jealous of people who have a classical education. The best education is the yooniversity o' life, innit?'[1] There were two problems with financing college and both of them were to do with his father: Vic earned too much money to qualify for a large enough grant for his son and 'equated artists with gypsies and ne'er-do-wells'. He would not give Vivian enough to get him through art school. His son entered the Merchant Navy.

Tourist Waiter Stanshall was engaged aboard the liner *Orsova* at Tilbury in Essex, on 12 May 1961. He was blossoming into quite an imposing young man in every way: as well as hair worn long for much of his life (even when it began to fall out), he had very delicate hands, like those of a classical pianist. They seemed incongruous against his large frame, and he always took great care of them, particularly his

right hand: he was ambidextrous, but this was what he called his 'magic hand'.

The *Orsova* set sail for Hong Kong, Singapore, Borneo and Sydney, Australia from Southampton. On board he refined his ability to drink, belch, fart, smoke and fight, which would be vitally important in his career with the Bonzos. He also developed a lifelong interest in knives, inscribing one with 'AS' for 'Anthony Stanshall'. There was plenty of time to indulge a voracious appetite, which played havoc with his waistline. He would amaze his seafaring chums at lunch by devouring four pork chops, held between the greasy fingers of one hand.

Tourist Waiter Stanshall was demoted mid-cruise for spilling hot soup down a passenger's neck and banished below decks to join the 'U Gang' ('U' for 'Utility'). 'Down there were all the most useless, terrible, vulgar sort of people,' says fellow-Bonzo Rodney Slater. 'They were all the "geezers" who weren't allowed on deck to be seen by the public. They were confined to the bowels of the ship and were only let out after dark! He loved those guys, the stokers, the guys who cleaned out the latrines, the hard cases below decks.' At least below decks you didn't have to worry about how you looked. Vivian recalled, 'You didn't have to mix with the passengers and could grow a beard.'[2] Because of his height, he was encouraged by his shipmates to try deck boxing. Vivian got his face punched in every time.

'He had to do it, yet he hated it,' explains his son Rupert. 'He was a dreadful coward really. He went through with the ordeal but he'd go down with the first punch. The guys would be telling him, "Go on, you can do it. You're a big lad!" And then they'd put money on the other guy. Dad suggested that I went into the Merchant Navy myself at one stage but I didn't fancy that.' When the liner docked, there was an opportunity to get away from the ship's discipline. In far-off Port Moresby in Papua, New Guinea, Vivian said he went through a blood-brother initiation ceremony with a tribal people.

'The bushes parted and a savage face peered out and somehow intimated that he would like me to follow him,' Vivian later told a journalist friend. 'Being a young man, I went.'[3] How many of the magnificent tales of nautical adventures and outrageous exploits were strictly true was a matter for conjecture among his friends back in

England. He told the stories well, kept his audiences captivated and so the accuracy really did not matter to them.

'I got the feeling the story changed as time progressed,' says Monica. 'Eventually the story encompassed the entire world, but I'm not sure that the trip did. He certainly liked the idea of initiation ceremonies.' He also liked to bewitch friends with the account of his visit to a restaurant in Hong Kong where he had monkey-brain soup. He described sitting there surrounded by monkeys in cages mounted on the restaurant walls. 'You ordered soup and these monkeys knew what was coming,' he related with ghoulish delight. 'The chef pointed at one and the monkey screamed its head off.'

Seaman Stanshall was discharged from the *Orsova* on 16 October 1961 at Tilbury. Armed with the savings from his life at sea, he became a fully-fledged art student and began to lead the kind of life his father had warned him about. After a stint at West Essex School of Art, Vivian, aged nineteen, enrolled at London's Central School of Art, off Kingsway, in the autumn of 1962. He was overjoyed at his new-found freedom as a student living in town and his parents were there to help him choose digs. He did not like the first flat at all. 'Vic and Anthony went in,' says Eileen. 'Well, it was about four minutes later that Anthony came out, put his hankie to his nose and said: "I couldn't live in there. Terrible smell, Mum."' They had better luck with the next flat and Vivian had better luck with the landlady.

'After a while he came home one weekend, and I said, "How are you getting on with that woman?" He said, "She's wearing me out. I'll have to dump her. I can't stand it." So what he got up to with that woman I don't know. I didn't like to go into it any further. But he never had any bother getting girlfriends. They all seemed to like him and it seemed as if he knew a lot of people.' Vivian settled in well and proceeded to eat his way through his grant very quickly, forcing him to rely on friends to supply fish and chips. He spent much of the rest of his money on unusual brass and stringed instruments. Vivian had more than thirty instruments, including ukuleles, mandolins, recorders, ocarinas, and – most cherished – a tuba and a euphonium.

Vivian commuted to college on the underground. He regularly created public situations filled with tension to see what people's

reactions would be, a fascination with pushing the boundaries which stayed with him for most of his life: 'I started testing people when I was travelling by tube to Central School of Art,' he said. 'I bought some stuff called Wasp-Eez, which I bought for the name. I would scratch or roll up my trousers and apply Wasp-Eez and then I would find that the carriage would empty or they'd move away, and it's like the old one, if you start scratching, everyone starts scratching.

'I became very fast with the *Evening News* and the *Evening Standard* crosswords, which are cryptic. Since I'm left-handed, I write on the side. So everyone sits on the train doing the same crossword and I would fill in completely the wrong answer, but near enough to look convincing, which would bugger up the guy next to me. What becomes difficult is fitting in other words or getting a word to fit. But if you do this with confidence then he is truly thrown.'[4] On other occasions, Vivian would slowly and deliberately black in the whole of the crossword, square-by-square: 'and that was disturbing'.

He later teamed up with college chum and future Bonzo drummer Larry Smith to play more involved pranks. 'I have a rubber hand. This is an idea I got from a Victorian pickpocket, who would go to church and have false hands in prayer in the front while she was dipping her fellow-worshippers,' explained Vivian. 'I would have these obvious false hands and have Larry next to me and pick his bag, steal things very obviously to see if anyone would stop me. And people wouldn't do a thing! They would continue to read and if I looked at them, fixed them, to see if I was caught, they would return to their newspapers. They didn't in any way want to be involved.'[5] This was what struck Vivian. An individual could be in any kind of trouble or distress and everyone would pretend that there was nothing happening.

'I mean, we staged hangings,' he said. 'I came in with a hangman's noose and put this on top of one of the strap things and put it around my neck and stood on the seat ready to hang myself and jump off and it would be too long, you see, so that would be a nuisance. I'd keep shortening the rope and people would just watch this, they wouldn't try to intervene – it was absurd.'[6]

There were plenty of other like-minded new friends at the college. Roger Wilkes was a fellow-musician who taught Vivian to play

trumpet properly. Rodney Slater got to know him through the tight-knit art students' social circuit. Pop Art was becoming fashionable, which meant that a poor student keen on collecting could pick up the relics of the jazz age for next to nothing: 'Nobody wanted all the memorabilia like the old sheet music and gramophone records,' says Rodney. 'The grown-up world was the world of your parents, which you didn't want.' The students saw nothing of much interest in the blossoming teenage movements.

'Kids were already being exploited in terms of clothes and music. One sniffed a rat even back then. If you were a certain kind of person you just didn't belong in either world. You had to make your own world of craziness. Which was . . . the band. As members of the Bonzo Dog Doo Dah Band we lived our lives in the same way all the time, on stage and off. We remained individuals within the group but at the time we did it without thinking. It was just the thing to do.' Rodney Slater, a powerful master blower of the bass and baritone saxophone, was born in Croland, Lincolnshire in 1941. He played in a trad-jazz band with two friends from college, Chris Jennings and Tom Parkinson. They met trumpeter Roger Wilkes, drummer Sam Spoons and Trevor Brown, who played college dances, at the Royal College of Art. Together with Rodney and his friends, they formed a new outfit, influenced by bands like the Alberts, the Firehouse Five and the Temperance Seven. They met Vivian the day before he was due to start at college.

'He had nowhere to live,' says Rodney. 'Tom met him at the Pillars of Hercules boozer and brought him home. We were living in West Dulwich then. I had actually seen Viv at a party a few months previous. We were playing at some old church in Westbourne Grove and Viv arrived wearing a frock coat and a huge red beard. He was prancing around and kind of performing in the pulpit and I thought, "That's an interesting guy!" Then it all went crazy and the police came and before I could talk to him we all had to leave.' When Vivian arrived at Rod and Tom's flat in West Dulwich, he made himself at home and was invited to join in their music-making. Vivian recalled: 'There were instruments all over the place at Rod's house and he said, "Do you think you could play tuba?" and so I started with that. They

didn't have a vocalist.' Rodney and Tom brought Vivian along to the Royal College of Art for an evening session. Vivian listened for a while and then asked Roger if he could get up and sing something. 'He did either "I'm Forever Blowing Bubbles" or "The Sheik of Araby",' says Roger Wilkes. He delivered the song with a comic edge and was asked to join.

'I started posturing at the front,' Vivian said, 'got the smell of it and started dominating a bit, singing lyrics out of newspapers – all very Dada.' The actual date of the formation of the Bonzos was the night of 25 September 1962, when Rodney and Vivian decided to stay up late and listen to a transatlantic broadcast of a crucial boxing match between heavyweight fighters Floyd Patterson and Sonny Liston in Cominsky Park, Chicago. The young musicians decided on the name of the band while they waited for the broadcast to begin. The fight lasted for two minutes and six seconds. The Bonzos clocked in at eight years. 'Tom had come home to listen to the fight on the radio and brought Viv with him,' explains Rodney. 'We started talking about the things we liked and we all decided we'd like to have Viv as a member of our band. He couldn't really play anything. He was just a character. He did have a guitar with him and plonked away but he was going to be the singer.' Vivian readily admitted that he had not had any formal coaching in music: 'No. I wish to God I had. I think if I had done, I wouldn't have had the gall to make a row, I'm sure I wouldn't,' he later said. 'As people dropped out in the old band, so I took over whatever was needed.'[7]

Their name was the Bonzo Dog Dada Band, in honour of both the artist George Studdy's popular cartoon dog Bonzo and the Dada art movement. The Dadaists sought to overturn preconceived ideas about what art should be. With his 1917 piece, 'Fountain', one of the leading lights of Dada, Marcel Duchamp (1887–1968), took an ordinary urinal, signed it 'R. Mutt' and submitted it to a New York exhibition, causing outrage and consternation when it was predictably rejected. By decreeing that it was art, he said, surely the artist has then made it art? It was this sense of fun and anarchic rule-breaking that was alive in the Bonzos. What they wanted to say or play was always going to be more important than appearing to be the best in

the neighbourhood, or the highest paid. Like the Dadaists, the Bonzos had a love of their medium and similarly refused to stick with one style, moving from jazz to rock as the mood took them, continually experimenting and provoking their audience. Both Duchamp and Stanshall produced relatively little work, much of which was deceptively simple. They were fond of using puns, private in-jokes and references, wilfully obscure symbols and lots of innuendo.

The 'art-school Dadaism thing', as Bonzo Roger Spear puts it, was also the inspiration for some of the weird and wonderful effects. 'We used to use everyday things to confuse people. Instead of "Mr Jones" on a name plate outside a house, you'd put "Shopping Bag". Shirts and trousers – they're just good names. In fact I once bought a house, went up into the attic and there was a trouser press.' Roger immediately used it in the band. The Dadaists also created machines, as Roger would later do in the band. In 1959, Duchamp put together 'Rotoreliefs', machines powering discs with patterns on them. As they rotated, they would give the impression of three-dimensional images.

The musicians quickly tired of explaining what Dada was about and the band became the Bonzo Dog Doo Dah Band and then just the plain old Bonzo Dog Band by 1968. Stanshall commented: 'I'm tired of people joking with the name. I remember a chap at school called Smellit who kept mice. His life was made hell. Yet the bullies were called Sagger and Belcher.'

As for the Doo Dah, Rodney Slater says: 'I never came across anyone who used those words "Doo Dah"' except my mother, who used them all the time: "Oh, fetch me the doodah." When Rod met Vivian, he was surprised to hear him using the same quaint expressions. 'We both loved these strange expressions people used in different parts of the country.' At Maida Vale tube station one day, they heard that the train was cancelled. 'Bugger my rags,' exclaimed Rodney. Vivian had never heard that expression and he 'literally lay on the floor and was uncontrollable. Anything like that really made him laugh.' Vivian introduced him to Southend expressions. Vivian was fascinated by language and was always developing his vocabulary. During the first three years of the band's existence he went to night school to catch up with everything he'd missed out on

at school. He studied English literature and German at night school and was very serious about it, going to the evening class before he'd go to the pub.

'He adored Hitler's speeches,' says Rodney. 'Not because of what was said in them, but the way he delivered them. It was the hysteria that he created which Viv loved. He'd sit there listening to these speeches and began acting them out himself. We even painted a huge swastika on the ceiling of the flat we shared. You could see it from the street, if you knew where to look up at the first floor. There was this red ceiling with a big black swastika on a white background.' They shared the same sense of humour, danger and the ridiculous: on one occasion they returned to their flat from the pub by lying down in the middle of the road and rolling through Dulwich Village all the way home.

Until the end of 1962, the band line-up featured Vivian (megaphone), Rodney Slater (clarinet), Roger Wilkes (tenor horn), Tom Parkinson (sousaphone), Trevor Brown (banjo), Chris Jennings (trombone) and a drummer from St Martin's called Tom Hedges, plus any number of friends stopping in on a temporary basis. The students played at the Prince of Wales, a pub in Notting Hill Gate, and during intervals at St Martin's School of Art, at Central School of Art, the Royal College of Art and Camberwell College of Art. Most of the students from these colleges scattered across London would descend on the Royal College on Friday nights intent on tanking up. The main hall had a big stage and an upstairs bar which could cater for three hundred people. Rehearsals for the band were either on the main stage or in a room above the hall and people would drop in to hear them playing.

They were treated to a highly erratic form of 1920s jazz, far removed from the straight style of the big trad act of the time, the Temperance Seven, fronted by Paul McDowell. Vivian had a feel for comedy and within a couple of months he started to dress up. For 'Sheik of Araby' he'd wear a large Arab head-dress. He was a natural comic, making wonderful stage entrances and provoking laughter in the audience before reaching the microphone. It was fun, but it was strictly a hobby, an excuse for anyone to join and 'make a row', as the

band called it. Something to get away from studying. Art schools played a vitally important role in the development of the British pop and rock scene. The Who, the Kinks, even blues bands like the Pretty Things, Yardbirds and Cream, had art-school origins. The colleges provided a kind of support structure for a breed of highly motivated, energized youngsters desperately seeking opportunities for self-expression. If the hard graft of painting, drawing and design became too demanding, playing music provided a more instantly satisfying lifestyle. Art colleges underpinned the British music industry, providing grants, entertainment budgets, rehearsal facilities, venues and a ready audience.

Music-making could also be a distraction from art. Vivian wanted to be a great artist, his music always a secondary concern, no matter how well he did. 'Painting was so important to him that if he couldn't do it – it would have killed him,' says Ki Longfellow, Vivian's second wife. 'So it didn't matter if he fucked up the music side and wasn't taken seriously because that's not who he was. He could play at being a pop star or play at being a lyricist. If he failed as a painter, then he would have been a real failure as an artist. But he didn't fail as a painter – because he didn't paint! What he did do was spend the rest of his life being diverted from what he really was. That's what he regretted.'

Vivian's personality was beginning to blossom now he was free of his suburban roots. His role as the singer with a bunch of musical iconoclasts gave him the opportunity to be as expressive, funny and outrageous as he liked. Instead of being shouted at, criticized or punished, he was applauded. When he took to the stage and began singing and ad libbing his well-rounded vowels and distinct enunciation were assets rather than liabilities. The band stood out so much off stage, they barely needed to dress up for performances. Vivian favoured large, flat, cloth working men's caps or period smoking jackets, while smart double-breasted suits worn with white shoes and his hair parted in the middle gave him the appearance of a raffish gangster. He habitually wore large and ostentatious spectacles and even donned false ears and eyes from his favourite joke shop. It was an altogether more interesting outfit than the duffle coat-topped ensemble donned by

the average 1960s beatnik. The major influences on early Bonzo performances cited by Vivian were pioneering comedy band the Alberts, whose 'Sleepy Valley' he bought as a youngster, and *commedia dell' arte*, a theatrical movement that flourished in the Italian renaissance. The Alberts, together with 'Professor' Bruce Lacey, had been giving concerts that mined a surreal comedy seam some years before the Bonzos. In 1962 they had recorded for EMI such pleasantly daft items as 'Morse Code Melody' and they too had a striking stage act.

Like the Bonzos, Bruce Lacey collected traditional-jazz instruments. He too had an art-school background, coming out of the Royal College of Art with a degree in painting in 1954. He started doing cabaret, using props such as exploding pianos, and the Alberts provided music for his humour while he created the visual imagery for their act. They played 1920s jazz and music-hall songs, dressing up in Victorian costumes. The Alberts worked with Bruce for some years, staging 'An Evening of British Rubbish' at the Comedy Theatre in 1962. This gig was particularly influential for the Bonzos. Their tuba player, Tom Parkinson, who also did pyrotechnics for the Alberts, took along Roger Wilkes and Vivian to see the band play. Seated right in the front row, Vivian loved every minute.

'He started to dress in Victorian or Edwardian costume too, except the hats got bigger and his beard got longer!' says Roger. Sometimes the Alberts would augment their ranks with other musician chums, playing as the Massed Alberts for charity shows. The Temperance Seven and later the Bonzos were among their guests. Bruce Lacey himself thinks that he and the Alberts showed the Bonzos 'a genre in which they could work' and was at times 'rather pissed off' because he saw more than a few of his ideas being used by the Bonzos. Bruce made props for the Goons and television shows by Spike Milligan, Peter Sellers and Michael Bentine in the late 1950s. He made a robot called Rosa Bosom, who appeared as the Queen of France when the Alberts did a version of *The Three Musketeers* at the Royal Court theatre in London. Two other robots he called 'Electric Actors', one of which used to sing 'I'm Forever Blowing Bubbles' while puffing out bubbles from its chest. Roger Spear made a very similar machine

for the Bonzos' stage show, to Lacey's annoyance. In turn, the Bonzos were piqued when another trad act, the New Vaudeville Band, came on the scene and stole their thunder with 'Winchester Cathedral'. The truth was that the influences stretched back many years: bands such as Spike Jones and his City Slickers had been doing energetic parody numbers decades before the Alberts themselves.

Under the influence of watching the Alberts in action, Wilkes added tunes like 'Goodbye Dolly Gray' to the Bonzo repertoire and Tom began using a sousaphone on stage. Thursday at the Royal College of Art was reserved for practice night and the band was beginning to build up a set. They started to use explosions between numbers, like the Alberts. The first incarnation of the Bonzos had little time to perfect a set before band activity came to an abrupt halt around Christmas of 1962. The crisis was provoked by the sudden eviction of Vivian, Rodney and Tom. Their landlord took exception to the students' lifestyle, particularly their experiments in making scrumpy cider. Vivian suggested they use the fruit of a pear tree in the garden to brew some booze. They stripped the tree of pears, which they put in the bath.

'We added a few bags of sugar and waited for something to happen,' laughs Rodney. 'All that happened was nobody had a bath for two months because of this *mess*.' This was not the only aggravation caused by the troublesome tenants. One night Rodney caused a deafening explosion in the communal toilet bowl. 'I used an electric match packed with flash powder,' he reports. 'The instructions were: "Never let one off in an enclosed space." So I did it just to see what would happen. It cracked the bog. So that was another black mark.' The landlord finally asked the band to get out.

The band members recovered their poise to recruit more musicians. Vernon Dudley Bohay-Nowell (born 1932) was working as a lecturer and rented a flat opposite Goldsmiths College in New Cross, south London. He was older than the rest of the band, which meant he was the butt of many ageist jokes, but he was a good musician whose Home Counties accent was a match for Vivian's. Unique among Bonzos, Vernon owned a car, which proved very useful to Vivian, who never learned to drive. Vernon brought another asset to

the band. He was letting a room to a friendly young student called Neil Innes (born 1944), who happened to play the piano.

Neil was a gifted musician, who studied piano from the age of seven until he was fourteen, when he decided to switch to guitar. He bought himself a particularly cheap example. 'It was such a bad instrument I thought it was really difficult playing guitar. It was more like playing an egg slicer. I put music to one side because I got more interested in painting.' At the age of eighteen, Neil went to Goldsmiths, where he met Vernon. Neil recalls being 'a bit smothered' when he too was invited to join the band. 'I just pounded away with the chords on the piano while others went mad on saxes and tubas.' He could also sight-read music – the 'dots' were largely a mystery to Vivian. First introduced to the Bonzo singer at the New Cross Arms, Neil was intrigued. 'Viv was in his large phase. He had trousers like Billy Bunter and wore a Victorian frock coat and horrible purple pince nez glasses and carried a euphonium under his arm. He also had large false rubber ears on. The music was awful. Dreadful row. We used to rehearse up there in the canteen with a lot of people who came and went. It was very confusing.' The Bonzos started as they meant to go on: noisy and loose. Their skill lay in developing a polished act which allowed for improvisation. The cheerful incompetence was in part exaggerated for comic effect, though which parts were exaggerated was not always clear either to band or audience. In these early days, they were far more ramshackle than they later pretended to be.

By this time, Vivian was squatting in a large Victorian house in Chalk Farm, near the legendary Roundhouse venue. Roger also took a room there and when Rodney popped over, the three would have a jam session. The next house Vivian moved to had no windows and was freezing cold, but 'he put up with it', says Roger, 'and I think he could easily have ended up living on the streets and enjoying it'. The line-up was similarly changing. Rodney was back, Vernon was a permanent member, mainly on banjo, and Roger had found a new percussion man, Martin Ash. His skill with playing cutlery, as much visual as musical, led to him adopting the stage name Sam Spoons. He improvised instruments with a cast-iron banister 'borrowed' from one of the stairwells in the Royal College, with weightlifter's bars

fitted to the bottom. Brackets were salvaged from old pianos and from them hung cymbals. Says Roger: 'Sam was hilarious and fitted the band perfectly.' Sam was also a more successful art student than Vivian, who found that very hard to cope with.

'The ultimate was to apply for the Royal College of Art,' says Vernon. 'If you could get in there you could lead a wonderful life for another three years. Sam got in. Viv didn't. He hated the idea of Sam being his superior.' Mostly, though, the band were just having fun. Their first pub gig was at the Warwick Arms in the Portobello Road, west London, which Sam had procured as he lived just around the corner. Vernon and Neil found a regular gig at the Bird in Hand in Forest Hill. When they began playing a regular Kensington Arms gig they were spotted by Roger Ruskin Spear (born 1943). The son of a Royal Academician artist, Roger played the saxophone in 1920s-style jazz bands. He came to see the Bonzos with his trumpeter friend Lenny Williams in tow.

'I couldn't believe anyone was that bad,' recalls Roger with awe. In the context of a stuffy trad-jazz scene, where most bands were note-perfect but played with no passion, the Bonzos represented freedom and fun. Another friend who sometimes played in the band, Sid Nichols, introduced Roger. That night he and Lenny sat in for a session and the arrangement became permanent. Roger thought the props the band were using were fantastic, particularly Vivian's take on the Temperance Seven's life-sized dancing doll. Only the Temps' doll was an exquisitely made Victorian beauty, while Vivian's, christened Alma, was a rough papier mâché bird, a 'grotesque woman covered in warts' according to Roger. Vivian danced romantically with the doll attached to his feet.

With a background of study both in the sciences and art, Roger was uniquely placed to take the Bonzos beyond Albert-copying in terms of robotic props and with ever more dangerous explosions. The band became more popular as they gained experience. They were asked to play a lavish twenty-first-birthday party, held in a large private house in Kensington, at which Vivian turned up roaring drunk and promptly collapsed on the carpet. The band had to play without him.

By early 1963, Roger Wilkes graduated from the Royal College and left the band to concentrate on his career as a furniture designer, under pressure from his girlfriend, Rosalyn. She came along to a gig immaculately clad, with a mink stole. The band generally behaved so badly they all found it difficult to keep girlfriends and on this occasion they were so coarse they were thrown out of the venue. Rosalyn made it abundantly clear to Roger that she did not care much for their lifestyle, and so he bowed out, to be replaced by Bob Kerr, on cornet and trumpet.

Rodney Slater was coming to the end of his course and Vivian had one more year to go at Central. Now established enough in the band to make his opinions known, he took the opportunity to create further line-up changes by picking on their trombone player, John Parry. Vivian was 'a terrible snob', says Vernon, 'and so anybody like John, who didn't have a degree, was in "a different class"'. Vivian criticized Parry's playing, his punctuality and his 'cheap trombone'. When Parry crashed his scooter on the way to a gig, Vivian sent a letter to sack him while he was in hospital.

The band got a new regular gig at the Tiger's Head in Catford. It was bigger than the Bird in Hand and the band now included Syd Nichols, the replacement for John Parry. Syd and Vernon would alternate on tunes like 'Tiger Rag', played at tremendous speed. The band rocketed through old novelty numbers such as 'Ali Baba's Camel', 'Little Sir Echo' or 'When Yuba Played the Rumba on the Tuba Down in Cuba'. They were developing an original cabaret act of manic invention. A typical evening began with an extremely slow and sombre version of 'Rule Britannia', accompanied by the Queen Machine. This contraption gave a series of Royal Waves, until the climax of the anthem, when a shattering explosion 'invariably got the audience's attention', recalls Neil Innes. It also set the tone for the evening, which passed in a bewildering stream of explosions and maniacal playing, supported by props, visual gags, shouting, abuse and yet more explosions, so many that some in the band later developed severe tinnitus, Vivian among them.

They discovered that if they taped their explosives more loosely they got a red flash and lots of smoke. Roger had a wind-up

gramophone case on stage and he would wire up the fuse, put it in the case and let it go off. The case gradually filled with flash powder, which was very sticky. One night at the Tiger's Head somebody dropped a lighted cigarette end into the case and it all lit up and burned ferociously. 'I've never seen a pub empty so quickly,' says Vernon. 'They all went outside with their pints and had to wait for half an hour before the smoke cleared!' All these explosions and fires did at least mean they could frighten an unruly or unappreciative audience into submission. The rush of bangs, the cartoon speech bubbles held up, the props – it all came at a dizzying pace. Between and indeed during the numbers there was all manner of comedy business as the band dressed up as camel drivers, policemen, ice-cream salesmen, sword swallowers and tap dancers. Sam used three wooden blocks for an old music-hall routine, appearing to be juggling the blocks, while one was attached to his belt.

For the audience, the show was exhilarating, shocking and hilarious. An early set list gives an idea of a typical gig. It starts off with a number which has, inevitably, 'explosion' written against it. Their choice of tunes that night included 'Ain't She Sweet', 'Bubbles', 'Abie', 'Alexander's Rag-time Band', 'Whispering', 'Yes Sir, That's My Baby', 'Ukulele Lady', 'Sheik of Araby', 'Bill Bailey' and 'Tiger Rag'. The Bonzos alternated between 'fast', 'slow', 'novelty' and 'waltz'. Halfway down the list was marked 'Military medley' and, in brackets underlined twice, an ominous 'pyrotechnics etc.'. They ended with 'There'll Always be an England'.

Whenever the band needed a new number, they would go out and scour the second-hand shops for a song with a silly name. Spotting 'I'm Going to Bring a Watermelon to My Girl Tonight', they'd hand over a few pence for the sheet music and it would become another Bonzo favourite. Few people in the average pub crowd had been exposed to much in the way of 'live' theatre or come across such apparently exotic characters outside of a music hall. Stanshall's stage persona in particular seemed to change before their eyes. He was sophisticated, knowing, worldly and effete; then crude, coarse and streetwise. The effect was mesmerizing. Audiences sat entranced by the spectacle. The songs, gags and routines took hours to work out

and the band put in many anxious hours to improve the performance. Their reward was gales of laughter. Even Vivian's father might have been mesmerized and cracked a smile, had he turned up. Vivian's brother Mark, then running antique shops in London, came down to the Tiger's Head to see the band, who also played three gigs a week at the Deuragon Arms in Hackney. It meant cranking out a lunchtime gig, rehearsing all afternoon and then rushing over to the Tiger's Head for an evening show. Landlords were happy to have them, as people bought much more booze during the show, and the band were actually making something of a living: a whole £25 a night in some venues. They were the envy of any impoverished student, still at college, but earning the equivalent of the national wage.

'Until the year I was taking my finals we were working six nights a week,' said Vivian. 'At an earlier stage, from the Royal College days, the band consisted of maybe forty people with the same attitude and it didn't really matter if they could play or not. I can remember turning up at some boozer which was so tiny and the stage was so packed that we performed along the top of the bar. Sometimes there'd be one pianist and nine banjo players. You never knew who was turning up. Eventually people would say, "I'm an artist" and drop out. As far as I was concerned what we were doing was merely an extension of what we were doing as artists and a damn sight more fun. So it just narrowed down to those of us who weren't serious about "art" in the context of art school.'

It became increasingly obvious that Vivian Stanshall had a real talent for mime, mimicry and visual comedy. Long before the age of professional Elvis lookalikes, he loved to offer skilful imitations of Presley, even at the risk of causing offence to teddy boys, who loudly protested at his mockery of the King. Most audiences howled at Viv's increasingly clever and theatrical performances. This was not just the result of art-student foolery. He took his craft more seriously than anyone knew, spending the summer of 1965 at the Edinburgh Festival studying with the mime artist Lindsay Kemp, whom he had met at the Central School of Art. It was the same Kemp who later took David Bowie under his wing.

Kemp's show, 'Bubbles', was at the Traverse Theatre Club over the summer. Andy Roberts, guitarist with the group Liverpool Scene at the time, remembers Vivian as 'a pasty-faced chap' on stage. There was lots of Marcel Marceau-style material, involving pretending to be trapped in a box and similar routines. 'The show was sly, camp, gentle and revealing,' says Andy. 'Viv looked stunning in white face and he did these epigrammatic interludes where he came on playing the euphonium and stopped to say something like "Death is nature's way of telling you to slow down". Then he'd play the euphonium and walk off.' By the time Vivian returned to London, Neil and Vernon had found new gigs, at which an emboldened Vivian showed off the vastly improved theatrical and mime techniques he had learned with Kemp. He started faking a strip routine to 'Falling in Love Again'. He mimed taking off everything, including breasts, which were tossed camply over his shoulder. At this point Sam generally came in with a cymbal crash. The other band members added their own unique parts to the atmosphere: when Vivian went into a dance routine, Roger Spear enhanced the act with a home-made strobe light, a clever creation from a simple baked-bean can with holes in, through which a light was directed. It gave the effect of Vivian dancing in a silent-movie scene. Audiences were stunned. Nobody had used such effects in a live pop music performance before.

'The first time we used it the band couldn't play because it was so bloody funny,' says Rodney. 'It looked so real. Viv would do a lot of things like that.' Often it was ad libbed. Sometimes he did a routine about famous artists, becoming Manet the Jewish boy or Pissarro the Irish impresario. They were all names he would change around to much hilarity from the band, who were often as impressed as the audience. He also improvised a complex routine around a spoof of Raymond Chandler private investigators, which became a Bonzo album track, 'Big Shot', a number he sprung on the band during a gig. The Bonzo Dog Band were really coming together and would be complete with the addition of one more, flamboyant, member.

3
The Dopal Show Will Appear in Person as Themselves
1966

The Bonzos became more polished and their parodies of character-less pop and jazz more accurate. They turned their attention to the smarmy excesses of perma-tanned showbiz stars who affected mid-Atlantic drawls and exuded insincerity from every heavily made-up pore. In pricking the bubble of the self-important, Vivian had the perfect partner in his friend Larry Smith. The two improvised high camp satires of the starry elite, nowhere better than on 'Look at Me I'm Wonderful', from the *Keynsham* album of 1969. It featured Larry as the archetypal entertainer, beautifying himself for his big show.

Rapping on the dressing-room door, a stagehand alerts Larry Smith, busy applying his makeup. Time for the star to go on stage and face his public. Larry needs no encouragement. If anybody is going to upstage Vivian Stanshall and the band it will be the very gorgeous Mr Smith. 'Look at Me I'm Wonderful' reflected the exuberant person-alities of its writer and its performer. Larry and Vivian became friends early on in their college days. They shared the same sense of humour and a similar need for attention. Larry brought charm and a touch of class to the band when he joined at Vivian's request.

Larry Smith (born 1944) was a lively tap dancer – earning himself the nickname 'Legs' – a driving drummer and enthusiastic tuba player. He could also sing, but his main role was to smile sweetly at the audi-ence, strike coquettish poses and break the ice at parties. He was a

perfect foil for Vivian, both on and off stage. They wound people up with their saucy double act, some thinking they were gay, when both had a roving eye for the ladies. It amused them to let people think otherwise. They visited pubs and picked each other up, arriving separately and standing at either end of the bar, waving coyly. Vivian would beckon over the barman and say, 'Excuse me, would you ask that nice-looking gentleman if I could buy him a drink?' They were slung out of more than one pub for their efforts.

Larry was the band's number-one fan at their Kensington Hotel gigs for months before Vivian invited him to join in 1963. 'I am writing this on stage, dodging kisses while roses are being sprinkled at my feet,' he wrote. 'We are making eight pounds a week each. You can stay with me and you can learn the tuba.' Instead, Larry went to America in 1964, when he still had a year at college to go. He thought then he would be an advertising executive. He was offered a job at an agency in New York, which he initially intended to take up when he left college. On his return, Larry shared lodgings in Islington with Vivian.

'We would take about three hours to get ready to go out,' says Larry. 'Viv would be poncing himself up as Oscar Wilde and I'd be poncing myself up as Scott Fitzgerald. We both wore spats, collars, waistcoats and studs. Then we'd go out. We ran the gauntlet of abusive lorry drivers and building workers as we walked down the street.' The two would often mince down to the Turkish Baths, then in Kingsway, and pamper themselves.

'We developed a great empathy,' says Larry. 'Absolutely. There were times when Viv and I were on stage in the band doing these duets which were wonderful. We were very tight and emotionally involved and we knew what each other was thinking, so it was lots of fun.' Whenever the two did fall out, it was over who was getting more attention.

Tuba player Ray Lewitt joined the long line of ex-Bonzos early in 1966 and Vivian finally got Larry in. He was not much good on the tuba, but was a fantastic tap dancer. When Vernon sang 'You're the Cream in My Coffee', he added the line 'When I see Larry dancing . . .' at which point 'Legs' would appear sporting a

magnificent pair of fake boobs. He took to wearing American foot-ball shoulder pads and carried a Charlie Chaplin cane. His wild routines were a highlight of many Bonzo numbers, notably the splendid 'Hello Mabel'. Busking with Vivian in Holborn tube station on the Central Line, he developed his act. 'That was because the echoing sound was fantastic,' says Larry. 'The marble floors were fabulous for tapping. I would tap dance for the punters as they came home at night in the rush hour. Viv took the hat round and then we'd go off for a drink.'

The Bonzos did not believe they would make a professional living out of the band. Careers came first. Vivian and Larry were offered jobs heading a design company in Italy. Their new start rather clashed with another keen interest: drinking. Vivian very quickly showed the effects: a relatively small amount was enough to change his patterns of speech and he could put away huge quantities when he wanted. The two friends behaved disgracefully at a party given for new London employees and could hardly stagger back to the Islington flat. Larry just about opened the door as Vivian had by this time passed out. Some of the other party-goers literally dragged him upstairs by his arm and accidentally dislocated it. Vivian later discov-ered that when he executed some funky move on stage with the micro-phone, his shoulder on occasion came out of its socket. This unnerving ability to dislocate limbs was one of the few things he shared with the other members of his family. Both his father and brother Mark could do it, although neither of them could dislodge so many bits and so spectacularly as Vivian. Grisly surgery proved to be the only effec-tive treatment eventually, in which the arm was cut off and reattached.

That night in Islington also led directly to the swift retraction of the job offer. Instead of design in Milan, Vivian and Larry looked to the Bonzos for future employment. The band looked more inviting as each member realized he did not wish to continue as an artist. Vivian wanted to stay at college. Roger Spear and Neil lent him some paintings for his postgraduate show, which he passed, receiving a grant for a further year. It was a smart trick: 'He was a first-division rascal,' laughs Neil. 'He could rascal for the nation at Olympic level. Like a lot of people who are basically ruthless, he had a sentimental

streak. But once he was up and running nothing could get in his way. He was probably too ambitious.'

To take the band to a professional level, they needed a manager. Reg Tracey was the first of a series who had the thankless task of trying to keep them in order. They met him over Easter 1966 at the Tiger's Head pub in Catford, signing during their first club tour in the summer. True to form, they were all very drunk when pens were put to paper. Reg made much of the fact that he was the brother-in-law of Kenny Ball, a top British jazz trumpeter and bandleader. Poor old Reg. The Bonzos were tight-knit, as together as any gang Vivian could have wished to be a part of back in Southend. Outsiders had to work hard and Reg's chances weren't helped by his voice. A take-off of his unbearably dull tones can be heard on *Keynsham*'s 'The Bride Stripped Bare by "Bachelors"'. 'So the boys got together and formed a band,' drones the voice, 'fate played the straight man and since then they've never looked back.'[1] The way Reg spoke was so entertaining for the band that it was a major factor (apart from the booze) in ensuring he became the Bonzo's manager. He had contacts with the influential Bailey Brothers club circuit and organized a tour for the band after they finished college in the summer. It was a superb training ground. They could play, drink cheap booze and see starring acts such as Tom Jones, Shirley Bassey and Louis Armstrong. They took just one day out to organize a show that was to form the basis of their regular act for the next five years.

Reg quickly secured the band a deal with Parlophone Records. In April 1966, they recorded their first single, a splendidly raucous performance of the 1920s classic 'My Brother Makes the Noises for the Talkies'. The record begins with a tremendous crashing and banging sound. The row was supplied by the Bonzos' own Rowmonium, a box filled with metal which they took on the road in order to make even more noise whenever possible. The Bonzos' reading of the song was energetic and high-spirited, capturing their live feel and filled with the special-effect noises of the title. 'Talkies . . .' was backed by 'I'm Going to Bring a Watermelon to My Girl Tonight'. It was much played on the radio, which made up for its failure to hit the

charts. The band made their first TV appearances on 'Thank Your Lucky Stars', 'Blue Peter' and 'Late Night Line-up'.

The press began to sit up and take notice of these upstart ex-students. Journalist and author Chris Welch first saw them performing at the Tiger's Head in April 1966 and wrote an enthusiastic feature on the Bonzos for *Melody Maker*. A banner headline proclaimed 'Musical Mayhem' above a picture of a nine-piece incarnation of the band. Vivian appeared clutching a tiny ukulele, Rodney played what looked like a combination of a sax and clarinet and Neil Innes seemed to be playing the world's smallest saxophone, no bigger than a kazoo. Comparing the band to established acts, he told the paper: 'We're not doing a Temperance Seven – we're murdering the Temperance Seven!' The *MM* had discovered the band entirely by chance, the Tiger's Head being only a mile away from Chris Welch's home in Catford. It was a Sunday evening when he took sister Margaret and cousin Terry to the pub at the end of Whitefoot Lane for a quiet family drink. They were sitting in the bar overlooking the main road when they heard the sound of a clarinet being played – or tortured – in the rear lounge. The pub often hosted visiting jazz groups. But this kind of clarinet playing broke all the rules; the squealing, whooping and wailing noises seemed more suited to a circus act.

'As the band began to play a trickle of customers found a way in,' Chris wrote later. 'But we scarcely noticed as the tables filled up. We were transfixed by the performance. The first number may have been "Tiger Rag". At any rate it was loosely traditional jazz and the band stomped through with incredible energy and amazing cheek. It wasn't the horrid untogetherness of the Portsmouth Sinfonia, because some of the Bonzos could play very well and the rest tried hard and knew the right noises to make. It was raucous and funny and a just retribution for every trad band that took a break and cried, "Oh, play that thing!"'

The Bonzos looked to the north for their next move and with Tracey's connections, they embarked on a training that would earn them a little more money and make them a whole lot more accomplished. They were moving up a gear. The band's first fully professional nightclub engagement was at La Dolce Vita, Newcastle, and it

was non-stop from then on. 'We did two shows a night, driving hundreds of miles from one gig to the next,' says Neil. 'Looking back I don't know how we did it. I'm sure that's what made us all loonies!' Life on the northern club circuit was a profound culture shock. These Home Counties lads with their southern ways and posh accents were unprepared for the plain-speaking northern club crews. The Bonzos honed a tight-knit show in their intensive schedule that was far ahead of the average cabaret act. It was here that much of their best material was developed. When London swung in the late 1960s, the Bonzos' surreal material, their vivid clothes and energy in performing led many to assume they were part of the psychedelic scene, but the band were not inclined to conform to youth movements any more than they were to the Establishment. Dada and the club circuit were the influences, not fashion or recreational drugs, though most of the band were enthusiastic drinkers.

The booming world of the northern clubs, with its mixture of the glamorous and the down-to-earth, became the butt of comedians' jokes and was celebrated with a TV series, 'The Wheel Tappers and Shunters Club', complete with typical master of ceremonies in a flat cap. The atmosphere was also captured on the Bonzo track 'The Bride Stripped Bare by "Bachelors"', the title taken from a Marcel Duchamp work of 1923 which depicted the kind of mad machines Roger Spear might later have dreamed of making. Jointly composed by Stanshall and Innes, it was a world-weary re-creation in song of the band's experiences on arriving at yet another club up north.

'Bride . . .' is based largely on the Greaseborough Social Club where, says Neil, cabaret acts were introduced with a certain lack of ceremony. 'The chap with the flat cap would sit there, tap and blow into the microphone and say, "Kindly bring your empty glasses back to the bar. Hot dogs on sale in the foyer. And now here's Yana." And if the people were still talking he'd say, "Come on, give the poor cow a chance."' That typical club proprietor voice is in the song: 'Eh, lads, welcome t'club . . .'[2]

The Bonzos were invariably exhausted when they set up at a new venue: 'We arrived at the gig looking rough,' they sing on 'Bride', 'not happy, we'd all had enough: of eight hours on the road.'[3] The

accommodation itself was not much of a sanctuary on tour. Most guest houses had never seen anything like the Bonzos. While they were at Batley Variety Club, they stayed in the same digs for a whole week. The couple who ran it were particularly friendly and as the band's engagement drew to a close, the lads asked the husband if the two of them would like to come and see the show.

'I'd love to come,' replied the husband, explaining apologetically, 'but the wife, she doesn't like animal acts.' The band fell about – not least because they just could not work out where the wife thought this 'animal act' had hidden its Bonzo dogs for the last week. Hotel receptions were 'empty and cold, with horrid red wallpaper forty years old', as they sing on 'Bride . . .'. These places 'stank like a rhino house'.[4] In the morning, the band would be breakfasting with anyone from Tina and Tom the knife-throwing couple to Johnny and Bernice the singing jugglers, who did magic with budgerigars: 'We enjoyed these dreadful stage acts we saw every night,' says Larry.

The song also features a chilling reminder of the conditions the band faced in the back of the van travelling between these venues – 'Mr Slater said, "Poo! I can smell vindaloo".'[5] Most of the other Bonzos shared Vivian's crude fascination with bodily noises. 'When he had money he'd go out to the best restaurants. He would eat and drink and then after the meal he would give out this incredibly loud belch,' recalls Roger Wilkes. 'It was like this belching rasp, and he'd just sit there and wait for the reaction. Farting was his other great hobby.' Anybody who could let go with a real trouser-trembler was okay in Vivian's book. This was the reason he respected Sam Spoons.

'There's one great thing about Sam. We were on tour one day and we were all in the minibus and Sam farted,' Vivian told Roger Wilkes. 'It was the most vile stench and so bad we had to stop the bus and get out. It was the greatest thing he ever did. I admire anyone who can fart like that!' It was another reason why the band found it diffi-cult to keep girlfriends. Vivian, the most daring curry eater in the band, was also the windiest. 'On the road these dreadful oriental smells would come from the back of the van,' says Rodney. There would be a muted chuckle from the back and a cheerful, 'Sorry, dear boy!' The boys also started having conversations in belches. Everyone

would join in and ended up with their stomachs in knots. Vivian could recite the alphabet in belches and he got the gold medal when he managed to get his intestines around 'Birmingham'. During later solo gigs, Vivian often sat down at the piano on stage to play a tune, farted, then turned to the audience to explain, 'That was a bum note.'

'The Bride Stripped Bare . . .' follows the band to the venue, telling how their loyal road crew sets up the band's equipment at the venue, where a poster bills them as the 'Dopal Show' who will appear 'in person as themselves, woof, woof!'[6] The full billing for the band at one place had actually been 'Bonsa Doz Do-Pal Showband'. But when you think that a busy northern club promoter would be trying to take 'Bonzo Dog Doo Dah Band' down over the phone from a southern art student, 'Bonsa Do-Pal' was a pretty good guess. As 'The Bride . . .' goes into the coda, it develops into a chorus of threats and warnings, all clearly ingrained on the band's collective conscious-ness from their time on the northern circuit: 'You can have a drink in your dressing room, lads, but you can't come into the club looking like that!', 'Any artiste mentioning football will be paid off immedi-ately', 'It's not me, lads. It's the management that makes the rules' and 'That's a brand-new scratch on the piano. Cost you £75 to put that right.'[7] The scratch came from a routine the band developed around 'Blue Suede Shoes', and was a gag Vivian would return to many times in his career. There would be a huge explosion during the song, the musicians would all stop playing and start to mime, as if the sound had cut. There was complete silence. Only Vivian appeared to be aware of this, as the band carried on pretending to play. He'd look around for inspiration and then, as if the Bonzos were a stuck record, he'd kick the stage and they'd all start playing again. There was nothing to kick at Greaseborough except the grand piano. The owner was outraged. 'If there's a scratch on that grand piano we're docking your pay.' They learned more useful lessons from other performers. Initially reluctant to be told what to do, they eventually became enthusiastic about some tricks, such as rehearsing for a special trick ending, or 'false tab', as the regulars on the circuit called it.

There was also plenty of time for drinking. 'We would do these cabaret clubs and have a drink at the bar after the show,' says Larry.

'Then at 1 a.m., the bar would close and we'd carry on drinking with the management. So although we wouldn't get drunk before a show, we had a lot afterwards.' During the day on tour, there was not an awful lot to do, other than go back to the club where all the gear was still set up and rehearse and work out numbers. The professional status also brought a little bit more money for the band. 'Now we get £100 a performance,' Vivian told an interviewer, 'so we're all having our clothes made. We've added a lot of porridge, a lot of fruit and veg, sequins, rhinestones and things.' The hundred-mile (or more) journeys between gigs were less fun, stuck in an overcrowded and increasingly smelly vehicle, but there were ways of diverting themselves in the large, left-hand-drive Daimler ambulance that Vernon used to transport the band. When Vivian rode in the right-hand front passenger seat, he fixed a dummy steering wheel in position and pretended to drive, while leaning out of the window and glugging from a bottle of whisky. Vernon secretly steered the ambulance in a suitably erratic fashion, zig-zagging down the road. Passing motorists were horrified to see what looked like a drunken maniac at the wheel.

The ambulance was an ancient beast, with a three-ton concrete floor, so it could not be turned over. In its previous incarnation, the floors were designed so the patients would have a smooth ride. Three lucky band members sat up front while the rest, in the back, perched on ordinary kitchen chairs. None of these chairs was fixed to the floor. Every time the ambulance approached a roundabout, often at about fifty miles an hour, the hapless passengers in the back were alerted by a mocking chorus of oohs and aahs from the front. Chaos reigned as the van tilted sideways and chairs, band members and equipment flew in all directions. On other journeys, when being a Bonzo was all too much, the jolly characters who lit up the stage with their brilliant performances simply became grumpy young men who got on each other's nerves.

The Bonzos developed their own techniques for coping with being cooped up. For one thing, there was the official 'Bonzo certificate': 'This is to certify that _____ on _____ did behave vulgarly and bestially during a performance of the Bonzo Dog Band and he or she, whichever is applicable, is hereby titled Pig of the Day and

is now eligible to compete for the title of Belcher of Britain 196_. "The noises of your bodies are a part of our play."' Another approach to relieve the tension was much more straightforward: 'We used to have fits in the van where we'd all decided to scream,' says Neil.

'I thumped "Legs" Larry Smith once,' says Rodney. 'Viv hit him as well. It was terribly funny.' Vivian and Neil, now the creative centre of the band, had a tremendous argument in a dressing room. Neil said, 'Right, outside,' and opened the door. Vivian strode out and just shut the door. 'We all laughed so much it hurt,' says Rodney. 'Viv and Larry had a tremendous wrestling match in the back of the car once. It was just nonsense that erupted. Nobody got laid out.'

If the band did not let each other get away with anything, the people they met on their tours also treated them with a commendable lack of ceremony. Backstage at one of the working men's clubs one night, Larry asked one of the local staff members, 'I say, old boy, do you know where the loo is?'

'Aye,' replied the man and gave him directions. But when Larry got there, all he could see was one of those massive, old-fashioned, china sinks attached to the wall. He called out to the man again: 'Couldn't find the loo, old chap,' he said. 'All I could find was a bloody great sink.'

'Aye,' said the man, again. 'That's it.'

'I couldn't possibly piss in a sink!' snapped Larry.

His interlocutor was unmoved. 'Some of the biggest names in show business have pissed in that sink!' came the curt reply. 'We've had Shirley Bassey on there, Frank Sintra, Buddy Greeky, they've all been on there.' An impressively inaccurate list of stars and particularly evocative in its inclusion of Ms Bassey. 'If it's good enough for Shirley Bassey, it's good enough for you,' he snapped, ending the conversation.

There were as many memorable moments for the band on stage. Neil remembers: 'We had a marvellous week at the Ace of Clubs, Leeds.' The venue had a rising stage which came up out of the floor to a height of two feet. On the second night someone thought it would be a good idea to switch it on.

'We started rising at the front but not at the back. So Rodney's effing and blinding and trying to protect his saxophones. He didn't know which one to save first. The back was jammed and Roger pretended he was lying on the edge of a precipice. There was an almighty bang in the end when the back of the stage was released. Viv was in hysterics and couldn't control himself.' On another occasion, they set up on a rotating stage, which spun them around to reveal an audience who were throwing bottles and generally kicking off. The stage kept rotating and the band made a judicious exit without having played a note.

Vivian was in his element at the heart of the chaos. His commanding stature, his impish humour, his wild array of accents, the vocal and physical contortions and bizarre outfits, not to mention the array of instruments he played, completely won over audiences. Neil sat watching him, from the safety of his piano, with a mixture of nervous anticipation and wonder. If there were any hecklers in the audience, Vivian could dispatch them with ease. Looking down airily, as if they were simply impertinent subjects, he'd say something like, 'You could give the kiss of life to a hippopotamus', or 'I don't come round and interrupt you when you're performing', and invariably got away with it. He was simply being himself. In Manchester, as Vivian and Neil were leaving one of the many Indian restaurants they frequented, they met a little old lady along the street, pulling a wicker shopping basket on wheels. Stanshall dropped on one knee and started singing 'One Alone' to her. He went all the way through it: 'One alone to be my own, I alone to know her caresses . . .' and she listened. She might have whacked him or called a policeman. But at the end of the impromptu recital, the lady just said, 'That was really nice. Thank you very much.'

'It *was* really nice,' affirms Neil. 'He was being completely guileless. I remember watching him and getting a lump in the throat. Nobody else could have done that. But he was dangerous. He was dangerous the minute he went on stage. You had to watch him. You'd think, "What the hell is he going to do?" He might come out and say, "Good evening ladies and gentlemen. The next time I say that, I want you all to shout 'Balls!'" ' And the audience would happily

oblige. At one venue, the band ran across a comic from the circuit who was seated with his drink in the bar. He approached Vivian and glumly told him, 'You know that thing where you get the audience to say "Balls"? I tried that in Jarrow and got paid off.'

'Nobody else could do it like Viv,' says Neil. 'He was definitely our front man. Once, he got food poisoning in Sunderland from shellfish and he couldn't possibly perform. The rest of us had to try and cope and I remember desperately trying to get through "Jollity Farm" without him and it was really hard work.' At another club, Vivian was conducting the band with gusto and managed to dislocate his shoulder yet again. Larry Smith helped him away, pouring a large brandy down his throat. The ambulance men were called and Vivian was taken out of the club on a stretcher, getting the medics 'to make it look as much like a straitjacket as possible'. With a blood capsule foaming away in Vivian's mouth, they lifted him over the tables, much to the delight of the audience. 'They all came up to touch the body. All theatre. And they said, "Bloody great! Aye, bloody great, champion."'[8]

Vivian became used to certain conventions of performing that passed by sophisticated metropolitan types. BBC producer John Walters, a great champion of Stanshall, worked with the Bonzos on Radio 1 and made the mistake of thinking Stanshall would relish seeing a popular northern singer of the day called Lovelace Watkins. When a Lovelace show was announced at the Talk of the Town in London, John got tickets for himself and John Peel, their partners and Vivian. While the southern contingent prepared to enjoy an ironic view of events, the rest of the club was filled by the inevitable busloads of Lovelace's northern fans. Vivian, accompanied by a girlfriend, arrived wearing a kind of string bow tie, a purple sombrero and a purple vest, with blondish hair bursting out all over. 'Hello amigos! How are we all today?' he boomed, glancing over at the ladies. 'Ah, the *memsahib*!'

Vivian bounded on to the dance floor with his girlfriend. 'Come on then, darling, let's trip the light fantastic.' This involved a kind of proto-punk pogoing routine. As the rest of the dancers pirouetted placidly around, Peel and Walters could occasionally see a flash of

purple sombrero as Vivian bounced up and down. By contrast, Lovelace himself was a bit of a letdown: Vivian didn't see any inherent comedy in the melodramatic ballad style, which made Walters realize that he really could not always understand what made the man tick.

'I've seen all that kind of thing in northern clubs before, dear boy,' Vivian explained. He knew that one of the reasons the Bonzos went down quite well was that, like Lovelace, they had a perfect cabaret act. Vivian held hard-working entertainers in respect. The Bonzos worked the clubs like anyone else. If people requested chart hits, they would generally play them. 'We would turn up and find that we were billed as "Britain's zaniest trad band",' explained Vivian, 'and so we'd be Britain's zaniest trad band – until we got bored with it. But I liked that.'[9] One of Vivian's bits of business involved wearing a gorilla mask and impersonating Frankie Vaughan. They inevitably met the man one night and Vivian, a confirmed fan, was mortified, though Vaughan laughed it off.

The band's reputation was strengthening through their increasingly powerful live shows. A young radio producer named Richard Gilbert was one of the converts. He first saw the Bonzos at University College. 'I found them quite extraordinary,' says Richard. A particular stand-out for him was Vivian's Elvis act: the gold lamé suit with the stuck-record routine. Richard determined to get the band's frontman on his BBC radio programme, a World Service show called 'The Young Scene'. Having seen them two or three times, he managed to get Vivian into Bush House to interview him for his show and went on to write about the Bonzos in the national press. He became quite close to Vivian and discovered his genuine enthusiasm for rock'n'roll went as deep as the Bonzos' affectionate parodies suggested. There was an Elvis Presley club which held their annual convention in Nottingham and in the latter part of the 1960s Vivian took guitarist Andy Roberts and Richard Gilbert along. Rather than trying to upstage the acts or fans, Vivian did not attempt to stride around in his gold lamé outfit. He was content to soak up the atmosphere of the event.

The Bonzos played all over the country. They were booked down south just after the summer by an art school for a ball in High

Wycombe, Buckinghamshire. Before the show started they repaired to the bar, which was set up in the cellar. To their alarm they found the local chapter of the Hells Angels had somehow got tickets or simply forced their way into the building. The bikers jumped over the bar and were pouring their own pints of beer; the staff were too frightened to stop them. The band hastily retreated back up the stairs into the hall and on to the stage to hide behind the red velvet curtains. Reg Tracey was on hand to supervise the gig and he signalled when it was time to go out and perform. There was already trouble out front. Shouted Reg: 'Get the curtains open and start playing!' The boys kicked in with 'Cool Britannia' as missiles hurtled towards the stage. Vivian edged back and Big Sid shouted to their manager: 'Don't be an arsehole – close the curtains!'

'No, play on!' insisted the manager, like some World War One general ordering his troops over the top. Heavy objects rained down on the stage and some of the Hells Angels decided it would be fun to jump up, grab the instruments and start playing themselves. There were two huge dustbins either side of the stage which had been there for decoration. Trumpeter Bob Kerr picked one up and yelled, 'You're not having my trumpet!' and hurled the huge bin at the Hells Angels. They rolled back out of the way and at the same moment the curtains were drawn and the band fled. Meanwhile the police had been called to quell the riot.

Outside the hall Reg was furious. 'Don't you ever do that to me again,' he warned. 'If I tell you to play, you will play.' Bob Kerr said he certainly would not when his instrument could have been destroyed. So Reg said: 'You're fired!' Big Sid said, 'If Bobby goes – I go!'

'In fact,' says Vernon Dudley Bohay-Nowell, 'Bob didn't care because he had just been asked to form the New Vaudeville Band.' The New Vaudeville Band. Not a name to be mentioned around Vivian Stanshall. While the Bonzos were great live, they were not doing so well in the record market. There were already rumblings of competition on the horizon. There were now several comedy bands playing 1920s-style music, including Spencer's Washboard Kings. It came to a head when composer and record producer Geoff

Stephens wrote 'Winchester Cathedral', done in Temperance Seven style, complete with camp megaphone-effect vocals. It was a smash hit, reaching UK No. 4 in September 1966. Astonishingly for such a novelty number, it got to US No. 1 the following November. It was a bitter blow to the Bonzos.

Even worse, it was all studio men behind the hit. There was no actual Vaudeville Band. Bob Kerr was one of the Bonzos who was asked to form a live Vaudeville act and he took the chance. It was later rumoured that the Bonzos had been asked *en masse* to do the gig, which Bob insists was not true. He also asserts that it was nothing to do with the sacking – he simply left after one of their northern tours due to personality differences with Vivian. But it made no difference to the way his departure was received by the Bonzos. Vivian, in particular, was extremely angry. After their triumphant American tour the New Vaudeville Band went out on the same British cabaret club circuit as the Bonzos. Sometimes they played a club only a fortnight after the Bonzos, who would leave abusive messages on the changing-room walls. In return, when the Vaudevillians played a venue before the Bonzos, they left an envelope with the manager for them. Inside were little books: *How to Play the Cymbals, How to Play the Trumpet*, one for each Bonzo. Each one was marked with one of their names on the top: *How to Play the Banjo: The First Steps*.

'It was a bit of an in-joke, but I think Viv took great exception,' says Bob. Underneath it all, Vernon Bohay-Nowell believes that, as with John Parry, snobbery was at the root of Vivian's real problem with Bob. 'We'd all been to art school and got our degrees. Bob didn't have one, so Viv called him "a little pig",' says Vernon. 'He particularly didn't like Bob telling him what to do musically and he was very jealous of anyone who was a superior musician.' 'Winchester Cathedral' itself was covered by all sorts of artists, including Frank Sinatra and Dizzy Gillespie. When the Vaudeville Band folded, Bob eventually started his own Whoopee Band, an outfit that was still playing more than thirty-five years after he left the Bonzos. While he was swanning around America at the peak of the Vaudeville's phenomenal chart success, the poor old Bonzos were still travelling in Vernon's rickety ambulance. Somehow the indignity of using this

mode of transport, when their pop-star contemporaries were being ferried around in a Rolls-Royce, only added to the simmering atmosphere of discontent.

Says Vernon: 'When we were on the road Larry, Viv and myself travelled together because I had the transport and we were the dirty stopouts. Viv and Larry never wanted to go home, while the others did because they had wives or girlfriends. There was a lot of grumpiness in the band mainly because we felt so impoverished. I was older and so I could understand the situation. I didn't get upset when things went wrong. The others were more egotistical about their careers and the things they were going to do. I realized you had to make some allowances. We were on to a good thing and we ought to have gone far. Somehow we had to try and be tolerant of the different factions within the band. The trouble was some of the guys were not prepared to make those concessions. There was a lot of built-in friction all the time.' Plenty of bands with far fewer members experience worse difficulties. Holding a hyperactive, creative bunch like the Bonzos together was a matter of managing extreme tension.

The fractious group were more determined than ever to make the transition from pub and vaudeville-style cabaret act into a fully fledged rock and pop act. This meant parting company with Reg Tracey and finding a new manager. They settled on Gerry Bron, a gentleman of the old school whose family had long associations with song publishing acting as agents. His father was publisher Sydney Bron and his sister the actress Eleanor. Gerry worked with his wife Lillian in their rapidly expanding business, which handled such luminaries as Manfred Mann. Bron was later to set up his own Bronze label with a roster including Colosseum and Uriah Heep. Before the Bonzos could go with him, however, they had to work to pay off Tracey, the first in a series of not particularly favourable contracts: 'Viv was nasty about working off all the gigs that Reg had booked for us,' says Vernon, 'and made one or two slanderous remarks. Gerry had to pay £3,000 in compensation to Reg, which in the end came out of our pockets. Viv was always doing outrageous things which upset the apple cart.'

Gerry took over the Bonzos in late 1966. It was on the recommendation of bassist Jack Bruce, from Cream, that he took them on and he would manage them for about two years. Bron thought their act was 'wonderfully funny' and went backstage after the show to see them. He saw their huge potential, while finding them a tremendous handful, once rather desperately describing them as 'five lunatics and a musician'. He was straight and direct in his dealings with the band, but worked them hard, getting as many bookings as possible. Vivian would later complain bitterly about the workload and their lack of money, compared to the bigger rock acts of the day. However popular they were with a cult audience, the Bonzos could not compete as a major concert attraction with the high-earning bands they admired, like the Who or the Rolling Stones. This was one factor that accelerated the change from performing comedy routines to trying to be more like a pop group. It served to highlight how each member was moving in a different direction with his music. As the trad jazz took a back seat and instruments were plugged in, discontent mounted within the ranks.

'I didn't find it easy to get a deal for them,' says Bron. 'We spent months making demos in an attempt to get a record deal. I only got one in the end because I approached Liberty, who had just started in London. I persuaded them they wanted a happening English band.' Liberty eventually decided they did and the Bonzos recorded *Gorilla* for them. Gerry Bron proudly handed over the tape and told the record company to press 50,000 copies, assuring them that every last one would walk off the shelves. So Liberty pressed just 2,000. By the time it was released, the Bonzos had already become pop stars, none of them more so than Vivian Stanshall.

4
'Is *Mrs* Penguin at Home?'
Home Life

One-time bingo caller, tourist waiter and art student Vivian Stanshall had become a *bona fide* pop star of the late 1960s, courted by the media and fellow-stars. He was the toast of the town, surrounded by hordes of fans and admirers, and he could be relied on to provide great anecdotes and good quotes for the press, even when he was asked to talk off the cuff about a topic as unpromising as the young Prince Charles, then at college: 'I keep praying that he's going to freak out when he becomes King,' said Vivian. 'He's at Cambridge, isn't he? Something evil must happen to him there. Supposing he turns the Palace into a bawdy house? Supposing he goes about stabbing poodles and laying waste the countryside. I wish we could go back to absolute monarchy. At least we'd only have one clot to contend with. I've got nothing to do with the way the country is run and nor have you, so we might as well have a tyrant on the throne. He could bring back beheading and drown people in malmsey. It would be nice to flood the Albert Hall and stage animal fights, with hippos eating maidens. At least it would make you laugh. Just something to sweeten the pill.'[1]

Vivian's parents were not overwhelmingly impressed by their son's elevation into the pop elite. Vivian's mother remembers Stanshall Senior gave some grudging acknowledgement of their offspring's new-found status, but 'he didn't care really. Vic didn't care much about

anybody else except himself,' says Eileen. She recalls a paternal presence at Bonzo performances 'now and then', though Vivian's brother Mark insists it never happened.

'I think Mother was very pleased that Vivian had done something odd, but then it always looked like he would,' Mark says. 'But Father, emotionally speaking, was a pretty cold fish and Mother was much more emotional, so really she married the wrong bloke. That's why she and Vivian got on well, because they needed the comfort of each other in a way.' By now Vivian had found someone in London who offered the support, sympathy and understanding he needed. Although Vivian's mother had been against his first love, she clearly approved of Monica Peiser (born 1944), the girlfriend Vivian knew from college. He met her when he was still going to art school in Southend and would bring her to the Stanshall home in Beech Avenue.

Monica and Vivian had much in common. They shared the same sense of humour and love of art, music and books. She joined in the gags, jokes and games. As a young student, Monica read French literature and went to Central School of Art in the early 1960s to study art and design. At the canteen table, having lunch on a perfectly ordinary day, she became aware of a presence. All around her fellow-students were seated at the Formica-topped tables, chatting, eating egg and chips and the usual greasy student fare. Amid the hubbub and animated discussion she could not help but notice a young man watching her from a distance. She noted his loud check suit and a stiff celluloid collar with studs and tiny glasses. She also observed the pair of huge rubber ears he sported.

She still shakes with laughter at the memory. 'I was conscious of somebody coming and sitting down beside me, but I wouldn't look up, I was so in awe of him. I didn't know what on earth to say to him.' She looked up only to discover something else ghastly. The vision before her had segments of pink, plastic ping-pong balls neatly inserted over each eye, under octagonal spectacles. It gave his face an aspect more menacing than comic.

'One pair of those tiny glasses he wore were really horrid. They were silver-rimmed in blue glass, which was extraordinarily frightening, especially on a man with a huge red beard. I was certainly

curious about him.' She had known of Vivian before that day in the canteen, having been friendly with fellow-student Larry Smith. 'The two of them – Larry and Vivian – were always together. They were like brothers. But Larry was much more outgoing and chatty. It took a long time for me to get to know Viv.'

Monica was born in England of German-Jewish parents. Bilingual, her ability inspired Vivian to learn German. 'He did O-level German and he spoke it with the most appalling English accent, which I teased him about. He never accepted that he didn't have a perfect German accent.' Vivian's fascination with language went right back to his years as a teenage teddy boy when, he later said, 'my major achievements were learning a lot of Gypsy tongue and getting involved in fights, brawls and outrages'.[2]

Ki Longfellow, Vivian's second wife, also encountered his alleged linguistic abilities: 'He could do anything, which is how he got away with his cod French and cod German, which he professed to speak fluently. But he didn't have a clue. He got away with it an awful lot. He tried it with me but I can speak French and I knew perfectly well that he couldn't, although his German was just a little better.'

Monica: 'He also spoke Swahili. Well, I've no idea whether he really spoke Swahili. But he claimed he could speak the language, which is a fine claim. Who could doubt him? He was always interested in Africa and knew a lot about the tribes and their traditions. He collected African tribal art. Did he go to Africa? In his dreams. He had very vivid dreams, almost to the point of not knowing which was reality. He often went to ancient Rome.' The attempts to learn Swahili came from doing the rounds of junk shops as a youngster, where Vivian bought books on exploration and African culture.

When she realized the date of Vivian's twenty-first birthday was not far off, Monica discovered that he had nobody to share a celebration with and the two went to a college dance. 'I always say my fate was sealed on 21 March 1964. From then on we were inseparable. The three of us, Larry, Vivian and myself, were all great friends.' Vivian proved a much warmer, more gentle person than appearances implied. Monica was charmed to discover that a kinder nature, almost parental, lurked beneath the beard and the comedy accessories.

'He used to tell me stories, which were lovely. I'm sure I wasn't the only person that he did that to, but it was delightful when he told them to me and with such a rich vocabulary and wonderful command of the language.' She lost patience, though, with his more obscure flights of fancy, saying, 'Don't be so silly – using words that nobody understands. What is the point of using language that nobody can understand?'

'Well, they *should* understand!' he'd roar. Monica remembers, 'He could switch on the very big voice, which was terrifying.' She was introduced to the rest of Vivian's family, including his father. They all met up in the City and she discovered he was a real City gent – bowler, pinstripe suit, black jacket and carnation. Monica had heard of such people but didn't realize they actually existed. In a way, she says, he was also 'acting' for most of his life. He was not as high up in his company as he made out, and forever being the upright citizen; these were some of the reasons she feels he was hard on his son, who was unconcerned by what others thought: 'His father hated him because he was exactly himself. He could brush opinion aside,' says Monica.

Vivian was also unconcerned about making himself the centre of attention in public. He would bellow in restaurants, on underground trains and even in the cinema. On one occasion she accompanied the Bonzos to Cardiff, where they decided to go to the cinema in the afternoon. The whole band went to see a screening of Alfred Hitchcock's *The Birds*. More disturbing than the sounds of screeching birds diving to attack was Vivian making extremely frightening noises, roaring in the back row. By the end of the film, the other patrons were cowering under the seats.

When the young couple were alone together, Vivian was gentle. 'He did model his voice on Noël Coward, including the inflections and rather old-fashioned choice of words and even his dress,' says Monica. 'I never heard him swear or use obscenities in the home. That was something for out there. Never with me.' But then that was very much the way he had been brought up in Southend. The alcohol was a different matter. The culture of the band was very much one of drinking and Vivian took to it with his customary energy and

passion. As a pop star, drinking was to be expected and few people around him saw it as a problem. Rod Slater was one of the few who spotted the danger signs relatively early.

'One of the things you could never do was enjoy the pleasure of having a drink with Viv,' he says. 'You could never do that. I remember the last time I had a drink with him, we got kicked out of the pub.' Rod had simply popped around to Vivian's place in north London and off they went to the pub. 'He had two pints of beer and he was away. He was causing chaos. Suddenly the penny dropped at last. I realized that I must never drink with Viv again because this was what happened. And I never did. I never had a drink with him again.' The idea of a couple of pints and the resumption of normal activity was not quite Vivian's way. His active mind and eager desire for stimulation – whether mental or physical – meant that he became over-excited by alcohol quite quickly. If he did over-indulge it wasn't long before the next phase would set in, when he became silent, tongue-tied and morose. But for much of his time with the Bonzos, he was far more concerned with being creative, with reading, painting, drawing, playing music and widening his circle of friends. In the early days of their romance, Monica was one of the few band girlfriends who dared to travel with the Bonzos to their various pub gigs. At the Deuragon Arms and the Tiger's Head she collected the money for the gig. 'It was great fun and I adored the music. I found the whole thing exciting and exhilarating.' The couple became inseparable. When at last the band was a success and its lead singer a star, they could afford to live together and raise a family. Vivian and Monica were married on 1 January 1968 at Colindale Register Office.

'It was an awful place and it was snowing. The registrar came in eating her sandwiches out of a paper bag. She sat down at the wedding desk to finish her sandwiches. It was par for the course,' she laughs. There was not even time for a honeymoon. The next morning the bridegroom had to rush off with the Bonzos to record a TV show. 'The band were extremely busy. So in fact we never had a honeymoon. I think he was frightened of not being home. He later developed agoraphobia and I think that was the start of it. Unless he was with the band, which was his safety net, he wouldn't go anywhere.

He would go out, but he wouldn't go on holiday. He had to have a structure to the evening, or he couldn't relax.' The Stanshalls settled at 221 East End Road in East Finchley. Monica remembers their time together was largely characterized by hilarity: 'We giggled like children endlessly,' she says. Vivian was always hatching some mischief, laughing at some absurdity in the newspaper or just chortling. Wherever they were, whatever they were doing, there was some kind of merriment near the surface.

The couple's son, Rupert, was born 27 June 1968, when Vivian was twenty-five. His manner was coloured by many of Vivian's traits, including a dark sense of humour and a distinctive speaking voice. With his red hair and fiery temperament bubbling beneath the surface, there was soon a startling physical resemblance to his father. To Rupert's chagrin, the kids at school did not fail to connect his name and red hair to Rupert the Bear. The character had been a favourite of Vivian's.

Intelligent, precocious, and exposed to many and varied intellectual pursuits and eccentricities, Rupert was surrounded by books and instruments as a child. He was encouraged to take an interest in natural history and was sent to Christ's College, a respected school in Finchley. He had problems as a student and his relationship with his mother suffered.

'Monica couldn't control me,' he explains. 'She wanted me to be the academic super-boy, because Vic was uncontrollable.' The boy was more interested in selling, from the time he was in school. If anything, his father was more inclined to study. Vivian devoured books and took a keen interest in zoology and tropical fish. He also attempted home-improvement projects, in his own fashion. Monica remembers: 'He liked digging holes. He dug up our garden, making a huge hole which was going to be a pond, but never was completed. It was just left – as a big hole. He liked anything creative and making a pond was a creative act. When I finally left the house in East End Road I was told that I had to take down all the shelving. This not only held heavy rows of books but six-foot fish tanks full of turtles. I found the shelving had been fixed to the walls with six-inch nails. No screws or Rawlplugs. Just nails, whacked into the walls. The whole

lot could have come down at any time.' The mania for physical creation was often an excuse to put off writing or working with the band. It also gave Vivian a reason to get busy with his power tools.

'Now, power tools and alcohol do not mix,' explains Rupert. 'He bought himself a bench saw, which he installed at 221 East End Road and which was kept in the lean-to garage, full of props from the Bonzos. I always remember it was full of Mickey Mouses and speech bubbles which I used to play with. He was always sawing things up and making sculptures. The machines he used were a bit daunting and he'd say to me, "Grrr – this has got *big* teeth on it." The screaming coming from the shed on a regular basis, when he'd caught himself, was louder than the saw itself. He had this big thing about how all tools and chisels must be kept clean and sharp. Then he would forget them. He wouldn't put the caps back on or remember to clean the chisels. He'd pull them out and you'd hear this angry roaring: "Rah, rah, rah!"'

Vivian was very much the absent-minded artist. He became absorbed in whatever it was he was doing and daily chores went straight out of the window, unless they involved his work. 'He was really hot on his musical instruments,' says Rupert. 'As a result I was always very careful with stuff. I didn't break anything, so he'd let me tune things. But on the whole – you didn't dare touch 'em. Even if you'd get them out of the case, his sensors would let him know you were there and what you were doing.'

As a child, growing up with an unstable artist as a father affected Rupert. 'When he was sober he was more interested in himself and when he was pissed he was quite interested in getting something out of someone else.' He sent Rupert to have bass guitar lessons with Ronnie Lane of the Faces and the boy learned the trumpet at school. Rupert liked other big brass instruments as well. Several mangled specimens of tuba lay in the garden, pressed into use as planters, which were fun to play around with for Rupert, and he liked to climb inside his father's big tuba case.

There was not much fatherly advice about issues other than music, however. 'It was very easy to say things like, "Whatever you want to be – be lucky." It was all that sort of stuff,' says Rupert. 'Easy ticket,

isn't it? But as a dad he did spoil me with Scalextric toys and that sort of thing. To me he was normal, but God knows what that would be to somebody else. I thought he was normal, but nobody else thought he was. He was my dad so he's gotta be normal, hasn't he?' It was a lot for the boy to live up to, though. Not only was his father famous, but from an extremely young age, Rupert always had the unshakable feeling that his father wanted another member of the band to collaborate with, rather than a son to look after: 'He couldn't handle a child,' says Rupert. 'He needed someone he could bounce off, so I had to grow up bloody quick.'

At 221 East End Road, it was just Vivian, Monica, Rupert and a few dozen assorted fish, reptiles and downright terrifying beasties. Vivian took his interest in wildlife seriously: he was a member of the Zoological Society and attended their meetings. At London Zoo, he used to have discussions about reptiles with some of the keepers and swap locusts with them. But the main subjects of interest were the forbidding tanks cluttering Vivian's home. 'I'm trying to become a pisciculturist,' he told *Melody Maker*. 'I'm less interested in fish than I am in turtles, really. I like evil fish of archaeological interest and things that are not strictly fish like axolotls, on the knife-edge of evolution. It's a cool world in a fish tank. If you get a balanced aquarium, you can watch them eat their children. It's like life, very cruel, which is why I like it. I often watch in the nude and a rubber mackintosh.'[3]

Guests at the Stanshall household frequently came face to face with their worst nightmares, when all they were expecting was a cup of tea or glass of beer. They watched Vivian feed the fish and turtles raw meat and those who stayed the night shared a bedroom with large tanks from which emanated creepy gurgles and splashes. Vivian found the expression of alarm on his guests' faces as they contemplated trying to sleep with monsters of the deep, lurking only inches from the bed, hugely entertaining. As the tanks were often pretty murky, it was difficult to make out what was inside. 'There's piranhas in there,' Vivian would confide in his most doom-laden tones. He maintained his zoological interest even when he was on tour. Given a large turtle by Glen Colson of Charisma Records, he kept it in the sink in his hotel bedroom. Unfortunately, the abandoned turtle was left hungry

while the singer was away at the evening's performance, and when he finally returned to the room to inspect his latest acquisition, the outraged turtle leaped out and bit him.

Roger Wilkes also remembers the illuminated, bubbling Finchley fish tanks. 'He loved turtles and snakes. He lost one in the house. A big snake. It went under the floorboards. He said one evening: "Just watch out, it may show up."' This was not uncommon. Many of Vivian's friends speak of different occasions when he would casually announce that something horrifying and scaly had nipped out of its tank without permission.

'There was an aquarium in the hallway and when we looked at this fish he said, "Don't touch it, or you'll be dead within half an hour,"' recalls his drummer friend John Halsey. 'Then he said, "I've lost a snake. I had this bloody snake in a box under my bed and it's gone." I didn't know if he was winding us up or not but he said some deadly snake had escaped and was somewhere in the house.' Mark Stanshall remembers Vivian would take any opportunity to exploit people's natural anxiety around slithery, scaly things. 'He used to claim that when he went away he used to let a couple of snakes out,' says Mark.

Vivian explained the best way of retrieving one of his pets: 'Black bastards,' he growled to Mark. 'You have to get 'em with a dustbin lid.' Rupert Stanshall grew up among the would-be escapees and confirms, 'Yes – a couple of the snakes escaped. I can't remember if they were pythons or boa constrictors. He lost one by putting it in a rabbit run, with a tortoise . . . It seemed like a good idea at the time. He put it in the run, and it buggered off. Another one he lost in a small toilet downstairs. I've no idea what he was doing. Allegedly, he was trying to help it give birth. He told his dad about that and Vic would never use that lavatory again in case he got snakebite.'

The aquatic specimens got the worst of it. 'He once had a catfish which got boiled,' says Rupert. 'He was – er – not very careful with the fish. The turtles only lasted because they are so hardy.' Vivian was more encouraging towards Rupert's naturalist instincts than he had been about music, giving his son membership of the Young Zoological Society. 'So I began to keep snakes and that sort of stuff

too. I ended up with about twenty tanks in the house and Dad had loads more. It had rubbed off on me because he kept turtles, snakes and various fish that didn't last very long.' Rupert could soon identify garden spiders by their Latin names and Vivian kept a few of the larger species.

'The tarantula snuffed it,' he told an interviewer sadly. 'We didn't notice for three days and it had been such a lively little rascal.' Any space in the house not covered by tanks was used to display examples of his other passions. Upstairs he had arranged his props from the band. In the front room he had rows of African masks and talking drums and on the stair was a zebra's bottom, mounted on wood, which gave the effect of the zebra having been caught running through the wall. This was, it is safe to assume, the only house with a mounted zebra bottom in the whole of Finchley, the constituency that elected Margaret Thatcher as its MP.

That the Stanshall house was in such a conventional neighbourhood meant unsuspecting sales representatives were regularly lured to East End Road like docile mice to one of Vivian's snakes. He regularly sent off for items from the classified advert sections in magazines such as *Exchange and Mart*, which offered everything from concrete coal bunkers to bass saxophones and tropical fish. If something caught his eye, he would order it under an assumed name, his favourite being St John Danvers. Sometimes a company representative called to follow up the response. The woman from Dolphin Showers was one of those who drew the short straw.

Vivian spotted an advert in the paper for a portable power shower that he could assemble at home. He wrote off for a free demonstration, signing his application Mr Penguin. It was not long before the Dolphin representative called. That day, as he related it, Vivian was cleaning out his fish tanks, naturally wearing a full wetsuit with flippers, and was just getting his turtles out on the floor when the front doorbell rang. He flapped down the corridor and opened the door.

'Yes?' There was the woman from the shower company. To her credit, she looked the vision up and down and, with great presence of mind, merely asked, 'Is *Mrs* Penguin at home?' With the help of

his friend Andy Roberts, Vivian arranged a time for the Dolphin representative to return to meet the lady of the house and discuss the installation of a hot shower. There was a garage by the side of the house with a small window facing the front door. During the following week they set up an 8mm movie camera inside the garage pointing through the window. They dug a grave on the front lawn, piled up the earth and put a crude wooden cross on top.

'I got in the garage at the appointed time and waited with the camera for the woman from Dolphin Showers to show up and meet Mrs Penguin,' says Andy. 'Vivian was going to answer the door in a black suit and tell her in sepulchral tones that he was terribly sorry but Mrs Penguin had been called away. I was standing there poised for hours to film this woman's reaction.' It was not to be. For some reason, the rep never returned to East End Road. Another female official, however, this one from National Insurance, experienced the same treatment. She arrived to discuss some contributions that Stanshall had not paid. He invited her inside to talk, in his turtle room where he kept Stinky, the man-eating turtle. Stinky was only two inches in diameter, but would obligingly clank up against the glass tank, which was labelled 'Man-eating turtle'. Vivian came into the room wearing an old woman's wart mask and bright yellow trousers with his stomach hanging over the waistband. The woman was absolutely terrified. They decided to shake on a deal for no money at all and she left – another one who was never to return. He also had an argument, says Rupert, with some men in the street when he was 'dressed in his Jewish renaissance black cloak and hat. He frightened them off. I think they thought he was Dracula.'

The local constabulary were aware of Mr Stanshall's presence, and once almost arrested him for breaking and entering. Admitted Vivian, 'I must say, the one I met last night when I was breaking into the house was a perfectly nice chap. But it was quite obvious he thought anybody with long hair had no right to live in a house, and it was my house. I had forgotten my key and didn't want to wake up the wife.'[4] The family put up with this kind of thing on a daily basis, but then it was hard to be surprised when their garden was kitted out with an eight-foot-tall gnome who smoked dope. A tube was connected

through the kitchen to a set of bellows on which Vivian stamped to make the papier-mâché gnome emit clouds of smoke.

Whenever the urge to create some new piece of art or invention took him, Vivian utilized whatever came to hand, no matter whom it belonged to. 'He used to pinch things. If he liked something, he'd just pinch it,' says Rupert. 'I don't know if he did it to friends, but he did it to his family. "Oh, I like that ornament." Gone. And he had a habit of altering them and decorating them in his own special way, which could be anything from painting over them to sticking fag butts on them.' The Bonzos sang about suburban convention. This was Vivian's own 'pink half of the drainpipe'.

5
Do Not Adjust Your Set
1967–68

A year dominated by the hippy revolution, 1967 ushered in the dawn of a new age of experimentation. All the freedoms denied to Vivian as a child were now available to the young performer. It was the year that the Bonzos enjoyed their own kind of flower power. They released their debut album *Gorilla* to wild acclaim, and even the revered Beatles embraced them. Everyone wanted the band that made the music industry laugh at itself at a time when music was a very serious business indeed.

An uproarious party was thrown at Raymond's Revue Bar in Soho for the October 1967 launch of *Gorilla*, 'Dedicated to Kong, who must have been a great bloke'. The band played a half-hour set, including 'By a Waterfall', complete with a tacky wheel covered with silver paper. A whole circus of animals was hired, with people riding camels and elephants around Soho Square.

'They had a champagne reception in the park and all the press were invited,' recalls Lee Jackson, bass player with the Nice. 'It got a bit riotous and one of the camels panicked, back-kicked a Mini and stove in the side of the car.' Vivian tried to imagine the driver's insurance claim. 'My car was kicked by a camel in Soho Square.'

The album reviews were encouraging. Typical of the comments was: 'A knockout! An hilarious, often brilliant first album that combines some marvellous send-ups and some attractive new songs.'

The public were slower to embrace the record and sales were slow. 'There have been distribution problems,' explained Vivian. 'I think the record company are swapping over to some new steam machines or something.' Overall, though, he said the success had made an 'amazing difference' to what the band were doing.

Gorilla has rarely been out of circulation in the EMI/Liberty catalogue since its release. It is packed with some of the Bonzos' most memorable moments, kicking off with 'Cool Britannia'. Larry Smith urged the others to go more rock'n'roll as the album was being recorded and Neil suggested they should do 'Rule Britannia' in a 'twist' style. Vivian came up with the lyrics, a kind of double satirical poke which highlighted the pomposity not only of the Establishment, but also of the facile buzzwords of the time, which he clearly thought were really just as ridiculous. He sang about taking a trip and the painful hipness of the in-crowd in a succinct track.

The most enduring of all the tracks was the trad-jazz spoof 'The Intro and the Outro'. The Bonzos used the old jazz convention of introducing the band's players and instruments in turn. They took it to ridiculous lengths, with an increasingly bizarre selection of instruments and players including, Eric Clapton on ukulele, the Count Basie Orchestra on triangle, General De Gaulle on piano accordion and J. Arthur Rank on gong. The Rawlinsons, a *Gorilla* innovation who would be fleshed out on later albums and would be so central to Vivian's solo career, made their first appearance here on trombone. 'The Intro . . .' was one of the Bonzos' most original creations – even if the 'Outro' was based on Duke Ellington's 'C Jam Blues'. Some of the names dropped in the song have dated but it is the way in which the basic riff was layered so cleverly which makes the piece stand up years afterwards. They only had a four-track recording machine, and each newly introduced instrument would play only a few notes then drop out, but they managed to give the impression of an increasingly fuller sound.

'Jazz Delicious Hot Disgusting Cold' was another standout that in many ways epitomized the whole Bonzo approach. Skilled masters of parody, their secret was to know exactly what to play badly and loosely for comic effect. It was not something that a band who wanted

to be stars could have done. A breakneck trad workout, 'Jazz . . .' was not played badly as such, but the clichés and the air of studied Dixieland perfectly capture the stiffness of a very English kind of jazz. It is a favourite of BBC producer John Walters, who recorded sessions with the Bonzos. He had come across the kind of enthusiastic amateurs parodied in the track all the time, particularly that guy who has one phrase that he cannot seem to get away from, like the clarinet solo in 'Jazz . . .', and those outfits which rely on the sort of tremendous crashing stop-chord section the Bonzos use towards the end of the track. 'Absolutely blissful,' says John. It's a song that has everything, even the cringingly inappropriate cry of 'Oo-ya, oo-ya, oo-ya, oo!' at the very end. It is all there, the history of English trad jazz in one song, a parody of those scholarly efforts at doing jazz with absolutely no feeling for that, or indeed any, form of music at all – great British rubbish at its best. John asked Vivian how the band managed to capture all that in one song. 'Well, it's easy, mate,' Vivian told him. 'We just all played each other's instruments.' And while John knew that this could easily be a Stanshall riposte made up on the spot, he thought it certainly deserved to have been the right explanation.

There was calypso on the album, in the form of 'Look Out, There's a Monster Coming', and plenty of the old novelty jazz numbers, like 'Jollity Farm' and 'Mickey's Son and Daughter', of which Vivian said: 'It's a wonderful title and a silly song. I like chanting rubbish.'[1]

Under the aegis of manager Gerry Bron, the band were now reaching a much wider audience. Busily promoting *Gorilla*, they guested on the BBC's 'Dee Time' in October, hosted by DJ Simon Dee. They also appeared at London's Saville Theatre in Shaftesbury Avenue, on 29 October as guests of Cream. The legendary supergroup, comprised of Eric Clapton, Jack Bruce and Ginger Baker, despite their sonic power, were matched by the Bonzos for a stunning set. Vivian's brother Mark remembers the Bonzos being particularly good that night.

The Bonzo pace was fast and the jokes came from every member of the band, sometimes all at the same time, whether a cherry bomb down a saxophone, or a band member coming up to a mike stand

with a real bathroom tap and 'tap, tap'-ing on the mike. *Melody Maker* raved about the first Saville show: 'The Bonzos proved a wild success before a predominantly Cream audience. From an uncertain start as the fans got to grips with the heady mixture of satire, vaudeville and musical anarchy, they concluded a superb performance to cheers, applause, and three curtain calls.'[2] There was genuine shock when Larry traded abuse with a heckler who had been shouting 'Rubbish! Get off!' A spotlight swung up to the box and Larry was seen struggling with this rude person. As the punter – in reality a member of the Bonzo crew – knocked the drummer to the floor of the box, he picked up a dummy version of Larry and hurled it into the audience to genuine gasps of horror. 'I was seen flying towards the stage and people really believed it was me!' says Larry. 'It was a fabulous moment.'

Both Clapton and Bruce became confirmed Bonzo fans. Clapton was particularly enthusiastic: mournfully confiding to Neil Innes: 'I wish I could come out on stage one day with a stuffed parrot on my shoulder.' It was partly this perceived freedom which earned the band respect within the music business and gave them the inalienable right to wear as many parrots as they liked on their shoulders; but as time went on, being labelled 'anarchic' or, worse still, 'wacky', would be as constricting as any identity tag attached to Clapton.

The Bonzos returned to the Saville on 19 November, when they supported the Flowerpot Men and the Bee Gees. In the run-up to gigs, Vivian could be found squatting down on his bedroom floor, surrounded by all manner of outlandish props. 'I'm making a "Legs" Larry mask at the moment,' he told one visitor. 'He doesn't know about it yet. When he's on stage I'll come clopping around behind him.' At the second Saville show, the group upstaged the star attractions again. Their set included 'The Head Ballet', to which the band attempted to do synchronized movements, turning their heads left and right, mucking it up and falling about laughing. The humour was lost on the Bee Gees' fervent young female supporters, eager to see the main attraction. This was a time when the Gibb brothers were at No. 1 in the UK charts with 'Massachusetts' and were being treated

with appropriate solemnity. Plans for the Bonzos to tour with the Bee Gees were quietly dropped.

Tony Bramwell was then working with Beatles manager Brian Epstein's North End Music Stores (NEMS). He remembers how the Beatles, by contrast, welcomed the Bonzos as buddies. Larry Smith became great mates with George Harrison, much to the annoyance of Vivian, who liked to keep the stars for himself. He and John Lennon frequently embarked on club and pub-crawling expeditions and wrote songs together. Karl Ferris, Beatles photographer, says that the two bands were very close. Vivian even claimed he had a hand in 'Lucy in the Sky with Diamonds'. Like many Stanshall stories, it was extravagant enough to make one wonder. Tony Bramwell confirms: 'The Beatles loved the Bonzos and Vivian helped John Lennon with some lyrics occasionally. But then everyone used to help with Beatle lyrics if they happened to be around.' Vivian also went drinking with Gary Taylor, guitar player with a band called the Herd (in which Peter Frampton played before joining Humble Pie), touring the low spots of Soho.

'Gary and I were both rather blotto and wandered into one of these dens of iniquity in Soho,' said Vivian. 'We started at the back and worked our way to the front, as each act changed. I was very surprised by the crowd, who are all young. I expected a lot of old men, but it was like a raincoat youth club. One could see housewives in the audience. It was all hilarious really. There was one story about a woman in a castle ostensibly embroidering when suddenly, for no reason at all, a violent gorilla ran on and tore all her clothes off. The bloke who writes the scripts must be a genius. I'd recommend the show to anybody. Well, it keeps you off the streets.'[3] The Bonzos performed in a similar setting, though fortunately with all their clothes on, some weeks before the Saville shows. Paul McCartney invited them to take part in the Beatles' self-produced movie, *Magical Mystery Tour*. He originally approached his brother Mike McGear with a view to using his outfit, Scaffold, but Mike said the Bonzos would be better. The Bonzos' contribution was a Mickey Spillane-style spoof called 'Death Cab for Cutie', filmed at Raymond's Revue Bar in Soho.

'We were persuaded by the management that we had to have

haircuts,' recalled Vivian. 'We all went off . . . and had these outrageous pooftah jobs done. It looked great, it was really stupid.'[4] While the crew were loading their instruments into the club, the drum kit was stolen and the band performed "Cutie" with a borrowed set. Joining them on stage was a strip artiste named Jan Carson, who delighted in teasing both Vivian and the Beatles sitting appreciatively in the audience.

At a fancy-dress launch party for the film, Vivian wore a yellow plastic mac covered in joke-shop fried eggs. 'Paul was really struck by that,' says Neil. 'We were all quite close at that time. I remember George Harrison saying to us that "Death Cab for Cutie" ought to be a single. But that was just one day in our lives. We'd do the *Magical Mystery Tour* and meet the Beatles and then we'd be up north again.' The Beatles used to film the Bonzos on 16mm cameras when the two bands ran into each other, sometimes recording in adjacent studios at Abbey Road. Their staff helped the Bonzos out with costumes on occasion and with explosives to meet fire regulations for the Saville shows.

Such was their visual impact that the Bonzos were invited to appear in a Pathé Pictorial newsreel film made for the cinemas. The band were featured in two segments playing 'Music for the Head Ballet' and 'The Equestrian Statue', an album track released as a single in November. It too failed to dent the charts. Between gigs, the band worked on more screen material, a pilot show recorded on 6 November for what became a pioneering children's comedy series called 'Do Not Adjust Your Set'. Gerry Bron met to discuss the show with producer Humphrey Barclay, who worked on the radio comedy 'I'm Sorry I'll Read That Again' with performers such as John Cleese. Barclay already had his main act for the new Associated Rediffusion TV programme and, having seen the Bonzos at some of their northern gigs, he gave them a spot as house band. They would perform a couple of numbers on every episode. There was no time for a break in all this. A packed date sheet involved endless travelling and it was little wonder that the musicians, who were at heart still art students having a laugh, became a shade unhinged.

Vivian, however, was having a marvellous time, no matter how

exhausting or demanding it all was. 'I loved it. Performing, to me, was like translating a drawing or a print or a painting into a palpable, three-dimensional and transient thing, something that was as brief as a rose or a fart,' he said. 'That was wonderful for me. Tremendous juice, I craved it. I always crave exactly what is bad for me. And how those audiences ever made head or tail of people tearing up telephone directories and singing shopping lists, I really don't know.'[5] As the band became more successful in the world of mainstream pop, other members were isolated. Rodney Slater and Roger Spear continued to blow their saxes in a defiant, continuous free-jazz raspberry at the world, but they had less and less to do with the musical policy. That was left to Vivian and Neil.

Roger Spear was almost an act in himself, happy enough providing a battery of machines. His home workshop was a forest of wires, painted tailors' dummies with huge flashing eyes and a sign over one machine which read, 'Warning: This Machine is Very Boring'. Roger also created a 'notorious publicity machine'. Converted from an old washing machine, it had a stock of replies to any question posed to it and fed out reams of lavatory paper while a pair of hands clattered away on a typewriter. There were countless other machines and gags from Roger, many of which went wrong or were banned at the last minute by club management afraid of an electrical accident.

The punishing schedules sent every week to each Bonzo by Bron Management Ltd left no time free to discuss musical direction. During typical weeks in November and December 1967, the band packed in university gigs in Bath and London, a week at Wetheralls club in Sunderland and a full week at the Latino, South Shields and La Dolce Vita, Newcastle – this last alone included a 'double': a Sunday show at 8 p.m. as well as their nightly 10 p.m. shows from Monday to Saturday. This was followed by more club engagements at Tito's, Stockton-on-Tees, and La Bamba, Darlington. Some of the time the band still had to lug their own gear as well. Despite their hard work, they were paid only a wage and were always in deficit. After the gracious granting of a couple of days off for Christmas, the date sheet for 26, 27 and 28 December held an ominous warning for the band: 'Possibility of Belgium'. On other days off, Vivian, Larry and Neil

were invariably required to attend rehearsals, photo sessions, press interviews and make appearances on radio and TV. Often they had to remain on standby, even when time off was promised. Saturday, 25 November 1967 was reserved for 'possibly recording "Colour TV Show". We will let you know.'

Lack of time and big egos together meant the band was hardly able to keep stable. In early December, it was announced that Vernon and Sam had left the group. Vernon says the problem began months earlier, because he used to go home to Devon over summer and Christmas. 'I was expecting to meet the band when I got back from the summer holiday,' says Vernon. Rodney said to him, 'I don't know whether you should come.' Vivian was annoyed with Vernon for not appearing during August. The writing was on the wall. Says Vernon: 'In converting from a group in which everyone made a contribution, into a pop group which had a lead singer and a backing group, Vivian had become the lead singer and the rest of us were subordinates. Because of Viv's personal success people allowed themselves to be put in that position.' More than that, Vivian just did not like Vernon that much, and had tried all sorts of tricks to get him out. Larry had been looking for a chance to play drums and that meant Sam left. The core of the band was now really Vivian, Neil and Larry. 'It was Rodney and myself who had got things going in the early days and to be turfed out was most distressing,' says Vernon. 'They were in a desperate hurry to turn the Bonzos into a pop group.'

The split was announced in the *Melody Maker* on 23 December 1967. Vivian tersely commented: 'Sam and Vernon have left because of disagreements within the group about musical policy. We want to be free to do anything. But not doing "send-ups". That's a phrase we hate. And we don't try to be vulgar to be sensational, we just use vulgarity to make abstract ideas more palatable.' A replacement bass player was soon on board, in the shape of Dave Clague. He had come to London from Norfolk earlier in the year to work with an associate of Gerry Bron and ended up doing sessions for the Bonzos' album *Gorilla*. Says Dave: 'Vernon and Sam were still around, but I came in because Vernon was ill and so I did half the *Gorilla* album on bass. When that was done they decided they didn't want Sam and Vernon

in the band and they got edged out.' He also appeared at the Saville gig with the Bee Gees, but it was not until the end of the year that his tenure was made official.

Vivian broadened his field of work outside of the band. He was invited to design the cover for the Christmas edition of *Melody Maker*. It was remarkable in those days of union power and Fleet Street rules that *MM*'s sub-editors, headed by hardened layout man Bob Houston, even contemplated the idea of an outsider being allowed to touch the front page. There was a moment's suspicion and just a hint of hostility when the two men finally met in the local *MM* pub, the Red Lion. Vivian handed over a series of cartoon sketches with a Christmas theme. Houston relaxed when he saw that, yes, he could work with Vivian's ideas. The all-important Christmas issue with Vivian's design appeared to great acclaim. At the centre of the design was a picture of Jimi Hendrix sporting a massively enlarged hairstyle and holding a crystal ball. Around young Jimi, Vivian let his mischievous delight in punning – both verbal and visual – run riot. In one corner Santa Claus was 'clawing' his way into the scene. 'Ho, ho, how ripping!' In another panel, three wise men attired in psychedelic gear looked around for the star of Bethlehem, but could not see it anywhere – it was, as the panel's headline ran, the 'Magi Mystery Tour'. One character accused another of 'Chriswelching' in front of his wife. 'I'm sorry,' replied the other character, adding, 'I didn't realize it was her turn.' In among the festive groaners, perhaps the most understated character was an effete-looking artiste. Eyes closed, his thought bubble ran, 'Help me, underneath the tinsel and sequins, I'm basically normal! (sigh).'

There were three major TV performances around Christmas for the Bonzos, a 'Colour Me Pop' on the BBC on 21 December, during which they performed a forty-minute set, with some inspired surreal links between the numbers. The pilot episode of 'Do Not Adjust Your Set' was shown on ITV on Boxing Day, 1967. It was a great Christmas treat for Bonzo fans, who got to see the *Magical Mystery Tour* on the BBC that same day. The film was a rare flop for the Beatles, although the Bonzos' hilarious 'Death Cab for Cutie' was certainly a stand-out. The year ended with the band playing at a New Year's Eve party

at the Flamingo Club in Wardour Street, Soho. Celebrations went on until the early hours. They had much to celebrate. After so much TV exposure it seemed 1968 must be the Year of the Bonzos. All they needed now was a hit record.

January started with Vivian's marriage to Monica and the happy couple had little time together before the Bonzos got stuck into the television show. 'Do Not Adjust Your Set' got into its stride in early 1968. As the result of a technical error, the second week's episode was shown first, with an unscheduled commercial break, and there was an abrupt ending when the show overran and technicians pulled the plugs. A flood of phone calls from viewers to the TV station and news headlines in the press the next day helped ensure maximum publicity. The mixture of slapstick humour and off-the-wall pop music meant that what was ostensibly a kids' show began to find a cult following with adults as well. Each episode went out at 5.25 p.m. on Thursdays, billed as 'The Fairly Pointless Show'. In a typical week the cast included future Pythons Eric Idle, Terry Jones and Michael Palin, who also wrote the script. Comic actor David Jason and Denise Coffey appeared in the show – Coffey would work with Vivian again, appearing as Mrs E. in the 1980 film of *Sir Henry at Rawlinson End*.

The entire, fresh-faced cast were featured on the colour cover of *TV Times* in February 1968 (the Bonzos were also to feature on a front cover) and the first series of 'Do Not . . .' ran from 4 January to 28 March 1968. It won first prize at the Prix Jeunesse International TV Festival for its fourth episode, and another prize in Germany that July, a week after Rupert Stanshall's birth. It was the launch into stardom for the future Pythons, while the Bonzos did not do as well, largely because they found it difficult to be disciplined. Vivian would not take kindly to direction and the band fooled around so much they infuriated their management and confused the TV crew. As a result many of their best sight gags were rendered ineffective.

'We never found a way of getting them over,' says Gerry Bron. 'It was partly because Vivian did not understand television. We would do a run-through. Vivian would be holding a prop in his right hand but it would only work for the shot if he was holding it in his left hand.' Invariably, trouble would start when the harassed manager

implored his artist not to screw up the shot, to be assured his instructions would be followed to the letter. In the final take, he would do the opposite once again.

'He was always very spontaneous, never calculated. Comedians like Morecambe and Wise knew exactly what they were doing,' says Bron. 'They would rehearse their act to perfection. If you do something consistently and it's funny, then it gives the director a chance to work out his shots. But if the artist changes things all the time, then he's going to miss the gag.' The show did give the band wider exposure. They performed 'Equestrian Statue', Neil singing while sitting on a bike which had a dummy horse's head mounted on the handlebars. In the instrumental break, Vivian came out to do a camp dance with one of his hideous mannequins, whose arm fell off just as the chorus came back in. In another episode, he performed a fairly lengthy introduction discussing comic books by way of kicking off the story of doomed interplanetary love, 'Beautiful Zelda'. Many other jokes went on behind the scenes and involved the hapless Lillian Bron, Gerry's wife and partner. A well-meaning if forceful character, she quickly became a focus for their pranks.

She was forever being asked to supply outlandish stage props at impossible times and it was rare that the band did not need something at the last moment with a deadline looming: their props might include an outsized mouth from which Vivian could blow kisses, or a set of disturbing poached-egg special FX eyeballs. They performed 'Monster Mash' in a full Frankenstein's laboratory set, complete with horror makeup and a spoons break: 'And now, ladies and gentlemen,' announces Vivian midway through the track, 'the part in the programme that's going to give me great personal pleasure – I'm going to introduce you to the electric spoons.' Pointing out mad professor Slater, Vivian continues: 'You'll notice that the brainiac device is already in place and the professor is introducing the special magneto bulb into the oral stricture. And, yes, the maximum voltage is up and in a few moments the countdown is going to begin . . . The professor is confident, he's dribbling . . .'[6] A manic spoons solo concludes with the inevitable explosion. On the morning of recording these kind of numbers, there would be frantic requests for more explosive devices

or a copious supply of confetti. The magnitude and stupidity of the items demanded seemed to become ever more daunting. It got to the point where if they did not ask for anything before show time, Lillian got seriously worried. She made an early call to the television company one morning to check that everything was okay. Vivian picked up the phone. He told her that they urgently needed a very large tank of water to dive into – which of course they did not.

She told him she would do her best but, honestly, he could have given her more warning. Challenged, Vivian added, 'Well, it's worse than that. It needs to be painted orange.' Lillian Bron spent a day phoning around trying to find a suitably large tank and then having it painted in the appropriate colour. She managed to get it to the studio in time and the show's director was astonished to see some workmen fling open the studio doors midway through the rehearsal and wheel in the bright orange tank. The Bonzos collapsed with fits of laughter at the arrival of this completely unnecessary piece of equipment. Gerry Bron summoned Vivian, Rodney and Neil to a meeting for a dressing down. En route they stopped at a joke shop and kitted themselves out with over-all rubber masks of tramps and monsters.

Neil: 'We went into the meeting and Gerry says, "I'm not talking to you if you're going to wear those masks." It was all so silly. He was sitting behind a partition and all he could hear was our voices mumbling through these masks, refusing to take them off. And we'd got him. He suddenly snapped and said, "Right, well that's it. I'm having nothing more to do with you people." So we said, "Can we have that in writing?" And he said, "You're not getting away that easily!" The problem was he wanted us to do all these gigs and there was hardly any time for clear thought about what we were doing or why. We had moved from being a jolly student band playing 1920s music to a pop and rock group and you can't say we did anything really well, musically. Not compared to the people who did it for real.'

A younger viewing public began to discover the band through their TV appearances. A typical fan was Roy Hollingworth, who would later become a reporter for *Melody Maker*. In 1968 Roy was living in Derbyshire, rushing home from school to catch 'Do Not Adjust Your Set' on the telly. Recalls Roy: 'I had never seen anything like it in my

life. I loved the Stones and the Beatles but the first time I saw Viv with the Bonzos, I couldn't believe it. Their show, with all its gimmicks and devices, seemed completely surreal. It became a cult in our street. All the kids were seriously into the Bonzos even though nobody really knew who the hell they were. When I saw Vivian Stanshall singing, I thought "I have to meet that man." Vic then was a tremendously good-looking guy and he was a very powerful performer. I started to emulate him a bit, which was pretty hard in Derby and was probably my downfall!'

During 1968, the band also performed on a live Friday-night show for the BBC called 'How It Is'. The show's production team included Tony Staveacre, who would make a documentary featuring Vivian many years later. 'Vivian was brilliantly inventive. I remember he wanted to have the band performing at a breakfast table and cut out a hole in a newspaper, so he could sing the number through the hole. He knew exactly how he wanted things done.'

Vivian also had a tendency to prevaricate, a weakness that was to develop to gargantuan proportions in the 1970s as his concepts got bigger and his perfectionism more consuming. In May, Vivian went to Gerry and said the band was getting stale. Their manager was sufficiently concerned to hire a studio where the band could settle down and get to grips with writing new songs and routines. After a few days he phoned to inquire about their progress and was assured that everything was going very well. Gerry then asked if he could come down and hear what they were doing. 'Oh, no, it's early days, we need a bit more time,' was the airy reply. A week went by and Gerry had the same conversation. After ten days he impressed on Vivian that he really should come down and hear what they'd been doing. Like an errant schoolboy, Vivian confessed, 'Actually, we haven't got anything done.' He explained he had been working on building rabbit hutches for his menagerie back in Finchley and somewhere for his turtle to live as well.

'I don't think they ever came up with anything new after that,' says Gerry. 'If Vivian didn't want to do anything, nothing happened.' It was not just evasion on Vivian's part. The glaring excuses were to some extent a way of blocking increasingly demanding pressures on

the band. With little time for them to relax, it was no surprise that Vivian made at least some attempt to get on with his personal life. Monica was heavily pregnant with Rupert, a little over a month away from giving birth. Each of the Bonzos really needed a proper break, rather than merely time to write new songs. Their existing material was still doing well. Gerry Bron agrees that the band were something special on stage. 'They were totally original and they put on one of the best and funniest shows I've ever seen. One night they had a power failure at a gig. There was no electricity so there was no PA system. Vivian just got up and told jokes until the power came back. Afterwards, I apologized to the promoter but he hadn't even noticed. He thought it was all part of the act!'

The Bonzos also thought they should be doing better, given the amount of time and effort they were putting in. Other British groups, from the Beatles to the Who via Lulu and the Small Faces, were cracking America and they wanted a shot as well. 'We all thought Gerry was very straight but he just could not get us to the States,' recalls Larry. While Gerry Bron had already begun to make overtures on their behalf, he knew they were not ready for a trip to America. Without a big pop hit it was hardly worth their while. And if they were going to play their old 1920s-style music, well, the New Vaudeville Band had already stolen their thunder. 'I tried to persuade Liberty records to take more interest in them, but I never went to America with the Bonzos. The trouble was their humour was too British. The Bonzos could have gone on making a very good living and given a bit of patience they could have broken America and played at big festivals,' says Gerry. 'But when you manage people you can only take them so far. If they won't co-operate, you can't *make* them successful.'

For the moment America represented the dream of a glittering future for the Bonzos. Surely the land of freedom and opportunity would welcome these crazy young Englishmen with open arms? They were determined to pack their saxophones, ukuleles, tap shoes, gorilla masks and musical hosepipes and head way out west. If Gerry Bron could not get them there, they would just have to find someone else.

6
I'm Singing Just for You
. . . Covered in Sequins
1968–69

During 1968 the band reduced their regular club commitments to concentrate on recording and TV appearances. There were still one-off shows booked monthly to keep them afloat, from colleges to London pubs, the kind of gigs that Vivian, his mind set on greater things, thought of as 'pointless'. The band appeared in Thames TV's 'Captain Fantastic' in July and there was also an outing described as a 'Magical Mystery Tour' due to take place at the Middle Earth club in Covent Garden in August 1968, featuring the Bonzos, Family and Traffic. It was cancelled at the last minute and the band played at the Roundhouse, London, later in August at an all-night gig with the Pretty Things and Terry Reid.

The Bonzos visited the Edinburgh Festival over the summer, accompanied by folk singer Philippa Clare. Born in Egypt, the daughter of a senior British diplomat, she met Vivian through his friend Andy Roberts. On first visiting Vivian, she marvelled at his large collection of instruments and even more impressive set of old 78s, gave him a rare record from her own hoard and their friendship was sealed. Unlike many, she did not find him daunting and even braved sharing a room with him in Scotland.

The band were all crowded into a single flat, in one room of which Neil Innes had a bed and *chaise longue*. Philippa was able to stay there for a couple of nights, until Neil's wife turned up and her luck ran

out. She drew the short straw and had to share with Vivian. It was, she shudders, 'an absolute nightmare. He climbed into bed wearing this long sleeping cap with red-and-white stripes and an uncured sheepskin waistcoat that absolutely stank.' Vivian gazed at Philippa.

'Don't think I'm going to roger you, dear,' he said.

'Well – the smell was unbelievable,' exclaims Philippa, 'and he would do things like put eggs in the bed. I'd get over to my side and – squish! There'd either be an eggs or a hairbrush. Practical jokes all the time. It was exhausting.' Philippa finally realized she would have to get up early if she wanted to get her own back. She tiptoed out of the room and mixed up all the raw egg yolks in a great big bowl. As he came in, she intended to tip it over his head.

'But he saw me coming and, because he was taller, he tipped it all over me instead. I had egg all over my hair. Neil very kindly put me under the shower to clean it up. But the water was boiling hot so I had scrambled egg in my hair for weeks.' During this jolly week the boys decided to go off horse riding. Vivian had never been on a horse before but climbed aboard a huge grey mare and galloped off into the distance, much to the astonishment of the rest of the party. He tried his hand at driving a car, something else he had never done before. He went careering off, straight across major roads without stopping. 'Right ho, off we go,' he called.

'He was absolutely fearless,' says Philippa. 'But at that time he was getting very pissed and falling into the audience a lot. Supporting us were some fire eaters – so one can imagine, it was absolute chaos.' Working with Vivian every day, she began to see a vulnerable side that he usually kept hidden. 'That was when I really began to like him. He had this other side to him which was just magical. He could be gentle, quiet and soft. He was very bright, but he was also very fragile. He was covered in these layers of complete lunacy and he pissed a lot of people off like that. The more he pissed people off, the more insecure he got. The trouble was, he always had to be larger than life. He could be incredibly rude to people.' He met his match back in London, at the 100 Club in Oxford Street, when he learned not to mess with jazzmen. The Temperance Seven were playing and a very drunk Vivian decided that he needed to be on the stage with

them. Philippa grabbed him by the belt on his coat and pulled him back.

'He was absolutely furious,' recalls Philippa, 'and when we got to the top of the stairs on the way out of the club he threw me down. Wrong place to do that. He didn't realize a lot of jazz musicians really liked me, and he got a good kicking.'

In early autumn, the band recorded a new single, 'I'm the Urban Spaceman', at the same time as Dave Clague was replaced by American Joel Druckman, Neil started to stand up and play the guitar, Larry abandoned the tuba in favour of the drums, and the lead trumpet player slot was dropped. The Bonzos were becoming rock and '. . . Spaceman' was an indicator of the turbulent times. It was not a tricky song to write (it took Innes all of an afternoon) or to play, but it was the nearest they came to a standard pop song and it represented all that was complicated about the Bonzos. They had gone as far as they could as a jolly jazz band, but felt ambivalent at best about becoming a mainstream pop act. Vivian wanted to sound like Oscar Wilde, Neil wanted to be more Beatles-esque, Larry wanted to be louder and Roger simply wanted to play novelty jazz numbers. Gerry Bron just wanted to record the next track.

The arguments could be stopped, they thought, by using a pedigree producer for their new single – Vivian's chum Paul McCartney. His presence was electrifying. Bored sound engineers, asleep or chatting, suddenly leapt up when Paul took the bass guitar from Joel Druckman and demonstrated how the bassline should go. The engineers could not see who was playing in the studio, but it had an indefinable hit quality which made them record it. McCartney wiped his bass guitar track and made the Bonzos play it themselves. He helped them sort out the production in this way for the whole song. He even started plonking away on Vivian's ukulele, at which point Lillian Bron happened to wander past. She looked at the instrument Paul was playing. 'What's that?' she asked. 'A poor man's violin?' Quick as a flash Paul replied, 'No, it's a rich man's ukulele.'

This time, Paul allowed the band to keep his version of the ukulele track on the final mix. Vivian played the tenor recorder, supplying the jaunty melody which carries the song. 'Having said that he wasn't

a natural musician,' admits Neil, 'every now and then something would gel.' Stanshall also announced his intention to use a contraption of his own devising, a length of hosepipe with a plastic funnel on one end and a trumpet mouthpiece on the other. He managed to tune it to B flat and played it by swinging the piping over his head while blowing through the mouthpiece to produce a whirring effect. With luck, he could get an impressive five notes out of it. The engineer muttered darkly about the impossibility of recording such folly, but Paul was sanguine. 'Sure you can. Just put a microphone in each corner.' With a final twang from Roger Spear on an instrument made from a string attached to a tailor's dummy, the track was almost complete. Gerry Bron felt it needed just another couple of tweaks, but he knew he was taking too much on as it was with the band. The solution was a young producer working in an office almost opposite his own in Oxford Street.

Gus Dudgeon was a rising young engineer, who later achieved fame for his work with David Bowie and Elton John, and he eagerly agreed to finish '. . . Spaceman' and the album, for which Bron promised a co-production credit. After three weeks with the Bonzo Dog Band, Dudgeon called Gerry back to say, 'You weren't doing me any favours,' but his partnership with the Bonzos stretched over two albums.

By the time Gus came on board, a lot of the budget had already been spent, and he decided to pay a surreptitious visit to the studios of his old employer, Decca Records in West Hampstead. He'd left them only about eighteen months previously, so when he casually rolled in one day, the 'Urban Spaceman' master tape under one arm, the doorman greeted him as if he had been off on holiday for a couple of weeks. Gus consulted the session chart for the three studios and found one that appeared to be empty. The doorman said the Moody Blues were booked in and were at lunch.

'I rushed up to Studio One, had a look at the desk. There was obviously a mix in progress,' admits Gus. 'So I marked all the faders, took them down, changed all the EQ and mixed "Urban Spaceman" very quickly. I knew they were coming back, probably in three-quarters of an hour. I just had time, maybe half an hour. I did three

takes, put everything back as it was, got into my car and fucked off.' 'I'm the Urban Spaceman' was released in November and the band felt that Paul McCartney's contribution should best be kept secret. Despite Gerry's promises to Gus Dudgeon, the production credit was simply to read 'Apollo C. Vermouth'. Eventually the truth leaked and there was a palpable sense of relief from management and record company when the single charted, climbing steadily over the weeks to peak at No. 5 in January 1969. The Bonzos played 'Top of the Pops' to celebrate. Coincidentally it was the first of a trilogy of hits Gus produced with extraterrestrial connections: 'I'm the Urban Spaceman' was followed by David Bowie's 'Space Oddity' and Elton John's 'Rocket Man'.

In true Bonzo style, even the one undisputed success of '. . . Spaceman' was marred by one of the chaotic mishaps that plagued the band. When Gus Dudgeon remixed album tracks for a compilation LP, he thought it would be fun to segue 'Monster Mash' into 'Urban Spaceman'. It was a neat one-off. Since then this version has been used for practically every other reissue of the single: 'It starts off with this manic laughing which was never on the original single,' says Gus. 'That's so bloody aggravating. It's like having a bit of another track on the front of your biggest hit.'

Now the band were almost at the top. Surely now, all the tensions exacerbated by the lack of public recognition would melt away? For Vivian, that was not even the issue. He would rather they did not need to prove themselves commercially: 'I used to think one didn't need hit records to get on,' he said. 'I suppose it annoyed me to think it took a hit record to get us in the public eye, because when we started we had something different to offer, and there was nothing like us on the scene.'[1] The last thing he wanted to be was simply just another part of the merchandizing process. It was not why he wanted to be in a band, when 'Pop followers have grown up and standards have risen. I don't like the machinery of pop,' he added. 'I had to fill in some God-awful form asking me my favourite food and colour. I can't believe anybody wants to know, even if I could tell them. It distresses me there could be still a market for this kind of information.' The band were packed off to larger venues, as their

record company and management wanted to exploit their fame.

'We were put out to sniffle around in the area of ballrooms and things. We were sent in directions that were completely unsuitable for us.'[2]

'Urban Spaceman' retained Bonzo charm while having the right combination of melody and quirkiness to appeal to pop fans. It was not a funny record or a rampant rock performance either. They had learned that comedy by itself was hard to sustain in a chart single. Frank Zappa, reviewing the single as a special guest of *Melody Maker*, noted that the 'urban spaceman' said 'I've got speed'. 'I've heard about the Bonzo Band, but I think this is rather opportunist,' said Frank. 'Every speed freak in the country will want to identify with this.'[3]

'It couldn't have been further from what I had in mind,' sighs Neil. 'I was so naïve in those days. In "Equestrian Statue" I wrote the line, "It's a sight to bring you joy, you feel so gay." Well "gay" is a good word. It rhymes with "day" and it means cheerful. It was only just emerging at that time that "gay" meant homosexual. I had no idea that "speed" meant amphetamines. I suppose the Bonzo approach to things was quite puerile, but we were very young.' Another popular novelty jazz number the Bonzos revived was 'Ali Baba's Camel' (originally by Noel Gay with lyrics by Charles Gaynor): 'You've heard of Ali Baba/Forty thieves had he/Out for what we all want/Lots of LSD', or rather 'lsd', the pre-decimal abbreviation for pounds, shillings and pence. The forty thieves were after money, not psychedelic thrills.

'. . . Spaceman' was important for the band in another way. It was proof that the electric instruments were overwhelming the brass and acoustic sounds. More in keeping with the original Bonzo spirit was Stanshall's B-side contribution, 'Canyons of Your Mind'. Vivian was on Elvis-alike vocals, on one alternate version introducing the song with 'This is the B-side of our platter . . . and I'm singing just for you, covered in sequins.' He also provided some sterling belching, and the song featured a truly awful guitar solo, complete with screams of adoration from the rest of the band. Not everyone got the gag. At one gig, Rodney distinctly heard a withering remark from a punter. 'God,' he said with disdain, 'that fucking guitarist is crap.' There was a nod to the strength of the track in that, even as a B-side, it was given

a memorably visual outing when the Bonzos appeared on the TV programme 'Colour Me Pop' in 1968, in which Vivian accompanies the line about crossing the mountain on chest regions with some frankly lewd jiggling gestures, while keeping an unmovingly urbane expression on his face. As the rest of the band do the guitar-hero-worshipping of Neil during the solo, Vivian takes the opportunity to nip off and put on a large and disturbing monster head in which he performs the last part of the song.

The American record company the Bonzos dealt with requested 'Canyons . . .' for a US single release. Vivian's drawl on the track and his reputation for delivering a brilliantly accurate Elvis impersonation was not enough for the US executives. They felt it wasn't 'American' enough. Gus Dudgeon booked some recording time to prepare a new version with Vivian. 'Right, I've got an idea,' Stanshall told Gerry and Gus in the studio. 'They'll like this. Just run the intro for me.' Gus got a level on Vivian's voice and started to run the tape. 'Hi, sports fans!' said Viv in a perky NBC kind of voice. Gus waited for the next bit. Vivian motioned that he should stop the tape. 'Right! That's it. I'm off to the pub,' said Vivian chirpily, adding a reassuring 'They'll like that.' The great Americanization operation was complete.

At the same time as they recorded the single, the Bonzos worked on a new album, *The Doughnut in Granny's Greenhouse*, on which '. . . Spaceman' and 'Canyons of Your Mind' were notable for their absence. Normally, a single would be a taster of an album and it goes without saying that said single should be on the album. 'Urban Spaceman' did not appear until the following year's *Tadpoles*, to the confusion of fans. *The Doughnut . . .* boasted some classic tracks all the same. 'My Pink Half of the Drainpipe', jointly composed by Innes and Stanshall, with its tales of hedge-cutting rivalry in suburbia, was an artistic high. Vivian's lyrics were becoming ever more elegant. Here he conjures a simple series of uncluttered images in focused correlation with the ghastly suburban inanity of the material. Vivian took the part of the metropolitan bore described in the song, rather than distancing himself, perfectly satirizing the claustrophobia of being that blinkered middle Englander. As Pete in Harold Pinter's *The Dwarfs* points out, 'Every particle of a work of art should crack a nut,

or help form a pressure that'll crack the final nut. Do you know what I mean? Each idea must possess stringency and economy and the image, if you like, that expresses it must stand in exact correspondence and relation to the idea.' Just the title 'My Pink Half of the Drainpipe' fulfils those criteria. We know precisely what the band are singing about; it is a succinct invitation for the listener to visit a crashing, banging world of neighbourly normality that is too horrifying to bear and too funny to ignore.

The surreal 'We are Normal' sat beside old-school Bonzos like the Innes-penned 'Hello Mabel' and a comment on the white blues boom of the time called 'Can Blue Men Sing the Whites'. A darkly ritualistic finale was provided by the wilfully obscure 'Eleven Moustachioed Daughters', a piece which Vivian would revive in later years. The album's title, *The Doughnut in Granny's Greenhouse*, was another mystery. It was another scatological reference, a euphemism for the toilet, which the Bonzos had heard on 'The Two Ronnies' show.

'We worked on at the album at Chappels in Bond Street, which my ex-boss from Olympic studios was running,' says Gus. 'He and I had never really got along terribly well.' The relationship was not about to improve now that the Bonzos were on site. The band had been there only a few days before they attempted to record a tuba full of water. Gus was soon able to report the conclusions of this musical experiment: 'You get wet and you get some bubbles and the occasional note trying to force its way through the water.' You also get a lot of water all over the studio. Absorbent carpet tiles on the floor meant nothing was seriously damaged, but it was all the excuse that Dudgeon's ex-boss needed to summon the young producer for a terse meeting in his office the next day. After this incident the band had to find a new studio, settling on Morgan studios on the High Road in Willesden Green to record the rest of the album, where Gus was able to observe the working methods of the band, with all their exacting attention to detail.

'I never really knew who played what,' he reflects. 'People would just pick up things with an authoritative kind of air: "Oh, I'll do this." They'd pick up a banjo and you'd think, "Does he play banjo?" And

they'd play and, oh no, he obviously doesn't! But the point was, it didn't matter – because they'd sort of flail through it.' They used innocent members of the public on the recordings. Both 'We are Normal', the first track on *Doughnut . . .*, and 'Shirt', saved for the following year's *Tadpoles*, include vox pop interviews and snatches of conversation recorded outside Morgan. The gloriously eccentric members of the public who stop to chat with the Bonzos were no set-up, but recorded on location in Willesden. An extra-long lead was plugged into the recording desk and the microphone was handed to intrepid 'reporter' Larry. He braved Willesden High Road in search of the voice of the people. As pedestrians and traffic stopped at the zebra crossing directly outside the studio, Larry prompted them into talking. It was soon apparent that the public were reluctant, perhaps because Larry wore a lime-green satin jacket, a pink T-shirt with a big silver star in the middle of it, enormous baggy trousers and huge pink platform shoes. He also had very long hair and a pair of dark glasses. In haste to avoid him, one driver of a motorcycle and sidecar shot off from the crossing at such speed he nearly crashed. Another approach was required. Vivian hit upon an idea 'to attract a bit of attention'.

He took all his clothes off, says Gus, 'apart from his underwear, which was absolutely disgusting. It was about eight sizes too big, full of holes, tea stains and joint burns.' Vivian grabbed a papier-mâché rabbit's head, with one ear sticking straight up and the other bent, and headed out to the street. He leaned casually on a parked car a few yards away wearing the rabbit head. 'That'll help!' he told Gus. 'That'll stop 'em.' The results are just about discernible among the echoes and strange noises at the start of 'We are Normal' on *Doughnut*. Joel Druckman says: 'Here come some normals. They look like normal . . . Hawaiians.' One man is asked to comment on Vivian, on the other side of the street. Is Vivian normal? 'He's like a rabbit. He's got a head on him like a rabbit.' Here were the Bonzos in the era of psychedelia and trips, and they went the other way, going to some trouble to create a hallucinogenic vision for real. Nobody would be able to spot the joke on the record. The idea of normality was the key for the Bonzos, endlessly fascinating.

'I think I'm normal,' Vivian told one interviewer, 'yet I was on a tube train the other day reading through a telephone directory for silly names like Wardrobe or Stanshall. I was laughing away and people were gawking at me as if I were a freak. But laughing was normal to me. It's a state of mind. Let me put it this way. I came up to town for a recording session on an 8.30 a.m. tube the other day and I could not believe that people could put up with such indignity. The indignity of wearing such grey, shabby clothes and being squashed together – putting up with each other.'[4]

The interview exercise in Willesden hotted up at the third attempt, when Vivian dressed in a relatively straight manner and made a serious effort to get people on the street to talk. The results were used on 'Shirt', with Vivian at his most urbane. All that was necessary to get away with the most outrageous performance was to appear legitimate. 'You simply said, "I'm from the Home Counties", didn't even say BBC,' said Vivian. 'Or, "I'm Number Three" . . . Now, if you give the magic of numbers, this is from nursery rhymes. There were three wise men, not just some wise men, three. That's really strong, it's exciting. So you say, "I'm number twelve from the Home Counties", well, that's it, you're established. It doesn't matter what you look like, you can get away with anything. "I'd like to talk about shirts . . ." You think, "This is barmy!" You've got these people, you're taking up their time and they're sitting there talking about shirts!'[5] Vivian shaped the interviews, drawing the public into the world of the Bonzos . . . and shirts.

The track begins with some odd crunching noises, which we hear Vivian explain are 'Roger's wah-wah rabbits, you heard them eating endives there, that's very cheap at this time of the year'. This was not another Bonzo gag, it was absolutely accurate. Roger did have some rabbits eating endives and he did indeed run the sound through a wah-wah pedal. Vivian begins his spoof broadcast from Willesden in his best BBC radio-commentator fashion, interviewing a selection of the public and achieving greater success than Larry enjoyed. Further proof that the Bonzos' surreal take was based on reality was provided in the second introductory sketch for 'Shirt', a little skit set in a dry-cleaning shop, the name of which is 'Fifty-nine-minute Cleaners'.

The customer asks for the fifty-nine-minute clean, only to be told that 'fifty-nine minutes' is just part of the name of the shop and, after much prevarication, finally learns that it is actually going to take five weeks. 'Five weeks? Blimey!' This was also largely true – the Bonzos encountered one such cleaning establishment on tour when they were in a desperate hurry to spruce up their stage gear.

'Trouser Press' announced the arrival of a brand-new dance: 'Do the trouser press, baby!' It too was very real. An ordinary Corby trouser press, owned by Roger, made the extraordinary sounds. Elsewhere in the music business, the sitar was then finding fame with any band who wanted to add a bit of 'exoticism' to their sound. The Ravi Shankar of the trouser press was Roger Spear: 'I wired it up with a contact mike. Whatever part you touched it was live,' he says. 'This was a particularly rusty trouser press and it made some beautiful sounds. Bang, rattle, crash! I used to use it on stage. I would take my trousers off, put them inside the machine and would be playing away and there would be a smoke capsule hidden inside. When I finished the solo there would be bits of trousers and smoke everywhere.'

Gus was drawn into the friendly, informal way of working and loved the chaos. He was the same age as the band members and, just starting out, the experience of working with the Bonzos was a great initiation. They were, he says, 'different in every conceivable way. It was totally anarchic, with absolutely no regard for any convention or law; I mean the rules, whatever the rules were for how you broke a band; how they performed on stage; how they performed in the studio. Everything went out of the window. I think they knew what the main thrust of any individual song was, but what was going to wind up on the track was very much just spur-of-the-moment. The whole ethos kind of filtered through everybody working on it. Just have a bloody good laugh, enjoy yourself. We'll give you the raw material.' They were not into hanging around in a studio, perfecting the sound, tweaking the mix or arranging string sections. They would sometimes make requests for altering the track almost as an afterthought on leaving the studio. 'Solo for "Hello Mabel",' Vivian breezed to Gus one day. 'Let's get some animals in. What we need are elephants,

tigers, lions, wah-wah rabbits, pigs, anything you can think of.' It was up to Gus to get the animal effects in and to put the track together. Often, they would pile through three tracks in an afternoon and only later – when it was too late – realize the importance of getting proper credits for each track to receive royalties. Faster recording times did at least mean there were fewer arguments, though with so many creative members, tantrums were never far away.

'Somebody would fuck off and all of a sudden your bass player wasn't there,' says Gus. 'They were absolutely at each other's throats. It was like a marriage. That was the nature of their relationship. If it got out of sync, then they'd just shout at each other.' Larry and Vivian were particularly good at yelling. The studio air would turn blue with the sound of unbelievably vulgar insults. One or other would stalk out for a while and then there would be a great making-up scene. The morning after one particularly heated row, Gus was first in the studio. Vivian showed up, radiating good humour; he was off for a spot of fishing. 'By the way, old boy,' he added. 'I've bought Larry a sandwich, I'll leave that for him.' Gus put the sandwich on the end of the mixing desk and Larry turned up to discuss the plan for the day's work. At length the producer casually passed the sandwich to him. As he began to cue up the track, Gus noticed what looked like a pile of cigarette ash on the side of the desk where the food had been. He brushed it off and as he did he was horrified to feel that the stuff under his fingers was squishy and wiggling and . . . was actually a heap of maggots. He looked round to see that by now the sandwich had almost made contact with unsuspecting Larry's mouth.

'Larry! No!' shouted Gus, grabbing his arm.

'What?' asked Larry, bemused. He followed the producer's gaze and the two of them stared in deep shock at the sandwich. Between the bread, a mass of writhing, wriggling maggots waved back at them. The two considered Larry's lucky escape. 'It was worse than horrible. It was fucking evil.' says Gus. Even now he cannot quite believe what he saw. 'And when you think these guys had just made it up on the phone that morning!'

Somehow, the album was completed and released in the same month, November, as 'I'm the Urban Spaceman'. By the end of the

year, the band consolidated their position, *Doughnut* eventually peaking at No. 40 in January 1969. They were bracing themselves for another twelve months of manic effort. Vivian sounded a note of caution. 'We are all nervous wrecks. We go on stage physically exhausted,' he told *Melody Maker*, hinting that the band were on the point of breaking up after Christmas. Vivian was going to become a teacher, or 'try to get a job as a disc jockey'.

'Do Not Adjust Your Set' won a second and final series for the new year. The future Pythons provided the bulk of the material and the Bonzos were again the house band, also appearing in a few sketches. More work. During a break in filming at Teddington studios in January, Vivian told a reporter: 'I am sure we're all certifiable.' Though said in jest, there was clearly an edge to proceedings. Neil Innes added, 'We have to have padded rooms. No shoelaces, razors or lights, you know.' As well as travelling to one-nighters, they were having to fit in daily recording sessions and the TV show, which ran from 19 February to 14 May 1969. The band were clearly exhausted. Vivian revealed that he kept 'finding myself in rooms and wondering what I'm there for. I think perhaps we are all undergoing nervous breakdowns.'

They were still determined to make it to America. With Gerry Bron managing, it seemed unlikely, so the band asked Tony Stratton Smith (born 1933) to become their personal manager. Where Bron was businesslike and had the organized approach of a music-biz professional, Tony Stratton Smith was a more intuitive personality. A portly, avuncular man, 'Strat' was foremost a journalist and writer, who had built a successful career outside of show business. Starting off as a local newspaper cricket correspondent, he then joined the RAF. He was sports editor on the *Daily Sketch* and later the *Daily Express* and wrote books. On a writing trip to South America he met the composer Antonio Carlos Jobim and became interested in the burgeoning pop music scene. Returning to London, he was encouraged by the Beatles' manager Brian Epstein to try his hand at pop-group management instead. He also set up his own independent label, Charisma Records, in order to promote a widening circle of bands and artists. These were to include Rare Bird, Van Der Graaf Generator, Genesis,

Audience, Lindisfarne and Monty Python's Flying Circus. Stratton Smith liked off-the-wall creative people with something original to say, particularly writers and poets. His tendency to back outsiders resulted either in expensive failures or highly successful winners, and it was no coincidence that his other interests were gambling and horse racing.

The Bonzos completed their UK dates and prepared to conquer America in April 1969. In yet another line-up change, Joel Druckman left the band. He was replaced by bassist Dennis Cowan (born 1947, died 1974), who became a close friend of Vivian. The organization in the States was poor and the reality of the promotional jaunt was a desperate rush to play at a few venues in New York and San Francisco. They grabbed any other rock gigs going. The Bonzos did two nights at the Fillmore East, New York. On the first night they were introduced as the warm-up band, playing with the Kinks and Spirit, neither of whom wanted to open the show. So the following night, the Bonzos decided that, if they had to be the warm-up band, then they would indeed be exactly that.

'The audience was comprised of stoned sheep,' said Vivian. 'We borrowed all these running shorts and things and came out and did some PE for a bit. I loved it. I must start carrying a whistle. So we did a warm-up for about fifteen minutes with beach balls and things and they were dumbfounded. Then the curtains closed and we went round the back and put on our glittery togs and did our set. And I don't think they ever asked, "Who were those guys?" They made no reference to it. Extraordinary.'[6] The band determined not to Americanize their set, like the cast of *Beyond the Fringe* before them and the Monty Python crew later. And the audiences got it.

'We played everything with such conviction they must have thought things like pink halves of drainpipes were relevant and important,' says Larry Smith. 'We had such enthusiasm and we were having such a good time on stage it got across to the crowds.' During the interval, half the audience would come backstage, bearing gifts for the British visitors. They brought lavatory seats, bras, knickers and *objets d'art*. Vivian was deeply touched when he learned that four of the audience at the Fillmore East had travelled all the way from the depths of Ohio

just to see the Bonzo Dog Band. 'Leaves me speechless how anyone could come that far to see anything – it would have to be Lourdes for me,' he said, 'or a levitating poodle.'[7] As the Bonzos played to more of the right people the reaction was greatly encouraging. Says Neil: 'It was quite extraordinary. Everywhere we played it was great. In Detroit, where a large percentage of the audience was black, they loved us – even when Roger sang "Swanee".' Picking up on the response of black audiences, later in the summer of 1969, an earnest Dutch interviewer asked the band about their Britishness and why they wore masks. Were the Bonzos aware that they were very British?

'Yes,' said Vivian without a trace of weariness at the observation, 'I can't really help that.' Persistent, clearly confused as many were by the band, the interviewer asked if they were proud of this fact. 'No, I'm not particularly proud of it, but I'm geared to behaving this way, so I behave this way. It's the role in which I feel happiest. It's as simple as that. I'm not being political about it. I'm not insisting on our superiority,' Vivian added, 'as we stride over the black backs, you see, whipping them and turning them into treacle.' The interviewer jumped on this throwaway line, suggesting that there was some political statement in wearing 'Negro masks'. Did they have any comment on that?

Vivian quickly responded, 'No, not really. They love it. Especially when we went to America, people said, "You know, you're going to get shot for that, afterwards in the alley, stiletto, that's it." But it wasn't like that at all. Because Negroes obviously dig jokes about Negroes, just as we would dig jokes about white guys. So it's good putting it on. The worse the joke, the better Negroes like it. It's all working in reverse.'[8]

Masks were important to Vivian: 'Oh, yes, I think it is important to see that one is using masks and to show the value of masks and the truth of masks, you know,' said Vivian. 'One should see that they're masks, in order to see invisible masks, let's put it that way. As well as I know that it's creating an astonishing effect visually, which is, I think, valuable in impressing our obscenity on the public.'[9] Another aspect of the Grande Ballroom, Detroit gig which Vivian found particularly heartening was the way in which people seemed to appreciate

different elements of the gigs. He felt that in the UK, the band were pigeon-holed as a novelty act.

'I found it somewhat saddening that it was treated as a fringe, avant-garde cabaret, and just that,' Vivian told an interviewer from an American radio station. 'Although, and here it sounds as though I'm sucking up, in America I was surprised at the perception of many audiences. For example, in a musical passage I would go into some mimetic routine which would be spontaneous and off the top. I remember a bloke coming up to me in Detroit and saying, "Were you thinking of Beardsley when you were doing such-and-such in the middle of whatever it was?", and I was. I was thinking about Beardsley monkeys. And that I found shocking and exciting at the same time. I didn't get that sort of reaction in England.' Vivian was probably thinking of the drawings of Aubrey Beardsley (1872–98), such as the monkey figures carrying a sedan chair in *Juvenal*. An artist renowned for testing the boundaries and shocking the Establishment with his erotic art, Beardsley was also a friend of Vivian's hero Oscar Wilde.

The Bonzos' tour was a mixed trip in that the band's reach was limited by poor record-company support and the lack of palpable hits. The audience were much more responsive than the organization. 'In general, our concerts are put together by apes who are limited to getting what they, in their own particular swamp, think are your most commercial attributes . . .' said Vivian. 'In the States we had this thing that said, "Bonzo Dog No. 1 in England". Then it had two pictures of our album, very badly designed, and at the bottom in dayglo letters it said, "Dig?" . . . question mark really big. Can you imagine the thinking behind that? The perverts who sat around a table thinking, what's the name of this band? . . . They think people are all sitting around flicking their fingers and going, "Crazy, man, groovy." They really think people are like that.'[10] Vivian was much more enamoured with his first taste of the country itself. 'We are a bit cloistered over here. Things are happening much faster over there, so it seems,' he said. 'I have never been in a place where there were so many people being so rude to me.'[11] The band determined to get back to the States and try again.

Manager Tony Stratton Smith had been busying himself with his

Charisma Records project back in London. The Charisma label provided a friendly environment for its artists, but the band were still not moving forward. Tony was assisted by Gail Colson, who brought to the newly established label her young brother, Glen. He fulfilled a variety of roles for the burgeoning company, from press officer to A&R man, and was to work closely with Stanshall, who made a big impression on him. Glen remembers looking on with fascination when Vivian used to go to a whelk stall in Cambridge Circus after he had already had lunch, buy a pint of whelks and be sick in the cab on the way home. Another favourite meal was vindaloo with a dollop of yoghurt on top, eaten at a restaurant in Soho, where he would terrify the waiters. The Colsons' father in turn found a fan in Vivian. Jack Colson ran the Magdala pub in Hampstead, which became a favourite rendezvous for Charisma artists. He had served in the Royal Navy during World War Two, and had been captured by the Germans. Vivian often visited the pub and swapped old navy stories and professed to prefer Glen's father to his own, just as he would always retain great affection for Larry Smith's father, Alec.

In mid-July the Bonzos flew to Ireland on a trip that surpassed every other band outing for its ramshackle adventures. The band was part of a package that included the Nice, also managed by Tony Stratton Smith, and Yes, the progressive rock band signed to Atlantic. Visiting English rock stars then had very little knowledge of Northern Ireland or its politics. When they arrived in Belfast, Roger Spear proved this by warming up with 'Cool Britannia' on his alto sax in the street outside the Ulster Hall's stage door. This was rather too close to 'Rule Britannia' for the locals. Even more baffling for the band was the fact that driving through certain parts of the city, every inch of available space was painted in red, white and blue stripes, even the metal drains in the road. They thought the locals were having a street party. All the acts stayed in the same Belfast hotel and *Melody Maker* journalist Chris Welch shared a bedroom with Vivian. As Chris unpacked his bag Vivian headed for the downstairs bar. 'No going through my things while I'm out, you sneak,' he warned.

Downstairs, the bands laughed and joked together in the restaurant. Both Yes and the Nice were great fans of the Bonzos and were

quite content to let Vivian take centre stage. When the waitress arrived bearing a plate of hot food Vivian began to flatter her in the guise of some Victorian dandy. 'You are very beautiful, my dear. I have fallen madly in love with you. Tonight you must come to my room. You must give the call of the dove – "coo, coo". And I will give the cry of the wildebeest – "Arrrrgggh!"' The round-eyed girl, hypnotized by his speech, let out a scream and sent the plate and its contents crashing to the floor. In the chaos that ensued it was the hapless waitress who was reprimanded, rather than Vivian. He was often less than diligent in ensuring the ordinary victims of his pranks were not hurt. It was making an impact that was the more important concern for him.

The first Bonzo concert in Ireland was a success. The fans went wild in Belfast for all the bands and the groups set off in good spirits by coach to Dublin for a gig at the National Boxing Stadium. While they waited for the evening show, Larry and Vivian spent the day parading up and down Dublin's streets in search of cockles and mussels. 'Excuse me, do you know where we can find some seafood?' Larry asked a passer-by. Two men came over and asked the first man, 'What does he want?'

'He wants to buy some seafood – as he calls it.'

'Well, you could go that way.' The third man pointed vaguely in the direction of the sea. By now more people materialized out of nowhere and a whole posse of at least a dozen bystanders stood, arguing and pointing. Larry and Vivian quietly sloped off and left the animated crowd still engaged in loud discussion and blocking the pavement. That evening the Bonzos took some time out to sit with the audience while the Nice performed. During a moment's silence Vivian suddenly cupped his hands to his mouth and bellowed a sonorous warning in his best Irish brogue. 'There's a pig loose in the theatre!' To his disappointment, the crowd failed to stampede for the exits as he had been expecting. Much of the following day was spent on an interminable hot drive to an outdoor festival in Cork in the south-west of Ireland. The managers promised that this would be a blockbuster that would make the time-consuming and expensive trip to Ireland all worthwhile. With three of England's hottest bands

making up an exciting bill, it was to be a major, sold-out event.

As the coach reached the outskirts of Cork, they began to look around for the crush of vehicles and streams of people heading for the festival site. Yet the roads and surrounding fields remained strangely empty. Someone spotted a tattered poster stuck on a wall advertising some sort of musical event and, having made inquiries at outlying cottages, the roadies went ahead and established that the gig was at the town's football ground. When they arrived there was not a soul to be seen for miles around. No sign of the promoter and only the remains of a makeshift stage that seemed to have been abandoned. The managers went white.

The skill of the organizers was much in evidence in the office. 'Look – this is the power supply,' pointed out an excited crew member: it was an electric-kettle flex with the three-pin plug missing and the bare wires stuffed into a socket with the aid of broken matchsticks. There was an air of complete bewilderment and disbelief as the three bands milled around the muddy pitch in their patent-leather shoes, purple scarves and skin-tight satin loon pants. The roadies tried three times to set up the gear, but each time they plugged in the amps, the power failed. Clearly the matchsticks were not up to the job. It was painfully clear that after driving for five hours to the ends of the earth, there would be no performance that night. The stranded musicians sat down on the pitch and cried with laughter. At that moment an awful stench struck their nostrils. It was wafting from a ramshackle building which bore the legend 'Cork Pork Abattoir'. That was the final insult. Vivian let out a roar as a shame-faced Stratton Smith appeared to make his apologies. 'De-bag the rotter!'

The musicians surged forward bent on revenge, fully intending to remove their manager's trousers. For someone of his size, he made off with a remarkably athletic burst of speed across the football pitch towards the setting sun. The mob were gaining on him when suddenly a loud explosion rent the air and a shower of rust cascaded from the corrugated-iron roof of the stadium. Roger Spear had let off one of his flash bombs. The sharp retort saved Stratton Smith from further humiliation, but unfortunately it also had the effect of drawing irate locals to the scene. By now everyone just wanted to escape back to

London. An aggressive young man, one of the few who had turned up for the show and clearly believing he was being seriously inconvenienced, demanded to know why the concert had not already started. As the sole festival-goer he felt he was being ripped off and even being shown the electric-kettle flex did not pacify him.

With several hours to go before they flew home, the three bands, their managers and press crew adjourned to the nearest pub. After several pints of Guinness everyone was in a better mood and Keith Emerson of the Nice began to play on the pub's old upright piano. All gathered around and began singing John Lennon's 'Give Peace a Chance', with slightly altered lyrics: 'All we are saying is give booze a chance,' a version which the Bonzos later recorded, but did not give an official release before their split. As Keith launched into 'Honky Tonk Train Blues' the locals became increasingly excited. One youth began beating time with his beer mug on top of the piano. When the glass shattered, showering Keith with fragments, the lad thought it such excellent sport he took a succession of mugs and began smashing them to pieces. 'Come on – out,' said the roadies, and they headed for the airport.

Vivian was relaxed as the rickety plane taxied down the runway. 'If we crash we'll all be fucking legends.' As the plane flew over the Irish Sea on that moonlit night of 20 July 1969, the captain's voice came faintly over the intercom. 'Good evening, ladies and gentlemen. The Americans are about to land on the Moon.' The day had been one giant leap backwards for the Bonzos. Roy Flynn, the manager of Yes, remembers it very clearly: 'Yes were the only band to get paid on that weekend. I think we got £75. There was absolutely no publicity for the gig in Cork. All those hairy musicians must have looked like Martians in an Irish landscape. The promoter hadn't told anyone that three English bands were coming. Even if anyone had turned up, the stand they built was so small only two hundred people would have seen them.'

The Bonzos enjoyed a more successful outing the following month at the 1969 Isle of Wight Festival in Wootton, where they arrived four days after a trip to Holland. It was the kind of setting that Vivian relished. 'We are a nation of watchers and pop festivals can be joined

in,' he declared. 'Groups should turn their speakers around and invite everybody to be one of the band.'[12] They had done something of the sort at a Marquee gig, giving out 300 whistles so that everyone could join in. The Isle of Wight event was massive, with Bob Dylan topping the bill, the Who and the Nice among the supporting stars. It was probably the biggest audience the Bonzos would ever play to and one of their members went missing.

'Moonie and our Larry Smith were sloshed and flying around in Moonie's helicopter,' said Vivian. 'We went on without a drummer and I called out to the audience saying, "You will have to clap along to this one because we haven't got a drummer." Jim Capaldi [drummer with Traffic] came out of the audience and the band really cooked. When "Legs" Larry eventually arrived he pushed Jim off the drum stool and gave him a bloody tambourine. I was miffed because Capaldi was playing so well.'[13] Capaldi was sidelined, and the Who's power-house drummer had to settle for congas. As it was, they were lucky to get Capaldi, who hardly knew them. 'There were very few people who would have got up to play with us,' said Vivian. 'We were poking fun at most of them and they couldn't handle not being serious.' As the Bonzos' set finished, Vivian Stanshall announced that more guests were coming, including guitar-teaching legend Bert Weedon, who had been name-checked in the Bonzos' 'We are Normal'. Weedon, he alleged, was busily tunnelling his way from Middlesbrough and was presently under the Irish Sea.

Keith Moon, attempting to escape the fisticuffs that frequently accompanied his life with the Who, found Vivian and Larry great playmates. Lee Jackson of the Nice recalls one episode when Moon joined the band on some dates in the West Country, where they stayed in the same hotel: 'Moonie was playing drums with the band while Larry was tap dancing. They were doing four or five gigs and the first night they get to the hotel the officious manager told them they had to wear a tie to eat in the restaurant. The following night the whole band, including Moonie, came parading down the central stair-case, all wearing ties. They were bollock naked – apart from the ties.'

Back on the mainland in August 1969, the Bonzos released a compilation LP called *Tadpoles*, featuring some of the songs from 'Do

Not Adjust Your Set'. The set included 'Hunting Tigers Out in Indiah', Roger Spear's surreal 'Shirt', the rather romantic 'Tubas in the Moonlight' and – somewhat late in the day – 'I'm the Urban Spaceman', which followed 'Monster Mash', another superb vehicle for Stanshall. The song was originally a US No. 1 chart hit for Bobby 'Boris' Pickett and the Crypt-Kickers in September 1962. Rodney Slater preferred the version by Vivian, who 'didn't half alter some of the lyrics', says Rodney. 'I will always remember that manic laughter at the end of "Monster Mash". I was sitting in the studio and the huge speakers filled the whole room with this unbelievable laughter. Of course, everybody else started laughing while he was doing it and it was the kind of laughter where you almost can't breathe. The head starts to ache and a band tightens across your chest.'

The flip side of the album had more relics from the early days like 'Ali Baba's Camel', and 'By a Waterfall'. It was all rough and ready – they had not always even bothered with a studio. 'Dr Jazz' and another oldie called 'Laughing Blues' were recorded on a cassette machine at a live gig. The Bonzos paid no attention to the erratic shifts in sound quality, and were happy to improvise mixing techniques. The Bonzo era was a time of greater tolerance and, as a music-industry insider, Gus Dudgeon saw their reputation rise, if anything, through their radical attitude.

'They were really highly thought of within the music business,' says Gus. 'Everybody just loved them to death. And if you mention them now to people, they go, "Oh yeah, Bonzos, fucking great." Weird people that you'd never think would have heard of them, let alone appreciate or remember them. I think that was part of their carrying power. Within the business they were kind of nurtured.'

Another chaotic session for the album resulted in 'Mr Apollo'. This variant on the Charles Atlas body-building adverts featured strong guitar work and some great dialogue from Vivian, in a kind of fore-runner to the spoof radio ads he would do for Radio 1 in the 1970s. With Mr Apollo's technique, listeners are assured, they can wrestle poodles successfully and turn the tables on bullies. Even shaving legs is not too tough a proposition for someone willing to dedicate ten years of their life. As ever, Vivian had to push the song that bit further.

He originally had another line in there, 'kick spastics and laugh'.

It was down to Gus to rein him in, and despite Vivian's protestations that it was only a bit of fun, he did take out the offending line. 'Mr Apollo' was an unsuccessful attempt to find a second hit single, when it was released backed with 'Ready Mades', the title taken from another Marcel Duchamp phrase. Just as 'Canyons of Your Mind' was rejigged for the US, 'Mr Apollo' was dubbed for release in Germany, for which Vivian did a spirited job of redoing the dialogue. The mock advert was all the funnier for Vivian's attempts at German pronunciation and accent.

Tadpoles was the last recording Gus worked on with the band, and he remembers that while Vivian was together and purposeful most of the time, he was starting to lose his control. 'On "By a Waterfall" he was absolutely sloshed,' says Gus. 'You can hear it, if you listen to it closely. He was completely paralytic.' Halfway through the song Stanshall fell off his stool. 'I had to stop the tape, go down into the studio, pick him up, give him a cup of coffee and carry on.' It did not bode well for the band's second attempt to crack the elusive American market.

7
Can Blue Men Sing the Whites?
1969–70

Tadpoles reached UK No. 36 in August 1969 and the Bonzos were firmly established as stars. No matter how well they did, however, they never seemed to be respected as more than those knockabout students they once were. Humour was considered to be lightweight next to the portentous offerings of 'serious' rock bands. This irritated many in the band. They might top the bill and have to squeeze in some little dressing room. Those crazy Bonzos will not mind squashing up, the promoters clearly thought, they are just the comic turn. Once down as 'lovable lunatics', says Larry Smith, 'it's very hard to command good money and better treatment'.

The band prepared for their second six-week tour of America, to promote *Tadpoles*. They also announced that a new album would be released in November, but not with the help of 'Strat'. The Bonzos had outgrown another manager. 'Eventually we fired Tony,' says Larry. 'We were a pretty impossible band to manage. In the end we cast everybody aside.' Vivian was to take the mantle of manager on his own increasingly fragile shoulders. The second American tour followed far too fast on the heels of the first one to have any chance of success, and it was another responsibility for Vivian that autumn. He had a very young son waiting for him thousands of miles away. There was hardly a chance for him to fulfil his paternal duties and he could see the boy was already starting to form his own character.

'My boy is seventeen months now and he is equally knowing as I am,' he said, 'but his vocabulary is in terms of sights, sounds, smells and touches. He is as knowledgeable as I am.'[1]

The Bonzos had been too busy playing disorganized gigs at home to formulate a proper strategy. The organization was just as bad as it had been on the earlier tour and the novelty of the USA had very much worn off. It was the same thing all over again. Audiences were not hard to win over. The band might come on to what Rodney was fond of calling 'the sound of cattle crossing' and leave to ecstatic ovations by the end of the night. The record company seemed unable to exploit the reaction; they promoted the band in one city just in time for a concert in a different state altogether. The Bonzos were ready to give it all up for good.

'We gave the impression both on stage and off that we were completely insane and had absolutely no sense of values,' says Larry, and that was how they were treated. 'It was complete anarchy.' They found that their dates altered, the price of gigs changed from the contracted fees and their albums were unavailable in the cities where they played. Even the label was not right – *Gorilla*, *Urban Spaceman* and *Tadpoles* were released in the States on Imperial, better known for its R&B and rock'n'roll catalogue. In Cincinnati, the frazzled frontmen, Vivian and Neil, could not bottle up their feelings any more. They ranted to a reporter for more than two hours about the iniquities of a system that consumed their creativity. Open-mouthed, the hack could only comment, 'We won't understand these people – they're artists.'[2] It was an attitude the band encountered everywhere.

Awful news from England hastened the end of the American tour. The band learned Roger Spear's wife had suffered a miscarriage. At first the record company did not even tell them, and as soon as the news of his wife's condition broke through, just before a show on 18 October, Roger wanted to go home. His family had been trying to contact him for four days, but no messages had reached him either at the hotel or through the booking agency. The band cancelled a TV appearance, cut short the tour and quit. The American press, ignorant of the tragedy, were less than sympathetic, *Rolling Stone* headlining a hostile piece 'Bonzo Dog Runs and Fucks Itself'. Stanshall

told a UK reporter they expected to earn $25,000 from the US dates but had to pay their travelling expenses out of the income. They were breaking even at the time of their departure, but were afraid they would lose money if they stayed any longer.

'If we weren't all so depressed, we might have stayed,' a weary Stanshall explained. 'If the record company had sufficient interest, they might have paid for Roger to go back to England then rejoin us here later. But the attitude of the band was "Isn't this ridiculous? We're wasting our lives. We've just been wrecked. We're going home because we consider our main purpose is to write, record and perform. That's what we're interested in. We're not interested in becoming commodities to be bartered about by leeches in any country. Who needs it?"' The US record company dismissed Vivian's claims. They issued a statement declaring they were merely distributors and that it was up to the UK company to act as 'babysitters'.

Stanshall was not impressed. 'We are not coming back until we have something we can trust. We were sitting in a car and looking out of the window and thinking, "My God, what have I become? What am I doing?"' He realized they were taking a big risk in stalking out of America. 'There's a good chance we won't get into the country again and we're turning down national television. We're going to disappoint people we enjoy playing to, which is all terrible.' The American talent agency in charge of the Bonzos promised they were working on another tour, which they hoped to set up for March 1970. The Bonzos, however, would never come back.

Vivian was hardest hit by the tours. All of the band were exhausted and frustrated by their experiences, but something indefinable happened to Vivian on that second visit to the States. He came back a sufferer of regular panic attacks and addicted to the Valium he was prescribed to combat them. He was heading for a nervous breakdown.

Part of his condition was easy to explain, the result of the band being pushed too far over a number of years. It was a culmination of a number of factors. Vivian was overworked, drank far too much and did not have enough time off. He was also very sensitive, experiencing the world without the defensive barriers most people use to filter

stimulus. His mind overloaded and he often found himself in what he called 'quite a big pickle'. He told one journalist, 'I get myself so hypersensitive, I've got so much pouring in, I haven't enough output channels.'[3] He was also unable to relax. The flow of ideas was continuous and the need to paint, write, record and make things was overwhelming.

'I taught myself a long time ago not only to write, but to draw pretty passably in the dark, which is a real curse. I don't think I ever do relax really. I tried to hypnotize myself. It's this grasshopper mind.'[4] Some of his circle thought he compounded his problems by taking some potent drug out in America. It was a controversial point. His second wife Ki is adamant that he would never have played with his mind in that way, but Neil Innes has long suspected that Vivian might have dropped LSD. He started to get 'spooky' after the American tours: 'Whether he'd had a bad acid trip I don't know. None of the Bonzos were into drugs but he could well have been spiked with something and with an imagination like his, that's not good news.'

Waiting in England, Monica also heard rumours: 'He certainly came back from America a different person. A different personality.' At the London office Gail Colson was kept informed by Bonzo roadie Fred Munt. He told her, she says, that 'the first time Vivian dropped acid was in New York. He had to stay with him all night because Vivian was crawling up the walls. Vivian used to like to try everything and thought he was in control. That's what he used to do with drink as well. He would like to see how far he could go and see how much his body could take.'

Some people had their drinks spiked with the drug at the time. Gail thinks Vivian did it voluntarily. 'He actually decided to try LSD. And while he was tripping he tried to climb out of a window and went out on to the fire escape.' His friend Andy Roberts did not witness the rumoured trip, but saw the results. He 'assumed that's what happened because I had seen it in other people I knew as well – the side effects of acid'.

Vivian said himself that he was not in principle opposed to recreational drugs. 'I think any kind of experience is valid, provided one understands what you are putting yourself through,' he said. 'I am

most interested to see how I would react under any kind of situation, because life is usually very boring. If it gives a greater insight into things, then the use of drugs is a good thing, but to become addicted is not. I think it ought to remain illegal because I like the ceremony attached to taking drugs. It would be dreadful to buy joints in a jolly pack with washing powder names.'[5]

Ki believes it was not a drug that caused Vivian such trauma in America: 'He tried grass once in a while but it made him panic. Vivian never took acid in his life. This is crucial to understanding the man. He was terrified of "psychedelic nonsense". He wouldn't drink from punchbowls or eat from canape trays in case someone had spiked anything.' Vivian told her his panic attacks were brought on by something metaphysical rather than drugs-related.

'He was on stage with the Bonzos and had a kind of transcendence, an almost out-of-body experience,' says Ki. 'The audiences were getting bigger and more reverent. He remembered playing in New York and the whole audience lighting matches in the dark and it was mystical. A strange thing had happened to him where he felt he was beginning to float on stage and that he could lean out over the audience and their energy would hold him up. He even felt it was possible to levitate. I don't think he was crazy, I think it was right. It was a natural, human thing. The connection between himself and the love of the audience during the moment of creation when he performed was a very spontaneous, organic interactive thing.

'The band had become for a him a safe place. He knew if he went too far in terms of risk, that the band would fill in and pull him back. This was happening to him more and more on the stage, and then one evening he actually experienced stepping out of his own body. This was a beatific experience but, unfortunately, that part of him that relates to reality said, "Fuck!" He just went into a panic attack on stage – his very first. He collapsed. It wasn't exhaustion. It was a psychic trauma.' The panic attacks became a regular feature in Vivian's life. 'When you have a panic attack you cannot deal with business; you cannot go on stage. It's all over. And it won't stop,' explains Ki. 'A panic attack is an overall bodily sensation which is all-consuming. You might as well be on acid. It's a trip of absolute fear. There's

nothing you can do to stop it except through years of hard work. His experience on stage was a natural high, a moment of gnosis, a transcendence. It was his gift to be that sensitive, that touched by genius – and his curse.'

In the middle of the tour, there was no time to look deeply for the cause of Vivian's collapse. They needed to complete their dates. To alleviate the panic, Vivian was prescribed Valium, a drug that was to blight the rest of his life. Then relatively new, it was being handed out casually to anyone who had a nervous problem. Its addictive qualities were understood only later. Valium, also known as diazepam, is a member of the benzodiazepine family, a sedative that causes depression of the central nervous system, usually used to treat anxiety, insomnia, seizures and muscular spasms. Diazepam is also used to combat the side effects of alcohol withdrawal. In the late 1960s people began using it to alleviate stress as casually as they might use aspirin to cure a headache. Few were aware of the possible side effects.

'Like a great many people out there, I didn't know what was happening to me,' Vivian later said. 'I overworked myself and had what I thought was a heart attack and was prescribed some little blue pills. These are tablets to make you better and, like all tablets to make you feel better, if you feel worse you take more, until I became heavily addicted to them.'[6]

The accepted medical advice now is that alcohol should be avoided by patients taking Valium. Sustained use can lead to addiction and getting off it can be a nasty journey through the horrors of withdrawal symptoms such as insomnia, headaches, nausea, sweating, anxiety and tiredness. All were conditions that affected Vivian. There are other possible effects of diazepam, including ataxia, a severe loss of balance leading to falls. So on occasions when Vivian would be swaying around on stage, being witty if a little slurred, the audience could not be aware that this might have more to do with his medication. Falling off stage may not have been Vivian playing for laughs.

Valium is a sedative, but heavy use can lead to exactly the opposite, making the user excitable, angry, confused and depressed. It can also induce speech problems. For a personality like Vivian's, this was a disastrous pill. Coupled with his fondness for booze, Valium's hold

effectively destroyed his ability to work consistently. In later years he would try several times to bring a case against the medical profession for his addiction.

'He never came off tranquillizers. Never. He became horribly addicted,' says Monica. 'He was taking an awful lot of tablets. How many I don't know, because he always lied. When you take that much stuff, your mind isn't working properly. You are not able to function properly and he knew that.' The rest of the band saw it too, but could do little about it. Vivian could dissuade people from making awkward or unwanted attempts to get behind his defences. Chums and colleagues would just get him another drink if he seemed out of sorts.

'Vivian was the sort of person that you couldn't really help because he was so . . . pig-headed and so *big*-headed,' says his brother Mark. 'Anything you said to him normally got turned around and stuffed back. He was too clever for his own good. I also think he rather enjoyed the "tortured genius" syndrome. So you couldn't really give him any advice. As soon as he went on stage and people began to adore him, he became even more impossible, frankly. His whole world was a stage. He just *had* to be the centre of attention everywhere. He just loved that.'

By the time Vivian returned to England to resume a life after the events in America, he had recovered his poise sufficiently to make the return trip without a problem, although another facet of the panic attacks was his increasing fear of flying. Monica and Rupert welcomed back a changed man. The Valium had a lot to do with it. Stanshall knew this, but by the time he realized it, it was too late.

'It annoyed the fuck out of him,' says Gus Dudgeon. 'He was always complaining about it. It had obviously really got him down because I guess he realized that he had enough problems in life already. He knew in his heart of hearts that he was responsible for his own alcohol intake. That was down to him. But when somebody says, "Look, this will calm you down, you won't need to drink so much. You'll be cool," and gave him something, he thought, "Marvellous." Next thing he knows he's hooked. And it really irked him.' The first serious panic attack Monica remembers him having was in the kitchen of the Stanshalls' Finchley home. He went into the kitchen to make tea and

the next moment there was a crash and he was on the floor with sweat pouring off him.

'I thought he was having an epileptic fit,' says Monica. ' He began to be frightened, and it was the start of his fear of going out alone anywhere, which had never been the case before he went to America. He was different. It was subtle, but it was enough. It changed our relationship and I imagine it changed his relationship with the other members of the band. He became more aggressive and the aggression, he said, was caused by fear. Fear of what? I don't know. Life. Self. Everything. It seemed that it was unfair he was gifted in so many departments. He said he couldn't separate one from another and it was all swishing around in his head.' Bonzo Dog activity continued at its customary pace now they were back in England. They had to put the American tours behind them and get on with producing new material.

Vivian's only respite came through painting. 'It was the only time I ever saw him in a state that vaguely resembled relaxation' says Monica. 'It wasn't what most people would call relaxation. I don't think he knew what that was. Any interruption to painting would result in him saying: "What do you think about this line? What about the colour there?" Interruption to anything to do with music and you'd get your head bitten off. It was completely different. Somehow an interruption to painting was to be invited. Come and share this experience with me. Latterly with music it seemed like the child who hides the page he is writing. "You can't see it because it's not quite right." And there was a fear that it was never going to be quite right.'

If there was a positive aspect to the American tour, it was that in walking out, they were attempting to control their destiny to some extent. Vivian cut his hair and was optimistic and energetic in interviews. At last he understood the workings of the music business: 'People who are creative, people who are the sacks of potatoes for these people to sell, are by nature lost before they have begun,' he said. 'You have to be business-like about the way in which you're going to utilize what talents you have to get the best and preserve you as a creator for later years.'[7] The Bonzos looked towards producing their fourth album as a less cohesive group. Gus Dudgeon noticed

how his charges were changing during the making of *Tadpoles*.

'They used to jointly seek out targets,' he says. 'So they'd pick out a particular thing they wanted to send up and they would do it *en masse*.' Now they were indulging in individual send-ups. 'That's kind of where I saw it all crumbling. They were trying to express their own ideas without it being a corporate thing where they'd all join in and figure it out together.' The Bonzos had got to a point where they had an incredibly slick, fast hour-and-a-half act which, said Vivian, 'worked like clockwork – it was as greasy as Engelbert's comb – but after a while we thought we'd chop all that and just go on and see what happened. For a while it worked, it was really good, but it petered out after eight or nine performances. It was liberating and exciting but we had to have some kind of structure.'

By the time the band got to make *Keynsham*, which was released in November 1969, the production duties were largely divided between Innes and Stanshall – further stretching a man under incredible tension as manager and performer. Within a few years, bands would routinely take months or even years to produce just one album. The Bonzos recorded four within two years.

'We didn't have a holiday,' says Neil now. 'That's a sure way to break up a band. That's why when we came to make *Keynsham* I suggested in a dressing room somewhere that maybe none of this was really happening to us. We were all institutionalized somewhere, but we all believed we were sharing a similar reality. It was an off-the-wall idea but everybody picked up on it and so *Keynsham* was born as this strange kind of personal thing.' The album's title referred to a district of Bristol where dwelt one Horace Bachelor, who advertised his 'Infra Draw' football-pools method on Radio Luxembourg. His lugubrious announcements and endless spelling out of 'K-E-Y-N-S-H-A-M' were a source of huge irritation to listeners, but amused the Bonzos.

'That seemed to me to be the only never-never land, the only tangible Shangri-La,' said Vivian. 'The fact that this man was disembodied and he lived there.' They recorded at Trident Studios in London with engineer Barry Sheffield. Keeping the idea of the band dreaming their life, the opening track, 'You Done My Brain in', Innes

explained in contemporary interviews, is 'an affirmation of madness and *Keynsham* itself is our "id" – our subconscious'. It was more serious than before, though there were lighter tracks, such as the highlight 'Sport (The Odd Boy)'. This particularly impressed a young Stephen Fry. The celebrated actor, author and comedian was, in 1969, suffering under the iron heel of his sports master at Uppingham public school. His best friend, Rick Carmichael, introduced him to the Bonzos' records. The most impressive feature of the Bonzos for the youngster was undoubtedly their lead singer. Stephen was delighted by Stanshall's voice: 'It had two registers, one light and dotty, with the timbre almost of a 1920s crooner and capable of very high pitch indeed . . . the other was a Dundee cake of a voice, astoundingly deep, rich and fruity . . . great, gutsy trombone blasts of larynx-lazy British sottery, to use a Stanshally sort of phrase.'[8]

Perhaps the daftest item to be found on *Keynsham* was 'Mr Slater's Parrot' which, after a few charming vocal choruses from Vivian, degenerated into a series of squawks over a clarinet theme. Once heard it was almost impossible to erase from the conscious mind. Vivian's liner notes often provided a surreal and atmospheric accompaniment to the songs and on this occasion he wrote that this song was, 'Own up time. A paradox. Homely fun. Demands for the right to live like a civilized human-bean.' The parrot in question was inspired by Rodney's pets and living with them made him very much demand the right to live like a civilized person.

Rodney remembers: 'I had two. And the fucking racket drove me mad! I lived in a flat in Chiswick then and you could hear the parrots screeching 150 yards down the road. In the end we got rid of them both. The African parrot was a vicious little thing. He'd have your hand off as soon as look at you. The noise got too much. Viv was really chuffed about me getting the parrots and that's why he wrote the song.' Another stand-out track was 'Busted', by Innes and Stanshall, a satire on pointless flower children and their opposites, the commuters. A young hippy complains, 'I got busted/My old mother was disgusted/Said I never could be trusted'. When fellow-Bonzo Dave Clague released demo and alternative versions of some of the band's songs on *Anthropology* (1999), the development of the

song became clear. The demo version is looser, less satirical and takes the side of the busted kid. On *Keynsham*, Vivian sings: 'In the soft grey squeeze as they mind the doors/Like a sacrifice for the Minotaur /All together in the blood-rush hour/Come on fishface, you got the power'.[9] The *Anthropology* version has a subtle, but delightful difference in the wordplay, which is in some ways even more attractive than the band's official album version: 'The soft grey squeeze of the underground/Don't get caught in the blood-rush hour/The holes that roar and the beat that hangs/The bacon breath of the Minotaur'.

Keynsham was a serious record by Bonzo standards, as the band realized their standing with the record business was not going to change. 'We just carried on through fiascos and ridiculous books and signing absurd bits of paper,' said Vivian. 'I'd just sign them to get them out of my life and never see them again. And at the same time I was still trying to make things and masks and do this, that and the other. *Keynsham* may not be interpreted as an attack on the system – on the surface it's just another happy little piece. In fact, it's a particularly vitriolic condemnation of this maelstrom of hatred and greed.'[10]

A reception was held to launch the album at a theatre in London's Tottenham Court Road. Among the attractions was a fearsome giant, kitted out with a loincloth, who was supposed to come out and scare the punters, but who had an attack of stage fright and refused to leave the dressing room. The band did their stuck-record routine and there was also supposed to be a deluge of 'harmless rubble' from above the stage. A technical hitch, however, meant that the rubble fell at completely the wrong moment. Behind the façade of jollity-as-usual for the press and fans, interviews after the press party revealed that the underlying malaise within the ranks and the disaffection with so much of the music business was still uppermost in their minds.

Neil addressed the press with hesitancy. 'It's difficult to say whether the album is successful or not,' he said. 'Like the Bonzos, it splits off into many different directions and although there is an underlying theme this is difficult for the average listener to detect or understand because it is no more than hinted at in the lyrics.' One thing was sure, said Neil defensively, 'We don't want to be misinterpreted as people who parody everything. We've tried to steer away from that and we

also refuse to be pop stars, which is why we left America.'

Grumbled Roger Spear, 'Our trouble is that nobody takes us seriously.' Neil finally raised everyone's spirits by saying, 'Oh, well, I'm going to join the Beatles and get three years' back pay.'

When Vivian gave his view of *Keynsham* to the press, it was much more personal than any of them could have realized. He said Keynsham itself was meant to be the village outside the asylum. 'The people in the village hate the inmates.' What Vivian did not say at the time was that the concept of the asylum was followed by his own experience. Around the time of the album's release at the end of 1969, Vivian suffered the mental breakdown that had been building for so long and was admitted to Colney Hatch hospital, London, as a voluntary patient.

'The moment he was in there and institutionalized he started to kick and fight,' says Monica. 'He was not a man you could organize in that way. He did feel that he was superior.' At Colney Hatch, Keith Moon proved to be great support. The Who's drummer was very concerned about his Bonzo pal and his visits stopped, says Monica, only because 'he arrived in his pink Rolls-Royce, and the director of the hospital threw Vivian out, telling him he was using the place as a "pop star's holiday camp"'. Back home not long after his release, Vivian grabbed a brush and painted the sitting room jet-black and then the window frames a glaring bright yellow. He even creosoted the floor, which smelt strongly for months.

'I can laugh now, but I was very shocked at the time. It wasn't a rebellion. It was deep, deep depression,' says Monica. 'A terrible depression that lasted a long time. He also shaved his head, for the first time, and bled a lot. It happened at Christmas dinner. It was very distressing.' Vivian left the dinner table and assembled relatives, and went upstairs. In America he had cropped his hair and now he wielded the scissors on his trademark locks and returned to take his seat as if nothing had happened. Monica called the local doctor. He would not see Vivian, but simply repeated all the prescriptions he had given before. These consisted of larger and larger doses of tranquillizers, setting the pattern for the years ahead. Vivian would recount one festive experience when his doctor explained, 'I'm sorry, it's the

holiday period, we've had a bit of a rush. We're out of Valium. Would you mind having something else?' Which more or less summed up the medical attitude of the times.

In Leigh-on-Sea, Vivian's mother was not fully aware of the increasing seriousness of her son's condition, and he did not tell her. When he was feeling the pressure, Vivian would be on the phone to her two or three times a day, careful to keep the worst details from her. The relationship with his father was still as difficult as ever, even though Vivian had been away from home for years and now had a family of his own.

Vivian's father was also heading towards a nervous breakdown. Now almost sixty, Mr Stanshall was approaching the end of his working life and, explains Vivian's brother Mark, he'd enjoyed 'quite a nice working office life with decent lunches. Then one day his company was taken over and his old guv'nor and other people left, isolating him, so it wasn't the same working conditions any more and that sort of broke him down.' Stanshall Senior retired early and, as Vivian was to point out some years later, without the framework of office life and with few outside interests, spent his declining years 'vigorously watching television'. When Vivian mentioned his father in a 1972 interview, he made no mention of any problems. It was all very matter-of-fact.

'My ancestors were quite base, really, but by years of bloody hard work my father made himself a company secretary, and then a director of God knows how many companies,' Vivian recalled, adding with a flash of that rather cold attitude the Stanshalls seemed to adopt when talking about one another, 'Of course, he's killing himself with work now; he's a machine.'[11] For all their many deep-seated differences, this was exactly what Vivian was in turn doing to himself. For a while Vivian, like his father, was able to conceal his breakdown from the rest of the world. Just a few months later, Vivian referred in the press to the head-shaving as if it were just another pop star's change of style. 'I'd had it outrageously long since I was sixteen,' he breezed. 'It was good to outrage people with it. I had it chopped off because I was doing a lot of fibreglass work and it was a nuisance. I was sticking to the glue.' In any case, this change in appearance, which

might seem outrageous for anyone outside of music, was tolerated and even encouraged because of his star status. His increasing fears were drowned with booze and partially contained by Valium.

Stanshall continued to manage the Bonzos, conducting business with Charisma Records perfectly well. Glen Colson did not notice any signs of heavy drinking. The creative process continued at a great pace as well. After *Keynsham*, the Bonzos collaborated with singer Arthur Brown on an extended work called the *Brain Opera*, on which they planned to include the track 'Mr Apollo'. The *Brain Opera* went through many incarnations over the years, but initially it was proposed that Vivian would narrate the work, for which he brought together a whole family of new characters. These included Riff Cliché and his Chameleon Band, who sometimes went under the name of the Rebel Trousers.

Vivian said: 'They're just bandwagon jumpers who take on the current fad. And there's Craig Torso, who is hyper-sincere. And Johnny Hawke and the Pavement Oysters. They're rough village-hall, provincial louts, represented by Rodney most of the time. Vince Vacant is a sort of solo singer who believes his own publicity. And there is Hugh Neck and the Originals, which is self-explanatory.' Some of these characters would surface later in the Bonzos' *Craig Torso Show* and Vivian's post-Bonzos work. Vince Vacant, for example, would make a comeback in the 1970s, when Vivian recorded a series of programmes for Radio 1 with Keith Moon called 'Radio Flashes'. There was a jolly vivisection song, which was to resurface in *Sir Henry*, a suitably upbeat number over which Vivian and the boys sang, 'We are three vivisectionists, we go out at night with big, brown sacks, commandeering little cats.'

Some of the *Brain Opera* was recorded for sessions on Radio 1, though it was never given a full release. The band had wanted to perform the full-length *Opera* in the States, and planned to record it. It was a pipedream. During the spring tour alone they had lost $24,000, and so there was no chance they could stage an elaborate show and take it back there. Said Stanshall later: 'When we got back to England we had to work our balls off for three months doing boring pointless work in clubs, taking anything we could to get us

back in the black again. It was a miracle the band stayed together.' But it was to be a short-lived miracle; the pressure was simply becoming too great.

'I never felt so poignantly and desperately that I was being strangled,' Vivian revealed later.[12] He was disillusioned and, says Rodney, he felt that 'nobody was ever doing what he wanted. He ended up feeling he was dreadfully under-exposed. He felt short-changed by the experience. He became bitter about the music business and quite rightly so. I agreed with him. Of course he wasn't built for that. He was a contradiction. We all were. We weren't built for that kind of industry. They would never understand us.' They were all just as dissatisfied with the way the band was working. The fun had gone out of it. There would be no more attempts to conquer America and, the band finally agreed, there would be no more Bonzos. They made their shock announcement at the end of a show over Christmas 1969 at London's Lyceum Ballroom. Vivian, shaven head glinting under the stage lights, told a surprised and disappointed audience they were 'giving it the pill'.

Vivian told the press: 'The break-up had been in the offing for a week or so. The point is the band started out as six mates, but we were reaching a stage where we were throttling each other as individuals. Neil Innes is writing more and more complicated stuff. I want to do more reading and poetry and Roger Spear has never been interested in rock'n'roll. So really none of us were getting a fair crack of the whip.'

They had lost sight of their original aims as a band. Vivian later explained, 'I just didn't think it was fair to get up there and yatter on about art and fart having not seen an exhibition for about, oh, almost as long as the band were together. It was becoming more and more incestuous. We would have wound up as the kind of things we set out to – not to destroy – but to make people re-examine, perhaps.'[13] Stanshall felt the band were in danger of becoming mired in self-parody. He planned a solo career and Roger Spear proposed an exhibition of his sculptures and machines.

The group had just to play some pre-booked gigs to March 1970, mainly at colleges. These recaptured some of the carefree moments

from the early days and were some of the best gigs for the band. The pressure was off; they could play without thinking of the next move, the next single, the next album.

Glen Colson was roped into the band to play drums on the last tour. With some awe, the young musician observed how the band sat in resolute silence on the coach from gig to gig on journeys that lasted up to two hours. The peace was disturbed on occasion only by Roger Spear standing up to shout, 'Rubbish!' and sitting down again. The live show was formidable, with the Bonzos up to eight players once more, including extra guitarist Anthony 'Bubbles' White. One date featured four drummers, Keith Moon, Larry Smith, Glen Colson and Aynsley Dunbar, all thumping away on 'Rockalizer Baby', and every night was a sell-out. Each venue was packed with fans determined to enjoy a last sight of the band playing live.

They said goodbye to London at the Regent Street Polytechnic on 21 February, supported by a band called Gun Hill. The final gig was at Loughborough University on 14 March, booked by the college's social secretary, Rob Dickins. It was the start of a long friendship between Stanshall and Rob, who soon afterwards started to work at Warner Bros Publishing, eventually rising to become chairman of the company and a significant figure in the latter part of Vivian's life. In early 1971, Dickins was just staggered to find he had got the legendary Bonzos for their last ever show together.

'I was a huge fan,' recalls Rob. 'We were all besotted by the band, but particularly him. It was a fantastic night, because all the troubles went out of the window and they just did an amazing gig.' The promoters had to turn people away, such was the outburst of Bonzo-mania. Neil Innes later wrote about how he felt as the band headed for home, south down the M1 motorway in the early hours of the morning after the last gig: 'It was a riotous evening with all sorts of "famous guests" joining in, most memorably chief roadie Fred Munt's throat-ripping "Long Tall Sally". It was bloody good! Playing those farewell gigs was the only businesslike thing we ever did.'

Bonzo Dog Band albums were to be treasured by fans for years to come and regularly discovered by new generations of admirers. Vivian himself had already encouraged a whole range of new talent to dare

to be different, from singer Jarvis Cocker to humorist Stephen Fry: 'In terms of myself, he was an incomparable influence,' says Stephen. 'The voice, with its mellow mixture of dusty wireless valves, was alone enough to make me want to be some kind of actor (radio actor was my first thought) – but then also his faultless ear for the rhythm of language and his remarkable way with imagery, subverting cliché and so on – that too influenced me, I think, in countless ways. They say the poet Tennyson knew the "quantity" of every word in the English language except "scissors" – Sir Viv too had an absolutely assured touch with the weight, balance and rhythm of every sentence.'

What could not be recaptured was the sheer energy of the Bonzos' performances. After the final gig in March, Vivian was visited at his Finchley home by *New Musical Express* journalist Keith Altham, who asked about the split. 'Frankly I'm amazed we lasted as long as we did. It was astounding that we were able to get away with it for so long. We were completely unsexual, unattractive and everything a pop group should not have been. The fact that we were able to communicate something to people by singing songs about trousers and wardrobes was a remarkable thing. People tried to categorize us and work out who our audience was, but they never could. We were our own audience. We went on stage in the hope of entertaining each other, destroying something and creating something else in its place.

'What stopped us was we began to progress far more as individuals than we did as a group. Roger was building machines and props which never saw the light of day; Neil was writing songs we did not have time to rehearse or perform and I had about two hours of sketches and playlets which there was no time to do. Our output was so small it frustrated the creative efforts of the individuals.' Vivian was already starting to work as a solo vocalist and planned an album of children's songs which he wrote largely for the benefit of Rupert, then aged two. He planned to produce a few records and said, 'It's bound to be the same old rubbish. Silly poems set to music with squawks and other noises in the background. I can't say whether I see myself as a comedian, a singer or an entertainer. I think I'm a plumber.'

When the Bonzos split up, both press and fans alike consoled

themselves with the belief that Vivian Stanshall would now embark upon a dazzling solo career. It seemed likely that 'Mr Apollo', 'Tent', 'The Canyons of Your Mind' and 'My Pink Half of the Drainpipe' were only curtain-raisers. Now on with the show. It soon became apparent, however, that the band was not so much a cage as a framework for Vivian, in which he was able to work on material in a relatively disciplined fashion; he would never again produce such a sustained body of work.

8
A Festival of Vulgarity
1970–71

The Bonzos scattered in all directions after the split. Neil Innes formed the World, which made one album, *Lucky Planet*. They disbanded before the record was released. He went on to record a solo album, *How Sweet to be an Idiot*, would also work with Monty Python and teamed up with Eric Idle for his 'Rutland Weekend Television' series. They would later create the Rutles band, a clever spoof of the Beatles that was a hit in America. Neil also had his own TV series, 'The Innes Book of Records'. He continues to tour, record and present television programmes.

Roger Spear toured with his Giant Kinetic Wardrobe, presenting a scatty show with music and robots, which Vivian for one thought was impressive. 'He is in the process of proving what he has always said, and that is that machines can be just as entertaining as real people,' said Vivian. 'I have seen his show four or five times and it is getting better. He will win in the end.'[1] Larry Smith released the catchy single 'Witchi Tai To' on Charisma Records, under the pseudonym of Topo D Bil, and toured, making cameo appearances with George Harrison and Elton John. He also recorded a version of 'Springtime for Hitler', the immortal song from Mel Brooks's film *The Producers*.

Vivian bounced back quickly, letting off an explosion of new projects, showering new songs and bands over the early part of 1970. As early as January, Vivian rapidly set about forming and publicizing

a band, ahead of the outstanding Bonzo dates. The idiosyncratically spelt BiG GRunt was put together primarily for a Radio 1 'Top Gear' broadcast. The line-up included Roger Ruskin Spear (sax), Dennis Cowan (bass), Ian Wallace (drums) and former Bonzo Anthony 'Bubbles' White (guitar). They were later joined by singing roadie 'Borneo' Fred Munt. They recorded four tracks in March, including 'Cyborg Signal', 'Blind Date', 'Eleven Moustachioed Daughters' and 'The Strain' (which was later on the Bonzos' final *Let's Make Up and be Friendly* album). The session was broadcast on Radio 1 later that month. A tongue-twisting, country-tinged tune called 'Labio Dental Fricative' was Vivian's first single, credited to the Sean Head Showband, comprising Dennis Cowan, Remi Kabaka and guest star Eric Clapton.

Another single, 'Suspicion', was released under the banner of Vivian Stanshall's Gargantuan Chums, including Keith Moon. It was a splendidly tongue-in-cheek version of a 1964 hit by the Elvis soundalike Terry Stafford. On the B-side was the only original song credited to the Gargantuan Chums. 'Blind Date' follows a hopeful young couple who meet to find she is a pygmy and he is a gorilla escaped from the zoo. The track captures the nervous energy of that all-important first date: 'I softly brushed your lips in the fur-tongued horror of a kiss – they were filthy.'[2] It was written for Matt Monro. 'I sang it to his manager, who collapsed under the desk. I just couldn't write a straight song,' Vivian confessed.[3] In February, Vivian was interviewed by *Melody Maker* about his new projects. Once ensconced with a drink at the Red Lion in the afternoon, Vivian, sporting his octagonal glasses and shaved head, talked excitedly about his post-Bonzo plans.

'The BiG GRunt will be the next band but I want to make solo singles with different musicians under various silly names. The next single will be a ballad and I'd like to use lots of really ugly choristers.'[4] When asked if he had shaved his head to tie in with the Sean Head Show Band, he replied sharply, 'No, I'm not that dedicated. It would be like forming the Leg Off Band and having a leg amputated. Improve your body – have a leg off!' He revealed how the band got together so quickly. 'We greased the corridors. It made everything go

so much quicker. Also – everyone on the session was bullet-shaped. The BiG GRunt is coming along nicely. We intend to concentrate on the physical-fitness aspect and we will have a bit of road training before we actually get on the road. We discussed going to a Turkish bath where some of the boys could sport with each other. Dennis Cowan and I have been planning to do some weight lifting – a bit of pushing and pulling.' The interview lasted until 3 p.m., afternoon closing time. The lights were switched off and the staff began pointedly emptying ashtrays and removing the sea of bottles from Vivian's table.

'Aren't you Vivian Stanshall of the Bonzos?' asked the barman. 'What are you doing these days?'

'I'm selling wigs.'

'No, really . . .'

'No, seriously . . .' replied Vivian, opening his satchel. As if he had been waiting for someone to ask him that very question, he happened to have in the bag what looked like a large yellow tea cosy. 'Only five shillings and eleven pence, and absolutely undetectable. Now to don London's most unconvincing wig.' He put the tea cosy on his head at a rakish angle and winked conspiratorially at the flummoxed barman. The interview continued in a drinking club in the West End. 'I'm very excited about the new band,' he said, ordering the first of a stream of large Scotches. 'We won't scrap all our old material like the *Brain Opera*. That might well be recorded in the future. The BiG GRunt should be more musical than the Bonzos and have more character. The gags will be in a more rhythmic sequence and tie in with the music.'

As the Scotch began to take its effect the interviewer told Vivian: 'Saw Jimmy Page the other week. He's been reading Aleister Crowley. He asked me to give you a message. Come to Pangbourne Abbey where the law is enforced.'

Vivian lifted his lolling head and peered blearily. 'Tell Jimmy the cream of the owl will be poured on the Bishop's trouser leg. Would you mind getting me another drink, dear boy?' The discussion eventually returned to Vivian's music. With a gig due at Aston University on 25 March, he wanted the new band to work for limited periods. This would enable him to build more of a life at home.

'You have no idea how refreshing it is to be able to sit at home and read for a bit or watch telly. I have been making wardrobes and shelves and getting back to normal. Reading back some of the stuff I wrote last year, a lot of it seems completely incomprehensible. The whole group scene makes you insular and cut off from normal things. That's why lyrics become so obscure and why people in groups begin to lose their real friends.'

Vivian lowered his defences to be confessional: 'I am going through a complete purgatorial metamorphosis,' he said. 'I go through periods of terrific elation and work like stink, and then I feel deep depression and want to go up to the lavatory and screw a hook in the ceiling.' Without missing a beat, still with tea cosy on head, Vivian suggested going to the scrumpy bar in Waterloo he had once frequented with Larry Smith. Mercifully, this idea was abandoned when Vivian suddenly remembered he was due at Broadcasting House for an interview with DJ Anne Nightingale. She greeted the skinhead with horror. 'What have you done to him?' she hissed to his interviewer. Vivian was escorted to the nearest large mug of black coffee while Anne attempted a brief interview. Clearly a broadcast was out of the question. Another cab was hailed and Vivian was sent home in the direction of East Finchley. The next day his interviewer inquired whether he had got back safely. 'No,' came the aggravated reply. 'The swine took me to Heathrow Airport.'

The BiG GRunt did not go as far as Vivian hoped. They played a few well-received live dates and also appeared on the Easter edition of the Peter Cook and Dudley Moore show. Neither single made the charts, the band folded and Vivian headed for another clinic. Monica struggled to keep the family afloat. She put Rupert into a nursery, she said, 'so I could go out to work, as we had no money. I did my best to support the family. We had a mortgage to pay and we had no furniture. That wasn't a problem. We just didn't have any. Vivian though spent a lot of time with his terrapins, which had to be fed on raw steak. Having been fed, their tanks then had to be sucked out with a hosepipe into buckets. He spent a lot of time doing that. I managed to hold things together but I had no idea this was going to be a pattern. I was in a state of shock I suppose. After all the excitement of the

American tour and the hit record and articles in the newspaper and then suddenly nothing.' The question was – now what? Vivian had any number of ideas, but he could not get it together.

'Nobody came to see us apart from Keith Moon. Because of the break-up of the band, things had gone sour there and it was a very lonely time. I can't remember how we managed. I'm quite good at blanking out the painful bits. Thank God some people helped, but people don't know how to deal with his kind of severe behaviour. He didn't sleep because when you take that many Valium tablets your metabolism goes completely. He was taking them in huge doses.' Vivian soon discovered that alcohol sped up and enhanced the effect of the Valium. 'He was balancing the two, which is dangerous and precisely what you shouldn't do.'

Vivian was trying to compensate for the sensory overload he felt: 'Everything is giving me information all the time and the only way out of that is a pint of Burtons . . . is to clog yourself up. One can berate Noah and Sir Walter Raleigh, but if it weren't for those poisons what the hell would we be like? Would we be invisible? I should think we'd certainly be ready for lift-off. I think the only thing that can take my mind off it is making love and laughing, which in my condition is usually at the same time.'

As his bands broke up in late spring, Vivian found he could not cope. 'It was weird. I had a tremendous spurt of creativity,' Vivian later told writer Charles Alverson, 'and ideas were pouring out so fast that I had to dictate them to my wife. But then I slowly became a real vegetable. I found that I could look at a page of print and didn't have any idea what it said. Then it got down to paragraphs, sentences and even words. I just couldn't read. It got so I'd sit there and say "carrot" fifty times in a row. Finally, the quack was called and I was put inside.'[5] Vivian spent two months in Halliwick hospital in north London. He was on a large dose of medication, combined with group-therapy sessions, which included up to forty patients and three doctors. 'There were people bouncing off the walls all day and screaming all night,' said Vivian. He managed to persuade the doctor to cut his dosage down to a third and at least then, 'I wasn't floating around in such a haze.'[6]

Vivian was convinced he was 'not quite as loony' as he somehow felt he should be, as if he did not qualify to be in the hospital. 'You sit in group therapy and hear some woman whose husband deserted her tell how she woke up one day and found her kid dead of malnutrition, and you begin to wonder, "What the fuck am *I* doing in here?"' Vivian simply upped his performance to appear as suitably mad as he thought was required. 'On visiting days, I used to sidle up to outsiders and ask them if they wanted to see foaming at the mouth. Or I'd invite them in a very matter-of-fact way to come see the scratches on the walls.'[7] The senior psychiatrists soon decided that Vivian was fit enough to leave the place. 'I got the impression that they didn't want anybody to return. They were somewhat less than warm and welcoming.'

Later in the year, Vivian got back together with Neil Innes. They worked some more on *The Brain Opera*, still with a view to a theatrical performance, which did not in the end come off, and they also formed Bonzo Dog Freaks with Andy Roberts, who played with the Scaffold, and had first met the Bonzos when both groups played at the White Heather Club during the 1967 Edinburgh Festival. That same year Andy became a member of the Liverpool Scene, fronted by poet Adrian Henri. They were, like the Bonzos, an eclectic band who mixed rock, folk, satire and poetry, and were signed to Stratton Smith's Charisma Records. In May 1970, Liverpool Scene broke up and Andy joined Freaks. Vivian and Neil Innes were joined by Ian Wallace (drums) and Bubbles on lead guitar.

Says Andy: 'Bubbles was great. He was a very fat chap and was in the garden at Viv's house one day, freaking out because he was scared of wasps.' The guitarist was chased around the garden by this wasp and, meanwhile, Vivian was oblivious in the kitchen. He shouted, 'What's the matter, dear boy?' A panicked Bubbles yelled something about the wasp. 'When I hear a bang,' came the reply, 'I'll know it's got you!' It was Bubbles's size (coupled with a fine moustache) which had endeared him to Vivian, rather than musical ability. The Freaks would be real freaks.

'If he saw someone walking along the street with some ghastly physical defect,' says Andy, 'Viv would go over and ask them if they

played bass. I remember a midget drummer showing up once who was only four feet high and had shades and looked perfect. But he couldn't play, unfortunately, even though Neil got him this tiny little drum kit.' The band itself did not work out, and there was much rancour between them and their management, Hemdale Ltd. By May the following year the outfit was defunct. A decade later, the idea for this kind of band resurfaced on Vivian's 1981 album *Teddy Boys Don't Knit*. On the song 'King Kripple', Vivian sings about the sideshow musicians in his group. There was an obese piano player and a hunch-backed drummer to keep the beat. Vivian cast himself as King Kripple, the leader of the band of freaks, a pub band of nightmares.

Vivian relied heavily on the companionship of Keith Moon. His hell-raising antics passed into rock legend, and together with Vivian Stanshall, an explosive personality whose musical safety-net had been cut, the two demolished much of the remains of swinging London. Vivian had found someone else who was interested in testing out how extreme you had to be in public to get a reaction from people. Their friendship stretched back to the days of the Bonzos, when Moon and Stanshall would have fun with trouser salesmen.

The two stars went into shops asking for a pair of strong trousers. They would demand to see how strong they were and grab a leg each, pull and tear them in half. As one leg would come off they'd say, 'Well, they're not very strong.' This routine was expanded when they hired a one-legged actor to hang around outside. When the shop assistant demanded to know what he was supposed to do with two separate trouser legs, in came the one-legged man saying, 'Ah, that's just what I'm looking for – I'll take two pairs!' The trick was first pulled at a branch of Marks & Spencer during the 1969 Bonzo tour of the West Country. They repeated the trick in Taunton and this time Marks & Spencer alerted all their branches to watch out for a team of trouser-tearing lunatics operating in the area.

Post-Bonzo stunts were helped by Keith's enormous financial reserves, the reward for his success with the Who. He owned a pub in Chipping Norton and used it as an opportunity to get away from the rock-star persona with Vivian. 'We would both dress as forelock-tugging servants and carry bags, solicit tips, this sort of thing, and

grovel,' recalled Vivian. 'This made Uriah Heep look positively haughty; we'd snivel. And they loved it, people love being grovelled to.' The pair would deliberately drop a customer's bag and cower with a look of abject terror. 'Oh, I'm sorry, sir,' they would say. 'You can hit me if you want, you can hit me.' The customer would be suitably magnanimous: 'Oh, no, I don't need to hit you.'

'Go on, hit me, I deserve it, I deserve it,' they would insist. Vivian found the average punter's reaction quite incredible: 'Madness, really. Keith at the same time would engineer them into going into this restaurant which boasted the finest wine cellar in the south of England. There was unbelievable amounts of booze and very good stuff too, and mussels – at outrageous prices – and we'd manage to get these people to spend about thirty quid a head on a meal, which Keith seemed to think was jolly funny.'[8] With more of Keith's money, they visited theatrical costumiers and hired Nazi uniforms in late 1970, deciding, explained Vivian, to 'test people's reactions. I dressed up as Heidrich and Keith was the Führer'. He appeared unconcerned when he talked about the effect these highly symbolic outfits might have in the streets of Soho: 'Nazi uniforms? Jolly smart. I think they have a similar effect to green peppers. The idea was to confront the uniforms of the Speakeasy with another uniform. Both uniforms are really ridiculous.'[9] He did not mention that they had also visited a Jewish-owned restaurant during their day out. At the Speakeasy club in Soho, drummer John Halsey was playing in a band called Fatso. 'He and Keith Moon arrived wearing their Gestapo outfits,' says John. 'It burns brightly in everyone's memories of Viv and Moonie together, but at the time we just thought of it as these two pissed guys parading around.' The pair were photographed in uniform by Barrie Wentzell, showing Moon as Hitler sitting, like some ghastly spectre of a ventriloquist's dummy, on Stanshall's knee. Keith Emerson and Lee Jackson of the Nice were in La Chasse Club in Wardour Street when the pair arrived complete with an entourage.

Says Lee, 'We heard them singing "Deutschland Uber Alles" as they were coming up the stairs. The door burst open and Moon came in dressed as Hitler with a false moustache, followed by Vivian Stanshall in a full SS outfit. "Legs" Larry was in a brown-shirt outfit

and they also had various road managers as stormtroopers. In a knap-sack they had a tape recorder which was playing loud German martial music. They all goose-stepped into La Chasse. Everyone was gob-smacked. After an hour they went off for the evening.' They had also gone to the German Bier Keller in Soho Square and to Isow's restau-rant in Berwick Street. In the German pub, the barman told them to leave.

'I can't serve you,' he said to Vivian.

'You can't serve the Führer?' barked Vivian.

Finally the barman said, 'Well, look, if the Führer sits in the corner . . .' This was the key moment for Vivian, seeing the reaction of the barman: 'It was OK to serve the Führer, provided the Führer sat in a corner where most of the customers couldn't see him.' explained Vivian. 'It's a non-story, but I think it's great about the atti-tude. The thing is offensive, but provided that it is not seen, then it is all right and we'll continue to take your money and serve you lager.'[10] They continued on to another Bier Keller, where Vivian left Keith 'at the bar talking to a potato-headed Teutonic giant, a real Kraut. I was dancing with an accordion-playing lady with plaits, doing the *Schuhplattler* and God knows what.' While Vivian was engaged in the thigh-slapping, traditional Bavarian dance, Keith was thrown out of the club by the barman, coming back three times and being ejected on every occasion.

'At one stage we had a roadie with us who just happened to be carrying a mike stand, not for protection, he just happened to be carrying it,' said Vivian. 'A bloke dashed up to us in Greek Street and said, "I fought in the last war for this and you think you're making a mockery of what I've done for my country." Then he saw the mike stand and he said, "Oh, film, oh, jolly good, fine, that's all right then, good show, my word, you certainly look like the Führer." '[11] Once more, Vivian found it 'amazing' that people were quite happy for the most out-rageous or tasteless things to go on, as long as it was for the television or a movie. Many people thought their act was less a test of social reaction and more a bid for cheap publicity.

Glen Colson: 'No, no, it was performance art. He and Keith Moon were into that and this was a very shocking example. It was an outrage.

That was the keyword. Viv was into outraging people. And he found a blood brother in Keith Moon. Performance art is braver than acting, but it was always done as a stunt.' This was a pretty desperate kind of performance art, which smacked of despair and a random kind of anger on Vivian's part, rather than an artistic agenda. Later on that day, back at the Speakeasy, there was little to indicate that anything out of the ordinary had happened. A regular jam session started up, featuring, among others, Julie Driscoll, Zoot Money, Noel Redding and Ollie Halsey. Vivian played the fire extinguisher, soaking everyone in the audience in foam, including fellow-guests Led Zeppelin and the Who.

The two friends experimented with different uniforms on other occasions. 'I had many heart attacks dressed as a vicar,' said Vivian. 'I used to tie my hair back, and put a dog collar on. I would have increasingly dramatic attacks in Oxford Street and Keith, parked on the other side of the road, would say, "For God's sake, help him, I am myself disabled," and nobody would stop, in the middle of London. I can assure you that I make a very convincing priest, it's quite odd. Then I took to foaming blood capsules to make it look even more dreadful.'[12] But impersonating a member of the Church proved to be a test too far in the end, even for Vivian.

'It came to an unhappy close, that priest period,' he said. Keith and Vivian had been larking around in Moon's room, playing with a balsawood aeroplane, when it flew out of the window. 'I stuck my head out, still dog-collared and priestlike, to see where it was, and it had fallen at the feet of an actual priest. That nonplussed me and so I said, "Oh, been to the ecumenical council?" and he said, "Yes, be seeing you there, I expect." And I felt terribly saddened.'[13] Perhaps Vivian was thinking back to the time when his mother had wanted him to be a priest, and how he believed that he would have made a good man of the cloth. And in his testing people in general, perhaps Vivian was exploring a fear of what might happen if he one day needed help.

'This happened for real to me,' he said. 'I went out one morning at six o'clock and had an anxiety attack and got tachycardia and palpitations which left me on the ground for four hours and people

just walked by . . . Eventually, I grabbed a postman. It's all very depressing.'[14]

Even when they were not testing people, Keith and Vivian were the best of buddies, not least, says Glen Colson, because 'Moon always wanted so badly to be Vivian Stanshall and Vivian wanted to be Keith Moon. I watched them and Moonie so wanted to be that intellectual snob and Viv would have loved to have been in the Who and to have written *Tommy*. He was flattered too that rock stars loved him.'

Vivian talked in interviews about his friendship with Keith: 'I rescued him from the gutter,' he declared. 'I was going down Wardour Street one evening for a coffee when I saw this dreadful man calling to me from the gutter. I threw my overcoat over him and gave him two shillings for a cup of tea. We became engaged in conversation and I took him to a sauna bath to clean him up. I was surprised to see a young prince beneath the dirt when I wiped him down with a man-sized tissue and he promised to repay me some day. Now we are chums.'[15] There is a real tenderness obvious in that quote and in 1980, two years after the drummer's death, Vivian was anxious to expand on their friendship: 'When I became close to Keith, we were living in each other's houses for about three years,' he told one interviewer, going on to detail how much Keith had done for him when Vivian had his breakdown. 'Keith had a lot of time for those kind of gestures, which a lot of people wouldn't suspect. They hear about him smashing and breaking and being outrageous, but there was a generous and compassionate side to him that doesn't get much publicity.'[16] Their extremes were too much for most of their friends to keep up. 'Viv saw himself and Keith as two very naughty boys,' says Vivian's journalist friend Roy Carr. 'They used to push each other, to see how far they could go. You'd reach a point where you'd say, "Well, I'll see you later, lads!"'

When Keith broke his collarbone just before recording the 1970 'Top of the Pops' New Year's Eve special, Vivian stepped in to help him ensure the show went on. Keith wore a shirt over his arm cast and taped a drumstick to his wrist. Obliging his somewhat inconvenienced friend, Vivian tied a rope around Keith's wrist. 'We then threw the rope over a lighting pipe overhead, the one that holds the

floods [lights] and all, and I kept an eye on the television monitor,'
said Keith. 'Every time I was on camera, I'd give the signal to Viv
and he'd give a pull on the rope.' The drummer's hand flew up and
flashed down again, landing with a satisfying crash on the cymbals
and causing immense merriment among the musicians.

By the end of the year, Vivian was beginning to miss the structure
to his work given by the old band. He told *Rolling Stone*: 'I haven't
had any kind of criticism for ages, and my work tends to sprawl all
over the place. That was the best thing about the Bonzos. Anything
you suggested got ridiculed at least five times. I'd like to get some of
my work out and see how it does.'[17] He was working on a musical
called *Warm Steps*, he said, had completed a pilot on Scottish tele-
vision, and had done some advertising work.

Radio was the medium most suited to his measured, warm tones.
He could record self-contained pieces without needing to get a band
together, tour or involve himself with management companies and the
other wearying accessories of the music business. His opportunity
came in 1971, through Richard Gilbert, who had championed the
Bonzos on 'The Young Scene' back in the 1960s. Richard became
the second producer of a newish programme called 'Start the Week',
then presented by Richard Baker. This long-running show would
achieve legendary status on Radio 4. Gilbert soon thought of Vivian
as a guest.

'The thing that always impressed me about Viv was he had this
extraordinary voice,' says Richard. 'I thought he would be an absolute
natural for radio.' The two men got on very well. Richard Gilbert's
intelligence, erudition and precise conversational style were all qual-
ities that Vivian admired in people. Gilbert was a talented writer, who
would go on to write for *The Listener* and various broadsheet news-
papers, and he had a genuine love for music, as well as a warm affec-
tion for the distinct gifts of performers like Vivian, who were then
rarely allowed airtime on Radio 4. For Vivian, this was a perfect and
well-balanced working relationship and it introduced him to a new
audience. The average age of the Radio 4 listener was fifty-plus,
more than thirty years older than the target group for pop-music
radio and a world away in terms of cultural preferences. It was a

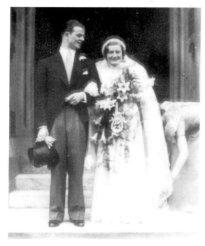

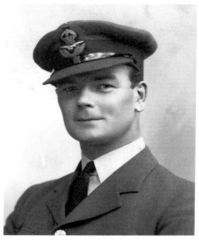

1. Victor Stanshall and Eileen Wadeson marry on 19 June 1937. The wedding was held at the Church of the Sacred Heart of Jesus in Quex Road, London.

2. RAF Flight Lieutenant Vic Stanshall in 1941. He presented a fearsome aspect to his son when he returned to his family after the war.

3. Eileen and young 'Narnie' in the garden of their wartime home in Shillingford, Oxford, 1944. 'Just me and mum and me and my voices,' Vivian said of these early years, 'evacuated from the East End. Idyllic'.

4. Mark and Vivian Stanshall pay a visit to Father Christmas at Selfridges in 1951.

5. Vivian, just out of his teens, makes an early bid to be the centre of attention in the pub.

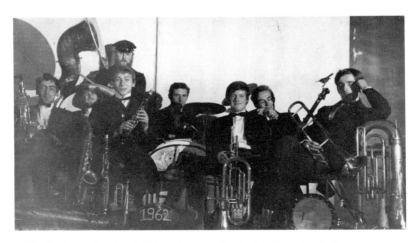

6. The first Bonzo Dog Doo Dah Band line-up at the Royal College of Art in the summer term of 1962. Left to right, Claude Abbo (saxophone), Tom Parkinson (sousaphone), at the back with cap Vivian Stanshall (tenor horn), Rodney Slater (saxophone), Tom Hedges (drums), Roger Wilkes (trumpet), Trevor Brown (banjo), Chris Jennings (trombone).

7. Vivian in self-analysis in Whitley Bay, 1968.

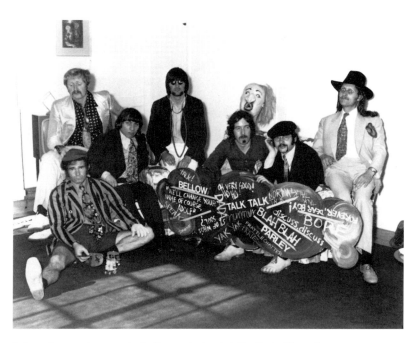

8. Seven key members were in the Bonzos during their first flush of fame. From left to right, Sam Spoons (seated), Vivian Stanshall, Rodney Slater, Roger Spear, Larry Smith (Alma the dancing doll behind him), Neil Innes and Vernon Dudley Bohay-Nowell.

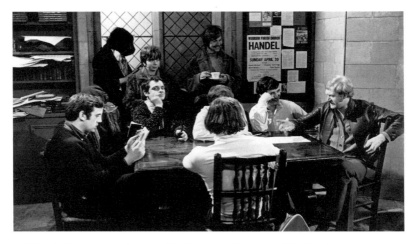

9. Vivian holds court at a rehearsal of 'Do Not Adjust Your Set' in Wembley, late 1967. Left to right, Terry Jones, Neil Innes, Larry Smith (at window), Denise Coffey, David Jason, Dave Clague (standing), Eric Idle, Rodney Slater (foreground), Michael Palin, Vivian Stanshall.

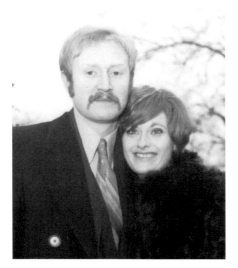

10. Vivian and Monica marry on 1 January 1968 at Colindale Register office in London. Monica: 'The band were extremely busy. So in fact we never had a honeymoon.'

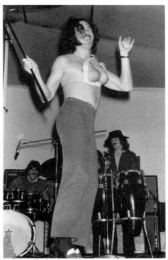

11. The very wonderful 'Legs' Larry Smith at the Isle of Wight festival in 1969, flanked by Jim Capaldi of Traffic and the Beatles' Ringo Starr.

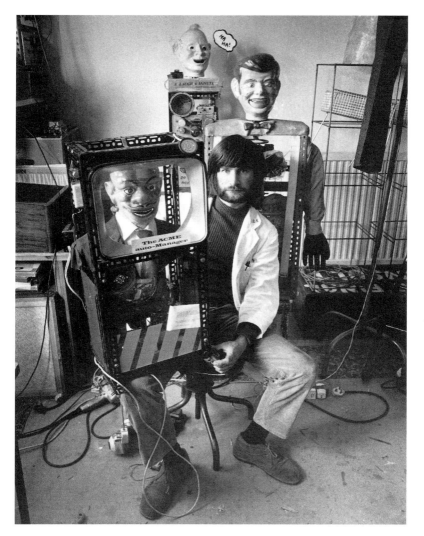

12. Roger Ruskin Spear, creator of the Bonzos' mechanical stage madness, with some of his inventions in 1970.

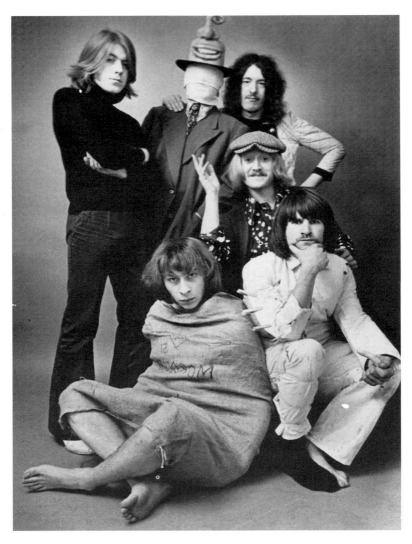

13. The Bonzo Dog Band in a publicity shot for *Keynsham*, with (clockwise from left to right), Dennis Cowan, Larry Smith, Vivian Stanshall, Roger Spear and Rodney Slater.

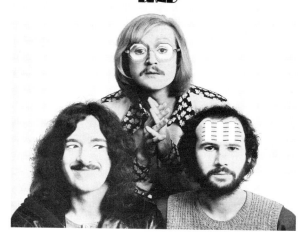

17. *Tadpoles*, 1969

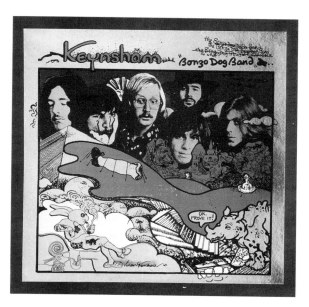

18. *Keynsham*, 1969

14. A publicity still for the BiG GRunt, Vivian's first post-Bonzo outfit in the early part of 1970. Around Vivian, left to right, are Dennis Cowan, Roger Spear and former Bonzo roadie Fred Munt.

15. Keith Moon and Vivian at Track Records for a 'Suspicion' single publicity shot, in early 1970.

16. In the months after the Bonzos split up, Vivian abandoned his trademark long locks and formed the Sean Head show band.

brave move for Richard to suggest that Stanshall should record a weekly ten-minute slot on this most revered of British broadcasting institutions.

Vivian effortlessly made the transition between pop and mainstream broadcasting. The audience at that time slot, 9.05 a.m., was a very mixed one. Vivian would come in at the end of the programme to tell a story illustrated with music, using his gift for bizarre and surreal connections to parody genteel Radio 4 serials affectionately. He played excerpts from records, rather than recording music for the programme, working the song into the plot. His choice of music was creative and surprising – mixing the likes of George Formby and Jack Buchanan with Tammy Wynette. The stories became a regular feature of the show between 1971 and 1972, and Richard gave them repeat airings on an afternoon show he later did with presenter Jack de Manio.

'They were well received,' says Richard. 'We used to get lots of letters, particularly from older people who were entranced, as well as from younger people who were fans of the Bonzos. He did that fairly regularly.' BBC radio in 1971 still had a very formal air about it and when Vivian came in to record his pieces, eyebrows were raised by the guardians of the Broadcasting House portals as he swept past wearing what one of Richard's colleagues disparagingly referred to as a 'suit made out of deckchair material'. This outfit would often be complemented by a beret worn at a rakish angle. With a half-bottle of brandy in one hand, Vivian Stanshall would enter the studio, place a Mickey Mouse alarm clock on the console and settle in for the session. On occasion he was accompanied by one of his African musician friends, who sat in the corner playing huge, stacked drums. The younger producers loved this, while the older guard, who did not even need to be veterans to remember Radio 4 as the Home Service, looked on somewhat disapprovingly.

'There was something wizard-like about him,' says Richard. 'I really did admire his talent. He was highly original.' The sessions ran smoothly, at least once Vivian made it to the studio. What proved more difficult for Richard Gilbert was getting the scripts out of his charge in time to get in the records for the show. Vivian's excuses for

their and, on occasion, his own non-appearance became ever wilder, until Richard could take no more.

'Old bean, very sorry, can't come in this time,' Vivian said. 'We've got to get Rupert to a doctor. He's been in contact with a diseased parrot, we think he may have psittacosis.' The producer finally told him exactly what he thought of such unbelievable nonsense – only to discover that this was completely accurate. Around Christmas, the Stanshalls bought an African grey parrot, the kind that talks. They kept it in a brass cage for what would turn out to be the whole of its short life. It never spoke. Monica named it Harpo and just three days after they purchased it came downstairs to find the parrot lying dead by its perch. As a member of the Zoological Society, Vivian was keen to find out what caused this unexpected demise. He bagged the bird up, stuck it in the freezer and wrote to the society. They suggested he send it to them and they would find out what killed it.

A man from the Ministry of Agriculture and Fisheries turned up early one morning. The family had to fumigate the house, he said, and provide a list of everyone who had been through it in the past few days. They all had electro-cardiograms at the local hospital to test for psittacosis, which can become pneumonia in humans. About a hundred infected parrots were imported into the UK, they learned, four into East Finchley. Three days later, Rupert developed a bad cough and Monica immediately called in the doctor, who packed mother and child off to an isolation hospital. When Vivian visited, he had to wear the full green-wellington-and-special-gown outfit. Rupert made a full recovery, though others were not so lucky, one woman in the Finchley area dying from the disease. As a result of the outbreak, laws on the sale of exotic birds were changed. Vivian related the extraordinary story of the African parrot on his 'Start the Week' slot and to almost all of his friends. These included a few of the Monty Python team, whom he had known since 'Do Not Adjust Your Set' days and it could be that this was the inspiration for the later legendary deceased bird of Python fame.

Vivian also aired extracts on his Radio 4 slot from what would become 'Rawlinson End', a spoof of the breathless style of episodic stories which could be found in women's magazines. 'He had such

a wide knowledge and interest in so many different areas,' says Richard. 'He was very fond of a lot of the traditional British aristocratic eccentricity combined with all the surrealists and Dada people. He had so much inside his head that no wonder it was almost near to exploding sometimes, because he was so eager to meld these things together. He was very knowledgeable about all sorts of different music, and I just think that being in the rock business was wrong for him. He didn't fit in and I don't think he had the right kind of understanding management.' In the rarefied atmosphere of Broadcasting House, Vivian's talents shone. The stories he read on 'Start the Week', accompanied by excerpts from records rather than original tunes, were far more gentle and less ambitious in production than 'Sir Henry at Rawlinson End' would be on Radio 1.

One of the Radio 4 stories was full of echoes of Vivian's early naval career, bound in a gentle parody of the cosy conventions of radio serials: 'The same dreary start of another week – work, wash, work, nosh, sleep, splosh,' began Vivian. 'Five days of drudge and drear, a tin full of tuna and cress or the ever-popular cheese and tomato lightly dusted with brick. An ordinary morning, yes, but for ex-seaman Robbie Beckles it was a day of tension.' Beckles is waiting on the seafront for the SS *Sausage*, a steamship containing his sweetheart, the captain's daughter, and the seaside setting is a basis for some fine descriptive passages from Vivian: 'In the slime, lugworms cast Walnut Whips of wonderful design and shy, soft-shelled crabs scrabbled like grey hands softly,' he reads. Oceans away, the sweetheart of the hero is caught on the *Sausage*, as it founders and she stands on deck playing a ukulele while it goes down (a cue for Vivian to play an extract of 'Ukulele Lady'). The story takes on a gently surreal quality as the girl heads for land, sat on a barrel, using her uke as a paddle, and worried about attacks from whales, which someone has told her are nothing but giant tadpoles. As a young Vivian had once claimed concerning himself, she meets some natives who are friendly cannibals.

A broadcast for Valentine's Day related a charming and straightforward tale of an ordinary housewife's life brightened by the arrival of a pink, scented card among all the bills on one 14 February. Betty

and her husband Bill have an unexciting marriage and the arrival of the Valentine's note brings her to life: 'The letter was pink and addressed to her, and it smelt very faintly . . . of cheese. "Well, I'm blowed!" she blew. "I wonder 'oo this is from," and she peered closely for the postmark. But there was none. She quite forgot the cold as she cooed into the parlour for the paper knife that never got used. She wasn't going to tear this one with her fingers.' It is a card with a picture of a cow on the front and a rhyme inside. As romantic music swells, Betty wonders who of her acquaintances it could be from. When she thinks she has guessed, 'she filled the room with a smile so radiant, it made the coronation cups and horse brasses on the mantelpiece sparkle'. It is George, who owns the local supermarket, an excuse for Vivian to spin a couple of George Formby tracks. Betty goes to the shop for her day's provisions and makes a special effort to dress up. She is struck by how the other locals have gone out of the way to look smart: 'As for Mrs Jackson, she was wearing hot pants and a wet-look rubber poncho, and she's the wrong side of fifty I do know.' George the shop owner, Vivian reveals, has given cards to all his regulars to cheer them up for the day. It is a simple story warmly told, revealing a side of Vivian that engaged affectionately with his characters. His anarchic instincts were given rein on another radio station, aided by his partner in hell-raising, Keith Moon. Over the summer of 1971, they put a BBC Radio 1 show together for John Walters, then producing the John Peel show.

Stanshall and Walters first met when the Bonzos did sessions for John Peel's show in the late 1960s, and subsequently some of Vivian's post-Bonzo bands had also appeared on the show. Like Richard Gilbert, John Walters immediately saw how suited Vivian was to radio. With a degree in fine art and a college background, Walters was able to stand up to Vivian and coax him into delivering some of his best material. The show Vivian did over August 1971 was a fill-in job for John Peel, who was taking his second annual holiday, then an unheard-of luxury for a DJ.

'As with everything, Viv then took off,' says John Walters. 'I thought he'd be waggish and introduce the next record. Then he started. With Viv, you opened the floodgates.' The idea was to do four programmes.

Vivian told him he wanted to call the show 'Radio Flashes'. The title was a reference to cartoons in children's comics like the *Beano*, where arrows and flashes would be depicted around talking radio sets. It was also a surreal *double entendre*: the idea of someone doing a quick nude flash on radio appealed to him. Perhaps mindful of the pitfalls of working alone, Vivian did not want to do the show solo.

John Walters remembers: 'Viv brought Keith along and was very much his mentor and guru. Keith was clearly happy to be seen around with Viv. I rather suspect that's where all Keith's "Hello, dear boy" routine came from. In my opinion it was a straight copy of Vivian Stanshall. Moonie was a great mimic, but he could only be funny if you stood him beside a table of trifles, lit the blue touch paper and stood away as quickly as possible. Suddenly there'd be trifle all over the place and he would be seen as a bit of an entertaining character. But I think he liked being seen as Robin to Viv's Batman.' He got to be that in a parody of 'Dick Barton'. He played Lemmy the lovable Cockney and Vivian played Colonel Knut, master detective and all-round good egg. He also played arch-villain the Scorpion, who would try and do away with Knut at every turn.

Other characters included Bruce Reason, motoring correspondent. Stanshall could not drive himself, but his aim was to portray Bruce Reason as a rational sort of chap, all right apart from suffering from the occasional funny 'three-point turn', who fitted a circular saw on the front of his car to beat traffic jams. There were a raft of dismal music-biz types in the shows as well. Leeching agents and pop stars like Johnny Wardrobe, dim-witted with far too much money – 'he's against seal-hunting, make a note of that, and rabbit-teasing too', says his manager – were played by Vivian.

In one show we hear an intrepid music journalist questioning legendary star Vince Vacant about his wardrobe. He has bought millions of pounds' worth of clothes in a single afternoon, from trendy boutiques such as Must be Joking, and Oh Ducky of Carnaby Street. Hippest of all his clothes is undoubtedly Vince's 'latex-foam Yorkshire sombrero, with concealed musical box and surprise cocktail cabinet'. This was from Hung, Drawn and Fleeced, also of Carnaby Street. Sometimes Vivian would take the listener to the backstage 'artists'

paddock' at some surreal 'rock and booze' festival, pointing out the stars as he went. 'There's the Hare Krishna band. I never know which one's Harry. Hullo! Shalom!'

'Radio Flashes' also featured spoofs of radio adverts, an idea ahead of its time in the pre-commercial-radio era. Vivian had, he told John, gone into a chemist's shop near Broadcasting House to hear the man in front of him loudly telling the shop assistant: 'We're going for a family picnic in the country. We're always pestered by wasps. Do you have an anti-wasp spray?' The chemist recommended Wasp-Eze.

Then it was Vivian's turn at the counter. 'Aha, my good man. I'm thinking of going to Kenya on safari. I have this great fear of camping out in the night and being trampled by big game. Do you have any anti-rhino spray?' To his disappointment the chemist was quite unfazed and replied, 'Well, I have nothing specific for rhinos but I can give you our all-purpose repellant spray.'

John says: 'He realized he had been beaten by reality! So he actually bought some but he told me he was going to do a series of gags.' Vivian later said he had been working on the comic potential of Wasp-Eze as far back as art-school days. The result was a spoof ad, on which they played Bach's 'Air on a "G" String', the music for the long-running Hamlet cigar advert.

'Hey! Yes, you. Bet you haven't noticed many elephants around Broadcasting House just lately, have you?' says Vivian with a perfect mid-Atlantic adman twang. 'Why is that? OK, I'll let you in on it. We had the whole place sprayed not so long ago with new Repel-E-Phant. Uh-huh. Repel-E-Phant, the aerosol answer to today's pachyderm problem. Repel-E-Phant was developed by the same thoughtful people who brought you Rhi-No, the revolutionary rhinoceros repellant. It was pretty popular with the Royal Family as well.

'Just spray a little Repel-E-Phant on your legs or exposed areas first thing in the morning – it's good to have a routine, that way you won't forget. Let it dry and you're ready to go . . . just stand down-wind and watch those big grey chaps pack their trunks.' Vivian's finely modulated voice was exactly right for radio, and between the sketches and records, there were frequent breaks for these spoof ads, which – along with Kenny Everett's shows – were clear influences on the prank

phone calls and fast-moving spoofs that broadcasters such as Victor Lewis-Smith and Chris Morris would later get up to on Radio 1.

John Walters called Vivian's more subtle wordplay 'verbal time bombs'. One of these was planted in a link back to the show after a record was played. 'Well, that's the Shangri-Las with "Leader of the Pack",' said Vivian, 'which of course means "songs of the luggage".' It was not until a couple of days afterwards, while travelling to work on the underground, that John Walters suddenly connected 'Leader' with the German for songs – *Lieder* – and 'pack' with *Gepäck* – German for luggage – and embarrassed himself by laughing out loud.

The programme was a hit with the listeners, but recording the shows proved increasingly difficult. The routine of a BBC studio was far more disciplined than the laid-back Bonzo sessions, and Vivian's drinking began to affect his performance. He started the run fine, but soon began to come in late and turned up with plastic bags full of bottles. In the end, Walters was relying on Keith Moon to be the straight man, which – given Keith's fearsome reputation – was when he really knew things were getting bad. At the session for the last episode, Vivian kept the others waiting for two hours. When he finally turned up and got settled behind the microphone, Walters told the engineer to start recording.

Vivian turned to the producer and said, 'Hang on, mate. I've got to write the bugger first.' And John just thought to himself, 'Oh. I'm finished.' Somehow, they got it done and Walters did not even stay to hear it back. He went to Crystal Palace to see the football.

Vivian was not slacking. He just could not focus on finishing his work. He continually scribbled away, often lying in his bed surrounded by notebooks and other paraphernalia. He relished stories from everyday life which struck him as amusing for whatever reason, and just as he might get some gags from an ordinary trip to the chemist's, he was also forever cutting out newspaper articles which had some kind of appealing element. One typical example he read to an interviewer concerned the bravery of a tiny poodle, reported in a newspaper, who fought off a German shepherd when it attacked 'hair bristling, teeth bared'.[18] Vivian took all these strands on board when he came up with new material. He reintroduced old characters or

gags in different projects, trying to improve his work and make it ever better, desperate to get everything just right and quietly becoming anxious when he felt he had not.

'Session musicians he worked with complained he was a perfectionist,' says one friend. 'He would change his mind halfway through a piece. He just had one of those brains that flits here and there. There was a lot of unconscious brain activity going on. But what you ended up with was always wonderful. "What is he *on* about? Oh, well, give it a go." And whatever it was – it sounded great.'

Vivian's panic attacks also made it difficult for him to get material together and he was often at his best in a group setting like the one that coalesced around him at the Edinburgh Festival in 1971. This became a loose outfit he called Human Beans. 'At the festival, we found a lot of people who had such cerebral sympathy with each other that we needed scarcely any rehearsal. It was so comfortable, exciting and liberating gigging with them that Human Beans evolved out of it, and I thought we should perform as a group whenever we could find an audience.'[19]

Unlike the Bonzos, this lacked the framework of a regular group, but it did free Vivian to approach people on a more ad hoc basis. 'I keep a long list of people: mimes, musicians, poets and madmen, and when someone offers me a date, I call around to see who's available. Whoever it is comes along, and they're the Human Beans for that gig,' he said. 'I always include at least one poet. One thing I learned in Edinburgh is that when a good poet is put in front of an audience which wouldn't ordinarily go to a poetry reading, they go down unbelievably well.'[20] Something about Vivian's creativity and his charisma kept people interested in working with him. 'The incredible thing is that the same people who haven't been paid yet, will still come along and play when I get something going. It's completely daft,' he added. There were many more ideas, scribbled down and added to teetering piles wherever he lived: a book of poetry, an autobiography and a picture book with Vivian as a figure combining both Christ and Van Gogh (two characters his friends said he did tend to resemble), with a toilet seat for a halo and sticking plasters over his stigmata.

The scatter-gun, energetic, passionate approach to work spilled

over to his social life. On the Soho scene, *Melody Maker* journalist Roy Hollingworth shared lodgings with photographer Barrie Wentzell at a Soho studio flat in a corner turret above Carlisle Street. The flat was a sought-after sanctuary when Soho's pubs and clubs were closed. Larry Smith, Barrie, Vivian and Roy frequented a complex of clubs in the cellars beneath Soho.

Says Roy: 'You'd leave one place, go down an alley, give three knocks on the door and you'd get in the back of somewhere else. You'd leave a place that closed at 2.30 a.m. and go on to another that stayed open until 3 a.m. and Vic [Vivian] knew every one of them. We used to go to places I never knew existed, relics from the old pre-war musicians' late-night drinking dens. Some of the types in there were amazing, old jazzmen, boxers and prostitutes. I don't think we ever talked about music. It was serious raving and living on the edge. He liked to party and just talk and engage in good repartee.' Even when the diligent reporter tried to get an early night, his sleep would be disturbed, often in the most alarming fashion: 'I can remember settling into bed, having finished raving, while Viv had gone off somewhere, probably to the Speakeasy or the Limbo Club, where he could dance with the strippers. Then having gone to bed, I'd hear this frantic banging on the door downstairs. I looked out the bedroom window and there was Vic down there with a case of beer.' It was 4 a.m. The sparrows were up and the milkman was coming out of the dairy: 'The clubs have closed, old boy,' yelled Vivian. 'Come on – you and Wentzell, get out of bed!'

Roy let him in and the two flatmates had to get up and drink a case of beer with him: 'There was this absolute belief in raving. It was meant to be taken seriously. It was a way of life. He'd keep us up all hours playing the ukulele. On Saturdays Viv would come round and we used to go busking around Soho. We'd stand on the corner of Carlisle Street with guitars and the ukulele and just busk. Vic would sing absolute nonsense and people would stop and give us money. We'd earn more in a couple of hours in Dean Street than I'd get working for the *Melody Maker*.'

Roy Hollingworth was concerned about Vivian's drinking to the extent of writing an article in 1971 which called for the Bonzos to

get back together. Vivian was, wrote Roy, 'going to kill himself if somebody doesn't reform the Bonzos and look after him'. Even Larry Smith, hardly one for discreet moderation, urged caution. 'Don't buy him another, Roy,' requested Larry at one point, 'because that's another nail in his coffin.' And this from the drummer and ace tap artist who was having problems with drink himself. He knew Vivian's problems better than most: 'His life is Bonzo Dog. He'll die if we don't get together,' said Larry, while Vivian drank himself into what Roy described as 'horrible oblivion' beside them. Roy and Larry both thought that Vivian knew the Bonzos best and a Bonzo project would help him recover his equilibrium.

9
The Crackpot at the End of the Rainbow
1971–74

The Bonzos made a return to recording late in 1971. It was not a permanent reunion, and it was not even a voluntary one. The band were told they had to do another album to complete their contract. Work had started on building the Manor studios in Oxford, constructed by Richard Branson's Virgin label, and the Bonzos would be the first band in. They assembled for recording in November 1971, with a line-up of Vivian, Neil, Dennis Cowan, Larry Smith and Roger Spear, together with Bubbles White (guitars), Andy Roberts (guitars and fiddle), Dave Richards (bass), Dick Parry (saxophone) and Hughie Flint (drums).

Vivian phoned journalist Roy Hollingworth in early November to ask for a lift to the Manor, where he was already overdue by several days. He had just flown to Edinburgh for a gig and then returned to London and was nervous about the new enterprise. Virgin sent an old army ambulance decorated with a skull and crossbones to pick up Wentzell and Hollingworth from Soho Square and Vivian from East Finchley. Once again, the band were given second-class treatment. Not for the Bonzos a plush limo with chilled champagne on tap, or even windows, although the ambulance did come equipped with five or six hippies who reclined on mattresses that took up the whole of the back. The others crushed into the front and they raced away at speeds of up to fifteen miles-an-hour, inevitably breaking

down somewhere along the North Circular in London. Vivian decided to hail a cab instead of hanging around waiting for the ambulance to be repaired.

'I'm not coming the superstar bit,' he said to Roy, 'I'm just bloody tired and I've got a session and that thing is just silly.' The task for the unsuspecting taxi driver was to get them to the Manor studio which was, they knew without doubt, somewhere or other in or near Oxford. On the way, Vivian wanted to stop at every pub, introduce himself to the landlord and have a chat. And there were a lot of pubs on those winding Oxfordshire roads. Slowly, the cabbie became drawn into the adventure, as he began to relax in Vivian's company. The passengers continued to drink, Vivian topping up from a brandy bottle between pubs. At the last stop, he bought a packet of cigarettes and offered one to the driver, who explained that he did not smoke. Vivian had not heard him, struck a match and thrust it at his face. The cabbie blew it out. Vivian struck another. And another, forcing the driver to concentrate on both driving and avoiding severe facial burns for much of the remainder of the journey.

By the time they arrived at the Manor they were all in a pretty bad way. Roy admits that both he and Wentzell had been accused of being 'bad company for Vic', but the journalists felt they were just trying to act as friends. Vivian was poured out of the ambulance at the studio, a duck-shaped ukulele clutched in one hand. Neil Innes, who greeted them at the studio, was not best pleased. 'Thank you for bringing a dead artist,' was his tight-lipped comment. Meanwhile, the cab driver wandered off to see Richard Branson about his fare. 'A couple of voluptuous ladies came out and asked him if he'd like some tea and that's the last we ever saw of him,' says Roy. 'He's probably a chief executive for Virgin cars by now.'

Vivian did not make the recording process easy. As a journalist, Roy did not see anything unusual in that: 'We all behaved like that at the time, although there were more serious types who could make music and make money. I do remember going into the studio one afternoon and Neil had been trying to record Viv singing something for a long time and it was getting a bit tense.'

The way Vivian later told it in interviews, at first they had decided

simply to fulfil the contract without any embellishment: 'We decided to do it all in one go – sod overdubbing and all that nonsense, give us a couple of mikes and off we go . . . Twenty minutes a side? "Right, set your watches" – and we just went straight off. It was utter madness. I was just squawking and screeching, but some of it came together really remarkably well, so it proved we still do have that sort of feeling. But we decided it would be grotesquely unfair to put it out like that.' The first day at the Manor was spent with engineer and producer Tom Newman trying to get the band to sort out some coherent ideas. A rehearsal tape exists which captures some remarkable piano playing and verbal improvisation. Neil Innes improvises a pastiche of Hollywood film themes as Vivian launches into a surreal outpouring of images. The pair worked wonderfully well together for a partnership that was supposed to have been in disarray. Neil's beautiful piano flourishes inspire his friend to ever greater heights until eventually Vivian runs out of material and can be heard begging for a break.

At the same time as the Bonzos were recording, an obscure young artist was also putting together his first album with Tom Newman. Mike Oldfield's groundbreaking opus *Tubular Bells* was to help establish Virgin as one of the most important and successful independent labels.

'The Bonzos were only meant to be in for two weeks and they ended up staying for two months,' says Tom. 'We had problems with equipment and they had problems with their heads. During this time Michael arrived destitute and desperate and we put him up at the Manor. We started doing demos for him and he helped out on the Bonzos' sessions while doing what became *Tubular Bells*.' Vivian was invited to be the Master of Ceremonies on Oldfield's album, introducing all the instruments. It was a kind of adult 'The Intro and the Outro', without Adolf Hitler on vibes. The nervous youngster had been too scared to ask Vivian, who was approached by Newman, though it was not a big deal to Vivian. He breezed in, recorded his part quickly and left. They needed the narration as a device to make the piece more dramatic, and it worked, but Vivian was not the least bit interested or involved, and did not ask for a fee or a royalty. *Tubular Bells*, much to his later annoyance, went on to sell millions of copies

and was performed to great acclaim with dozens of musicians at London's Queen Elizabeth Hall on the South Bank, when Vivian was invited to participate again. He got it completely wrong. He was always one and a half bars out. Once he started going wrong, there was no getting him back, so he was announcing the mandolin when the electric guitar was playing and the acoustic guitar when it was time for the glockenspiel. 'He was always one out, and Michael was furious.' says Tom. 'There was nothing he could do about it and in the end nobody minded.' The audience began to titter once they realized what was happening, but Vivian ploughed on regardless and apparently oblivious, and the applause was deafening.

At the Manor, Vivian also recorded an improvised piece quite apart from the Bonzo material, with Mike Oldfield in tow. Gleefully inebriated, he attempts a commentary on the Manor, roving the halls accompanied by musicians playing a sozzled version of the 'Sailor's Hornpipe': 'From the outside an ordinary house. A great house, true. Four hundred and eighty-three rooms, each one with its own marble wash basin and douche – bidet as it may. But inside . . . And the positions are reversed. A human failing, some say a disease, but a disease that Sir Francis Dashwood knew and knew well.' There is no time to ponder whether this is a reference to some unsavoury infection of the infamous lord who founded the Hellfire Club in the eighteenth century, as Vivian takes us further. Upstairs, it's a revelation, 'It's a discotheque', hold on, no it is not – Vivian's found a seventeenth-century masterpiece. He scratches off some of the paint and, 'beneath I can find hidden a fourteenth-century underpiece, made entirely of tiny pieces of eggshell. This lewd work has caused controversy in the world of embroidery and anthropology . . . It has enthralled distinguished professors and, in layman's language, it's blinking well baffling.' The truth about this mysterious painting, as our guide delights in telling us is: 'Buggered if I know. Yes, buggered if I know . . . from experts in fourteenth-century painting, renaissance greengrocers and recently revived members of the public. Buggered if I know. Vivian Stanshall, about three o'clock in the morning, Oxfordshire, 1973. Goodnight.'[1] This romp was later released on *Mike Oldfield Boxed*, a set containing *Tubular Bells*.

For the Bonzos themselves, sessions at the Manor progressed in fits and starts, producing the first full 'Rawlinson End'. The Rawlinsons had first appeared playing trombone on 'The Intro and the Outro'. The name 'Rawlinson' was from a BBC Radio 4 play. Listening in the Bonzo van on tour, the group heard the line, 'Oh, and the Rawlinsons are coming', a perfectly innocuous line in itself. It was just one of those things that touched the collective Bonzo mind and the group went into hysterics. The story came out of the hectic writing sessions with Neil Innes. The track was essentially one long 'story so far', in the style of a soap opera, a list of weird and wonderful characters and the predicaments they found themselves in. Though Vivian sent up the genre well, it was still far from the rich characters and complex mythology of Sir Henry Rawlinson, as created by Vivian in the next couple of years.

The band also recorded 'The Strain', another Bonzo toilet gag. It was also a comment on the band's situation, somewhat disillusioned and working their way through the contractual obligation scenario. The track was another done in about four or five takes, one of which was recorded in the Manor toilet, while Stanshall was indeed engaged in moving his bowels. 'After all,' comments Tom, 'one wanted *cinéma verité*.' There were occasional tensions, the inevitable Bonzo creative tiffs and flouncing off the mike in the sessions. Neil wanted the quality of the music to be given more prominence, Vivian wanted to be theatrical and said Larry wanted 'more sequins'.

There were opportunities to de-stress at the Manor. Tom Newman and Vivian shared an interest in Guinness and Newman taught Stanshall archery. 'He was into being macho,' says Tom. 'He wanted to be a Zen archer. He also wanted to be Charles Atlas and carried this Bullworker thing around with him. He wanted to kick sand in people's faces! But I suspect he was actually a scaredy cat.'

Vivian was bullish about the completed record. 'You can tell that we've been working away from each other,' he said. 'You'll get that when you hear the album. But it's come together. Musically, it's the best Dog album. We're pleased.' *Let's Make Up and be Friendly* had a cover featuring the original G. Studdy postcard depicting Bonzo the dog sitting in front of a mirror. It failed to dent the UK charts on

its release in March 1972, not least because Liberty did practically no promotion, but it was more than the perfunctory get-together it could have been. This was the last album and an accomplished swan-song. There was no tour in support and the members went their separate ways once more.

Vivian returned to radio in 1972, once more through Richard Gilbert, who had been asked to start a new magazine show between 9.30 a.m. and 10 a.m., a slot vacant when schools programmes were not broadcast. He thought it was an excellent opportunity to use Kenny Everett, the DJ and comic who was then in one of his periods of BBC exile. Everett contributed to 'Start the Week' and was then teamed with the dry humorist Kenneth Robinson for the new programme, 'If It's Wednesday, It Must be . . .' Robinson presented, with both Everett and Stanshall – who were almost equal runners in the prevarication stakes – contributing their pieces separately. Over the course of the series, which ran until 1974, other contributors included the poet, musician, playwright and humorist Ivor Cutler and Ron Geesin, the experimental composer who found fame through his work with Pink Floyd. Vivian's pieces followed the same lines as those he performed for 'Start the Week', stories interspersed with musical extracts, though the tales were a little shorter.

For most of 1972, Vivian returned to music, touring with Neil Innes as Vivian Stanshall and Friends. They played ten nights at the Edinburgh Festival, performing excerpts from what would be his first solo album, *Men Opening Umbrellas Ahead*. He also managed to fit in guest appearances on John Entwistle's album *Smash Your Head Against the Wall* and on *Basher, Chalky, Pongo And Me*, by ex-Liverpool Scene man Mike Hart. That same summer, Vivian, Monica and four-year-old Rupert went to the Isle of Wight, the home of Vivian's friend and official photographer, Barrie Wentzell. Vivian took to the stage on the pier when the Temperance Seven asked him to stand in for their lead singer over the summer season. The Temperance Seven, once so popular when the Bonzos were starting out, had just one original member. Cephas Howard was the 'leader of the band, on cornet and euphonium'. He was described jokingly by Vivian as 'a bluff but thoroughly disagreeable Yorkshireman'. The

two were great friends. Cephas lived in Shanklin, running a shop with a pottery attached. The seaside ambience of small towns like Shanklin was a great love for Vivian.

'I've a lovely hotel right slap on the seafront,' he said, 'and if I merely glance out of the window, I can just see the sheer sandstone cliffs about twenty feet away – I'm at the back. I'm surrounded by gorgeous rhododendrons and great clumps of palms. Of an evening, after the show on the pier, I slip off to the land of nod with a glass of cocoa and to the whisper of the surf. And in the mornings, as I spring god-like from the sheets, the wind wafts the scream of the gulls and the raucous call of the bingo . . . "Eyes down, ladies, cover up your middles, eighty-eight, two fat ladies . . ." Oh, I've really a kind landlady to look after me and right next door there's a seafood stall where whelks and lobsters serve people preserved in jars, fresh with jelly and vinegar.'[2]

Six nights a week, Vivian played the role of 'Whispering' Paul McDowell at the end of the pier in the tiny theatre. Performing with the Temps was, he recalled with pleasure, 'delightfully awful. Playing to non-existent audiences. The band used to march along the beach to drum up an audience. There was an organist just like Roy Hudd plays in [Dennis] Potter's *Lipstick on Your Collar*, dressed in tights, who would sing one of those awful Presley songs from *GI Blues*, "Did You Ever", and would point his crotch towards the audience's faces. One night a lady got up and poured a cup of tea over his head. There were all these theatrical superstitions, like no whistling in the dressing rooms. Apparently the pier was haunted.'[3] It was all very much what Vivian's Sir Henry Rawlinson called 'end-of-the-pier-pointlessness' and there was rich inspiration for comic material in Shanklin. 'There was a café on the pier, this funny little man ran it,' remembered Vivian. 'He displayed a ludicrously unpunctuated sign, "Spades Balls Sausages Teas".' That was later a title of an episode of 'Sir Henry at Rawlinson End' and Barrie Wentzell would take visitors to Shanklin to view the sign that had made Vivian wheeze with laughter.

The run of performances was not at all demanding for Vivian and it was consequently unstressful for him. 'All I had to do,' he said, 'was dress up, put some sequins on my nipples and prance about.'[4]

This left plenty of time to spend with the family, which he employed largely in teaching Rupert to eat whelks, much to Monica's horror. 'They really are the most disgusting form of seafood,' she says. 'He was mad on them. He introduced us to some horrible things to eat and drink. It was all seaside stuff. When we went to Whitstable the thing was to eat lobsters. I think we are back to Proust here: *Remembrance of Things Past* [*A la Recherche du Temps Perdu*]. The whole seafood thing was remembering Granny at Whitstable when he was a little boy. It was to relive a time when he was happy – and whistling.' On the front where Monica and Vivian would take leisurely strolls together, they met an astrologer who offered to do their charts. The Stanshalls readily gave him all the information he needed to make his reading and he stared at the various dates and years in a strange silence. They did not hear from the man again, until they ran into him by chance in the street. What about these stars then – would he give them the reading? 'If you don't mind, I'd rather not,' said the astrologer, backing away from them. Vivian and Monica exchanged stunned looks: 'I have been told since that we were amazingly incompatible,' she says. 'That was interesting. But I don't believe a word of it!'

There was not really that much going on in the town, apart from a disastrous version of *Fiddler on the Roof*, which played at the Shanklin Theatre. There were a few cabaret acts – Vivian spotted an advert in the local paper for an artist called Andy McRoberts, and he sent a clipping to his friend Andy Roberts in London, writing in the margin, 'I saw you and you were bloody awful.' Much of the time, Cephas Howard and Vivian hung out together and, said Vivian, 'The only thing to do was to get out of your brain.' The Temps man had been banned from just about every bar, pub and hotel in the area and Vivian helped him add to the list: 'We were thrown out of the Green Parrot.'

Vivian broadcast for Radio 4 from Southampton in a break from the Temperance Seven season. He put together a tight show with the rest of the band, linking songs such as their signature tune 'Pasadena' with an evocative description of his time on the Isle of Wight. His laid-back style was a perfect foil for the Temps' cool jazz, creating the

atmosphere of an Edwardian English seafront with Vivian as the itinerant singer, the touring musician passing through town.

'Good morning, *bonjour*,' he began. 'Although, considering the beastly hour I got up this morning, it's difficult to be *bon* at all. What am I *bon* about? I was "bon" about 1943, I remember the sirens used to keep me awake a lot. Awake, and that's a sad business, but I'm awake now, by cracky.' He had, he said, just got off the ferry from Cowes and 'with the fresh aftershave sting of the sea-spray still smarting my cheeks, I'm pink, primed and ready to do some squawking for you'. The Temps played their mellow jazz, a well-behaved version of the Bonzos, against which Vivian sang like an old crooner, relaxed and evidently enjoying himself, without a hint of parody in his warm voice.

When Vivian finished the season and returned to the realities of life in London, it was also to face all the projects he had on the go. There was a satirical show called *Up Sunday*, which ran between 1972 and 1973, in which he participated, and he was still trying to finish that first solo album, but was plagued by ill health. In February 1973 he talked to Steve Peacock, a sympathetic reporter from *Sounds* magazine. 'I just can't finish my album,' he confessed. 'It's been inches from finito for a couple of months but I can't get the vocals done; I don't want to go in and do a Satchmo job on it. Are you listening up there Warner Brothers – I'm really sick. The heart's still the same, comes and goes, y'know. I put my knee out of joint a couple of weeks ago, just because it was there, I suppose. I was hobbling around like Keith Michell in the later part of "Henry VIII". But, unfortunately, I never get obvious things like purple rashes or hideous eruptions so I could really be seen to be ill – I'd really like to look all thin and droopy, Beardsleyesque, if that's a word, lying pale and wan in a bed surrounded by lilies. Maybe then I'd be taken seriously. Illnesses, like hanging, should be seen. But I'm taking all kinds of pills and tranquillizers to keep me calm, so I just go around looking permanently dozy – going around saying "Om" all the time.'[5] There was, still, talk of re-forming the Bonzos.

'Well, Larry Smith went to the States with Elton John. It seems that after that they're offering us untold rolls of calico and beadwork

for some kind of contract, so if they can furnish us in the splendour to which we've become habituated, perhaps we'll do it again.' Just a few days before the interview, he said, he had been in the 'Top of the Pops' studio and he talked about his impressions of the new wave of glam rock – neatly summing up much of the following decade's contribution to music in the process: 'It was hilarious, I couldn't believe it. Endless troupes of guys with beer bellies hanging over their many-buckled belts, with glitter and sequins in their navels and eyes like spiders,' cackled Vivian. 'And they all look the bloody same – a festival of vulgarity.'

In this climate, he reckoned that another stab at the Bonzo Band would be welcomed with open arms: 'We're all beginning to miss each other and two years off the road is time enough to break your fingernails and recoup intellectually. They're screaming out for us of course – all these pooftahs and swollen asses strutting about . . . It was the beer belly with the ruby in the navel that really got me, and those dreadful white fleshy arms.'

For his own part, Vivian was determined to ensure his work did not get too much for him again. 'I must plot things properly,' he said. 'I want to do maybe three months on the road in a year and then spend the rest of the time recording, maybe doing radio and TV spots, doing a bit of carving, looking after the turtles and have a holiday. I feel as if I've been in this room all my life, a bit like Miss Haversham – twenty years of cobwebs and mouldering half-eaten dinners. But what I don't want to do is get into that awful thing of just going on and on all the time. One of the pleasant side effects of being ill has been being able to read a bit, knock up a few shelves and have a bash at woodcarving.' His rest was short-lived.

Among the Bonzos' contemporaries had been both Liverpool Scene and the Scaffold; a floating pool of talent from all three, singers, musicians, poets, humorists and artists, eventually coalesced into Grimms. Liverpool Scene started as the poets Roger McGough, Brian Patten and Adrian Henri, accompanied on guitar by Andy Roberts. With their ranks augmented by musicians such as Mike Hart and Brian Dodson, they enjoyed some success as a rock outfit. McGough had by then switched to the Scaffold, joining Liverpudlians John

Gorman and Paul McCartney's brother, Mike McGear. Scaffold enjoyed a UK No. 1 hit with 'Lily the Pink' in November 1968, the same month the Bonzos scored with 'I'm the Urban Spaceman'.

The name Grimms was taken from the initials of the members' surnames: Gorman, Roberts, Innes, McGough, McGear and Stanshall. Its flexible line-up included at one time or another such disparate talents as Patten, Henri, singer and keyboard player Zoot Money, Mike Kelly, John Halsey, Dave Richards, Gerry Conway and Ollie Halsall. Vivian explained his role was to provide the 'Danny La Rue part' – singing a couple of songs, doing a bit of 'squawking', bashing percussion, rasping the euphonium and slipping off stage to change into something more glamorous. Grimms seemed an ideal creative environment to substitute for the missing Bonzos. John Gorman in particular fizzed with ideas, but everyone came up with sketches for the show. Unlike the Bonzos, it had to be properly organized and Grimms even hired a stage director to create some kind of order for the sketches, poems and pieces of music. They set about rehearsing in north London for their second tour that March.

Vivian had plenty to contribute, but as with the Bonzos found it difficult to cope with the tortures of touring. He had got it all the wrong way round. He would always be the first up, starting the day fine, sparkling and in vintage form. On a day off after a gig at Swansea University, the group were staying at a fine old Art Deco hotel on the cliff tops, when he woke everyone up at 8 a.m., following a card game which had lasted until 5 a.m. He insisted his friends come down to the beach to collect 'some wonderful examples of Welsh granite' he had spotted. The whole bleary-eyed crew traipsed down the cliff path to collect huge great stones, which it turned out Vivian actually wanted for his turtle aquariums.

In contrast, by the time the others were getting ready to go on stage, Vivian would be starting to get tight. Everyone was frustrated by the unpredictability – it would get to his slot and he might be doing a reading from 'Rawlinson End' and would get slower and slower, causing Neil Innes to storm off the stage. On another couple of dates, Vivian's old chum Keith Moon turned up. At Greenwich Town Hall, in London, Mike Giles was already on drums. He used

to be in King Crimson and was not going to get off the drums to let
Keith Moon have a go. At this point, Neil Innes mentioned he had a
kit. 'I lived nearby in Blackheath and had bought my son Miles a
small Premier kit. It was duly set up on stage. Keith had some girl-
friend with him. She sat on the bass drum to keep it still and he
started bashing away. There was nothing left of this kit by the end of
the evening.'

John Walters recalled that John Gorman decided to finish the
Grimms tour after a particularly trying night when Vivian, who
turned up late anyway, fell drunkenly off the stage. Grimms collec-
tively decided they really needed to sort the act out. They agreed to
meet the next morning, but having waited two hours for Vivian to
turn up, Gorman said he had had enough, he wanted to end the tour
and left to go to the station. A taxi drew up outside the building and
John went to get in. As he opened the door, Vivian Stanshall, with
impeccable timing, clutching a plastic bag containing his trusty
ukulele, tumbled out of the vehicle on to the pavement. Gorman
stepped over him, got into the taxi and, slamming the door behind
him, simply said, 'Station, please.' When Grimms advertised a UK
tour to promote an album called *Rockin' Duck*, in October 1973,
Vivian Stanshall's name was conspicuously absent from the cast list.

'I found that all very unhappy. I don't know why it didn't come
off,' Vivian later said of the whole project. 'There was a terrific lack
of sympathy between musicians and poets. I told Brian Patten I hated
him – I can't remember why. He seems to think he's the new Lord
Byron. Recycled Byron. To be honest – never got past his voice.'[6]
More positive was that Vivian won over new allies from the tour. He
got to know the drummer who was to join Grimms after his depar-
ture, 'Admiral' John Halsey. Visiting him for the first time with John
Gorman, at Vivian's Finchley home, Halsey remembers the singer
was rampaging around his sitting room, wielding one of his fearsome
knives and bellowing. When they met again after Grimms, Vivian was
undergoing one of his periodic cures in some unpleasant Victorian-
built hospital. They found Vivian in bed playing his ukulele and in
fine form. And then, just a while later, Halsey met him again at Andy's
house, 'absolutely roaring and very proud that he had beaten the

medication,' says John. 'He had been able to down copious amounts of booze and the medication didn't work. He was actually rather proud of himself.' Halsey was baffled by him.

Andy Roberts also began to hang out with Vivian and the pair became good friends, particularly when Andy moved to London after one of the bands he was in split up. He had to return to London to live with his parents. 'It was driving me nuts so I used to go over to East End Road, Finchley to see Viv and we used to play music together. We also had a table-tennis table in the front room which we played surrounded by the turtle tanks. Viv was desperately keen to work it into the act.' Andy remembers another set of bemused acquaintances were the Eagles, recording in England. Andy first met them while touring in America some years earlier.

'They were working very hard but they had one evening off and they asked if I knew Vivian Stanshall. They really wanted to meet him because they had seen the Bonzo Dog Band in LA and thought they were fantastic.' The band were staying at a flat in Maida Vale, where Andy picked them up in his Mini van and drove them to Stanshall's house. They spent the evening smoking powerful African grass before tottering off to a local Indian restaurant. During the meal Vivian staged one of his fake heart attacks and Andy was despatched back to the house to get his pills, leaving the Eagles alone with their hero, a groaning and grimacing Stanshall.

'It must have been so weird for them. They had never been to England before and here they were with this complete madman. It was a curious episode.' Mostly, Andy knew there was very little he could do when Vivian was hitting the brandy and Valium and he would just make it clear that he was not available unless Vivian was sober. Sympathy and solace were readily available from Vivian's mother and from Rodney Slater, who was by then well into his second career as a social worker. Vivian, in a panic, would phone him up at any time of the day or night. Over time, most of his friends got to know how well he was by the frequency and times of calls. When he could not stand to be with anyone, Vivian found some peace on a little boat he used as a private bolthole near the Maida Vale basin.

Later in 1973, he became involved with the soundtrack album of

That'll be the Day. An unashamed wallow in nostalgia, the movie was set in the rock'n'roll 1950s, taking its name from the classic Buddy Holly song, and following the fortunes of one wannabe rocker played by David Essex. It was just the kind of project that Vivian had a genuine passion for. He had once gone with a group of friends to see Jerry Lee Lewis play at the London Palladium and retained a lifelong love for rock'n'roll. The film was a natural one for him. Its cast also featured many other top musicians, including Billy Fury, who played a frontman of a band called Stormy Tempest and the Typhoons. Vivian assisted with vocals when Billy was unwell. 'I bawled the songs during rehearsals, as Billy Fury had a bad ticker.'[7]

Fury's band included Jack Bruce, Keith Moon on drums and Ronnie Wood on guitar. Keith had been offered a part in the film and Vivian went down to join in the filming on the Isle of Wight, though he later admitted he had no idea how long for: 'Don't remember,' he told an interviewer, 'we were having such a bloody good time.'[8]

The soundtrack album featured a host of golden oldies, including 'Ally Oop', once performed by the Bonzos and on the album given a straighter reading by Dante and the Evergreen. Of the original songs, Vivian had a writing credit for 'What in the World (Shoop)', performed by Stormy Tempest, the band whose story was told in the film. This was little more than a piece of generic rock'n'roll mood music. Far stronger was Vivian's 'Real Leather Jacket', which perfectly captured the rebellious teen spirit of the 1950s. Vivian was drawing on his days as a teddy boy back in Southend and the result was a track with some top playing from the likes of Keith Moon, Graham Bond, Ron Wood and Jack Bruce adding to the atmosphere of the story of rebel Jimmy: 'He bought twelve-inch-bottom jeans with metal studs shining down the seams (he liked to show off just like any growing kid)/And on his leather belt he spelt "DON'T",' sings Stanshall, and the female backing singers answer, 'And no one did.'[9]

He also began a series of fruitful collaborations with superstar Steve Winwood. The Bonzos had shared dressing rooms on occasion with Traffic and Steve himself remembered running into Vivian at a festival in the very early 1970s, somewhere in the Midlands. 'We were both on the same bill and knocked around together a bit,' said Winwood.

'I went up to the Edinburgh Festival with him where he was doing something on the Fringe, some sort of ferret-down-the-trousers act, definitely post-Bonzo.'[10] Travelling back from the festival, the two broke their journey to visit a Highland fair, where Vivian was approached by someone claiming to have met him before. Vivian explained that it was his first visit to the area and the chap must be mistaken. 'Oh, I'm sorry,' said the man at last. 'It must have been a goat.'

Winwood and Stanshall stayed friends after the Scottish trip and embarked on a fruitful songwriting partnership. When they got together to write music it was, Vivian explained, a very different working relationship from the one he had had with Neil Innes, in which 'we bickered when writing together, or else I attended to the words and he provided the music, or vice-versa. With Steve, it was much closer because of our agreement spiritually – although we have hardly anything in common, we go out for walks and agree philosophically. We have a damn good sort-out with each other before we approach whatever the damn thing means.'[11] Vivian contributed 'Dream Gerrard' on *When the Eagle Flies*, the 1974 album by Winwood's band Traffic. At the time they wrote it, said Vivian, he was 'suffering a severe bout of depression' while at Steve's house. The others went out to have dinner one night, Vivian sat down and 'wrote not more than a quatrain about Gérard de Nerval'. When Winwood came back, he said, 'Right, that's a chorus. We need a verse for that.' He went off into his front room and started 'plonking away on the piano'.

The nineteenth-century French poet Gérard de Nerval has been cited as an influence on the surrealist movement and, given Vivian's grounding in Dada and surrealism, it was perhaps unsurprising that the tragic story of this writer was of interest to him. Nerval grew up in the French countryside and, like Vivian, cherished the memory of his upbringing as something of an idyll. He travelled extensively in the Far East, writing much on mythology and religion. At the height of his creativity, Nerval was afflicted by terrible mental illness and was put in institutions on numerous occasions. Legend has it that he once took a lobster for a walk on the end of a ribbon, leading it through

the Palais-Royal. The reason for this, he later explained, was that lobsters do not bark and they know the secrets of the sea. He was committed to an asylum at Montmartre. It inspired Vivian's lyric in 'Dream Gerrard': 'And it's a fact, you are cold, they react, dream Gerrard/Hippos don't wear hats, lobsters shriek if provoked/On long blue ribbons'.[12]

Nerval's poems were heavily symbolic and intricately patterned. One of his best-known works, 'Aurélia', deals with the obsessions and hallucinations he suffered. In 1855, the year after its completion, he hanged himself at the age of forty-seven, and was buried in the famous Parisian cemetery, Père Lachaise. Nerval was also one of the first, pre-Proust, to assert that a brief snippet of music can transport the listener to a forgotten time and, like Vivian's later autobiographical work, much of his poetry evoked the beauty and perfection of his formative years. The inspiration from the poet stayed with Vivian throughout his life. In 1989, he conducted a promotional interview with a young singer named John Wesley Harding. 'Nerval had a friend, Monsieur Eddie, who wore glasses so that he could better see his dreams while sleeping,' said Vivian, a novel way of prefacing a question about Harding's own dreams.[13]

As well as working with Winwood, Stanshall's many collaborations included an appearance on *Captain Lockheed and the Starfighters*, the 1974 debut solo album by Robert Calvert, one-time Hawkwind frontman. They met one another through the main man from the Crazy World of Arthur Brown. Having worked with the Bonzos on *Brain Opera*, Arthur already knew Vivian.

He recalled: 'I must preface the incident by saying that Vivian was one of the most fearlessly rude persons I have ever met. He could insult anyone deliciously, and seemed to take delight in it. Robert was no slouch in this area either. So I thought, being both artists of a like temperament, they might understand each other. I determined to introduce them.'[14] Arthur trotted around to the Stanshall house in East Finchley, taking Robert past the sign marked 'Chez Gevêra'. Robert went upstairs while Monica relayed the latest entertaining news about Vivian's turtles to Arthur. He barely had time to get comfortable. After a minute's quiet, there was a banging, shouting and

general kerfuffle from the floor above, and an object was thrown with some force through the upper window, and on to the lawn. It was soon followed by Robert, though he took the stairs at speed, closely pursued by an apparently enraged Vivian. As Robert pelted through the garden and out on to the street, Vivian was heard to bellow, 'And don't you ever come back again!' The way was paved for Vivian to appear in the sketches between the songs on *Captain Lockheed and the Starfighters*.

A concept album, *Captain Lockheed* concerns Germany's disastrous attempts to upgrade their post-war air force with Lockheed Starfighters. It featured most of Hawkwind, Jim Capaldi, and Arthur Brown adding his manic vocals to a couple of tracks. The result was gloriously unhinged 'aerospaceage' rock. *Captain Lockheed*'s concept allowed Vivian to bring out his most outrageous Germanic impersonations, as a state minister, a pilot, and a technician, at various points throughout the very loose story. It was right back to the time spent marching around Soho with Keith Moon, as with obvious delight, Vivian gives full voice to the role of the German Air Defence Minister: 'There must be a dramatic renaissance of the Luftwaffe,' he barks. 'The long-awaited reawakening of German air supremacy . . .'[15] He is also the enthusiastic recruit who wears mascara to remind him of his mother who crashed while attempting to fly a glider across the Atlantic: 'Spun down into the sea and was never seen again. They found only her false eyelashes, floating.'[16] There is a melancholic undertone to a later exchange in which a pilot goes over the cockpit checklist with Mission Control. There are five milligrammes of Largactil, ten milligrammes of Valium, plus 'the little white ones'. Then there is the final message by both pilot and Ground Control together: 'Our father . . . which art in heaven, hallowed be . . . *mea culpa, mea culpa, mea maxima culpa*.'[17] It was a quite deranged album.

Vivian got back to his novelty-jazz roots in 1974, playing with an initially hesitant Roger Wilkes. His old trumpet-playing pal decided to drop in on Vivian when he was on his way to visit another friend in north London, in nearby Crouch End. Having heard all sorts of stories about Vivian's breakdown, he wondered if he would be well

received, all those years after leaving the Bonzos. Reaching Vivian's house, he made his way up the garden path and paused outside the front door to eye a huge dustbin full of beer bottles. Taking a deep breath, he knocked, expecting to be told to clear off. Instead, Vivian practically pulled him into the house, affectionately addressing him by his old nickname, 'Wally! Let's play some music.' The lounge in Vivian's place was littered with instruments. Stanshall picked up a trumpet and thrust it into Roger's hands. 'Let's play "The Sun Has Got His Hat On",' he enthused.

'He got on the tuba and we started playing and it was wonderful,' says Roger. 'He was obviously lonely and had gone through a terrible stage and it was nice that he remembered my playing and the fact that I had taught him the trumpet.' Roger confessed that he had stopped playing and Vivian encouraged him to take it up again. The two musicians relaxed and enjoyed the jam session so much that it became a regular Thursday-night session for years. Sometimes Roger would bring a pianist and singer with him; invariably Vivian would bring only his dressing gown and sometimes not even that. Music tapped a deep and instant response with Stanshall, who would break into an impromptu jig like an excited kid. When he and Roger found neither had any money for liquid refreshments during one session, Vivian was unfazed. 'We'll have to play for it tonight,' he told Roger, grabbing a tuba and heading for the street, still sporting his dressing gown. The pair headed for the High Street, Vivian oom-pahing on the tuba and Roger accompanying him on the trumpet. The pub was packed with people, a number of whom Roger could see clearly knew Vivian. In the crowded room, the two broke into 'Goodbye Dolly Grey', at which point the barman grinned hugely. 'What are you going to have, Viv?' he asked. Neither of them paid for a drink all night.

Alongside jazz, Vivian was willing to try any kind of music. 'I don't know that I could pigeonhole [it],' he said. 'I like everything. Noël Coward I can listen to all day long.'[18] His passion for African music in particular stretched into all aspects of the culture – from his earliest days collecting books on Africa and attempting to learn Swahili to working with his African musician friends. It was these influences that pervaded his debut solo album, *Men Opening Umbrellas Ahead*,

finally completed in April 1974, and released that August, by which time he had been working on it for two years. He had been searching for inspiration even while doing his summer stint on the Isle of Wight.

'I used to take a boat out from the pier with my umbrella, tape recorder and ukulele. I was warned not to pass Dunnose Point, but then drifted past it and had to make a dash for the shore. I landed on this deserted cove where I encountered a stereotypical man with a handkerchief on his head eating a cheese sandwich. The Great British holidaymaker.'

'Excuse me, old bean,' Vivian asked, 'is the tide going in or out?' He got nothing back but 'blank looks and a grunt full of cheese sandwich'. Vivian persisted with, 'Well, let me put it another way. Has the tide got closer to you or farther away as you have sat here?' The response was 'yet more blank looks and undecipherable mumbles...'[19] The title came from a game played during the endless hours in the back of the Bonzo van. The process had been, he said, 'like the game of what was the largest word you could make out of the numbers of the registration plate of the car in front, those games that you play to take your mind off things. And so we did the thing with road-signs and I had "tuning forks ahead" and "beware giant worms" – without the pictures they're not very funny. I don't suppose they were very funny then, but you'd giggle like a schoolboy masturbating when you're in those situations.'[20]

The album was preceded by a single also heavily tinged with African ambience. 'Lakonga', backed by 'Baba Tunde', was released in July. Both were loose, freeform workouts, rather meandering in character. Perhaps this was not unconnected with how 'Baba Tunde' was recorded, according to Vivian. Keyboards were to be by Steve Winwood, but when he turned up, Vivian told him that the bass player had not arrived. 'Well, the taxi driver plays bass,' offered Steve. Vivian was intrigued.

'So this enormous West Indian walked in,' recalled Vivian, 'and I said, "Well, it's in D flat minor," and he said, "Mmm, me friend play kit." So the taxi driver's friend played kit. They just went straight in, no pissing about and it was amazing, absolutely great.'[21]

The album cover sported a bold design based on a black-and-white drawing by Vivian's artist friend Peter Till. A stark, red triangle gave the impression of a warning road sign, with the silhouette of a workman, who might be expected to be operating a shovel but was indeed opening an umbrella. Behind him kangaroos leapt over a maze beneath two lines of telegraph poles. The rear photograph by Barrie Wentzell showed Vivian's shaven head adorned by felt shapes depicting a map of the world with a model sailing ship approaching the equator. Vivian peered enigmatically from behind his octagonal-framed glasses, a hint of a smile playing around lips topped by a neatly trimmed moustache, one earring piercing his earlobe. It was a striking, witty presentation and augured well. Over ten tracks, Vivian sang and played the recorder, his beloved euphonium and ukulele. He was joined by Bubbles on guitar, Steve Winwood on bass guitar and organ, Gaspar Lawal on talking drums and congas and Neil Innes on piano and slide guitar. Jim Capaldi from Winwood's Traffic played drums and other percussionists included Rebop Kwaku Baah on congas and Deryk Quinn on kebasa. Vivian was signed to Warner Bros for recording and they also handled the publishing. Working there was Rob Dickins, who first encountered Vivian at Loughborough University for the last ever Bonzos gig. Rob and Vivian got on very well together.

'You always had to work in the relationship,' says Rob, 'but it was always worthwhile. He didn't relate to any of the other people in the record company at the time.' Vivian was enjoying the freedom of recording without the Bonzos. All the pent-up emotion from the time of the split and the years after spilled out. *Men Opening Umbrellas Ahead* was, he said, 'all about frustration. I was really pretty sick at the time I made it. It's one long squawk. It's a fairly articulate squawk – it's pretty painful in parts. It's very personal to me. I think it was all I was capable of at the time. Not only was I drunk and full of Christ knows how many tranquillizers, but I was absolutely furious. It seems to me now that at that point I was inevitably plunging into the abyss and there was no way out. I didn't think it was wholly my fault, in that state you magnify anything that prickles, and so it was probably a vitriolic attack on my own lethargy, but certainly I didn't bother to sugar any of that.'[22]

The album showed sparks of his humour and a clear intention to try to do something different, but from the first track, it was hard work for the listener. 'Afoju Ti Ole Riran (Dead Eyes)' develops into a diatribe against the music business. There are hints of the direction Vivian would take with the later *Teddy Boys Don't Knit* in 'Truck-Track'. It is a roadie song, probably inspired by 'Borneo' Fred Munt, although the lyrics are credited to Stanshall. His voice sounds strained on this quirky vignette about life on the road.

There is much more to be found in 'Yelp, Bellow, Rasp et Cetera', a very English blues. Vivian begins like someone who has released his inhibitions, but only because he has been told he can. He yelps experimentally and then mutters, 'That's – sorry, *dat's* de way a blues just got started.' And then he stumbles through the lexicon of the blues, giving us the vocabulary: it is 'always baby' and certainly never 'greengrocer' or even his newsagent who 'specially requested a mention if I could fit it in, no way, tough luck'. And there are, surely, very few other blues with punctuation. Just as you think he is going to give that old blues cry of 'baby', he wheezes 'b-b-b-boo-b-brackets', by way of introduction to a fast-paced aside that is like some mad office dictation. 'And put this in italics, "I'm fourteen and I can truly relate to you, man, comma, thanks awfully, full stop," where was I, close brackets, b-b-b.'[23] As the song approaches the fadeout, Vivian rails: 'Don't fade me out you . . .' he shouts, pausing ominously, '. . . beasts. Don't fade me out. I intended to mention disappearing tigers and commitment.' Adlibbing in low, dark tones, he continues the stream of consciousness, 'Commit me, Mother! They're trying to commit me . . . Commit him to the garden maudlin.'[24] It was both a clever satire of the blues and a powerfully dark shout from Vivian. Side one closes with the dark and cynical 'Redeye', a jaundiced view of various social stereotypes. Apart from 'old Red Eye' himself (widely interpreted to be Charisma boss Tony Stratton Smith), there was 'old Hawkeye' and 'young Crafty-Arty', a poke at the treadmill of fame and pop stars.

Less intense is 'How the Zebra Got His Spots', a kind of rock-steady calypso. It is a celebration: 'He loves to feel the freeness, the let-it-be-ness, fresh air circlin' round he, Talkin' 'bout a certain penis'.[25]

161

The lilting vocals and Caribbean beat offset the sentiments to make it a pleasantly cheeky ingrate of a song and a highlight of the album. It is a welcome lightening of the atmosphere on the album, standing out most rigidly. In a logical way, Vivian follows this up with the post-coital number, 'Dwarf Succulents'. The band noodle an easy-listening track in the background, for once sounding appropriate rather than intrusive, while a dreamy female chorus asks Vivian how it was for him. We hear him light a fag. 'I feel drained,' he breathes. 'Empty?' they ask. 'No, settling, filtering,' he responds, and they free-associate back and forth about this most indefinable of feelings, as Stanshall gets ever more poetic and grand in his imagery. And finally he asks how it was for them. 'Oh,' they chorus uninterestedly and deflatingly. 'So-so.'[26]

Aspects of sex permeate the album, not in itself a novelty in rock and pop music, but Vivian is more direct about the whole business and has more of a sense of humour than most. There is none of the macho posturing of a rocker here, no 'squeeze my lemon' euphemisms. According to Ki, his second wife, sensuality was the foundation, the guiding force behind every bit of Stanshall's work. 'He never drew, painted, talked or sang about anything but sex. Vivian was absolutely the most erotic, most sensual being I have ever met. Sexually obsessed people are revolting but he raised sex to the level of an artform. It was Tantric. He took that sexual energy that was in his body, and that was the source of all his creative energy. It was never mental. When you hear people describe Vivian's intellect and intelligence, forget it. Thoughts? It was just pure energy. Pure instinct. Pure genius. It wasn't a conscious thing – it was all body. He was just a living, breathing Pan.' Among Vivian's other planned projects – the many that littered his desk in a pile of paperwork, or filed in long envelopes – in the early 1970s was a play entitled *Prong*. 'Loosely based on erections', as Vivian described it. On *Men Opening Umbrellas,* sex is everywhere and when the sex is over, it is back to booze for 'Bout of Sobriety'.

He closes with 'Strange Tongues', which expresses the sadness of his condition. 'Strange tongues comfort me, darkened rooms calm me down,' he tells us. There is a possible reference to the true horror

he must have felt with his anxiety attacks, in this affecting and melancholic song: 'Fear follows in the wake of sleepless days, foul yellow fright/As thick as mayonnaise.'[27] It sounds like a frail and confused Stanshall lost in a wilderness. The album as a whole could have been a programme of poetry set to music, were it not for the ramshackle production and aimless playing. It should all have been rerecorded on a day when he felt better and stronger and when the band had a clearer idea of his intentions. Perhaps then it would not have been true to the spirit and the message. For better or worse, this was Vivian, vulgar, abusive, amusing, artistic and arbitrary. *Men Opening Umbrellas Ahead* comes over as a sometimes chilling documentary. Its entirely personal nature means that the voice of an anguished man, stripped of his pretensions, occasionally slips through. It is the unscripted asides that reveal most about the man alone in front of the microphone, desperately trying to communicate.

'I find it uncomfortable to listen to,' he said, adding wryly, 'I don't think that you'd pull anybody with that in the background.'[28] The album was not much promoted by Warners and was never chart material. But in the aftermath of *Men Opening Umbrellas Ahead*, Vivian was beginning a new and even more extraordinary phase in his life. He was to find new expression for his talents in developing *Sir Henry at Rawlinson End*.

10
I Don't Know What I Want
– but I Want It Now
1975–76

Broadcasting House was the natural habitat for Vivian – he always called it 'Brainwashing House'. His best-known work there was created with the help and encouragement of Radio 1 producer John Walters. On the John Peel show, Vivian brought *Sir Henry at Rawlinson End* to coughing, wheezing life. Developed from the original sketch on the Bonzos' final album, *Sir Henry* was Vivian at his best. He had achieved a perfect balance between narrative and wordplay. Funny, elegiac and interspersed with some of his most affecting songs, the tales of the squire went on to have a life on album and on the silver screen.

Vivian could work on short segments and there was not the weight of a big deadline. He could develop the story at his own pace, dropping in a quick summary of the story so far. It was a workable arrangement. Vivian was often to revisit Sir Henry, sometimes turning up to friends' places with a satchel full of notes. He scribbled lyrics in a manic, spidery hand and they were in no kind of order. Then, either on his own or with a colleague, he would spend half an hour throwing papers around until he found the bit he wanted. It used to drive John Walters mad, convincing him that nothing would ever be finished.

The first broadcast, in October 1975, was a hit with listeners. On numbers with such evocative titles as 'The Unbridled Suite' Vivian played guitar, euphonium and talking drum, and was accompanied

by gargantuan chum Bubbles White and by Pete Moss, arranger and friend. At six feet seven inches tall, Moss was an imposing character with a blunt London voice and, like Walters, one of the few people who could boss Vivian around. He was also a classically trained musician, who had played in a number of bands. He was recommended to Vivian by the brother of Dennis Cowan, the former Bonzo bassist, who died in 1974. Pete's qualifications impressed Stanshall: 'He's an MD [musical director] and he can play every blinking thing,' he said. 'Keyboards, bass and lead, rhythm, and what have you, plus violin and he can sing harmony.' What was more, he was far more fluent than Vivian at reading music, or as Vivian put it: 'Of course, he knows all the dots.'[1] Moss's home was just down the road from East End Road, in Hampstead Garden Suburb's Ossulton Way. Close to both roads is, coincidentally, Vivian Way, which leads to the National Hospital for Nervous Disorders.

Pete Moss was frequently phoned to join in Stanshall pranks. 'Come and protect a journalist from me,' Vivian would call him to say. On arrival, Moss would find Vivian having a perfectly civilized cup of tea with some green journalist kid who doubtless thought he was doing Mr Stanshall a favour by giving him some publicity and charitably boosting his pop star career. The part Pete played was to sit quietly until the journalist annoyed Stanshall, who would suddenly explode: 'What!' he would yell. 'How *dare* you.' Invariably, Stanshall strode out of the room while Pete made calming noises and assured the young journalist that the artist would return. Vivian, meanwhile, was raiding the freezer in which he stored food for his piranha fish – dead mice ordered from London Zoo: 'I think you've got a damn cheek!' Vivian would say on his return, casually dangling a dead mouse. He'd dunk it into the tank from which would come an ominous bubbling noise. 'More than one journalist rushed white-faced out of his house,' remembers Pete. He knew more or less what to expect from Vivian when they were in the studio and was to build up a reputation for unflappability. He was there for 'Christmas at Rawlinson End Parts 1–4', broadcast between 22 and 26 December 1975. Vivian sang 'Aunt Florrie Recalls', 'Uncle Otto' and 'Roar of the End', with musicians Julian Smedley and Andy Roberts. Six

further *Rawlinson End* segments were taped for John Peel's shows and broadcast between 1977 and 1979. He returned to Sir Henry on the radio in 1988, with stories including 'The Crackpot at the End of the Rainbow' and again in 1991, supported by Dave Swarbrick, Andy Roberts, Danny Thompson, Rodney Slater, John Megginson and Roger Ruskin Spear. Typically, the stories would be loose and often gags and songs reappeared in different forms, as Vivian honed them. Some of the songs would appear on his second solo album, 1981's *Teddy Boys Don't Knit*.

Producer Malcolm Brown was delegated to work specifically on the *Sir Henry* slots. Like Vivian, Malcolm enjoyed a drink and the two got on famously. He also went on to produce Vivian on record. The first reaction to *Sir Henry* was encouragingly positive: 'It went tremendously well, certainly in the initial stages,' remembers Walters. 'People would write and phone in, even people who clearly didn't quite know what they were listening to. They weren't Peel fans. They were housewives and school kids who said: "I switched on and there's this great story going on. Is it on a record? Can I buy it? What is it?"'

Since the 'Rawlinson End' of *Let's Make Up and be Friendly*, the concept had developed almost beyond recognition. The inspiration for the stories came from waiting rooms. 'Reading *Women's Own* in the dentist's,' explained Vivian. 'Reading "the story so far". "Horace has just discovered on the back of his neck . . ." and "Why did Aubrey leave the room . . ." and such-and-such. "Now read on . . ." Which is very exciting and provocative and almost aggressive. I liked that, so that's what I did. I used to write all those parts – part 93 and part 22, so none of it fitted.'[2] Later and, Vivian worried, 'maybe to its detriment', it got some thread as Stanshall got a clearer idea of who the residents really were.

Most of the Peel Show *Rawlinson End*s took place in and around the old family retreat of Rawlinson End, a sprawling, decaying example of rural England. The characters became more defined and one could spot regulars – Sir Henry, his wife Florrie, his brother Hubert ('in his mid-forties and still unusual'), Old Scrotum (the wrinkled retainer) and Mrs E., the housekeeper at Rawlinson.

In a typical episode, 'The Road to Unreason Part 37', from 1977, young troublemaker Gerald rebels by wearing safety pins through his eyelids, 'because he didn't trust no one and wanted to be wide-boy-awake just in case it came to something'. The star of the episode was absent-minded, unusual Hubert Rawlinson: 'During the summer months, he kept his windows covered with several sheets of blotting paper, because he believed it trapped and absorbed the energy of the sun. And each night, with proper thanks to Ra, he would take it down and squeeze "a little bit of cosy" into the room before retiring: "Hail to thee, Ra, and hah-rah-boom-de-ay".'[3] The plot was an incidental device. What was important were the puns, the absurdist take on life in England. Within the world of Rawlinson, everyday routine was given a surreal twist and it was Vivian's narrative skill which ensured it took on its own logic within the stories. He made sense of the horror and terror of ordinary existence through his eccentric characters. 'The Road to Unreason' also contained one of Vivian's most telling songs, 'Mrs Radcliffe'. In this, Sir Henry sings of his love for a Mrs Radcliffe, warning 'I tried and tried/to stop the beasht inside of me . . . /I knew when I've had a few/The Mr Hyde in me, two gins will set him free/That's how it will be, forever'.[4] A song which originated from the Bonzo days, as 'The Beasht Inshide', it was horribly prescient of the pattern of Vivian's own personal life over the years, demonstrating a searing sense of self-awareness.

The *Rawlinson End* tales followed the characters' meandering activities, in the fading glory of the country house and the nearby village, under the baleful gaze of the local town, Concreton, which seems to be waiting for the right moment to swallow it all up. The setting of *Sir Henry* was just as important to its success. It seems to be some time post-war, although the date is never made explicit. England's finest hour still hangs in the air – Sir Henry is proud of his 'small but daunting prisoner-of-war camp' on the grounds. We feel we are very much in the twilight of the British Empire. But this is not simply a nostalgic feeling for the good old days. Florrie, Sir Henry and the rest seem almost aware that they are fading away, that their England has the ability to be as unlovely as it can be appealingly pastoral: as racist, greedy and class-ridden as it is green, pleasant

and unhurried. Its time is almost up. They do not care. They positively revel in it. It is the glee with which the characters engage in their rather sordid take on the bucolic existence which infuses *Sir Henry* with such life.

'Don't think you need to invent that,' mused Vivian. 'It's not a very comfortable world. It's proscenium theatre, it's Francis Bacon sticking a frame around it.'[5] Sir Henry is a rogue, a Falstaffian rascal who belches and farts ('when Sir Henry broke a fast, you cursed double-glazing') his way around the house.[6] Vivian's narration wraps up the listener, warming and enveloping like a mug of mulled wine by a fire on a winter's day. John Walters felt that Vivian was making too much of 'this artist inside, a poet who ought to be better recognized than the funny man. Whereas the funny man was one of the great funny men of our time. He wasn't one of the great poets or artists of our time. I don't think he was. There was an underlying sadness but again – he always had to be right. He would never say, "Well, that was a load of crap, I'm terribly sorry." Or, "I was slightly drunk and you can't quite hear my voice." No, no, it was the doctor's fault for giving him Valium. It was always, "I'm okay, it's everybody else who won't let me do it."' Exasperated, John would urge Stanshall, 'Viv, don't bother with the purple passages, there's too much of it. Get to the funny bits. Drop the pseudo-poetry, lose all that. Get to what you do, your unique selling point. You're so good at spotting things and thinking of things.'

Monica Stanshall knew how important the right word was to Vivian. 'It had to be perfect,' she says. 'He would change a word, again and again. He would search for this one word.' In comparison with the early version on the Bonzos' final album, the dialogue crackles, from the moment Sir Henry is awoken by his housekeeper, Mrs E. She is summoned by his early-morning bellow. 'I don't know what I want, but I want it now!' he declares. Unfazed, she replies: 'Fried or fried, dear?'

The shows were aural portraits of the Rawlinson family, part-caricature, part-loving depiction, and aspects of Vivian himself were reflected in every member. His interests were so broad and so deep that inspiration came from almost everywhere for the stories. The

speech patterns of Mrs E. – energetic, sparky and heartfelt – were just like those of his mother, Eileen, but it was not all so close to home. He kept a scrapbook full of cuttings which he called the 'Book of Madness'. Sometimes they would provide ideas, and sometimes he would read them out on stage or to friends. 'Did you know that rats are incapable of being sick?' was one favourite, sounding much like something Reg Smeeton, the super-bore newsagent from *Sir Henry*, might say. Newspaper headlines were hoarded and read to visitors: 'A man accused of killing his hunting companion told a court in Lagos that he had shot him by mistake, thinking he was a gorilla,' Vivian read to one interviewer. Another was 'Hedgehog torturer fined' and the astonishing fact that: 'Many railwaymen habitually carry an India rubber with them to erase the offensive'. Adverts, too, like one for gardening equipment: 'the effortless stump remover'.[7] He also liked to take inspiration from people he came across travelling around. Unlike some of the more insular gags of the Bonzo years, one did not need to have lived with Vivian, or read the same books as he did, in order to enjoy the rambling, gentle absurdity of life at Rawlinson. If one so chose, there were many layers to *Sir Henry* which could be peeled away to reveal hidden jokes and double meanings at almost every turn.

There are, for example, the contract house cleaners – Teddy Tidy and Nigel Nice – a camp pair of resting artistes from the local village. Here are echoes of Julian and Sandy, the chorus boys played by Kenneth Williams and Hugh Paddick on the mid-1960s radio comedy show, 'Round the Horne'. These were based in turn on archetypes first used in *commedia dell' arte*, which had been an inspiration for Vivian in the Bonzo days. *Sir Henry* was full of this sense of tradition and the broad frame of reference made it so much more than a throwaway monologue. Vivian's almost fanatical obsession with language and its usage was intricately woven into the stories, what John Walters had called 'verbal timebombs' in 'Radio Flashes', strewn throughout the tales. One of the most subtle wordplays was in a song about Hubert Rawlinson, 'The Rub'. Detailing the comic peculiarities of this most unusual of Rawlinsons – one hobby is growing watercress in his eardrums – Vivian concludes with a jaunty

'Rub-me-up-the-wrong-way Hubert: there's the Rub'.[8] The listener has to be quick to spot 'the rub' is an anagram of 'Hubert'. Few other writers among Stanshall's peers would go to that trouble to make a gag. Or as Rupert puts it: 'He was a bastard when it came down to doing crosswords.' The real success of *Sir Henry at Rawlinson End* was that you did not have to get the linguistic gags, the quivering innuendo or the literary references to appreciate the languid music, sparkling dialogue and easy humour. Stephen Fry was a major fan, later writing, 'When I first heard the joke, "[Old] Scrotum, the wrinkled retainer", I laughed so much I honestly thought I might die of suffocation.

'Oh, very well, it isn't Alexander Pope or Oscar Wilde, but for me it was as delicious as anything could be delicious. With Stanshall it was as if a new world had exploded in my head, a world where delight in language for the sake of its own textures, beauties and sounds and where the absurd, the shocking and the deeply English jostled about in mad jamboree.'[9] Old Scrotum was based on a real-life person, another inspiration from the long hours travelling in the van with the Bonzos. Vernon Dudley Bohey-Nowell was older than the others and a target, as they all were in their own way, for a specific bit of ridicule. They made fun of the time he took to order his meal when they took a break and thought Vernon had a tendency to go on a bit when he was telling a joke. Vivian would turn round to mock, 'Oh, listen to old Scrotum! He's so slow and he always takes ten minutes to get to the punchline and you already know what's coming.' The Old Scrotum of *Sir Henry*, the butler, is much more of an archetype, the slow country servant, as revolting and sly as he is rustic and simple, an integral part of the patchwork of the decaying great house. This dark-tinged view of Englishness has echoes of Mervyn Peake's Gormenghast – indeed, Steve Winwood and Vivian also began an adaptation of Peake's classic for a proposed film.

The sessions for the Rawlinson shows were as ramshackle as might be expected. Often the band booked for the BBC studios would turn up to back Vivian with no idea of what they were supposed to be playing, even when their members were distinguished musicians such as Fairport Convention's Dave Swarbrick or John Kirkpatrick, one of

the world's foremost concertina players, who gave Bob Dylan lessons. That they were there at all was testament to Vivian's talent and considerable charm. 'I don't really know Vivian Stanshall,' confided Kirkpatrick to Pete Moss in a break. 'He just phoned me up.' They would gather in the studio with an increasingly nervous John Walters, waiting for some sort of plan for the session. The results were invariably worth the stress.

Vivian was 'able to say things which I simply thought: "I wish I'd said that",' says John. 'That's what put us very much apart. He would come out with something and you'd think, "Bloody hell, I'd never have thought of that."' It made John all the more concerned when Vivian was completely unable to get it together and he tried to shock him into realizing how much he was damaging himself. When he popped into the BBC office with the usual 'Hello, mate', one morning for one of the later Sir Henry shows, a tape of 'Radio Flashes' was on the top of a pile of recordings.

'Aha, dear boy,' exclaimed Vivian. 'I see you still have my tapes of all the old things. I bet you've been playing that.'

'No, frankly. I found it in the tape archive,' replied John. 'I thought, "I know that one day I'll get a call to say, "Have you heard? Viv Stanshall's died." I want to know where I can go to get my hands on it to pick out an amusing little sketch and to dash down to "Newsbeat" and introduce it, because I don't want to have to go through the archives. I'm planning ahead for your death.'

'Good God, mate!' replied Vivian, stepping back in amazement. Walters intended it to shock, but it was true. John was convinced it was only a matter of time. 'He was absolutely out of his crust a lot of the time. I thought, "If you don't think you might suddenly drop dead, you're the only bugger who doesn't assume that's a possibility."' But change was not going to come just like that and Vivian was, anyway, very aware of the situation in which he placed himself. His young family were also suffering. It was not that Vivian was unsuccessful after the Bonzos. Quite the reverse. He could not cope with the demands. When his son looks back on those years, he can see the relentless demands for his father to 'keep pumping it out', in Rupert's own words.

'He's got to keep pulling this stuff out of himself to keep comfortable. It is all to do with getting to know yourself and finding your own levels. He could never find that level of contentment – ever. He had lots of offers of work and all he would do was get panicky about it under pressure. He was trying to run a home on top of running his own business, which was based on his brain. If he spent six months on the bottle he still had the royalty income to fall back on, and that meant he could spend another six months on the bottle if he wanted. All of a sudden, when you haven't slept for a week, you've got to get yourself together again. The poor bugger could hardly cope. So he had to be out of his head constantly, just to cope with day-to-day stuff. It was physically draining too.' It had to get too much for Monica and that same year, 1975, the couple split up, leaving her to bring up Rupert alone. It was, she says, 'Self-preservation'. It had been a long time coming. In order for someone of Vivian's intelligence and sensitivity to keep up the boozing, he had to construct elaborate reasons and façades. It made for a secret world of 'lies, deception and self-deception . . .' says Monica. 'The cheating and sneaking away. It was terrible. I hope I never come across it again in my life. A drinker cannot really have a relationship of any sort, be it a friendship or a marriage, because the person becomes so dishonest.' She would confront him when he had patently just come back from the off licence and he might say he had been to get some bread. And the row would start. Monica would accuse Vivian of having been to buy alcohol, at which point, hurt, he would produce a bottle of mineral water.

'But what about the *other* bottle?' says Monica. 'You cannot deal with that. And then endlessly saying to people on the telephone, "I think I've got the 'flu," when they knew darn well he hasn't got the 'flu. It was exhausting and destructive. You can't be your own person unless you are prepared to let the other person sink. The theory is – let them go. But it's not easy when you find that person unconscious.'

Vivian got plenty of encouragement from some people to be outrageous and get ever drunker. Pete Moss remembers the atmosphere at a party during the recording of the 1978 album of *Sir Henry at Rawlinson End* at Steve Winwood's home studio.

'There were a lot of parties going on down there and the sad thing

is I always thought they were using Vivian as the court jester. I didn't want to be a part of all that because I genuinely loved him. It was a bit like the Oliver Reed syndrome. Stick him in the green room for half an hour with plenty of booze and you're guaranteed a good party. I felt they were using Vivian and was very sorry about that. Vivian liked to be the centre of attention, but he got it the wrong way round. I don't think he realized how much people were using him. He hero-worshipped anybody who could play better than him. So he'd get some weird people involved.'

The period leading up to the split was a terrifying one for eight-year-old Rupert, forced to witness unsettling scenes and lots of rows: 'I remember when I was a kid and we were still living at 221, he came round banging on the door demanding to see me and Monica wouldn't have it. That was pretty frightening. Bellowing and banging. I found that quite scary as a nipper.' Not only that, but as both his parents had come from families who did not divorce, Rupert's feelings were compounded by a sense that Vivian and Monica did not understand what he was going through.

'They didn't know what it was like to have split parents who fight and row and punch shit out of each other, who also happen to be eccentric and play mad music at odd times and paint stuff that's pretty weird and sit in toilets which are painted in such weird colours they make you hallucinate. I used to do that all the time in there. It was like astral projection. I would be sitting on the bog at 221 and the room would suddenly seem enormous. It was a nightmare and I was only a kid.' Rupert learned to be his own man. He knew his personal strength lay not in art or performance, but in selling. It was in its way as bold a step away from his father as Vivian had taken in his younger years and to make matters more difficult, he felt Monica did not like it either. Rupert's blow for early independence exacerbated an already tense atmosphere.

'She wouldn't recognize that when I was selling sweets and pens and things at school that obviously I was going to be a salesman,' says Rupert. 'I did every jumble sale and boot fair at the school and I would flog everything on the stall. I would have flogged the stall if I was allowed to.' In 1976 the Stanshalls were divorced and saw little

of each other for the remaining years of the decade. Vivian continued to see his son, though Rupert is clear he never wanted to see his parents reunited. At the time, says Rupert, 'he behaved so vilely, that frankly . . . No! I certainly didn't have any major desire for him to get back together again with my mother. He was abominable to her. He was abusive and always was incredibly selfish.' Vivian turned to his friends, phoning them, often late at night. He would engage them in long, rambling conversations.

He was just as capable of acts of quick generosity. Just after Rupert and Monica moved to a new place in Finchley, a cab turned up. Musicians use taxis more than most and as a non-driver, Vivian was particularly cab-dependent. To young Rupert's delight, he found his father had sent him 'a cat. In a cab. In a bag.' The cabbie simply knocked on the door and produced a bag from which was emanating some endearing mewing. 'He had sent it right across London,' says Rupert. 'Wow, thanks! She was a lovely little thing too.'

Vivian's professional duties were variable through the period. He was always being asked to add his golden voice to projects. In 1975, he narrated *Peter and the Wolf*, the Prokofiev classic for children, somewhat bewilderingly updated into a typical 1970s rock setting. Stanshall appears among a host of 1960s figures, including rock guitarists, synth players and Stéphane Grappelli on violin. As with his *Tubular Bells* role, he tells the story simply and without embellishment, around instrumentals based on the original tunes. The only recognizably Stanshall addition comes at the point where Peter's friend the Duck is eaten at the end of the first side. Vivian illustrates the awful event with one of his vintage belches, a most conclusive finale. *Peter and the Wolf* was an odd release, since the piece was originally conceived to introduce children to the joys of classical music rather than rock-guitar noodlings.

When Vivian himself came up with the idea of recording a version of 'Trail of the Lonesome Pine' late in 1975, it was far easier to imagine the song painted in the Stanshall palette than it was to listen to the updated *Peter and the Wolf*. Perfectly suited to his voice and expressive delivery, 'Trail' was another old novelty number for which Vivian had some affection. Returning to Warner Bros and working

with Rob Dickins again, he captured what his friend thought was a 'wonderful, wonderful' version. Pete Moss possessed a double bass and Vivian roped him in to play. The musicians went down to a boat moored on the Grand Union Canal in Maida Vale, owned by Tom Newman, who had produced the Bonzos' final album at the Manor and engineered Mike Oldfield's *Tubular Bells*. Vivian insisted on clambering up on top of the barge, where he would sit strumming his ukulele. These were not the best conditions under which to get a clean recording, particularly as the sight of Stanshall in full flow amused the punters at a nearby pub. They whistled appreciatively at him. Vivian never needed much encouragement to record the public in his work.

With prominent ukulele and Vivian on top form, it promised to be a strong single. Nobody knew the track apart from fans of Laurel and Hardy, since the duo had recorded it almost forty years earlier and had been dead for more than a decade. The chances of the Stan and Ollie version being released were surely slim, but the Bonzos had always been spectacularly unlucky in the music business and Vivian's misfortune eclipsed even their worst moments. Someone at United Artists did indeed have the bright idea of releasing Laurel and Hardy's classic rendition of the song, backed by the Avalon Boys. With Stanshall's session in the bag, he played the song on John Peel's show in October. As the details of the release were being finalized, the duo's version rocketed up the charts in November and December 1975. Vivian's recording was consigned to the Warner Bros vaults, never to be released. It was another black mark to add to the commercial failure of *Men Opening Umbrellas Ahead* and equally unfair – it was hardly his fault. Vivian's professional association with Warner Bros would not be renewed for almost twenty years.

The aborted single was backed with 'Terry Keeps His Clips On', which was not to be released until Vivian's 1981 album, *Teddy Boys Don't Knit*. A type of clasp called Terry's clips, as used by former Bonzo Roger Wilkes, supplied the original inspiration for the song. They formed part of a case Roger built for one of Vivian's precious instruments and when he said, 'I've used Terry's clips . . .' Vivian interrupted with a jaunty, 'Terry's got his clips on'.

At home, rattling around a house full of Bonzo props and weirdness on his own, Vivian thought up some more schemes to divert himself. He went up to town to play darts with the *Melody Maker* team, playing a side fielded by the Strawbs. He turned up dressed as a dart, wearing dart flights on his trousers, a spiked helmet and declaring he would play by lowering his head and running at the board. The Strawbs entirely failed to be amused by this, or by the state-of-the-art equipment Vivian had constructed to foil their efforts, such as shaped wire coat hangers which he claimed were sights to improve his aim.

He found a more appreciative audience when Procol Harum, best known for the hit 'A Whiter Shade of Pale', asked him to support them on their farewell tour of Britain in January and February 1976. He put a band together, called Vivarium, but billed as Vivaria. It featured Bubbles White on guitar, Dick Parry on tenor sax, and Pete Moss on bass and piano. It was not a rock band. 'No, I wouldn't say that: an illustrative band,' said Vivian. 'Played a few oldies.'[10] He also wrote a song with Harum's lyricist, Keith Reid, which took its inspiration from one of Vivian's many newspaper cuttings, this one concerning an unfortunate family named the Browns.

Vivian and Keith 'knocked up a song about the Browns that my gang and his gang could thrash through'.[11] Although Vivian rarely took a song directly from his Book of Madness cuttings, the tragic tale of the Browns had him guffawing out loud as he read it to Procol's writer. Vivian was sufficiently amused by the story to keep hold of the article and read it to visitors later in the year. With the drama that only a local paper can supply, the couple next door to the Browns are quoted: '"We'd been getting on quite well with the Browns. After our lavatory became completely blocked, I called the council. They were around in next to no time in their lorry. They went into No. 40, our house, and inserted their biggest pump into our convenience.

'"One of the council operatives switched it on. There was a tremendous rumble. Janet, my five-year-old, thought it was thunder. The rumble was followed by a tremendous whoosh. I nipped upstairs and flushed the convenience. It was working perfectly. No sooner had the operatives vanished when I saw June Brown from No. 42 coming up

the garden path. She was hysterical. Apparently, when the pump began to work, instead of sucking, it blew, and the whole of Mrs Brown's bedroom suite was covered with effluvia."' Vivian thought the choice of 'effluvia' to describe the devastating substance was particularly amusing. The paper goes on to record the reaction of the Browns themselves: "'The council are to blame," said Bob Brown. "We are camping out at June's parents. Our house is ruined. It's everywhere. The ceilings are in danger of collapsing, the lavatory pan has blown into the spare bedroom and the TV is all clogged up."'[12] The result of this was a number performed live – 'The Browns'. An apt title indeed. Vivian also performed other tracks and an accompanying set with his own band.

The tour followed the pattern Vivian set when he played with Grimms. He hit a peak around the second or third show and by the time they played their last night in Oxford, the anxiety of performing, compounded by drink and Valium and made worse by the emotional fallout of his split with Monica, overcame him. Disaster struck at a gig in Birmingham on 28 February. His band were doing the old stuck-record routine which had been such a winner in the Bonzos. While they mimed, he was supposed to leap off the stage and kick it, and the band would jump forward into the song again. That night, he'd been wandering around the stage in a long nightshirt and sandals.

'I jumped off the stage for a gag,' he said, 'and they had carpets.' Vivian slipped on the carpet, tore a ligament and dislocated his left leg. To make matters worse, he earlier 'told the bloke on the spot [light], whatever I do – because I like jumping off and running into the audience – whatever you do, follow me. So I put my arms around the bloke in the front row and went, "Ohhhhh, ohhh, ohhh!" Poor man. With the spot beaming down . . .'[13]

'The audience thought it was wonderful,' recalls Pete Moss. 'Then I realized he really had hurt himself. We stopped playing.' Vivian's saxophonist Dick Parry called out, 'Is there a doctor in the house?' Once more, the audience cheered at the crazy humour of this Bonzo man. 'We got him back up on stage and finished the night,' explains Pete, 'but he was in a terrible state.' He told Vivian to check himself

into the Royal Free Hospital when he was still in pain the next morning. Two days went by and Pete did not hear from him. Eventually there was the usual, chatty telephone call. 'Hi, amigo,' breezed Vivian. 'I've sorted this whole thing out. I've had acupuncture.' How exactly this was supposed to help a severely damaged shin was unclear. Pete was exasperated. 'No, you've got to go to a hospital,' he insisted. 'This is the last night of the tour. Everybody is coming to see you.' But that only put more pressure on Vivian.

'I'm coming down to see you,' he told Pete. 'There's only one problem. I can't walk.' Pete told him to improvise – get a broom for a crutch or something.

'That's a good idea, amigo. I'll see you later.' Grabbing an axe, Vivian beetled down to the bottom of his garden and chopped down a tree – there was the instant crutch, albeit not quite what Pete had in mind. With a football boot and sock on one end, he hobbled off in the general direction of Pete's place in Ossulton Way. But he got the house wrong. The door he knocked on was opened by a sixty-year-old Jewish lady who was somewhat alarmed to be greeted by a wild-eyed giant reeking of rum, wearing octagonal glasses, a knotted red beard and a nightshirt covered in moons and stars.

The figure, leaning on a big crutch made out of a tree with a football boot on the end, roared, '*Where's Pete?*' His bellow induced a scream of terror, at which point Vivian collapsed on top of the unfortunate woman. Somehow he managed to get up and stagger off, while she was left in a heap. Across Ossulton Way was the house of Dean Ford, lead singer with the Marmalade. He saw the whole thing and was doubled up, crying with laughter. When Vivian eventually turned up, Pete promptly confiscated the bottle his friend was clutching and refused to accede to his demands for its return on their arrival at the gig. 'I knew he was going to blow it.' At the venue, Vivian simply paid someone else £10 to get him a bottle of whisky. With time to explore the venue, Vivian discovered there was a trapdoor in the stage. Immediately, he decided he wanted to come up through the hatch rather than come in from one of the wings. He promptly stumped up another bribe for someone to let him try it. When show time came, the band could not find him and eventually started 'The Intro and

the Outro' without their star. This went on for some minutes and Moss began desperately shouting at the roadies: 'Where is he?'

'He's coming, he's coming.' He was. A hole in the floor appeared beside Pete, as the trapdoor swung open and up shot Vivian Stanshall on to the stage, complete with improvised tree-crutch. And facing the wrong way. 'Where am I?' he boomed. 'Turn round, Vivian,' hissed Pete. The singer tripped over his crutch with the football boot and crashed into Procol Harum's drums, completely demolishing the entire kit, half of which fell into the orchestra pit. 'He never really got anything right that night,' adds Pete, 'and it was the last tour we ever did.'

The musicians drove back in a coach down the M1. They stopped off at a Blue Boar service station and went into the restaurant. As if they had been waiting just for them on cue, a gang of Hells Angels were lounging around. Five musicians went in, including Keith Reid. The gang only had to look at Vivian to find all the excuse they needed to start trouble. And Vivian, ever keen to play the macho man, never even needed an excuse. He leapt on to a table. 'Come on,' he yelled, 'I'll take on the lot of you!' Even the band's driver, no pint-sized wimp, was shouting, 'Get down from there!' They all bolted for the coach, with the Angels in hot pursuit and Vivian shouting to his friend, 'Come on Pete – you and me!'

Weeks later, still 'in plaster ankle to bum', Vivian had pre-booked gigs to fulfil. He determined not to let the promoters down and sat on a drum stool to perform. Somewhat to his surprise, he found he preferred the low-key approach, realizing that when he had been out there giving it his all, 'I was hearing it but it wasn't there and nobody else was. And so I just haven't got a massive band and overdubs. I'm not going to bother with that any more, it's embarrassing.'[14] He was now happy to admit that he did not need or want to charge about like a student still in the Bonzos. 'No, it just wasn't there. Pathetic. I just didn't have the armoury to make that row.'[15] His new approach to performing could still be very variable, even when he had the chance to upstage Bob Kerr, the man he had fallen out with over the New Vaudeville Band.

The Bob Kerr Whoopee Band had a regular gig at the Golden

Lion pub in Fulham Palace Road. Sean the publican told Bob and fellow-Whoopee player Vernon Bohay-Nowell he had found a top-class replacement for them during their August holiday. He joked, 'I can get people who are better than you lot. I'm going to get hold of that fella you used to play with. Much better all together. Mr Stanshall.' The Whoopees had not yet gone on holiday the week that Vivian was due to make his first appearance and the two main men headed to the pub to see how he did. The place was packed and they squeezed in at the bar at the back. But there was no music and nothing seemed to be going on. There were other musicians there to back Vivian but he was upstairs, unable to perform. Eventually one of Vivian's girl-friends came down to speak to Sean, who was genuinely upset.

'This is no good at all. I'm giving everyone their money back and he can go. There'll be no show tonight.' The woman looked shocked. 'Oh, no!' she pleaded. 'Viv will be down in a minute.' It was too late. 'I'm not paying the bugger. He can go,' said Sean angrily.

Says Vernon: 'After Sean had given half the people's money back, nearly everyone had gone apart from Viv's most fanatical supporters. Then suddenly Vivian appeared. He got on the stage and he just abused the audience. He actually took his trousers down and waved his willy at ladies in the crowd and behaved in a really appalling way. Half the remaining audience got up and left. Only the hard core remained and they were enjoying this spectacle no end. They were delighting in his behaviour and shouting out, "Ooh, yer can't take it!" to the people who were leaving.' The two ex-Bonzos, still at the back of the room, shrank away for fear of being recognized.

'I didn't want to speak to him because I didn't want Viv to realize he had been observed by us,' explains Vernon. 'We had been doing well at the pub and that would only have rubbed salt in the wound. He was already in a terrible state, so Bob and I sloped off. Vivian had been booked for the whole month, but when we started playing back at the pub again after the holiday we heard from Sean that Viv didn't come back to do the other four weeks.'

Later in 1976 Vivian made another concerted attempt at drying out in a clinic. When he came out, he spoke to Chris Welch, explaining that he had not been able to continue with much music

while he had been inside. 'I couldn't take a euphonium in there,' he said. 'I took a uke in and I took that little guitar.' But he continued with his brass practice as soon as he got out: 'I'm trying to get everything as horny as possible,' he told Chris, who asked him if he would play something for him. '"Stranger in Paris"?' asked Vivian with obvious delight. 'Pleasure!'[16] He proceeded to parp away, blowing the tune out with some difficulty and laughter. The act of playing – or, as Vivian called it, making 'row' – was something that was still a simple and straightforward delight for him.

Vivian was in top live form when he played the Traverse Theatre in Edinburgh for a week's engagement during the festival that same year. The Scaffold had regularly played at Edinburgh since 1970, the Traverse had been for some time a regular haunt of acts such as Monty Python and poet Roger McGough attended that year. Vivian's performance made an indelible impression on fellow-musician Bill Watkins. As backing guitarist to McGough, Bill found himself, like so many others over the years, somehow roped in by Vivian to provide musical links between spoken-word items, including Sir Henry stories. Vivian had put on a bit of weight since the Bonzo days and was relaxed in the company of his old friends.

'One Saturday afternoon,' recalls Bill, 'Viv appeared from the Traverse kitchen dressed only in a pair of purple underpants, clutching two of those plastic tomatoes that Wimpy hamburger shops kept their ketchup in.' The musicians fell about laughing as Vivian made his unexpected entrance from the wrong door. They had no idea how long he had been lurking in the kitchen, where Bill assumed the strip took place. Striding on to the stage, Stanshall launched into an extraordinary routine, an improvised muscle-man act. Using the plastic tomatoes to represent different parts of the body – biceps, breasts, testicles – he squeezed the sauce all over himself, while working the audience up to chanting 'Strong, strong, strong . . . Very strong, strong, strong!' Vivian rounded off his performance with a rendition of the Bonzo classic, 'Mr Apollo'. 'I think I'll be bronze next year,' he remarked. By the end of the act, the audience were completely won over and the routine stayed in Bill's mind for years afterwards.

Stanshall returned to 1920s jazz back in London, recording an EP with Roger Wilkes, featuring 'Are You Havin' Any Fun'. It was recorded for the Harvest label with other guest musicians and released in October 1976. The pleasure he rediscovered during his sessions with Roger shines through. Vivian sounds as if he is giving his manifesto for life as he sings, 'Why do you work and slave and save? Life is full of ifs and buts, you know the squirrels save and save, and what have they got?', to which the back-up vocalists gleefully respond, 'Nuts!' It was an uplifting, summery track. The A-side is a cover of 'The Young Ones'. The backing is workmanlike, but Vivian's voice makes it a definitive version, his theatrical vocals recalling his sepulchral Bonzo reading of 'Monster Mash'. 'I need you and you need me,' growls Stanshall, with an almost audible, lascivious leer to his voice, 'oh, my darling, can't you see . . .' The EP was rounded off by 'The Question'. Carried by a melody which resurfaced in *Sir Henry at Rawlinson End*, the lyric is a simple variation on 'The question is why me not you?', but the highlights are little snippets of Vivian interviewing members of the public. It was the territory that Vivian so enjoyed, seeing the kind of reactions he could get from people.

'I went into Oxford Street and said to people, "Would you mind saying, 'Why me?' into a microphone?" and they'd say, "Why me?" and I'd say, "Thank you very much, that's fine," and they'd be following me, saying "Why me?" and I'd say, "I've got enough," and they'd say, "But why me? *Why me? Why me?*" Desperate to know *why me?*'[17] Some people giggle in answer, but others are clearly unsettled by the whole idea. One man mutters indecisively for a moment before solemnly declaring, 'I would need an explanation of the exercise first.'

The EP suggested that a new, upbeat album was not out of the question and Vivian had in fact assembled a band for five days of recording at the Manor that same year, with Zoot Money on keyboards and Steve Winwood on guitar. It was hoped this would be put together for Phonogram. It did not work out and the material was shelved. While *Sir Henry at Rawlinson End* came out on album in 1978, Vivian would not have a music-only release for another four years. By then, he was married for the second time.

11
The Fur-tongued Horror of a Kiss
Boat Life

Vivian Stanshall enjoyed making an impact on the lives of others. He invariably assumed the dominant role, shouting, laughing and commanding attention. He was the Ginger Geezer, in your face, the sharp-witted thinker dominating a conversation, or the combative thinker bellowing his opinions and making loud demands. Men, women and turtles swam in his personal fish tank, to provide amusement and diversion. He was unpredictable, spontaneous and sometimes unbearably selfish. He also needed affection, understanding and love. All that was lost with the breakdown of his marriage to Monica. He was left to manage his addictions and panic attacks alone.

'I don't think he could handle the weight of knowing what was happening, of being alive and conscious and being more than just flesh and bone,' says Rupert. Vivian had passing relationships, but underneath it all he felt horribly isolated. At this low point in 1977, Pamela Longfellow came into his life. She was a stunning young woman, dark-haired and half Native American, her background prompting her, with Vivian's encouragement from one of his dreams, to take the name Ki. Her 'exotic' aspect was a major attraction for Vivian, who was similarly intrigued by Monica's German-Jewish background. Beyond the looks lay a formidable creative talent and a sharp mind. Unlike Monica, who was also extremely intelligent, but far from aggressive, Ki relished challenging Vivian with her intellect.

He could be jealous of her achievements in writing and they fed off one another's creativity, both finding talent to be an incredible turn-on. Their sexual attraction was just as powerful.

Ki became convinced that he needed a space in which to create and conceived the idea of a floating-theatre venture. She found a suitable vessel called the *Thekla* in Sunderland, organised its renovation and the ship's voyage to Bristol, where the crew spent months refitting amid financial hardship. By the mid-1980s, she was able to hand over to Vivian a venue in which he staged the ambitious musical *Stinkfoot*. Ki concentrated her own creativity later on and apart from her work with Vivian, she went on to become a successful novelist in her own right. Even when it became clear to her that she could not live with Vivian, she never gave up on him.

Ki – then Pamela – Longfellow first arrived in England from the States in 1969. She came with a daughter, Sydney Longfellow, born in June 1963. Ki's 1969 sojourn in England was relatively brief. 'I blasted in and blasted out and came back in '72,' she says. 'I was living in Hampstead with Richard Thompson and the manager of Fairport Convention, Robin Gee, and Linda Peters, who became Linda Thompson.' Gee was Fairport Convention's tour manager. He met her while she was doing a book-keeping job for rock promoter Bill Graham in New York and came back with her. Soon after, Ki and Robin had a short-lived marriage.

In 1977, Vivian's friend Philippa Clare brought him together with Ki. 'Vivian was in a morose mood and he rang up and said, "I want some dynamic, hard-edged American woman,"' says Philippa. 'Ki had rung me up saying she wanted to meet a bright, eccentric chap, so I thought, "You two deserve each other." I set up this blind date for them in the Black Horse in Marylebone High Street.' Ki prepared at her friend's flat over in Belsize Park. Just below the flat was a bus stop at which her date was supposed to appear. She gazed down at the appointed spot, waiting. Her friend wanted to know who the mystery man was.

'I don't know. Some musician. His name's Vivian Stanshall.' The name meant nothing to Ki, but it did to her overawed friend, who swiftly played her 'The Intro and the Outro'. Ki was just about to

have second thoughts about the whole thing when Vivian pitched up, oblivious to them, standing 'in first ballet position at the bus stop', Ki later wrote. 'The building is Art Deco but my "date" is *fin de siècle* ponce, all Wildean frou frou and half-studied nonchalance. He is head-to-toe in forest-green velvet. A green velvet beret, the big, floppy kind. Green velvet pinched-waist jacket with a green silk brocade waistcoat. Green velvet knickerbockers and green silk stockings. A pair of black patent-leather pumps with big, green bows on the toes. A silken lace-edged hanky tucked up the sleeve. A green scarab ring on his index finger. And a fire-red beard tied in a neat hair-sprayed bow at his chin.'[1] In the pub, Vivian rolled the first of many fags, Ki watched and began to decide that he was attractive, 'not yet in body but in mind. There is an electricity to him, a snap and a crackle I have never encountered before. He is both pink in his conceit and blue in his sweet silliness. His words are awkward or calculated for effect – "Take that!" he is saying. "Am I not clever?" he is saying. "And yes," I am thinking, "you are clever and you are fast . . . can I keep up? Do I want to keep up?"'

The two went to a gallery in Highgate. At the end of the showing, Stanshall announced to the gathered throng, 'This is my woman. I am now complete.' At which point she panicked and ran into the street, hailing a cab, into which Vivian also climbed. She had no intention of getting into a relationship, not least because she had no plans to stay in the country.

'This was just a vacation trip for me. This was just me trying to keep my stamp on my passport from the Home Office. If you leave the country for two years, they'll take it away from you. The idea was to get in, renew my Home Office stamp and get back to California where I was living. So naturally I was booked to go back even though I'd met Vivian. It was just a blind date. It was never intended to be anything more. I was going out with a dashing international photographer who hung out of aeroplanes and looked like James Coburn when he was young. Can you imagine a person choosing Vivian over him? But I did – even though Vivian was pissed out of his mind when I met him!' Few friends warned Ki about the true extent of what a life with Vivian Stanshall might hold.

'Philippa told him – without saying so to me – that I was a prostitute and that she was buying him a date. He thought he was going out with a pro – and that's one of the reasons he was terribly nervous and had to have a couple of stiff drinks. She never told me he was famous. I had never heard of the Bonzos. She simply said he was a sad and lonely musician. And by then I had met a lot of sad and lonely musicians.' Vivian himself was still dealing with the practical details of the split with Monica. He destroyed much of his huge store of possessions, knick-knacks and clutter when he left their shared house.

'I had an enormous, emotional Viking farewell,' he said to writer David Hancock. 'It was a pyre about twenty-four feet square. And I had all these things there, paintings, strange boxes, advertisements, plastic legs from a hosier's and I just piled it all up and burned the lot. Then I went off and cried and cried and nobody saw.' Vivian left the cosy conservative suburbs and headed for the Thames, where he moved into a houseboat. It was a converted ex-Irish Navy patrol boat called *Searchlight*, moored between Shepperton and Chertsey. Eighty feet long, the sizeable vessel had been a submarine chaser in World War One. It was acquired by ex-Moody Blues singer Denny Laine, a recent member of Wings, Paul McCartney's new band. Vivian asked Denny about buying *Searchlight* over a drink at the Speakeasy Club and the deal was done.

'Viv never paid him,' says Vivian's friend, pianist and arranger John Megginson. 'The deal was for £4,000, but Denny never got the money.' Ki has heard this part of the tale before, and flatly refutes it. 'It's very annoying there is this idea that Denny Laine kinda gave *Searchlight* to Vivian. He sold it to him for pretty good money. And of course that kind of money for Vivian was never really available. He was always scratching for money but he paid £4,000, which was a big sum at that time.' *Searchlight* survived the war but was going to need all its powers to withstand Vivian. The preoccupied artist barely noticed the daily routine required to keep things in order. He was certainly not best suited to boat life, which necessitates a high level of regular maintenance. Vivian moved on to the boat on his own, as Ki had gone back to California after their first meeting, returned to

the UK a month later and decided to give their relationship a try: 'I was not going to live with him,' she says. 'I came back and stayed in London while he was moving.'

Searchlight was moored on the towpath next to Dumsey Meadow, off Chertsey Road. Visitors got to the boat down a little alley which led to the riverbank. Chertsey was to the right, and the boat faced in the direction of Walton. There were a lot of boats moored along the Thames, but only one owner sported a flagpole from which a Union Jack fluttered. Such a display of patriotism was further enhanced by the presence of Bones, Vivian's very British bulldog, who would closely inspect any would-be boarders, whether they had or did not have permission, and gave short shrift to runners. Vivian hated joggers, waited for them to run along the towpath, and then set Bones barking at them.

The surroundings presented a pleasant aspect. The slow-gliding river curved around and away – in one direction towards the metropolitan heart of London and in the other way to Windsor, wending its way through the county of Berkshire. Trees clustered on both banks and along the towpath ramblers and families strolled, often peering into the boats, wondering about the lives of the occupants. With time, they might well have begun to approach *Searchlight* with some trepidation, forewarned perhaps by strange cries, the glint of machetes and the sound of a ukulele plinking from within the depths of the superstructure.

Searchlight was long and slim, with a plaque boasting that it had been at Dunkirk. 'It took one minute to pass from port to starboard,' Ki later wrote, 'but ten minutes to make it from stern to aft.'[2] Stepping on to the boat, the odour of the chemical toilet, situated right in front of the boarding plank, was immediately apparent. Next to this was Vivian's bedroom, housed in a garden shed that had been bolted on to the deck.

'It's entirely gutted and a superstructure's been plopped on top,' explained Vivian to David Hancock. 'I'm making all my own stuff for the boat out of driftwood, but everything is wonky, which means there's no horizontals in there, apart from me when I've had a few.' The bedroom-shed was full of instruments, pieces of wood, bits of

sculpture and batik, all the clutter of an industrious artist. The room was mostly filled by Vivian's bed, around which were all his tapes and on which Vivian slept with his feet towards the river and head towards the towpath. The bed also served as a workspace. Everything was to hand, the mattress surrounded by ashtrays and notepads. The phone was within grabbing distance. Many of the props and animal oddities had made it on to the boat. There was the mounted zebra bottom, J. Arthur Rank's gong, a gorilla suit, the musical instruments and the forbidding tanks of various types of wildlife. There were books as well, with titles like *The Illustrated History of Dentistry* and *Men I Have Killed*. Along with all this were both Vivian's extensive record collection and his startling wardrobe of exotic clothes. Vivian was usually to be found in bed most of the day, sat upright, working. Below deck, the panelled walls segregated a large lounge, a galley and a bathroom. The forward cabin was beautifully decorated.

Years after the period he spent on the boat, Vivian spoke of it with great affection. 'Yes, that was wonderful. I was very, very happy there because there was lots of room,' he said. 'That was good for me, to be able to see the seasons change and see old cormorants diving and coots poodling about across the marshes in the mist when the sun came up. It was like a Japanese watercolour. I became friends on the riverside with water rats, and there was a family of wrens.'[3]

There were differing opinions among Vivian's friends about whether or not *Searchlight* was good for him. According to photographer Barrie Wentzell, it was 'a leaky old tub'. It was certainly more attractive in the summer. 'It was fantastic when they lived by Chertsey meadow,' recalls Vivian's Charisma colleague Glen Colson. 'I used to drive down to see them. He loved it there and in the summer it was beautiful on the river. He loved living the life of an artist on the boat, painting all day and recording music.' But there were more pressing domestic chores which needed attention on a boat, and Vivian would prove completely unable to handle them. Rodney Slater viewed the whole situation with alarm and suspicion – not just the boat, but the new relationship. 'When he got that boat it was definitely the end. I had stayed in touch with Vivian during the really bad times in the early 1970s, until Ki came along. She kept his old mates away and

he went along with that.' Roger Wilkes had no such problems. He was always on hand and had already started to visit *Searchlight* before Ki arrived.

'It was a lovely old boat. He spent a lot of time doing watercolours, oil paintings and incredible woodcarvings.' He fished driftwood from the river and used his fearsome collection of machetes and knives to carve on the bank. 'I often went down there and Viv played the ukulele and on summer evenings we'd play on deck.' On one such evening, Vivian suggested the two perform their old trick, singing for their drink. He led his friend to the Shepperton Bridge Hotel, a Victorian pub by the bridge. Vivian knew the guy behind the bar, who was giving him drink on credit, and asked if the two could play in the bar. This developed into another regular gig and the two would play 'The Old Kitchen Kettle', 'Nobody's Sweetheart Now', 'When You're Smiling', 'Come and Hear My Banjo Play' and the Bonzo favourite, 'By a Waterfall'. There was an adjoining restaurant which held birthday parties and receptions. As the evening went on the drinks flowed and requests came across from the diners. Vivian rose to the challenge and performed his famous strip routine, throwing his mimed boobs over his shoulder to loud applause. He and Roger revived 'Jollity Farm' as the guests crawled around the floor on their hands and knees, playing at farm animals. At closing time, they would be asked to join the party amid cries of, 'What do you want to drink, Viv?'

There was no time when he was not in performance mode. At the local off licence with Roger one morning, he cracked open a can at some early hour and a rather attractive young lady sashayed past. Much to Roger's horror, Vivian turned round and appreciatively commented, 'A lovely pair, madam.' Roger expected him to be smacked, but once again he got away with it.

Another visitor was a friend of Larry Smith's called Steve Buckley. Vivian's name often came up in conversation with Larry and Steve grew curious about him, knowing only his work with the Bonzos and the songs he had written with Steve Winwood. By the time Larry took him down to the boat, Steve was quite apprehensive at the prospect of meeting the man he had heard so much about. As they

boarded the boat, the young man felt a strong feeling of having 'crossed a line. You went on board over this rickety thing, which reminded you of a mini-drawbridge. You knew you were going across a threshold somehow. It just had that air about it.' He had a premonition as he climbed aboard. Whatever was going to happen, he felt, things would somehow be different. There was no sign of life upstairs. The two men went down the steps and discovered Vivian in the galley. He was pleased to see Larry, greeting his old mate ebulliently. Then Larry introduced Buckley.

'He holds his hand out,' recalls Steve. 'Well, what are you supposed to do? I took his hand.' It was, as Sir Henry once said, an understandable mistake. Vivian pulled at the proffered hand, glared menacingly and as Steve managed to blurt out, 'Pleased to meet you . . .' he was deafened by a booming 'WHY?!'

It was a useful lesson, admits Steve. 'You never say that again for the rest of your life. He destroyed me, temporarily. I had to really pull my forces together again.' He picked up a guitar and, having impressed Vivian with some strumming, reached a kind of silent truce. So they all went down the pub, where Vivian proceeded to make fun of a blind man sat in the bar. Somewhat shocked by the display, it was only later that Steve realized that he was supposed to have had that reaction – it was after all Vivian's local and in fact he did know the man, who good-naturedly put up with the banter.

Before Ki moved on the boat full time, former Bonzo road manager Rocky Oldham also spent time on *Searchlight* keeping Vivian company 'along with his snakes and his mice and all of that sort of thing'. Mostly the two men sat on top of the boat with air rifles, firing at cider bottles. Vivian had little work on at the time and Oldham saw he was energized, determined to get himself back into a regular productive mode. It was a relaxed time. Apart from the usual Houdini act from the Stanshall wildlife: 'The snake escaped at one point,' says Rocky, 'which was why I left, because the bloody thing was living in the bilges.' As Rocky moved off, Ki decided – against her better instincts – to join him on the boat. She soon discovered he was 'never less than astonishing – even when I woke up in the morning. I had already spent a bunch of time with Englishmen and my idea of

Englishmen was they were an awful lot of ponces. Back in the early 1970s they all wore those wonderful tight-waisted jackets and stack-heeled boots and bouffant hair-dos. But I had gotten rather used to that. I was coming in as an American who was used to guys who looked like *Grease*. So I wasn't *too* taken aback by the mascara. If Vivian had to appear anywhere in public, he had to go to the hairdresser's. And of course Vivian never went to a male anything. If he wanted something done, he'd go to a beauty parlour, not a barber. So in the middle of all these women having their hair done, there would sit Vivian having his hair, his nails and his eyelashes done.

'I can't remember what he put on his eyebrows to make them appear red, because they were blond. He was blond with fiery red pubic hair. Fabulous. And he had a very red beard. He didn't have any on the top of his head. Hence the hats.' Ki brought along her daughter Sydney. Then in her mid-teens, Sydney enjoyed boat life, she says, and the way Vivian was always telling stories. 'Things like the "invisible bower bird of Borneo" and stuff,' says Sydney. 'He liked to spin it so you were believing it as long as possible. Rather like his *Rawlinson End* stuff.'

A neighbour from another boat, the *Mikado*, remembers it was a happy period. 'He was always a very gentle and pleasant person. Certainly for the first few years,' says Peter Jackson. Some years later, he was to enter into partnership with the Stanshalls' theatrical projects. He liked the couple. 'To begin with they were very contented with each other.'

Rupert was a frequent visitor. He had to get used to the new American family. 'Sydney was a bit odd,' Rupert says. 'She and Ki were into all that spiritual stuff. Tarot cards and all that.' For Rupert, the atmosphere on the boat was completely different from the one he had encountered growing up at 221 East End Road, East Finchley. Back there he had felt a growing sense of isolation. His schoolfriends tended to stay away from the suburban home with its peculiar décor, 'but when I was twelve they would come to the boat at Chertsey with me to go fishing', he says. 'We would sit on the deck and fish and have a picnic. We'd go swimming and it was great fun. My mates used

to love it and they talked to my dad because, being teenagers, they couldn't talk to their own dads. Of course, he would chat to anybody and he was an excellent storyteller.' His attempts at relating with his son's age group were not always so successful, as Rupert got older. On one occasion Dad came home and found Rupert and a friend smoking dope at the Finchley house when Monica was out. Vivian began acting all worldly-wise. 'Yeah, I'll 'ave some of that,' he said, and sat down while his son handrolled one for him. He had two puffs on it, stood up, and said, 'I'm just going next door,' walked into Monica's room and fell face down on the bed. Laughs Rupert, 'He was out for hours! It transpired he had a snifter of vodka beforehand and we all know you don't mix drink and smoke. But he wanted to give "the big 'un" to my mate. Two lugs on this thing and he's out.'

On the boat, Sydney had her bedroom at the prow, the narrowest part of the vessel. 'You could hear this tap-tap-rat-a-tat along the sides all the time,' she says, 'from the ducks eating the algae.' The boating family of three would often sit on deck throwing things at the ducks, convinced that otherwise they would eventually peck the boat in two. Sydney also spent a lot of time on the Thames on her own little boat, *Rows*, or playing in the woods. Wherever she went, she carried her two pet rats with her. She also kept terrapins, but Vivian still had the same rather haphazard approach to keeping animals that he had employed back in Finchley, and she remembers he managed to poison them by insisting they be fed raw meat. He made an effort with Sydney, 'trying to teach me to play the mandolin and composing me little ditties to play on it, or giving me artist's materials'. He also roped her into some of his escapades. When another houseboat down the path began sinking, Vivian had the idea of seeing what could be saved from the wreck. Like some nautical Fagin, Vivian directed Sydney to squeeze through a small window – he was rather taken with the idea of the law of salvage, which applies to abandoned ships at sea, although how this affects a gently sinking Thames houseboat was less clear.

'Actually, it was more like grabbing a couple of pots and pans,' says Sydney. 'The boat hadn't been inhabited for some months.' Once aboard, she discovered that the gas had been left on and so the pair

inadvertently prevented a real disaster. Vivian managed to get it covered in the local paper as something like 'Vivian Stanshall Dives Through Porthole for Icy Rescue'.

There was an uneasy aspect to the relationship, 'probably with hindsight, sibling rivalry', as both competed for Ki's affection. Sydney's association with Rupert, who was just a few years younger than she was, was not so intense because he did not live on the boat full time. The two of them got on well whenever Rupert came down to visit, although he was less than enamoured of her interest in wildlife. In this she was only following Vivian, who had written about how Hubert – brother of Sir Henry – Rawlinson liked to do rather unusual bird impressions. Hubert's party piece, during a family get-together in one episode, was to grab a handful of worms and stuff them in his mouth. 'Pop-eyed, chewing furiously and flapping his arms, with the pinky tentacles writhing horribly about his chin, he advanced, "chirrup, chirrup!", to the table.'[4] To his son's horror Vivian did the same thing with spiders. Knowing how much Rupert loathed them he 'thought it was amusing to eat them occasionally, just to sort of frighten me when I was a kid. He would just pick them out the webs and scoff 'em. I was horrified. What a silly thing to do.' And Sydney terrified the younger child with creepy-crawlies.

'She kept a red, bird-eating Mexican tarantula,' says Rupert. The spider was named Pavlova, after the ballerina. She was as large as the boy's hand and lived on board in the company of a couple of turtles and another snake. 'We used to feed the snakes frozen mice that had been caught at the house. You'd find these mice lying about on the boat – defrosting. Waiting their turn. And the *spider*.' Spotting a kindred spirit, Vivian had encouraged Sydney's interest in nature, giving her a book of experiments in backyard naturalism, and she enthusiastically showed Rupert the enormous fangs on Pavlova.

'She turned the bugger over to show me these inch-long fangs. Suddenly it rights itself and *voom*! Straight at me. That put me off her. Just a bit. But I would still have to row her up and down the river at night, picking little spiders out of the webs around the boats and stuffing them into jars and taking them back to feed the big spider. I would empty the jars out into the boat, just to get my revenge. Was

it worse than *Sir Henry at Rawlinson End*? Of course it was!'

Ki began to come to conclusions about what troubled Vivian. She felt it was 'crucial to understand that his drinking wasn't because he couldn't deal with the music business and it wasn't because he was too bright. It was all because he scared himself with his own ability. When a panic attack hits you, then you can forget all your experience. All you experience then is pain. He didn't know what to do. There's no doctor you can talk to. When he tried to babble it out people thought, "This guy's gone nuts. He's gone bonkers." So what do you do? You pick up the first thing that will numb you and start drinking. The problem was he numbed the pain but he didn't deal with it. He would sober up and the panic was back. He was never in rages. He was not that kind of a drunk. All that was done for public consumption. With me, the drunker he got, the sweeter he got. It broke my heart. I had a sweet mess on my hands. He wasn't funny. He wasn't being creative. He wasn't holding himself together. Hell – he was a bloody mess. But it took me ages to realize that asking him to stop drinking was asking him to panic. He never dealt with what this all meant.' Their relationship was partly sustained by his irrepressible humour and spirit. Even at his lowest, he was always witty and funny. He might spark out in a glum mood, remembers Ki, only to wake up laughing out loud at some thought, plan or new absurdity. That time back in the Bonzos, when Vivian first had a panic attack on stage in America, was another major part of their connection.

'It's one of the reasons we were who we were together,' Ki says. 'Because I had had the exact same tremendous moment out of time, and the exact same recoil. Sex and gnosis and panic and laughter, that was who Vivian and I were.' In a practical sense, Vivian's collapses meant he left much of the running of the boat to Ki, often with little grace.

'He just ponced around on top of everything, and the relationship with me was very complex. Basically, all my life I wanted to be an artist as well, but didn't believe I was. So hooking up with Vivian was like, "Fuck it, if I'm not an artist, I will use all these energies to take care of an artist." But how much will you do? How far will you go? How much will you take?' Vivian found her determination and

adventurous nature very attractive. Rupert also believes that Ki's energy made her irresistible as far as his father was concerned. 'She is a steamroller and as a writer she is very successful because she knows what to do,' he says. 'But she is totally in your face all the time. You just have to keep back – which Vic couldn't do. She is a good-looker. She looks like Cher. She's also got this aggressive brain. He loved that. He could have fights with her mentally. He couldn't have that with Monica, who is not mentally aggressive. So she was a change for him. She was his ideal woman.

'The sexual attraction between the two was ferocious. And she's pretty good at dealing with powerful men in their own ways. And he loved that. There was a major passion there. No question about that. That's how it worked.'

As a young American woman living a strange new existence, Ki learned to cope, with remarkable fortitude. 'The English are so terribly private and so terribly proper. And yet, if you break any of the rules, and you can do that just by living on a houseboat, then you are no longer subject to their rules. This means they can actually walk by on the towpath, stand in crowds and peer into your windows. Can you imagine any proper Englishman doing that outside any house on any street in England? We used to have people go by on barges with loudspeakers shouting, "Over there is the home of Vivian Stanshall."'

Even the dog was abused by people on the towpath. 'It's these strange impressions people get. Bulldogs mean "Fierce. Will bite." And before this silly, waddling puppy could get to them – they'd whack it with a stick! That turned him into a biter and Vivian had to hide him for the rest of his life.' Bones also had a sideline in pungent doggy odours, which did little to endear him to some of Vivian's friends. Robert Short, a lecturer in surreal art and an acquaintance of Vivian, remembers the animal with little fondness.

'The dog was absolutely dreadful,' says Robert firmly. 'I mean, it was a farting machine and it just crapped everywhere. It was an absolutely disgusting dog. The most loathsome creature I think I've ever seen. It was terribly ill-mannered and graceless.' Vivian himself admitted as much when he introduced the dog on a radio programme

in 1982. Bones makes a brief appearance in the show, snoring loudly and contentedly at his master's feet.

'Bones is a slow, brown, lazy bulldog,' says Vivian, 'faithful and utterly stupid. Oh, my dog would make such a peaceful, wonderful companion, if it weren't for his appalling, wind-breaking trouser-coughs. They would shame Le Petomane.' Bones liked nothing better than to roam in the meadow adjoining the *Searchlight* towpath, interfering with the cows. 'He kisses them – but ferociously! The cows are only worried about his sexual preferences, although he does like to roger bicycles. The cows always return his affectionate smacking busses and he often comes home disgustingly sopping wet.'[5] Bones outlived his master by almost a year. Ki says the dog 'had to be taken away because the police were called to put him down. He had been hit by so many people as a happy puppy, by people who presumed he would attack them just because he was a bulldog.' Vivian gave Bones to his neighbour Harry, who in turn gave him to his mother, and the dog lived until early 1996.

This period on *Searchlight*, from the late 1970s to the early 1980s, was one when Vivian was the most content Ki would know him. 'It wasn't so much being happy or unhappy as being *safe*,' she says. He wrote once more with Steve Winwood in 1977, penning the lyrics for 'Vacant Chair', which appeared on Steve's eponymous album. The inspiration came from one-time Bonzo bass player, Dennis Cowan, a close friend of Vivian who died of a heart attack in 1974 when he was only twenty-seven. The funeral had been traumatic. Vivian went along with all the other mourners with the hearse to the grave, where they discovered it had, due to a misunderstanding, been dug for a child. For forty minutes the mourners took it in turns to dig a proper grave. Vivian took off his jacket and jumped into the hole with a shovel and helped, while the family could do nothing during this grim farce but stand around waiting. By coincidence, one of the clinics Vivian stayed in after Cowan's death was St Bernard's in Hanwell, the town in which Dennis was buried. Andy Roberts remembered the traumatic effect the death and funeral had on Vivian and wondered if he remembered it when he visited him in the hospital near the cemetery. In the immediate aftermath of Cowan's death,

'appallingly upset for a week', Vivian phoned Gaspar Lawal, the musician who had contributed to *Men Opening Umbrellas Ahead*.

'I was lachrymose and self-pitying,' recalled Vivian, 'and he said (in Nigerian), "Only the dead weep for the dead." So I said to Gaspar, "That's very cool of you." He said, "No, just get on with life," so the sentiment of the lyric is: although people must die, most grief and mourning is pity for yourself – but it's called "Vacant Chair" because there are funeral parlours that actually sell floral chairs.'[6] Part of funeral symbolism, these represent the chairs that will never again be occupied by the departed. Gaspar's original Nigerian phrase made it into Vivian's lyric: 'Let them alone for those down there speak our sorrow/While we can't share the joke together, yeah, we keep on going/My dearest friend till we meet again/O-ku Nsu-kun No-ko/The dead are weeping for the dead.'[7] The song gained a bitter relevance the following year. In September 1978, another of Stanshall's great friends, Keith Moon, succumbed to an overdose of prescription drugs.

'Poor old Moonie, he was so desperate,' Vivian said. 'I always wanted like hell to play drums like that, to get out that frustration, and I think he wanted to be involved in writing; but increasingly he became a social animal, while I, until I met Ki, was desperately lonely. I'm still visited with horrific self-doubts.'[8] Shortly after the death, an interviewer asked Vivian if, as a result of the death of Moon, he thought there was a destructive urge in rock music. 'Yes, I think that goes right through managements as well,' replied Vivian. 'It's a quarter of a century old now and it's still the "make a fast buck before it turns over", and that goes right the way through. That's the implication, that you're not going to last. It's absurd. It must occur to them now that it's not a good idea to destroy the goose – I mean, getting you tanked up.'[9]

Vivian returned to his own work when he recorded a version of *Sir Henry at Rawlinson End* on vinyl, released by Charisma in October 1978. It was largely a compilation of the first few Radio 1 shows, polished and even sharper in some respects and an introduction for those who had missed the radio broadcasts. 'With special thanks to John and Wally for their suffering and encouragement at Brainwashing House' ran the dedication inside. It was an extraordinary album, the

very best of the stories and more condensed into a 'day in the life of the Rawlinsons'. During the recording of one song at Steve Winwood's place, Vivian was playing the ukulele to Moss's cello and Steve's mandolin. Vivian thrashed the ukulele so hard the bridge was moving and the instrument began to sound higher and higher in pitch. Steve and Pete looked at each other and tried to match Vivian's key. 'We ended up a tone higher than we started,' says Pete, 'but in a weird way it worked.' Winwood in particular worked well with Vivian and quite understood his very particular creative needs. The keyboardist was playing the Hammond organ expressively and sensitively when Vivian requested, 'I want pinks and oranges . . . like balloons.' Totally unfazed, Winwood just told him, 'Well, just tell me what you want, Viv, and I'll play it.' Even on its release at the height of punk, the music press were impressed by this album that paid not a jot of attention to nihilistic rock'n'roll or the fevered political climate in the UK, the *New Musical Express* describing it as 'an eccentric nugget and an unrivalled delight'.[10]

Vivian's work was never so marvellously out of step with the times. All around him in the music business, the giant dinosaurs of rock were beginning to be hunted by the upstart scavengers of the punk scene. 'God Save the Queen' by the Sex Pistols was barely a year old and the era of Thatcherism was just around the corner. It made Vivian's unique world all the more beautiful in its difference – it stood apart from the transitional England of the time, tapping into a richer, deep-seated tradition. Out on *Searchlight* in Chertsey, Vivian had created a vision of his country as a gently declining rural society, the old world just below the surface. It was as valid a definition as any angry punk song and, though it would never have the commercial appeal of the fashionable new-wave music of the time, Vivian's coherent artistic focus meant that *Sir Henry at Rawlinson End* would never sound dated or tired.

Broadcaster and producer Richard Gilbert found Vivian in a positive mood when he visited him on the boat to interview him about the album for a Canadian radio company. The two had been friends since Vivian recorded for 'Start the Week' and Vivian kept in contact by letter: 'Enclosed please find one Paisley Sperm Bankers Club of

Great Britain members' knackerchief,' he wrote on 'Wednesday-the-Wotsit-of-Whenever' from *Searchlight*. 'Sadly, this item has been hand-laundered by the Tube and the management regrettably cannot be responsible for any residual traces of rusk.' During the interview, Vivian told of how he was wary of the pressures of the late Bonzo period. He now knew what to expect from the music business with the release of *Sir Henry*.

'The only nuisance is that this album looks as though it's going to be successful and I can see the same sort of things beginning to sneak up on me,' he told Richard. 'So I'm defiantly sticking to my painting and my carving and what-have-you.'[11] He wanted to have a defined period in which he would publicize and tour with the album, and after that, he would turn down any further attempts to do yet further work, giving him time to concentrate on new projects. 'I want to continue reading, feasting, gorging on so I've got something worthwhile to spout out.'[12] He found it wearying, he said, to be approached only to write about pink halves of drainpipes and the sweet essences of giraffes and all the same subjects he had covered back in the Bonzo days.

'It surprises me that it still seems necessary to underline them. When Duchamp signed the urinal "R. Mutt", that was that, really. I don't think he needed to go much further than that. That was done ages and ages ago. Yet people still ask me can I write an "Intro and Outro '78" and what about doing a punk spoof.' Vivian thought this was hardly difficult to do. Anyone could find their own Dada material all around them, in the newspapers. By way of illustration, he related a recent newspaper story concerning two German motorists who were concussed when they drove along in thick fog trying to see where they were going by leaning out of the window, with head-banging results. This was the kind of tale that always appealed to him. Similarly he described, with a huge laugh, an advert for rotary nostril clippers and earplugs with a 'terrifying screw device so that it expanded in your ear so that you definitely couldn't get any noise in, nor could you ostensibly get them out'.[13]

The public response to Dadaism was different when the Bonzos were active; the key elements were overlooked by a less sophisticated

audience; 'Very few people saw that. That comes now. I've noticed from reading the musical comics – only because I'm in them, I hasten to add – that we have Cabaret Voltaire, Père Ubu, The Bride Stripped Bare and all the rest of them. And what the hell do they know about Duchamp and Jarry and so on? It's very much a voguey thing, so everything is Dada now.'[14]

Despite Vivian's disparaging summary of the scene, there was to be some staying power in the new wave. Bands such as Cabaret Voltaire went on to build reputations and become influential in their own right, as did David Thomas of the group Pere Ubu. They took the name from the central character in Alfred Jarry's (1873–1907) seminal work of creative anarchy, *Ubu Roi* (1896). In talking of the influence of Dada and the Bonzos on later bands, Vivian also evoked parallels between the turn-of-the-century artists and himself. Jarry showed early promise in his writing, but did not keep up a consistent level of output. He was an outrageous character in his everyday existence and his life and work were a profound influence on Pirandello and other key figures in the Theatre of the Absurd. Alfred Jarry died in his mid-thirties, in poverty and an alcoholic and, while Vivian was probably not drawing too direct a parallel, at the time of the interview he was just one year older than Jarry had been at his death. Thirty-five was a key birthday for Vivian. He had been consumed by the idea of living the life of an artist, to the extent where he and Ki had sat up all night before his thirty-fifth that March. Vivian was convinced that if he really was an artist, he would die young. That he did not, he told Ki, meant to him that he was not really an artist. On one level, this is a somewhat adolescent response, a stage that all teenagers go through and something of a surprise from someone who could be as penetrating as Vivian. It was also a very pure and simple attitude to art and the nature of the artist. No matter how much he excelled in other fields, he always felt everything secondary to the art.

Either unconsciously or subtly, Vivian laid clues in his interviews to his essential nature and the pattern of his life. As Hubert once said in *Rawlinson End*, 'Thank God they all have heads of wood/I dread the day I'm understood'. Vivian's own character was now as rich as

that of Jarry and his dedication to his individuality as inspirational as Gérard de Nerval. He had moved out of the shade of his influences to occupy his own cultural place, his personal life adding an artistic flair in its own right.

'Why me, why won't it stop?' he later asked on a BBC show about his life and inspiration. 'I don't know. Are there any clues?' There were, left for others to pick up like the complex wordplays he scattered in his writing. His way of life was not an artifice and, in many ways one of the last bohemians, he was unable to control it.

The release of *Sir Henry* was also a time for Vivian to look back on the legacy of the band. Asked how he felt about the Bonzos spending so much money getting out of contracts or paying back advances, he was measured in his response. 'I suppose I feel bitter about it,' he said carefully. 'But on the other hand, cracking it up has done me a hell of a lot of good. I'm more balanced now, I'm better able to cope. If I hadn't been so over-awed, as is everyone, when someone says to you, "We're going to put you on to a piece of black plastic", and you say, "*Me?* And I can show my mum?" It's terrifically exciting, but there are the seeds.'[15] Richard also asked him whether he missed humour in rock'n'roll. 'Yes, I do. I really do. I don't understand,' said Vivian, adding with a northern accent, 'Making love 'n' laffing, what else is there, really? I mean it's all the same thing, actually. Well, it is in my case. Two lolly sticks and a bit of Elastoplast. Steady on!' he said with a wheezing laugh.[16]

Sir Henry on record was promoted with a one-off show called 'An Evening at Rawlinson End', at the Collegiate Theatre in London, on 18 October. Support included Leslie Welch, the 'memory man'. Vivian himself had used a fake memory act with Larry Smith in some of the Bonzos' routines and was an admirer of Welch, who was popular in the post-war years, appearing on such BBC radio shows as 'Workers' Playtime', apparently answering any question that the audience shouted at him.

Towards the end of the year, the record company arranged for Vivian and Ki to travel to America for more promotional duties. It was almost a decade since Stanshall's fateful trip with the Bonzo Dog Band and it was also a chance for Ki to return home and escape a

cold winter on the Thames. Not only did Vivian's anxiety mean it was now difficult to get him on to a plane, but they also had to find room, says Ki, for about fourteen suitcases. 'He had to have his fucking tuba and every instrument should he need to record any tune that might pop into his head. He had a bag of notebooks, another of reference books and sketchpads for anything he might want to draw. He also had bottles and bottles of water. Wherever he went you would hear this clink-clink, clink-clink of bottles. It wasn't just alcohol, this was water to help take things to ward off panic attacks.' In New York and San Francisco, Vivian found that not everyone had forgotten the Bonzos. The laid-back attitude of the hippy era had long gone and now it was the age of disco music. If the Bonzos had seemed quaint to the average New Yorker in 1969, by 1978 they were part of a distant, unimaginable past. The chances of anyone understanding the oblique humour of *Sir Henry* seemed remote. And yet there were those who remembered the Englishman with the theatrical voice and were thrilled, if somewhat surprised, to see him back again.

The business side of the music scene was depressingly familiar. Vivian enjoyed little in the way of back-up from the record company. Just as in the old Bonzo days, getting a gig was as much a consideration as the actual playing. Says Ki: 'He did as much as he could to find his audience – which must have consisted of what – twenty people?' An opportunity for work did at last come, from a producer Vivian met who remembered the Bonzos. Yale graduate and musician Gary Lucas was writing advertising copy for CBS, producing radio spots, was a scriptwriter and worked at a studio where one of the engineers one day called out, 'You're not gonna believe who we just had up here looking for work. Vivian Stanshall.'

Gary remembers: 'I fell out of my chair. I don't know how he heard about our studio but he'd made the rounds to say he was available to do voiceover work. So I said I'd love to meet him and use him. I was writing ads for the CBS "Masterworks" series of classical music albums. With Vivian's flawless upper-class accent, I thought he'd be great for an ad for Mussorgsky's "Songs and Dances of Death". Vivian swept into the studio and he was quite a sight to behold. He had a

red beard down to his knees. It tapered into a point. He had long hair and although he'd lost a lot of it, he still looked pretty striking. He seemed very thin and tall, a kind of gangly, scarecrow figure with this ginger-coloured beard. He was also wearing a pair of flared trousers that had the aura of the late 1960s. He was still cutting the figure of a rock star and looked very dashing. He was completely sober and I invited him to dinner at my flat in Greenwich Village. My wife cooked a really hot Malaysian curry and he loved it. He definitely had an aura about him.' But then Vivian often had a distinct aura about him after a curry. They had a 'magical' evening. Gary was impressed by his wit and knowledge. 'He had tremendous charisma and it was like meeting Oscar Wilde.'

With the ads and publicity for the album completed, Vivian ran out of record-company time and was greeted on his return only by an English winter. The Stanshalls 'were penniless', says Ki. They arrived back in January 1979. 'The *Searchlight* had not sunk for some reason, probably because it was frozen into the bank. We had to break the ice on our own bed to get in and sit there. The electricity was off and we lit these candles around this iceberg of a bed. For our dinner we ate what had been left on our doorstep by Charisma Records as a Christmas present. It was a huge tub of Beluga caviar. I loved the irony. There was so much of it. Caviar, fed with a spoon in the freezing-cold blackness.'

Once defrosted, Vivian went on a nationwide UK tour in late February with a show featuring material from the *Sir Henry* record, performed with the likes of Andy Roberts and the excellent American clarinet player Jim Cuomo. He also performed a solo evening of 'Poetry and Recitals' at Brighton Polytechnic in the same month. At times Andy thought his friend was 'bloody brilliant' on the tour, balanced by the evenings when the band were about to go on and were not sure if Sir Henry was even in the building.

In April, Vivian announced he was preparing a movie version of *Sir Henry* and was at Steve Winwood's countryside studio, working on the follow-up to the first album. The band gave the final live performance of *Sir Henry* for the year at the Theatre Royal, Drury Lane, on 18 April. Vivian played on his dense script. 'The rest of me

performance will be conducted in Bantu!' he cried at one point. The audience were responsive. At another flash of lunatic inspiration, someone pretended to anger, crying out, 'Is this what we paid for?' Another started a slow hand-clap.

'Yes,' smiled Vivian, 'I know.'[17] In the middle of his performance, Vivian came to an abrupt halt and the band petered out. He dropped to the stage, lay down with his arms outstretched, looked up at the ceiling and addressed his Maker: 'God: this is what I look like standing up!' he shouted.

'Since the end of the Bonzos Viv Stanshall has been thrashing about rather seeking a direction for his undoubted talents,' said one reviewer. 'It has been obvious ever since the release of his recent solo album that in the persona of Sir Henry at Rawlinson End he has not only found that direction, he has also produced one of the great comic creations of the post-war period. It's a strange event for a rock audience, as Viv stands behind a lectern reading his script and breaking into flashes of near incomprehensible song.'[18] *Sir Henry* continued at the end of the year, in the shape of episodes for the John Peel show. A typical show, recorded on 11 December 1979 for Christmas Eve, featured Pete Moss and John Kirkpatrick providing musical accompaniment, as Vivian delivered such menacing lines as, 'Dr Headstuffing held the winking scalpel aloft with the delicacy and firmness of a man who knows his job. The shaking had stopped and from the liver bared before the blade pulsed a ligament of concentration . . .' Fine Christmas fare indeed.

There was much else to celebrate in that festive season. Just a few months earlier, Vivian had once more become a father. Silky Stanshall was born in August 1979. 'I had no intention of being pregnant again,' says Ki, 'but when I met Vivian there was this sense that it would have been an incredible crime not to continue together and to produce something from this union, although I tried not to and had about fourteen abortions. This by the way was while taking all sorts of precautions. Vivian was not only incredibly sensual, he was incredibly potent.' This signalled a time of the greatest contentment for Vivian. He worked up songs for a new album, *Teddy Boys Don't Knit*, based around Silky. 'The Tube' was to feature guest gurgling from the baby

girl and 'Bewilderbeeste' and 'Calypso to Colapso' were inspired by Ki. On a radio programme, Vivian talked about 'father's neck', an afflic-tion from which he suffered. 'All dads risk father's neck,' he explained, adding, with enormous affection evident in his voice, 'by spending the early hours of the morning crouched by the cot in the Quasimodo mode, telling reassuring stories about owls who like cheese and the endless adventures of naughty teddies who really like nothing better than to . . . go to sleep, darling.'[19]

In Ki's words, he had 'all he needed of his own and this is what he showed us, plus his intense joy in just *making, making, making*'. At his most productive, Vivian was working from his bed on *Searchlight*, creating and puncturing the silence every so often to bellow, 'More paper!' He was not making any commercial forays with his art; it was the act of creating something which was such a strong imperative in Vivian. He once observed: 'What represents a bloke is what he creates, the only thing by which he can be judged.'[20]

In search of inspiration, he took extended jaunts from the boat. He would ride off on a bike, armed with two tape machines, so that he could record multi-tracks, plus one stringed instrument, a recorder, a mouth organ, a sketchbook and charcoal. Back on the boat, he would more usually paint or draw – he was a technically good draughtsman, composing in broad strokes first with the detail following. His work was often of strange figures in landscapes, with surreal or oblique connections between them, rather like many of the characters in his songs and plays. All the time he would be struggling to get his expres-sion right. But whether on board or by the riverbank, this was not the artist as serene contemplative, placid in his rural idyll. Vivian, says Rupert, was battling to get it together.

'He was *fighting* with the thing. Sometimes it was almost comical. When he was painting, he'd be swaying around in his chair with his beret on, literally fighting the canvas. The amount of action was amazing. He'd have this bloody great paintbrush and he'd be stab-bing away. It was great to watch.' One of the results of these riverside battles was discovered by ex-Bonzo, Vernon Dudley Bohay-Nowell, who found a carved tree stump on the towpath near Shepperton. He suspected it was Vivian's work by the way in which it was violently

mutilated rather than carefully crafted. Vivian admitted he struggled with his art. He called his paintings 'orgasms', at the same time confiding: 'If someone offered me an exhibition, I've got just about enough paintings, but like everything else I wouldn't be pleased with it. There are a few things that live on, but really I'd like an exhibition of what I'm going to do tomorrow.'[21] He was so unsure of his talent as an artist, and such a perfectionist, that he never signed any of his paintings. Just around the corner, he was sure, was that finished work.

The location of the boat was conducive to artistic struggle, if downright dangerous when Ki was not around, not least of the potential hazards being his habit of lighting roll-up fags with matches. Twice the boat caught fire and the second time they had to have the ceiling replaced.

'I was standing on the towpath one day when I could see a flickering light in his bedroom window,' says neighbour Peter Jackson. 'I went across and found Vivian had fallen asleep and set light to his bed. So I poured a bucket of water on him!' Then there was the river itself. He fell off the boat several times and went into the Thames. Coming up for the third time on one occasion, a huge shadow came over him, cast by his twenty-stone neighbour Harry. 'What are you doing down there?' asked Harry. 'Drowning,' replied Stanshall.

At an age when children are still able to adapt to their environment with relative ease, Rupert was generally sanguine about all of this, at least in front of his dad. 'What could you do? It was just him. But he was regularly in that sort of condition, and if not he was just being furious.' This was not the kind of frustration that came through artistic problems or personal angst. No – he just liked shouting. 'He loved the sound of his own voice. It was quite commonplace for him to be trumpeting about something.' Vivian made no secret of this. Shouting had been a source of immense satisfaction to him since the earliest days of the Bonzos and it was one of the reasons he so enjoyed living on a boat in the middle of nowhere.

'And that was fine, because I could shout,' he said. 'I like shouting and declaiming and using my voice and playing the tuba loudly and painting loudly.'[22] With Sydney off the boat, leaving to take a job as

an *au pair* in France, it was just Vivian, Ki and Silky. Silky was a source of great delight to Vivian, and – much as he had once planned an album of children's songs when Rupert was two – he wrote charming poetry for her, such as one piece of inspired nonsense, 'Actions Speak Louder Than Worms':

I've often wondered why worms are worms, instead of
 something else.
They're much too soft to be rhinos,
and too slow to be graceful gazelles.
They'd be No-Good-At-All as lions,
cos they haven't got big teeth.
(But I bet sometimes they'd like to be . . . deep . . . down –
 underneath.) . . .
Worms are much too pink to be frightening,
and even the big ones are shy.
They pretend to be snakes but they can't stay awake,
and if they see lightning, they cry.
It's well known that worms are escapists,
but sensible worms come to terms,
with the fact (there's no doubt – and they can't wriggle out!)
Worms do make the very best Worms.

Another shorter piece for her was devoted to one of the larger inhabitants of the zoo and began:

The hippopotamus
has such a great big, bulging bottomus, he goes from store to
 store to store,
trying on hats of extraordinary straw!
A fat lady said, 'There are such a lot of us,
with horrible great, big, bulging bottomus,
I never get trousers to fit, do you?'
The hippo said, 'No'
and stumped home to the zoo . . .

Vivian was still keen to do an album for children, given the working title of *Kid's Stuff*. Together with Roger Wilkes, he enthusiastically put together a demo tape which included a version of another 1920s jazz number, 'Felix Kept On Walking'. They got as far as planning it for release on Charisma, but further problems with health and finance prevented it from coming about. There was more to be done with the old scoundrel Sir Henry. The album was well received, the radio shows were always brilliant and he had been out on tour. The only thing to do was to make a film.

12
Some Geezer, an Ooly Ginger Geezer
1979–82

Tony Stratton Smith launched Charisma Films to complement the success of his fiercely independent and original record label. Success with the album *Sir Henry at Rawlinson End* prompted him to nominate it for the opening feature. Here was a marvellous vehicle for Vivian. Never one to play it safe, Tony was prepared to put Stanshall on the screen.

A young film-maker named Steve Roberts was approached to direct the movie. He first met Stanshall in the early part of the decade on the Joan Bakewell arts and current affairs show 'Late Night Line-up'. 'It was the kind of show that could command guests like the Prime Minister or John Lennon,' recalls Steve. For the young, arty crew, Vivian's wild act was quite in keeping with the show – at one point he was supposed to be sitting on a coffin to do a piece, but actually collapsed into it. He and Roberts quickly became friends and Steve booked him whenever he could get an excuse to use the Stanshall wit and music. Vivian repaid him with generosity when Steve's family suffered a near tragedy. Roberts was at home the day the police called to say a little boy had been knocked down by a car in the village where they lived. They thought it could be his five-year-old, Toby. Assuring them Toby was in bed, Steve went to check anyway. The bed was empty and Roberts immediately aged about ten years. Toby was released only after nine days in intensive care. Vivian heard about

the accident and at a time when Roberts could barely speak on the phone from stress and anxiety, Vivian got through and said: 'Expect me at any moment,' and put the phone down. A few hours later a taxi drew up. Though he had often travelled down to visit the family, he had not a clue how to get there, called a London cab and demanded to be taken to Kent. Toby was at home by then and confined to bed recovering from his injuries. Vivian went into his room and did not come out for three days. Steve would take him in food or drink and he would drink only tea or coffee. He sat and told stories to Toby for seventy-two hours. If Toby fell asleep he would fall asleep, too, on a bunk bed. Then when Toby woke up he would talk to him some more.

'Toby remembers that to this day,' says Steve. 'Vivian just gave three days of his life and then left.' When friends saw this side of Vivian, they felt that they had suddenly become the only people in the world for him. A few months after the accident, Vivian called to see the boy and found that Roberts was out rowing on the river with him. Vivian angrily asked Steve's wife, 'Why should he have a relationship with his son when I'm in hell with mine?' It all came pouring out.

'You could never have an equilibrium with Viv,' says Steve. 'You see, he adored Toby. I think he just loved a wounded animal. That was Viv all over. But I was eternally grateful for the way he helped him. I remember seeing Toby absolutely transfixed when he was sitting there with his head in bandages listening to Vivian talking.'

When Steve first caught *Sir Henry* on the radio, it was quickly a favourite. 'I was lying in the bath having a nice soak and listening to the show and when Viv began reading the Rawlinson stuff I very nearly drowned for laughing. It was so intensely absurd. I called him right away and he sent me the record.' Through Vivian, he met Stratton Smith and was offered the director's job on the movie. 'I had no idea what I was going to do with it,' admits Roberts cheerfully, but that was quite all right with the producer. He insisted the two men stay at his place in the country and was quite firm in underlining they should not come back until they had drunk all his booze and written a script. In early 1980, director and writer dutifully went down to Tony Stratton Smith's country estate near the horse-racing town

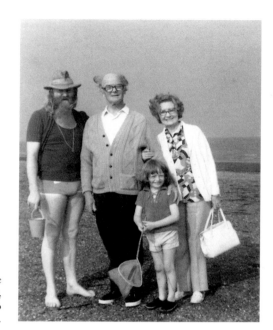

1. A rare outing for the Stanshall clan – Vivian, Vic, Eileen and Rupert – to Tankerton, Kent, 1971.

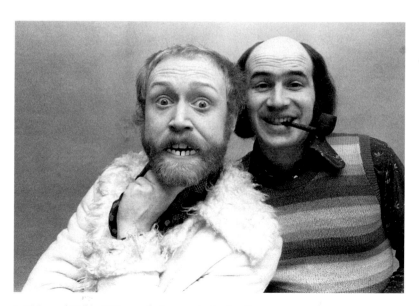

2. Vivian and Neil in 1971, a perfectly normal pair of ex-Bonzos.

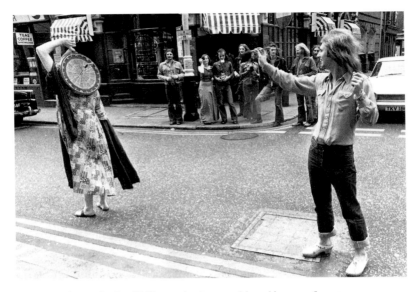

3. Vivian and journalist Roy Hollingworth, pioneers of the noble game of street darts, participate in a display match on Dean Street, Soho. In the background, members of the Man Band watch.

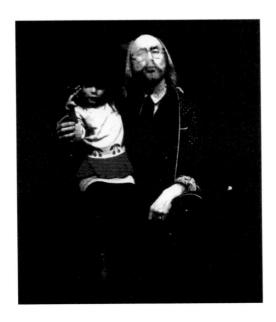

4. On the stage of the Old Profanity Showboat, December 1985, Vivian and Silky perform a ventriloquist routine during a break in *Stinkfoot* rehearsals. She 'inhales' and Vivian puffs the smoke out.

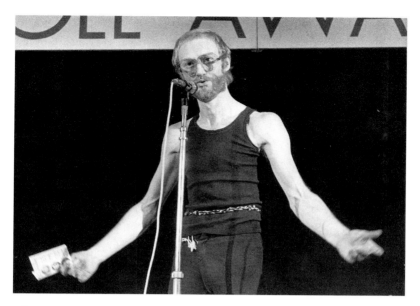

5. In 1971, Vivian hosts the *Melody Maker* Poll Winners awards ceremony. Guests included Emerson, Lake and Palmer.

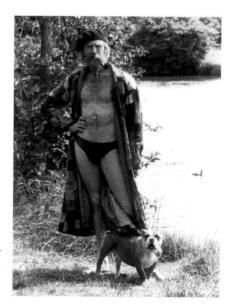

6. Vivian and Bones make the most of the summer weather on the banks of the Thames at Chertsey near *Searchlight* around 1980.

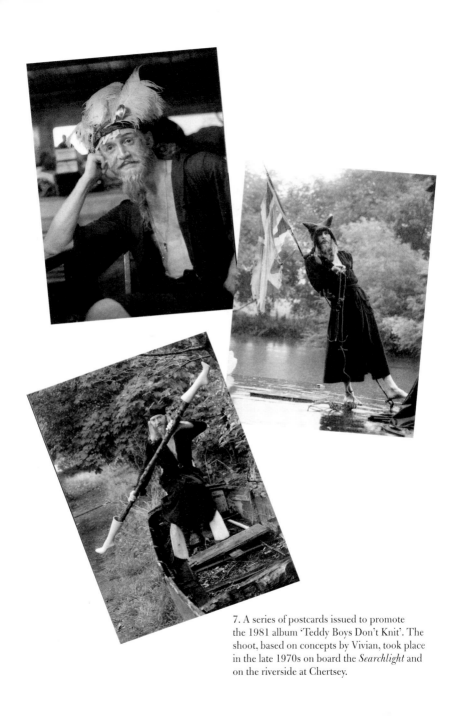

7. A series of postcards issued to promote the 1981 album 'Teddy Boys Don't Knit'. The shoot, based on concepts by Vivian, took place in the late 1970s on board the *Searchlight* and on the riverside at Chertsey.

8. Care for a spot of avocado?
Vivian on *Searchlight* in 1984.

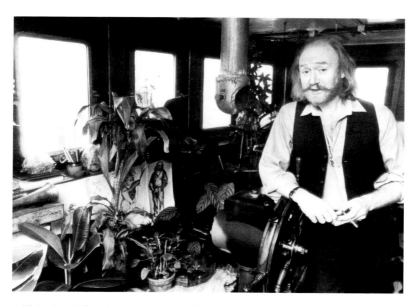

9. Vivian Stanshall ready to take the helm of *Thekla* in December 1985, a
publicity shot for *Stinkfoot*.

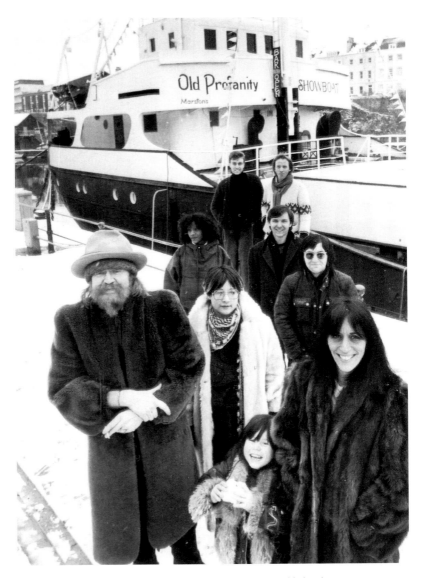

10. The first staff members of the Old Profanity Show Boat assembled at the Bristol docks on a cold day in winter 1984–85. Front row, left to right, Vivian Stanshall, Sydney Longfellow, Silky Stanshall, Ki Stanshall. Behind Ki, in sunglasses, Nick Kearney. Behind Vivian: Hirut Araya Bihon and her husband. At the back are Phil Trenchard and David Williams.

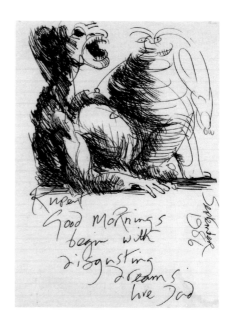

11. A note Vivian left for Rupert, then eighteen, one morning: 'Rupert, Good mornings begin with disgusting dreams, love Dad, September 1986'.

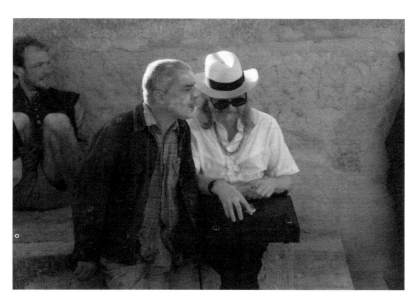

12. On set in Alicante, Spain for *The Changeling* in 1994. Vivian, right, listens to his art school chum Ian Dury.

13. Vivian Stanshall in the early 1990s.

of Newbury. They discovered that Strat had entrusted them with his house, his butler, the butler's deaf wife and their two dogs.

A routine soon developed in the house. Vivian would get up at 8 a.m., already drinking vodka and Roberts was expected to be right there with him. Steve felt he did not trust him otherwise. 'Come on,' he'd boom. 'We're in this together.' By midday they could barely talk. Steve was staggered to see the lines that Vivian would come up with under those conditions. A favourite was: 'Hubert put it about that swans were really giant snorkels and that they betrayed dinosaur leviathans gliding cold-eyed beneath the lake.'

'Imagine how that went down when we showed the film in New York,' says Steve. "Like *what*?"' If nothing else, at least Tony's fine house was conducive to writing – and drinking. Steve spent much of his time trying to stop Vivian boozing too much, with little aid from the butler who, it soon transpired, was fond of a drink himself. He would sneak into Tony's wine cellar, go through the bottles and replace them with water. Vivian got on very well with him. Not so high in Stanshall's estimation were the dogs. He took against their constant yapping and one morning he attempted to kill them with cayenne pepper and rat poison. Fortunately for them, the pepper made them sneeze. Anyway, claimed Vivian, he had not actually wanted to kill them, merely 'nuisance them'. The butler's wife was furious.

To patch things up, Steve and Vivian took the butler for a drink. His favourite venue was in Newbury, a hotel frequented by the racing fraternity. Stratton Smith was very much into the world of horse racing – he had his own stables and twelve horses and through Charisma Records he even sponsored an annual cup. Inside the bar, there were about thirty or forty men with their girlfriends. Vivian took one look at them and boomed, 'Why is everybody so *tiny*?' They were all jockeys. The newcomers settled down for a few quiet drinks, until Vivian announced, 'What this pub needs is a good old traditional English game. I see no shove ha'penny, so we'll play shove ashtray.' He got hold of a two-pound, ceramic ashtray and hurled it down the long table. It went straight through all the wine glasses and smashed them, covering everybody in wine, bits of glass, food and cigarette

ash. And then he hurled down another one after it. Forty furious jockeys grabbed hold of the three of them and threw them out of the door. Vivian was last, staggering out of the bar, roaring with jockeys hanging off his arms and shoulders while he attempted to swat them off. They pushed him down the stairs and the three men lay in a heap. When at last the outraged jockeys pushed off, Vivian dusted himself down, clambered to his feet and remarked, 'Humourless bastards.'

Unlikely though it might have seemed at times, Tony Stratton Smith's faith was eventually repaid when Roberts and Stanshall returned some weeks later with a script. The crew set about assembling a suitable cast, headed by the highly respected Trevor Howard. Best known for his appearances in such classics as *Brief Encounter*, *The Third Man*, *Mutiny on the Bounty*, and *The Charge of the Light Brigade*, Howard would also later appear in *Gandhi*. A man skilled at portraying intense officers and gentlemen, he was perfect for the part of Sir Henry Rawlinson. When Vivian first met Trevor Howard he sat staring at him, the kind of intense scrutinizing others had noted and felt very uncomfortable under. Trevor, sporting a broken nose, finally said, 'Are you staring at my nose?' Vivian said, 'No, I'm staring at you. I've never been this close to a man I admire as much.' Howard was totally charmed.

Vivian himself played Sir Henry's brother Hubert Rawlinson and ex-Bonzo colleague Vernon Dudley Bohay-Nowell was Nigel Nice, opposite Talfryn Thomas as Teddy Tidy. The parade of characters, many familiar from the audio versions of *Sir Henry*, included Humbert, Henry's dead older brother (now a ghost), Lord Tarquin Portly of Staines, Mrs E. the housekeeper, Seth One-Tooth (landlord of the Fool and Bladder) and Reg Smeeton (newsagent and walking encyclopaedia). Mrs E. was played by Denise Coffey, who last worked with Stanshall on 'Do Not Adjust Your Set'. Vernon was called early on to a Soho studio to rehearse a camp dance routine, as part of the Nice and Tidy act. He had to dance with another actor in the studio so they could work out the steps for the film and its soundtrack. 'I was paid £250 a day,' he says. 'The man I had to dance with had pink hair and was so perfumed I couldn't get near him.' During a

much-needed lunch break at the Soho studio, Vernon caught up with his old band mate. It was the first time Vivian and Vernon had met in the twelve years since Dudley Bohay-Nowell had been summarily ejected from the Bonzos. 'He opened up and told me he was having difficulty with his son Rupert at school,' says Vernon.

Two weeks after music was completed in Soho, work began on filming at Knebworth House in Hertfordshire, a mansion set amid rolling grounds. Almost immediately it was clear to Vernon that it was not going to be a smooth shoot. 'When we started to film, the sound recording for the dance sequence was entirely different from the one we had already done and rehearsed,' he sighs. 'We were suddenly given a totally different piece of music and a different dance rhythm. This was bloody stupid. We just weren't in sync enough to make it work and as a result the dance was never included in the film.' That pretty much set the tone for the making of the movie, as glorious an adventure as Sir Henry himself could have wished for. Like a ramshackle expedition setting out with inadequate funds and no map, the intrepid film-makers launched an impossible mission: to put images to Vivian's grand creation. Steve thought that the feel of the last days of the British Empire were conducive to shooting in black-and-white, a more expensive option than colour. Vivian requested a colour ending and title sequence, but as that would have meant redesigning and lighting the set for colour, it was completely impossible. The film ended up in sepia, but not deliberately. It was due to an error at the processing laboratory – Steve actually asked for high-contrast black-and-white.

'It came out a bilious green on one occasion,' he says, 'and then in sepia tone. I was going frantic. But the sepia added to the nightmare and absurdity, I guess.' Whole scenes had to be cut due to lack of money, which still left magnificent set pieces such as an indoor game of snooker on horseback. A suitably stately home to use for interiors was found in the Cotswolds. The rider finished the scene by getting his horse to jump through a large window. Crewmen had previously removed the glass from the window. Everyone agreed that the shot was going beautifully – apart from the owner of the house, who turned up unexpectedly and made it clear just how much he

did not appreciate what they were doing to his ancestral seat. Sums of money were swiftly handed over in order to placate him.

Back at Knebworth, the cameras followed Sir Henry as he indulged in one of his hobbies, clay-pigeon shooting. Or, to be more accurate, clay-prisoner-of-war-on-parachute shooting. The idea was that he would bellow 'Pull!', aim, fire, and the model prisoners would blow up, which they singularly failed to do. One of the ever-inventive crew who enjoyed connections with the less savoury areas of the East End of London procured some rather dodgy fast-action shotguns which pulverized the models satisfactorily. This improvisational spirit pervaded every aspect of the operation, including the central set piece of Rawlinson End, Sir Henry's 'small, but daunting, prisoner-of-war camp', in which he keeps highly cultured Germans in a very amicable arrangement. They continually try to find a way to escape without ever managing it and Sir Henry gives them room and board in return. The camp was constructed the wrong way round and had to be hastily rebuilt by the crew overnight.

This was symptomatic of the cheerful mayhem at the heart of the film. It was never clear what *Sir Henry at Rawlinson End* was all about. None of the characters had a function that made any sense whatsoever. Sir Henry's local man of the cloth, Reverend Slodden, seems devoted to stealing things and plotting against Rawlinson for reasons unknown. Sir Henry blacks himself up like a minstrel, donning a tutu and riding down the street on a unicycle in an attempt to be 'incognito'. There is a concerted attempt by the residents and friends of Rawlinson End to rid the house of Humbert's ghost, who roams the corridors without his trousers, pulling a toy dog along behind him. It was never easy to follow what plot there was, despite Steve Roberts's desperate attempts to pull some kind of characterization through the narrative with Vivian. Much as the director did not want to make a facile, straightforward kind of story out of the script, Steve knew the audience had to have something to hold on to. He thought that Vivian 'wanted to tell a story, but was afraid to'.

The director turned to producer Tony Stratton Smith for advice. 'What sort of approach do you want here? Do we control the bugger or do we let him go?' he asked. Stratton Smith was unruffled: 'I can't

control him either,' he said. 'Why don't you just do something that you love?'

'Can you imagine any producer saying that now?' asks Steve. 'My agenda was simply to get *Rawlinson End* up on the screen in a way that would not entirely disgrace us for ever.' Or Vivian. 'The man was a musician, a poet and a writer, so he knew we had to find a form. You don't just piss all over the walls and hope it will make patterns. He was well aware of that. The struggle was his particular sense of mischief conspired to defeat us at every turn. We had the most outrageous fun, though.' Until Vivian's heart condition came on severely. He was taking pills, but would experience intense fibrillation, which went on for hours. Everyone thought he was going to die. 'You had to put your arms around him while he was saying, "Don't let me die",' says Steve. 'You'd just say to him, "It's okay, Vivian, you ain't gonna die. It'll pass."' During these dreadful moments Steve could see the fear overwhelming Stanshall and could even feel his heart pounding.

'He had this façade of naughtiness and danger and yet he would weep and want to be looked after and cared for. To be honest I'm not much good at hugging blokes. I prefer the other sort. But with Vivian it was the natural thing to do. You wanted to protect the old bastard because he knew he was killing himself and that he wasn't going to last. He was terrified of death and he didn't want to die but he didn't know how to stop abusing himself, smoking or drinking. It was almost as if he lost his identity if he lost his reputation. And his reputation was as this wild man, the guy who would go on for ever. I think he feared to lose his character and he feared to lose his life just as much. It wasn't a joke to him at all. He knew he was out of control and when his body started to give up on him that scared him a lot.'

Steve tried to help him. When they set up to shoot a scene with Vivian from a distance, he made a point of sending someone to ensure his star was not drinking. Vivian was to sit on an island in the lake near the house and was to fish using a line attached to his ukulele. All was well, reported back the spy, Vivian was not sipping anything. Steve checked the scene through the camera lens to see Vivian with a bottle of vodka, blissfully unaware he was being observed. Steve

sent some crew members out in a rowing boat to fight him for the bottle and they discovered how he had smuggled the booze over. He filled some flat bottles with vodka and sewed them into his coat so nobody could find them. As soon as he got out there he ripped them out of the hems. Stanshall knew they were trying to keep the budget from going over £100,000, says Steve. 'Stuff like that could have fucked us rigid.'

Trevor Howard, for all his fondness for a drink, was completely professional on set. 'You keep that bugger under control,' he told Steve, 'and I'll do my job. The boy needs looking after and whipping into shape. This is a little out of court.' The rest of the crew were amused and horrified by turns. Vivian molested every secretary and PA on the set. Frequently he would, says Steve, 'get his dick out and put it on the table. "Morning! Needs a bit of exercise." The girls couldn't quite believe he'd do that.' Stanshall was never barred from the set, though like many writer/actors, he was locked out of the cutting room. Roberts faced the huge task of trying to make a film out of something that was 'based on language. It was surreal and it was word-based and movies aren't meant to be like that – as I've learned since. "Movie" means moving picture. It's got to go or the audience is going to give up on you after ten minutes and munch the popcorn.'

As far as Vivian was concerned, no allowance should have been made for the conventions of cinema. Steve thought he kept it loose, stuck to the spirit of Rawlinson, but any compromise was a sell-out for the author, who late in the day decided Hubert's part in the film was more central to the story. The time for that was long past – the film was almost done – but Vivian was always rewriting, just as he did with the music. While the two never had a disagreement, says Steve, 'I remember he gave me one of those bear hugs after a mixing session when you are not sure if it is affection – or whether he wants to break your neck!'

With a press showing on 24 October 1980, the film was well received in London by the critics. Vivian started giving interviews with his usual reluctance. Overcome with nerves, he threw up just as DJ Noel Edmonds was about to talk to him. 'They're going to give

me another go,' Vivian said mournfully to a journalist, as if it was the last thing he wanted to get right.[1] *Sir Henry* played out of festival at Cannes, to general bafflement. Vivian described it as a 'sur-Ealing comedy'.[2] The film was also given a limited release in America. With the experience of the Bonzos and the vinyl *Sir Henry*, Stanshall might well have expected poor back-up and organization in the States, and he was not disappointed. It was shown only in New York and Los Angeles, although where it did play, it got a good response.

'I was absolutely stunned,' says Steve Roberts. 'I was there when it opened in New York. People were queueing round the block on the first day and it got tremendous publicity.' That same year, 1980, much of the film and record material was translated into book form, *Sir Henry at Rawlinson End and Other Spots*, published by Pete Townshend's Eel Pie company. When the film was shown on TV in March 1997, a *Radio Times* reviewer commented: 'A mercifully brief, and smirkingly unfunny British oddity with Trevor Howard as an eccentric, boozy aristocrat at odds with an army of characters seemingly left over from other comedies.'[3] The real problem was that all the strengths of *Rawlinson* in its radio version became weaknesses on film. As Steve Roberts admitted, it was just too reliant on words to work. What had been marvellous flights of fancy on the radio became Vivian talking interminably over static scenes on screen. In that environment, his verbal gymnastics merely irritate and the film drags.

The spoken *Sir Henry* stories were imbued with such charm through the sheer force of his commanding vocal presence that the listener willingly followed him through all manner of mad, rambling digressions. Indeed, each story was largely one sparkling, fifteen-minute-long digression. In the filmed version, all the little verbal puns and subtle images of the absurd are lost. Sir Henry's prisoner-of-war camp creates a wonderfully incongruous image in the mind: the typical English estate – all manicured lawns and immaculate ponds with a camp towering over the rhododendrons. But when a film-maker has to build a set, the camp quickly loses the appeal of its incongruous appearance. To make the set worth the money, it is over-used and the gag soon wears very thin indeed. There are rare moments of

comic delight in the film, and the cast are impressive. In particular, J.G. Devlin, as Old Scrotum the wrinkled retainer, exudes decrepit, sleazy servitude with every rheumy glance, but just a year after the film had been released Vivian was already expressing his doubts.

'It seemed to me the record was pretty much a blueprint for the way it should have been directed,' he told *The FACE* magazine. 'The record is certainly flawed but it does have a rhythmic sense to it which I think the film lacks. I rewrote the bloody thing several times, but even at that stage it wasn't the brainstorm cocktail it was later to become. When I saw the rough cut, thank God I was drunk, because otherwise I would have been armed and there would have been bloody wounds – and more.'[4]

Glen Colson recalls the tremendous effort Charisma put into making the film. 'Tony Stratton Smith wasted an awful lot of money on that film. He pumped in half a million quid of his own money and I don't think he made any of it back. It never made a dime. He didn't even know where to distribute it once it was finished. No one wanted it. It was an arthouse film, so I had to go around trying to get people interested. Viv'd want to be in charge of the acting, the scripts, the music, and you can't be in charge of everything. You can't be Jack-of-all-trades when you're making something that big, because there are hundreds of people who work on a film.'

A month before the release, in September 1980, a year after Silky's birth, Vivian and Ki married in a Surrey register office, he now thirty-seven and she two years his junior. The date seemed somehow significant to them – as Vivian might have called in his days in the bingo hall at Southend, it was all the nines: 'The ninth day of the ninth month in a nine year. In other words, September 9, 1980,' says Ki. He wore his fake teeth and a plaid suit and her wedding ring was an eyeball – one of those used by people who have one missing – set in silver. 'The registry clerk didn't bat his own eyeball although we were all bubbly and excited.' She had not initially wanted to marry Vivian, after one failed attempt behind her. The birth of Silky made her rethink. 'It's odd how things change,' says Ki, 'because after that I was "his wife". Suddenly I was responsible to him. I was now required to do certain things because I was "his wife." He was a funny man.'

After the *Sir Henry* film, Vivian returned to music, enjoying some success as a result of writing more songs with Steve Winwood. With Pete Moss, Vivian spent some time at Winwood's home recording studio in Berkshire, and it was Stanshall who wrote the lyrics to the title track of Winwood's 1980 album *Arc of a Diver*. The album hit US No. 3, while the single 'Arc of a Diver' got to US No. 48 and was a great earner for Vivian. Writing the song, he said, had been 'effort-less. I used to think that there were lamas in Tibet that could write perfect verse – that, towards the end of his life, Dali could paint and know that he was going to make marvellous and astounding works. I don't think that's going to happen to me. I don't think it happened to them, but I think it's a marvellous idea to be able to flow perfectly. I don't know much about Indian mystics, but I figured that once you'd got past a certain age, if you could forget nuts and bolts, you could just play, sing or speak. You wouldn't have to consider your words or the next thing that occurs. You could actually do it. "Arc of a Diver" is about that.'[5]

Winwood said that Vivian's talent was such that he was not so much a wordsmith as 'a word-*chemist*, really. He found a route that brought together elements of the intellectual with rock'n'roll and comedy and poetry and it was just a unique combination. There was a side of him that was much more pensive and sensitive than the world really knew, and I think he felt he could express that working with me,' said Winwood. 'He definitely believed in the phonetics as "sound". That was the main thing. The "intelligence", as he called it, he would work on later. His words were very metrical, they had a rhythm of their own.'[6] Steve remembered how, during one of their collaborative sessions, he had to wait for Vivian to pitch up at a pub where they were meeting some producers. The record company was anxious for another hit and, while the two producers liked the music, they were waiting for the words. It was a quiet, country pub and Vivian created something of a stir on arriving. 'He made rather an art out of pub entrances,' commented Winwood. Wearing a loincloth and a long coat, brandishing a big stick, Vivian opened the door to the bar and peered from under the brim of his enormous hat at the cust-omers drinking or eating a leisurely lunch.

'I smell food,' he announced, 'or has somebody farted?' Vivian sat next to the young wife of one of the producers. She was very obviously pregnant and he started to explain that he was a doctor and had to examine her. Talked into showing the lyrics, Vivian finally handed over a song called 'Keep on Mooing'. It took the record company producers a while to realize Vivian was making fun of them.

Vivian returned to his own work in 1981, with an album characterized by high production values as well as being clear, concise, witty and candidly autobiographical. Seven years separated *Men Opening Umbrellas Ahead* and *Teddy Boys Don't Knit*, and the two albums were completely different in character. Much of *Teddy Boys* was written on *Searchlight* and recording began in April 1981, the first half at Regents Park recording studio, with the remainder at Morgan studios in Willesden, where the Bonzos once worked. Musicians included drummer 'Admiral' John Halsey, who had known Vivian since Grimms. Malcolm Brown had worked with Stanshall on BBC sessions and took the production helm. Pete Moss was the MD as well as musician. The band included Ollie Halsall (guitar), John Cuomo (sax and clarinet) and Roger Ruskin Spear. Neil Innes played piano on many of the songs and Vivian sang, played the 'baconium', euphonium and as many other -oniums as he could fit on the album.

Sir Henry was fresh enough in Vivian's mind for the others to note how keyed-up about the movie he was, but with Moss – quickly nicknamed Sgt Major Moss – directing operations, the assembled musos raced through five songs in about three hours. When anybody boobed, Moss was down on them immediately, barking, 'Stop! What's the matter with you? You made a mistake? You shouldn't be on the bloody session, then. Do it again and don't make any more bloody balls-ups.' This was standard procedure for session musicians, but a rare occurrence around Vivian Stanshall.

'I ended up writing scores so the musicians would have a fighting chance. That's why I ended up as his MD. Vivian wasn't really a musician,' explains Moss. 'On a twelve-bar blues he'd always play a thirteen-and-a-half bar blues! He just didn't have a twelve-bar mind. People couldn't understand that. Quite often we'd have classical people involved and they had no idea what was happening. I had the

task of trying to smooth the path between Vivian's brain and the fingers of the musicians. I understood where he was coming from, even though we were totally opposite.' Like others who worked with him, Pete found that Vivian was often, surprisingly, more difficult when he was sober. Without warning, the efficient side of his character would appear, like an 'explosion in a mattress factory' as far as Moss was concerned. Oscillating between one extreme and another, there were rare periods of equilibrium, which seemed almost as strange to his MD as the more usual moods. He took them all on board. In return, Vivian wrote in the sleevenotes: 'Music scored, scarred, over-sawed and shouted at by Pete Moss, MD'. He did really appreciate his friend.

Vivian often showed respect for those who managed to keep him in line – or as Pete Moss says, perhaps simply for those who were, like him, taller. Vivian still could not write music and had no way of notating the songs he played on a tape recorder. He relied on Pete to do it for him and was not above taking advantage of his generosity. Some time later, Moss found that his friend had put together a book of all the musical charts he had constructed for him – he was planning to put it all together on his own if need be. Producer Malcolm Brown also had to keep his eyes open for the booze that Stanshall had hidden all over the studios, often discovered in some obscure mike cupboard by an unwary sound engineer.

'Hey, there's some cans of beer in here!' a young tape operator, who had perhaps opened the cupboard to retrieve a length of cable, might exclaim. Like a discreet head waiter, Vivian appeared smoothly behind him, his officer tones attempting a swift cover-up: 'No need to mention this to Malcolm, old chap.' Or John Halsey would reach into his percussion box to get a tambourine out and find half a bottle of rum.

Malcolm had to be firm about when it was time to go with a take, his artist always ready to add one more bit to every song. From the moment Vivian arrived in the studio, he was at the centre of everything. His imminent entrance through the studio door was announced by a crashing and banging like someone throwing a dustbin down a long flight of stairs. In he walked, fresh from the taxi, carrying a euphonium, assorted banjos and a leg (a Stanshall-built instrument which

he played like a trombone). Stanshall gave out the lyrics, which had been thrashed out on cassette on his boat or while roaming about armed with bicycle, machete and ukulele. He rewrote and rearranged the songs in the studio. By the time they were ready to record Vivian was off in a new direction: 'No, it's all completely different now.' Pete Moss had to be firm. 'Not as far as I'm concerned, Vivian,' he told Stanshall firmly. 'This is the way it was given to me and this is what we are doing. Sit down and shut up.' In return, Vivian taught Moss much about recording – his own unique way of constructing material was completely different to the formal style of session playing. 'I learned that some of the weirdest things that you don't plan for can sometimes turn out as sparks of genius,' says Pete.

The twin approach worked. *Teddy Boys Don't Knit* features a stream of inspired songs with themes and lyrics that range from the vulgar to the romantic and the bleakly pessimistic to the joyful. There were winsome, quirky melodies, raucous rockers and carefully arranged set pieces, all testimony to his feeling that 'you should know what you're talking about', as he later told journalist Alan Clayson. 'I'm very careful with every word – mosaic work, almost. For me, it has to be as correct as I can make it and I can justify everything. I weep blood when I write lyrics. There are quite a lot of people I wouldn't write them for. I should also say that there are quite a lot of people who wouldn't ask me. You focus on yourself and say, "This is as good as I can be at this time," so you lose fear.'[7]

When it came to recording the music to those words, it was a different story. For most of the session, he was asleep. All the musicians turned up at 1 p.m. for a 2 p.m. start, by which time Vivian was out of it on a sofa in the reception. Moss organized the others in his usual fashion and, despite a few hitches, they had seven tracks recorded by 9 p.m., including 'King Kripple' and 'Nouveau Riff'. As they finished the last track, right on cue, Vivian slowly began to wake up, with an 'Arrgh . . . Bleugh . . . I say, Malcolm,' he grumbled. 'Well, we'd better actually do something.'

Said his MD scornfully: 'What are you talking about yer plonker – we've done seven tracks. It's all done.' The singer 'went *spare*!' recalls Moss. 'But I always maintained that was for the best. He just

dubbed the vocals on afterwards.' Part of the problem was his perfectionism, his fear of getting it wrong, and he knew that it was a handicap. Without the opportunity to fret over every part of the process, the album was quickly completed. This was a very positive phase for Vivian and there were tender moments on *Teddy Boys Don't Knit*, inspired by his happiness with Ki and their baby Silky and memories of his own childhood. In the past he dealt only obliquely with his background and roots. Here, a little older, he was willing to explore this raw area. The album consisted of three main themes: there was the rock'n'roll lifestyle (usually parodied as an excess, as in the opener 'King Kripple' and the bloated rocker of 'Nouveau Riff'), there was the personal ('Bewilderbeeste', 'Possibly an Armchair') and there were songs that took their inspiration from *Sir Henry*.

It was the swamp-rock blast of 'King Kripple' which opened the album. A pungent description of the most bog-standard of bog-standard pub bands, Vivian lumps himself in with this lot, King Kripple, the leader of this rather freakish outfit, perhaps a reminder of 'Bubbles' White and the band of unusual-looking people he wanted to get together back in the Sean Head Showband days. 'King Kripple' is confident, brash and an upbeat number to start the album. By contrast, 'Gums' is a quaint ditty based on the simplest of ideas, trying to find a pair of trousers to put on. It is time to take Gums the dog for a walk, prompting the search for the trousers. This is from the film of *Sir Henry*, in which the ghost of dead Humbert, Sir Henry and Hubert's brother, walks a stuffed dog mounted on a small trolley around the corridors of Rawlinson End. A highlight of the album is 'Bewilderbeeste', one of Vivian's finest songs, tenderly dedicated to Ki. With a pretty, haunting melody, Vivian sings without affectation, eased by the sensitive Spanish guitar of Fairport Convention's Richard Thompson. 'Calypso to Colapso' is full of surprises, with Jim Cuomo playing recorders behind Vivian's whispering vocals. With lyrical echoes of 'Bout of Sobriety' from *Men Opening Umbrellas Ahead*, the calypso form marks a return to Vivian's fondness for African and West Indian culture, here given softer expression. The track was also issued as a single in June 1981, backed with 'Smoke Signals at Night'. It was Vivian's last solo single. Only cover versions

and some collaborative work with former Bonzos were to receive a commercial release in the future.

'The Tube' is a cute and cuddlesome tribute to young Silky, Vivian's affectionate way of describing how the baby just seems to be an eating machine. Unashamedly an indulgence on the part of a clearly besotted father, the track was perhaps more for Dad's benefit than that of the child. Early words from baby Silky can be heard mixed in to the recording. With a swaggering drum-roll, 'The Tube' segues into the Cockney-lad bluster of 'Ginger Geezer'. This was most definitely the sound of a brash young Vivian, dressed up and ready to defy his parents, roaming the streets of 1950s Southend. You can see his thumbs tucked insouciantly into the tops of his pockets as he struts off in search of trouble. It was also a simple paean to Cockney rhyming slang, epitomizing his love of the 'risky', as Rodney Slater puts it: the pool-playing, hand-rolled-fag-smoking, artful dodgers he so admired. Geezers, oily rags, rabbit-and-pork – 'ginger geezer sees-'yaround'.

In the quiet following this raucous get-together around Neil Innes's melodian comes 'The Cracks are Showing', in which an introspective side of Vivian Stanshall comes to prominence, one which is all the more affecting for not having the maudlin undertones of *Men Opening Umbrellas Ahead*. It was a subtle acknowledgement that middle age was looming. In March, the month before recording began, Vivian celebrated his thirty-eighth birthday and this song refers explicitly to the passing of time. He strums a mandolele, making it sound like a delicate clock mechanism, discreet, yet unmistakable, as he softly sings: 'Heigh-ha-ho the way things are . . . /The clocks are baring their teeth. Tick – grandfather's stopped/Time for Time to flash her dazzling dentures.'[8] The band settled at Morgan studios for the remainder of the album, for which Vivian returns to the theme of ageing and his family at the very start of the second side. 'Possibly an Armchair' is one of Vivian's finest moments. It concerns his father's declining years spent at home without any interests. This was the first time that Vivian had written so explicitly about the relationship between father and son. Up to this point, his songs had generally, if they targeted anyone, been aimed at figures of authority in general,

or conformists. Now he was focusing his artistic light closer to home. Mark Stanshall shares his brother's acerbic view of Vic.

'My father wasn't terribly interested in anything or anyone. I don't think he ever went and saw Vivian playing. He just wasn't interested,' says Mark, who had experienced the same apathy when working in antiques. 'But there again, when I had shops on Sloane Square, he never bothered to come and see me either, so he was very fair.' Fair, but so cold. For all the performing that Vivian did, throughout his life, everyone noticed except his father. Vivian had to look elsewhere for paternal figures.

'The strange thing was he always used to call me "Father",' says Moss. 'I was also known as "O, stern one". I used to shout at him all the time. Otherwise nothing would have got done.' It was true that Vivian's father disapproved of his son's lifestyle, but even that was not with any great passion.

From the battlefield of familial relationships and the agony of broken lines of communication between father and son, Vivian moved to another song about trousers. Or rather, to 'Terry Keeps His Clips On', a song about the use of bicycle clips to prevent wasps crawling up trouser legs. First recorded for the abandoned 'Trail of the Lonesome Pine' single in the mid-1970s, it is not as far from the personal theme of 'Possibly an Armchair' as it might seem. The voice is that of the overbearing father figure again, exhorting his son to wear clips at all times to keep safe, and the song is one of Vivian's lightest, a jaunty, catchy number. To accompany the bicycle-clip theme was the sound of bike wheels turning, as played by one Chris Lycett, future Head of Live Music for Radios 1 and 2. He used his own vehicle, stolen shortly after the recording.

Vivian moves towards the close of the album with an interesting character sketch of a computer operator who harbours greater desires away from his desk. 'Smoke Signals at Night' featured Richard Thompson again, and piano from Rick Wakeman, of Yes, whose participation came about simply because Vivian grabbed hold of him and said, 'I say, amigo, come and play on my album.' Rick was on Charisma at the same time, and the politics were such that Charisma executive Andrew Sheehan flipped out. 'You're not having Rick

Wakeman on the album because it's a problem,' he said firmly and finally, closing the subject. The musicians and crew trooped off for a Chinese meal together, all bar Vivian. By the time they had returned, Vivian had recorded Rick Wakeman.

'It's not actually very well played,' says Pete Moss, 'but that was because Rick couldn't stop laughing. Malcolm Brown and Andrew Sheehan were furious, but this was the kind of trick that Vivian got up to all the time.' The final track is a return to the themes of opener 'King Kripple'. Like the first track, 'Nouveau Riff' is concerned with the seamy side of the music business. Here it is a faded rocker whose associates sponge off him mercilessly in a downbeat, yet somehow appropriate, ending to a unique album, Vivian's last apart from a further *Sir Henry* spoken-word album.

'I would have been happy to have done more with him over the years, had he not been so difficult to work with,' says Neil Innes, who found the whole process of recording *Teddy Boys Don't Knit* trying. 'I like a drink as much as anybody, but I've never been able to work on it. It's not fair. You bring your toys along and they just get trodden on.' Neil wanted to become more involved in the creative process, but Vivian's needs were central. They had been the two most ambitious personalities in the Bonzos and, while that creative conflict had often worked well, now it frustrated Neil.

'When you play with someone else, you want it to be better than what you do on your own. You don't just want to be blotting paper. We can all be selfish at times, but like everything he did, that aspect was larger than life. He was very, very selfish!' Periodically awash with booze and Valium, Vivian's emotional attitude was changeable and could be thrown into a spin with a panic attack, or he might be extremely thoughtful. Drummer John Halsey was in a serious car accident a couple of years after making the album and Vivian wrote to him. 'I suffered severe facial and head injuries,' says John. 'The letter started off: "Dear Admiral. Glad to hear you are having the face fixed at last." That was the opening line!' Sometimes Vivian called up to ramble incoherently and the next day, 'you'd call to see if he was okay and he didn't have any recollection of having made the call'.

Teddy Boys Don't Knit was released two months after recording, in

June 1981. *Melody Maker* spoke of Vivian's 'lyrical ingenuity' and was otherwise lukewarm in its reception.[9] It was understandable in the summer of 1981: the Sex Pistols were still relatively fresh in the pop public's mind, the Clash were going strong and Duran Duran had just hit No. 12 with 'Planet Earth'. If ever there was a less promising era for a 1960s renaissance man to release an album peopled with young men with bicycle-clip fixations and anguished artists dealing with traumatic father–son relationships, it is difficult to think of one. Vivian was perceived as self-indulgent, out-of-place and out-of-time. So, no change there, then – this kind of album was never going to be a mainstream hit. In the *Rough Guide to Rock* (Penguin, 1996), *Teddy Boys* . . . is dismissed as 'half-baked, the songs self–referential and either inconsequential or over-serious'.

While *Teddy Boys* . . . contained reference to Vivian's father, there was no mention of his brother Mark. Vivian simply wrote him out of the story. Many of his friends did not even know he had a brother. It wasn't surprising. The two brothers didn't get on and they acknowledged it. Their mother Eileen recognized that the boys, separated by five years, were very different. Vivian never went to visit any of the shops Mark ran, just as their father had not. 'I always thought that was a bit of a shit,' says Mark. 'I went to see him, but he was never there for me if I needed help. Of course, there was the age difference; when he was out chasing birds, I was still playing with Meccano, so that didn't help.' Mark also had similarly rich tones in the way he spoke, which was a bit close to Vivian's talent.

'Viv resented the fact that Mark had a voice almost as glorious as Viv's,' says friend John Megginson. 'He saw Mark as a bumbling wastrel, which was paradoxical coming from Viv. Mark, who has been an antiques dealer, restaurant owner and gardener, is a very likeable chap. But Vivian had a healthy contempt for everybody, unless proved otherwise. He liked an artistic angle to his relationships, even on a pretentious level, which stemmed from his problems with criticism from his father as a child. Because of the insecurity and inadequacy he carried all the time, he had to be surrounded with artistes.'

The brothers were more likely to run into each other by accident. One night, they both chose the same Indian restaurant for an evening

meal in Westbourne Grove. Mark arrived first and his brother came in without seeing him. So Mark got a notepad out and went over to take Vivian's order. As the brothers sounded and looked alike, it must have been quite something to see Mark march over and pretend to be a waiter, with unmistakable Stanshall tones. Leaning towards Vivian, Mark obsequiously enquired, 'And what would you like, sir?'

Surprisingly, Vivian completely failed to recognize his brother. 'I'm not sure, I might have a Madras,' he dithered. Quick as a flash, Mark batted back, 'Oh, you wouldn't like that, sir.' It went on for some time before Vivian finally clicked. Nothing of the poor state of the brothers' relationship – or even the existence of a brother – is hinted at on his most autobiographical work, *Teddy Boys Don't Knit*. Though it reveals much about Vivian with great candour, it keeps a sense of enigma about his true nature. Just as the front cover, painted by Vivian and depicting some kind of rock'n'roll dance floor, teasingly shows a flame-haired figure in the centre, bent over with face hidden. Perhaps, again, it was a quick flash from the ginger geezer himself.

Vivian made a near-return to radio the following year, 1982, through his friend and former producer Richard Gilbert, who asked him to come up with a programme he could do on his own. Vivian suggested a series on colour called 'Prisms'. He would take a particular colour each week and present a loose collection of thoughts inspired by each one. It was the perfect combination of his two strongest talents, art and language. He and Richard produced a pilot programme, 'Yellow'. What did the word 'yellow' conjure in people's minds? Vivian did a number of interviews in the street to find out. He used the show to list artistic variants of yellow and covered an enormous range of abstract connections and definitions of the word.

It was an ambitious piece, its atmosphere enhanced by unsettling use of beat-box music, a kind of ambient industrial soundtrack, mixing early drum-machine sounds with trumpet and synthesizer, predating the vogue for accessible pop science by ten years. His lively presentation was enriched by his radio voice: 'The colour you are about to hear described is not real. During the night this colour does not exist, except in your imagination. This colour is merely a wavelength of light, colour determined only from the surface from which it is

reflected. The sensation produced by the stimulation of light vibrations upon your optic nerve. And by a stimulation I too exist. But not for you. For you I am only electrical impulses and in the disturbed air about you. Only I can prove I am and then only to me and by the most vigorous, painful experiment. Even so, I am not wholly convinced.'

When Vivian pokes a mike at people and says 'Yellow', he is disappointed to report that 90 per cent of people say 'Blue', a response that was quickly 'tiresome', and so he uses only the more unusual ones. 'It's odd,' says Vivian of his survey, 'but d'you know, nobody mentioned a bee? Not so much as a ruddy wasp.' He uses a large number of quotes, fascinated by what people had to say, by communication and by what connections we all make for ourselves. As in Vivian's earlier Radio 4 work, there were clips of music from diverse sources, all mentioning yellow, from country and western to calypso.

The programme is filled with facts about yellow. To break up the stream of information, Vivian booms 'Fact!', 'Lies!', 'Apocrypha!' or just plain 'Nonsense!' depending on how outrageous a claim he makes for a piece of yellow trivia. His mind is, he says, 'littered with the busy furniture of a lifetime's love of worthless facts. For example, I know that the world record for constipation is 102 days.' This is, we are assured, 'Fact!' Nuggets of information burst out of him, he is desperate to tell us and pass on his enthusiasm for learning. From the yellow of General Custer to the Sioux Indians, from Nigerian tribes to the song of the yellowhammer bird and the story of its legendary healing powers, it is almost possible to hear the synapses crackling in his mind with the speed of his thoughts. Like *Sir Henry*, 'Yellow' was a contrast, seemingly rambling, but possessed of a compulsive internal logic and very funny. And it was this that Richard Gilbert had to present to his management. When the programme was largely completed, Richard met the Head of Radio 4, Richard Wade, for a lunchtime playback meeting. Feeling a little apprehensive, Richard turned up with the tape clutched in his hand, knowing that there had not really been time to get the show polished.

'I had to sit in his office while he had his sandwich and mineral water and play the pilot to him,' recalls Richard. From the expression

on Wade's face, it was clear he had some sympathy for expressive colour, but only inasmuch as his face became progressively redder as the show played through the enormous speakers in the room. He immediately said it was not the kind of programme the BBC wanted to broadcast, and that was the end of the matter. The show was not aired in any form. Richard Gilbert never found another opportunity to collaborate with Vivian, although he would indirectly provide invaluable personal help the following year. 'Yellow' was a missed opportunity for the BBC. If ever there was a perfect subject and treatment for radio, Vivian had discovered it, and he was the only man to present it.

'He was a natural broadcaster,' says Richard Gilbert. 'With a patient producer and also a tolerant Controller, he should have had his own show. He had an endless curiosity in so many things, which I always admired. Bit hard to get inside the tight formats that existed.' If he was disappointed at the failure of the show, Vivian did not let on to friends. He was working in the 1980s now, a shinier era and not as friendly as the 1960s. It was extravagant, but not in the cheerfully aimless way of previous years: now it was all geared towards how much the individual could get. Vivian's post-Bonzo career did not measure up well in this materialistic decade. He did not have the consistent output, the effort of just being Vivian Stanshall was becoming more physically costly with each passing year, he was still trying to get to grips with the previous ten years.

'The whole of the 1970s disappeared in alcohol and Valium,' he later told Stephen Fry. 'What I think happened two years ago happened twelve years ago. Rum business.' Many people had lost weekends, John Lennon had a lost year, but Vivian's was, literally, a lost decade.

'I was able to make things – a great many drawings and I even managed to record – but I was at an increasing remove,' he later said. 'As a writer and painter I am used to observing, and without the tranquillizers it was difficult to have a conversation with someone without noticing their gesture, their inflection, their parts of speech and so on, for inclusion in a song or a story; but with the added sclerosis of tranquillization, I became very alienated.'[10]

Vivian's reputation in the music business remained unaffected by his commercial performance and this helped to give him other ways into the music scene of the 1980s. There were connections he made with younger artists. He made a guest appearance on the Damned's 1982 single 'Lovely Money', released in June. One of the original wave of punk bands, the Damned had recorded a disco-tinged track about tourists to the capital and the joys of making money off them. With echoes of the improvised riff on 'The Sailor's Hornpipe' he recorded at the Manor studio in the early 1970s, Vivian provides a spoken commentary behind the last part of the song. While the Damned give their cheeky London punk personas full rein, Vivian is in the background, a sinister tour guide. With his own version of the history of London, Vivian talks about the grey tales of the Tower and launches into one of his favourite subjects, the days of the Empire. Taking his piece in a direction Sir Henry would happily travel, Vivian retells the stories of the days when brave English explorers would waltz into foreign countries, overcome the natives and make off with their wealth. With an energetic edge to his voice, Vivian immerses himself in the song, sounding happy to lend his tones to what otherwise is a minor track.

Given the Bonzos' attitude to the Establishment and Vivian's disregard for conformity, perhaps it was not surprising to find that Dave Vanian, Rat Scabies and the rest were admirers.

Whether working with punks or BBC producers, there was no shortage of ideas and opportunities. It was balancing the routine of everyday life with his creativity that not only made him suffer enormously, but affected Ki, who found it increasingly hard to live with his erratic behaviour. She began to think that what Vivian really needed was a space of his own, somewhere he could create in peace and somewhere he could perform: a theatre. Neighbouring boat owners became involved and were enthused by the idea, which became increasingly ambitious with time. By the following year, when they started work in earnest, there was a group of like-minded souls with their minds set on finding and converting a ship into a theatre, studio and living space. The Old Profanity Showboat was born.

13
Boy in Darkness
1983–84

The idea for creating a floating venue in which Vivian could perform was born early in 1982, when Vivian and Ki were aboard *Searchlight* and part of the Chertsey community of river folk. Their fellow-boat owners were much taken by the charismatic couple. Much hard work and injections of cash would be needed, but Ki and Vivian's alternative lifestyle tempted many pillars of local society to lend a hand. Bankers, lawyers, engineers, even brewers and cooks found themselves lured on a wild ride into the unknown.

As the idea was discussed and shaped over 1982, Vivian worked on projects such as 'Yellow', with Richard Gilbert and the Damned track, while Ki began talking about the new boat to the man who resided on *Mikado* not far along the towpath, but light-years away in lifestyle. Quietly spoken Peter Jackson was a plumbing and heating engineer. He was fascinated by Ki's visionary ardour. The original plan was quite modest. Ki's idea was to devise a *café des artistes* on board a Dutch barge. As Vivian became involved with the scheme, it became grander. He wanted it to include a recording studio and a pottery. As ever, he was most interested in the potential for helping along people he knew and making a community.

'Cabaret,' he said. 'I was only interested in the cabaret side. I wanted to bring down people who are possibly obscure on to the boat and exhibit them, if you wish. Curious poets, musicians, writers, talkers.'[1]

Jackson recalls: 'So we ended up with a dirty great ship. Vivian needed a lot of support, of course. Provided he had his health, he could do some sterling work. He was recording demos and doing a lot of work for Steve Winwood. He could quite happily exist in a creative state. Pamela [Ki] was going to run the external side of things and Vivian was going to have his studio and be creative. I was just the bloke with the oil can. It was Pam's idea completely, but it was always going to be very . . . burlesque.' Peter Jackson discovered the *Thekla* on a trip to Sunderland in April 1983. The ship was laid up and full of water. The German-built Baltic trader had been rusting away for five years. It was owned by a local businessman called Albert LeBlond, who offered it for sale at £21,000.

Peter reported back to Ki and Vivian and all three went to Sunderland to see the boat. They stayed overnight in a local pub in the village of Seahouses. Vivian spent the evening regaling the locals with tall tales and bawdy songs. Recalls Peter: 'It was a vintage performance and he was in his element. He was always great with people. When he was in the mood, he could just switch it on. Yet he was also intensely private. When the muse was upon him he desperately needed a quiet space to be creative. That's when he got really irritated, when pressures were on him and he couldn't get the peace and quiet he needed. When we got the *Thekla* he could sit and write great stuff like *Stinkfoot*.'

Vivian and Ki could see the potential of the old ship. 'It's like a cathedral!' said Ki when she saw the huge hold below decks. Dauntingly, it was clear from that first look that the work was going to be extensive and expensive, but with more recruits joining them all the time, the project – against all the odds – began to take off. The mammoth task came to the attention of the BBC in Bristol and the story of the conversion was told in a TV programme made by producer and playwright Tony Staveacre, who first encountered Vivian back in 1968, on an arts show in which the Bonzos appeared. 'The Bristol Showboat Saga' was commissioned for the 'Omnibus' strand, a long-running BBC arts series. It traced the rebirth of the ship over a year, during which time Tony Staveacre became a close family friend of the Stanshalls.

As the months passed, debts increased, there were unsuccessful attempts by neighbours to sell houseboats to generate cash for the scheme and the whole idea looked extremely wobbly. It was a testament to Vivian that there were always highly motivated and creative people around him. Neil Innes thought the attraction might be partly a physical thing. 'He was a very striking figure. He had that authoritarian voice,' explains Neil. 'There's something about that. It's a tribal, social thing. People tend to take notice of someone who appears to have a kind of authority, even though they are completely mad. The authority is still there. Mrs Thatcher comes to mind.' Many of the neighbours were just thrilled to be part of something so unusual. Peter Jackson 'thought it was the best thing that had ever happened to me. It was so different from my nine-to-five existence running a heating company. In fact, I was sick to the back teeth of running my heating company.'

From an early stage, ironically, it was Vivian who correctly identified the potentially fatal flaws in the project. It came not so much in the financial side of things, but in diluting their creative vision by involving too many people. 'One of the partners brought in this ding-a-ling housewife and Vivian said, "That's enough",' says Ki. 'So he stayed on the *Searchlight*, I dashed up to Sunderland and got the boat organized, while he got completely blotto as normal, and waited.' But there were other pressing reasons why Ki moved out with her children – she knew that Silky could not grow up in the environment in which Vivian was living on the boat. He was quite simply not safe when he was drinking and the boat was a danger.

The defining moment in her decision to leave Vivian came some months earlier, one traumatic night on *Searchlight* around Christmas in 1982. Vivian was waving around a knife and being dramatic, in which activity there was nothing at all unusual – mostly, he was a danger only to himself and even his dog Mr Bones would normally take it in his stride: 'He was an amazing creature,' Vivian remembered. 'He once watched me chasing my wife naked with a machete without batting an eyelid. He just gave his Oliver Hardy look.' Sydney, who was then twenty and had returned from her stint abroad as an *au pair*, remembers him that evening as being 'scary'. Against the

incongruous background of a decorated Christmas tree in a corner, Vivian, armed with the machete, was behaving alarmingly.

'Sydney saw it and Silky was in the middle of it,' says Ki. 'All she had to do was become terrified, which she was. Then I realized it was all over, which was devastating. I would just have punched him in the nose, but not with a baby there. He was raging around.' Ki brained him with a handy yucca tree plant pot, Sydney bit him, kneed him in the groin, and throttled him.

'I just stepped in that night,' says Sydney. She, Ki and Silky left Vivian on the boat and spent the night on Peter Jackson's vessel. Ki and Peter talked late into the night, the events on *Searchlight* giving them the impetus to finalize the plans for the floating theatre. By the following day, Vivian was no better and Sydney remembers 'he was arrested when he continued being scary'. Vivian spent a few days in prison, which certainly 'frightened him', says Sydney. 'But he didn't really remember his episodes too clearly, so it was more like more punishment/betrayal. I just know it changed things from then on in. Ki was unwilling to submit Silky to those kinds of experiences again.' Ki didn't care for Vivian any less; neither of them wanted to be apart. She could not be with him on *Searchlight* any more while he drank. It was just a matter of time. Later in the spring of 1983, Vivian returned to the boat one day to discover that Ki had gone, taking Silky with her and making it clear she was not going to come back permanently until he had dried out. She moved on to the *Thekla* in Sunderland on a full-time basis to work on refitting.

In the immediate aftermath of the split, Vivian felt abandoned in Chertsey. He knew his drinking was largely to blame. That did not help him at all. His feelings of isolation were intensified by a lack of easy contact with Ki. To phone him, she had to cross the huge, freezing boatyard to reach a ramshackle phone booth at the far end. It was evident to those who visited Vivian, such as his Charisma friend Glen Colson, that he was being pulled apart by the frustration and despair.

'He was a tormented man,' says Glen. 'Horribly lonely and miserable, when he had two families he had left behind him and millions of pounds' worth of work just sitting there waiting to be done.'

Over the ensuing months, Vivian's health and well-being went into

steep decline. He was effectively out of the *Thekla* project, unable to contribute his considerable energy to realize a vision that was all about his work. He was unable to be with the people he loved and unable to take his place at the centre of Tony Staveacre's documentary, an absence all too apparent in the programme. Feeling rejected, he sent reams of letters to Ki in Sunderland. Friends rallied around, keeping him company at his lowest ebb. One was a new acquaintance, Virginia Short. She and her husband, Robert, an expert in surreal art at the University of East Anglia, met Vivian through their friend, the producer Richard Gilbert. As a fan of the Bonzos, Virginia wondered whether he was approachable and Richard explained that he was having a difficult time. He would probably appreciate a call. Vivian was charming on the phone and she discovered they shared the same birthday. They also both came from Essex. He invited her to stay on the boat and the two became friends. The first time Virginia came down, she remembers, Peter Jackson visited and Vivian insisted for no clear reason that she hide in the cupboard, locking her in until Peter had gone.

Virginia noticed over the course of their friendship that he became visibly frailer. Between the time that Ki left and Vivian joining her in Bristol eighteen months later, Virginia saw how he went from having the run of the boat to being confined more or less to his bedroom. Partly this was down to the drink, partly also he was not eating well enough, his agoraphobia making it difficult for him to leave the boat to buy food. Peter Jackson and Monica helped out a great deal, she sending down food parcels. Between Virginia's visits, he would phone her late at night when he felt very low.

Vivian's mental processes were as sharp as they ever had been. On board the boat, the two would watch TV with the sound down and Vivian would improvise comedy scripts, which were invariably hilarious. Or he worked on one of any number of projects, some just for his own diversion. Virginia remembers him hearing that Richard Gilbert was writing for one of the men's magazines in London, about how a gentleman might go about pulling girls in London. Vivian was not impressed. 'He couldn't pull a pint, much less a woman,' he declared. In response, he started to write what became a long, funny

and increasingly outrageous article about being a tin fetishist. According to Vivian, this was just like a rubber fetish, except it involved Brasso and can openers. The piece may well have been based on a real-life fan who frequently pestered Stanshall. To Vivian's satisfaction, he learned the man had a bottom drawer full of rubber gear. Stanshall's article soon became too delightfully obscene for anyone seriously to consider publishing.

Despite his agoraphobia, Vivian and Virginia did on occasion go out, once up to London when Vivian said he was very keen to hear Robert Mitchum talk at the National Film Theatre. Disappointed to find the event sold out, Vivian enlivened the journey back by chatting up people on the train. One old lady had a dog who was being eyed up by Bones, Vivian's dog, while Vivian eyed up the lady and charmed everyone to whom he spoke. Robert Short, however, was less impressed when Vivian came to stay over at the couple's house in Norwich one weekend. Having agreed to meet in a pub, Robert turned up to find a crowd of locals, their drinks quite forgotten, staring at Vivian. He was clad in a 'quite gigantic, sort of Biblical, multi-coloured coat, a vast kaftan', says Robert. Grasping an enormous wooden crook, Vivian had his bulldog Bones beside him. On leaving the pub, the two were followed by a group of drinkers, who started jeering and throwing stones. Vivian stood his ground and faced the crowd.

'Piss!' he declared, accenting the sibilants with a menacing intent. 'It pisseth everywhere!' It was indeed gearing up to rain. The unexpected observation had the effect of stunning the crowd into silence and inactivity. As if captivated by the words of a wandering seer, they struggled to find a suitable response. Some looked upwards at the sky. Others stared blankly at the mysterious figure in front of them, giving the two men time to make their escape. The Shorts found Vivian difficult to deal with on his break in Norwich. The change of scene had done nothing to dispel his unhappiness and Vivian's older friends found it little different when he was back on *Searchlight*.

Ever reliable Roger Wilkes turned up for the usual musical sessions, to find that his friend had not eaten for days. 'He was getting very irritable and was just wearing his dressing gown, sandals and a long

beard. He knelt down in front of me and started yelling, "Take me to Chinese restaurant. Please – take me to Chinese restaurant!" He didn't have a cent. Well, I had a little van and I said I'd take him out for a meal. He started walking down the towpath in his dressing gown carrying a great big machete.'

Roger thought to himself, 'He's *not* coming like that. But I had to go along with him.' It was a summer's evening and to Roger's discomfort they passed people out and about for a walk, all stopping to stare at the vision passing them. Vivian was so hungry by the time Roger's van arrived at the restaurant, it had barely stopped before he leapt out of the van, still waving his machete. He went in and began ordering his sweet and sour pork, his four-foot machete in one hand and the waiter shaking behind the counter with fear, leaving Roger wondering whether or not his friend was attempting to impress the owners of the restaurant with his fearsome knife skills.

Vivian's friends could tolerate these outbursts on short visits. They could always run away and hide. It was much harder for Vivian's son. Rupert, now in his teens, would loyally visit the boat once a fortnight, only to discover their father-and-son roles had been reversed and 'nothing had been done since my last visit. The dog had crapped all over the floor, and there was no food in the place. The first thing I'd do literally was clear up, get him sorted out, buy some food, do his vodka run and then spend the weekend as I pleased. I'd go down with fishing tackle and a rucksack full of food and clothes. So I was completely prepared when I got down there.' He was having to grow up fast and, although he was able to tough it out in front of his father, he was developing behavioural problems at school, finding it difficult to contain his anger.

More than anything, he wanted to fit in with the other kids. He took up sport, even though he 'didn't give a shit about football. But if everyone else was involved, then so was I because this was *normal*. I've red hair and they called me Rupert. You bastards – I want to fit in! Give us a chance! I had to fight through school because I did get picked on. I was picked on because I had long hair and because it was red long hair, and because my dad was "different". He would turn up to the school concert at the end of term – inebriated and

really embarrassing. So I had to cope with that while at the same time trying to be normal. I'm not a hard geezer: I just talked my way out of everything.' On visits to Chertsey, he would be sent off 'as a kid at any old time of night, miles into the countryside to find an off licence. "Get me some vodka." And he'd give me the exact money for the vodka. The most I'd ever get for going would be a Yorkie bar.' Rupert had to fish for food some of the time, catching and eating eels and ensuring there was enough chopped wood to get the boiler going downstairs until it was glowing red.

Vivian did show his paternal side on occasion. He once phoned Ki and asked whether Rupert and a mate should be allowed to smoke some very strong marijuana on the boat. 'I'll speak to the missus, boys . . .' said Vivian, dialling the number. 'Darling – should I let 'em try it?' He decided they should not just in case they fell off the boat and drowned.

'So occasionally he would act just like a normal dad,' says Rupert. 'We used to do things like go cycling. Yes, we'd cycle up to the pub or the off licence, whichever one was more appropriate. We usually nipped in the Five Bells and had a few snifters.' Father and son would also go away together, sometimes on a trip to the seaside, down on the beach close to Rupert's grandmother, Eileen, in Leigh-on-Sea. Even there, Rupert had once to tell his father, despite the fun they were having, '"Look, if you get drunk, I'm going home." And he did. So I went,' recalls Rupert. 'He was absolutely gutted. But from then on he actually respected me. He then knew that if I said I was going to do something, I would do it. So later on he did make the effort to try not to drink when I was there. There had to be rules.' Rupert feels he learned to stand up for himself and for his beliefs, and learned to respect people more.

'I would not swap my upbringing for anybody else's. No thanks. Of course it would have been nice if Dad had been a *real* rock'n'roll star. But what an experience! It was wild. It was like walking into the Twilight Zone. I'd go from home with Monica, where it was all nice and carpeted and there were clean sheets on the bed, into a shit-hole on the boat with people shouting and making noise and armed with weapons. It was a boy's paradise.' When Rupert was around or various

friends called, Vivian was fairly safe. It was only when he was living entirely alone that real danger threatened. Within months of Ki's departure, Vivian suffered a fall on the boat and was taken to St Peter's hospital in Chertsey. As his anxiety attacks led to the accident, he was put in the psychiatric ward. On discharging him that spring of 1983, it was decided that he needed some help on the boat for a while. After many phone calls among friends, Larry Smith's pal Steve Buckley was volunteered for the task. A lonely Stanshall was clearly pleased to see Steve and Larry at the hospital when they arrived to take him back to the *Searchlight*.

Steve was glad to be a companion on board, although he had rather got the impression that this would be in partnership with Larry. He, however, soon sloped off, leaving Steve 'in charge of *Searchlight* and on board with England's greatest living piss-artist, poet, raconteur and screenplay writer'. Steve spent the summer of 1983 on board and invited his own friends down, sometimes other artists. Whenever children came on the boat, Vivian would light up. He missed regular contact with Silky and his natural instincts for storytelling kicked in immediately. As film-maker Steve Roberts's son Toby had discovered, his rich voice could whisk a young audience away to the fabulous lands of his imagination.

When Vivian was in good form, he controlled frequent panic attacks, often at 4 a.m. Steve slept in the forward cabin and would be woken by Vivian shouting desperately for him. On one such night, clambering down from his bunk to have a look in the dim light of early morning, Steve saw the huge figure of his friend coming down towards him. 'And the guy was huge, man,' recalls Steve. 'He looked like a cross between Merlin and John the Baptist or Moses.' Vivian calmed down, slept some more and arose early in the morning, despite the disturbed night. Both men started the day with a cup of tea or coffee, but Vivian would inevitably go for something stronger before long and the rest of the day was spent much as it had been before, writing, sketching and working on ideas from the expansive studio space that was his bed.

During Steve Buckley's stay, Vivian drafted what would become the second *Sir Henry* album, though he was always easily distracted

by other projects, and he encouraged his friend to put pen to paper: 'Why aren't you writing?' he chided Steve. 'My last minder wrote all the time.' This was Jock Scott, a friend whose poetry Vivian encouraged. Steve said that he was not a minder, a fact he constantly had to restate, especially when they were at the pub and Vivian, teasing another hapless drinker beyond endurance, would quickly point to his 'minder' in defence, much to Steve's consternation.

The two also drove to the *Thekla* to see Ki and Silky a few times, but there were occasions when Steve was not around to give his friend a lift. In which case, Vivian would take a cab, even when this involved enormous distances. He used the local taxi firm for almost everything else, including delivering takeaway Chinese meals when there were no friends around. The cabbies grew used to driving down the nearby road, parking up and bringing the food across the towpath. On one occasion they provided an extra service in saving his life when the boat went adrift and the cabbie arrived with the meal to find the boat had slipped all but one of its moorings. While its owner was comatose inside, *Searchlight* was swinging right out into the river. The driver rushed off to get the emergency services, who managed to secure the boat.

In Sunderland, documentary maker Tony Staveacre was alarmed by the state of his errant star. Tony really wanted Vivian to appear in the 'Omnibus' film, but was also aware that this central figure in the story was in no fit shape to contribute. 'I feel quite badly about a sequence we shot in the middle of the film with Vivian on the houseboat in Chertsey while the work was going on in Sunderland,' admits Tony. 'He was in a terrible state and I really think I shouldn't have filmed him. I didn't do it maliciously in the sense that people do documentaries nowadays. They'll show people in a drunken state and think it's a great coup. I needed Vivian in the film because he was the linchpin. I desperately wanted him to be in it because I knew that the whole thing hung on his creativity. If he was to be part of it, things could happen. So my film had a great hole in it which was, "Where's Vivian?" And Vivian was living on his own with his dog Bones on this houseboat in a dangerous state.'

Vivian's on-screen appearance was a shock for fans, many of whom

would not have seen much of him for some time. They were not prepared for a frail man looking and sounding so much older than his forty years. In his brief appearance, Vivian is seen busy painting, surrounded by his artwork, exotic artefacts and instruments. Bent over his canvas with his felt hat jammed down over his brow, it seemed as if the words came from nowhere, so completely did his beard cover the lower part of his face. Viewers included Mary, Vivian's first love at the age of fifteen. She had not seen him since she had turned down his offer of marriage more than twenty years earlier. And now, as she was later to confess to Vivian, she could not believe what she saw on the screen. 'I didn't recognize you at all,' she said, sadly. 'And you were totally incoherent.'[2] It was not so much incoherence as Vivian referring to the people on *Thekla* and his isolation from them, but viewers could not have known what he was angry about, that he was unhappy about being so far from the centre of things on the *Thekla*. As it was, he was very clear, loud and furious.

'Yes, I think they're idiots!' he said and, in a pointed reference to Peter Jackson, added, 'You can't have heating and plumbing experts and . . . what the hell . . . You must have an artist before you can have a successful do. Otherwise it's not worth *doing*! They can't do it without me.'[3] As things turned out, he was to be proved entirely correct. They did need just one person to provide a cohesive, guiding, artistic focus. Vivian also simply had 'reservations about the ship because of the other partners', according to Sydney. 'He didn't like to make compromises.'

Over poignant shots of Vivian alone, painting, Ki's voice can be heard giving a concise explanation of the situation and a desperate plea for help: 'Vivian Stanshall is a national treasure and he ought to be protected. He was born without any skin. There's nothing between him and all the sensations that the world has to give us. Because he has no protection, he is subject to anxiety attacks. Because he is subject to anxiety attacks, he takes things to avoid them, or he drinks. It keeps him from experiencing these things, but it also blunts his genius and it's killing him, of course. I created this project to present him, cocoon him, house him, give him a stage. Maybe some day, it still will.'[4]

While Vivian was leading an increasingly waterlogged existence on *Searchlight*, in Sunderland, the agendas of all on the *Thekla* began to diverge. Peter Jackson, once the captain, had been ousted by the rest of the crew. Work on the ship continued through all the various artistic and financial disagreements. The *Thekla* set sail on 30 July 1983, and arrived safely in Bristol after a stormy passage around England.

For the rest of the summer, while Ki and the crew worked all hours in Bristol, a routine developed on the *Searchlight* with Vivian and Steve. Entrusted with the task of buying provisions, Steve would visit the Gourmet, the local food and wine emporium in Shepperton. When he dared suggest they get something to eat as well as booze, Vivian would merely grunt, 'If you must.' Another necessity was tea. Endless pots of Rosie Lee were on the go, to be washed down with the alcohol. There were also pouches of Old Holborn rolling tobacco to hand, from which Vivian built – to Steve's fascination – creations that could, by no stretch of the imagination, be considered cigarettes. Every time he made one, bits of tobacco poked out from the top of the paper, which had been rolled more in the shape of a funnel than a tube. He attempted to light his versions of these ragged cigarettes, while continuing with whatever he was doing or saying: 'What shall we buy from the Gourmet today, Steve?' His friend always watched with astonishment as Vivian got a couple of puffs from these amazing roll-ups, sucking in his cheeks to pull down the smoke, as the construction completely disappeared inside his mouth for a few moments, at length to emerge with a mutter from Vivian: 'Can't seem to get it going . . . Roll me a bloody fag, will you, Steve?'

Like *Sir Henry* director Steve Roberts, Buckley switched between drinking with Vivian and then not touching a drop for days at a time, in a vain attempt to gain the moral high ground and dissuade his friend. Vivian told Steve that he had already tried Alcoholics Anonymous, with inevitable results. 'I met lots of wonderful people I just wanted to take out for a drink.' It was the same old story. What had changed was the attitude adopted by the medical profession towards the effects of stress and anxiety and the recognition that many people had become needlessly addicted to Valium and similar drugs. Granada Television invited Vivian to take part in a chat show that

summer, dealing with the kind of anxiety attacks he suffered. It was believed they were common in the entertainment industry. A Granada TV researcher asked Vivian to take part and, ironically, as Granada was based in the north, this meant flying from Heathrow to Manchester. The very idea of getting Stanshall to fly two hundred miles to appear in a programme about high anxiety was enough to provoke a panic attack in Steve, let alone Vivian. He took a leather satchel in which he kept his medication. As a kind of talisman for the short flight, Steve brought along a Walkman for his friend to listen to a copy of a song he had written with Steve Winwood, called 'Boy in Darkness'. The two had worked on a script for a version of Mervyn Peake's 'Gormenghast' trilogy which, like the song, was never released, the song title probably a reference to Peake's nightmare story of the same name, charting the further adventures of Titus Groan.

Pianist John Ogden and comedy icon and 'Goon Show' creator Spike Milligan were the other guests on the show. With a bottle of wine placed strategically under Vivian's chair, Steve positioned himself behind a curtain, watching his charge nervously. Spike helped Vivian with a couple of prompts. Vivian said he had suffered problems with drugs for years, but it was Milligan who coaxed him to be more specific about the drugs and to explain they were prescription tranquillizers, in case viewers perceived him as just another rock star indulging in recreational drugs. On the show, Vivian was nervous and less articulate than he would later be about the specifics of his anxiety and his dependency.

'Well, I get these bouts of terrible depression,' Vivian told journalist Roy Carr a few years later. 'I'd rather be addicted to smack than Valium. It's a nightmare. It's ruined my life. I've felt suicidal on more than one occasion. At least with cocaine or smack, you can get off it.' Even at this point, Vivian seemed wary of talking too much to Roy. 'The strange thing was Viv would tell you so much and then he'd clam up,' says Roy. 'He suddenly felt he was telling you too much.' Even someone as articulate and aware as Vivian found it hard to talk about something that gave him so much pain. That he talked of depression was enough, though Ki believes he was not referring to it in the clinical sense, explaining it was 'a numbness of spirit, a lowering

of sight and mind and soul. What Vivian meant when he said depressed was "despairing". He would despair of ever not panicking, of ever feeling fit, of ever getting the work out, of ever being good enough, of ever doing whatever it took to have his family live with him again.' Many friends and colleagues never really understood the scale of Vivian's problems and just put it down to outrageous behaviour.

'I always thought that there was an element of risk being with Viv,' says Richard Gilbert. 'I did one interview with him for some music magazine and that was when he had been through the worst of all the various cures. It was very painful, the way he explained it in detail. I had no idea at the time that he was so involved with terribly large amounts of tranquillizers.' Vivian was far less forthcoming on the Granada programme and Steve was just relieved he got through it and back to *Searchlight*.

Over the August bank holiday weekend, Vivian returned once more to Rawlinson End. He had been drafting a new episode called *Sir Henry at N'didi's Kraal* for a while and it was recorded with producer Mario Tavares. Among those on the album were Sean Oliver on bass, Bruce Smith on drums, Suzi Honeymoon on violin and Jon Glyn on saxophone. A striking sleeve – Sir Henry powering ahead on a toilet (which convenience features prominently on the record) was depicted in a suitably pungent cartoon by Ralph Steadman. The story charts the attempt by the irascible master of Rawlinson to find a lost tribe of Zulus in South Africa. An academic named Sir Geoffrey comes to meet him at his house and asks him to go on the expedition.

He represents the Geographic Society, of which Sir Henry is a member, and reveals the old man of Rawlinson is well thought of as an explorer. This *Sir Henry* story differs from previous recordings in that there is one definite plot line that sustains for the length of the album. It just is not nearly as polished as the original tales. Vivian's narration is slow and the plot is laboured. It is not helped by poor recording quality and amateurish effects. Vivian was particularly unhappy about producer Tavares adding sound effects which Vivian thought were unnecessary, such as crackling log fires, at any opportunity.

The best *Sir Henry* stories were always loosely constructed, but never plodding in the way that what passes for a plot is here. It focuses solely on Sir Henry, giving little room to develop other characters, and is largely an excuse for the squire to expound theories of Empire at great length. It seems at times that Vivian was trying out jokes for use in some future story. Many of the 'gags' are often convoluted, like one about Sir Henry painting numbers on his African servants because he cannot pronounce their names.

The result was a contradictory mix of Sir Henry's belief in racial superiority and Vivian's genuine affection for African culture. When Sir Henry finally reaches the tribe, ruled by the N'didi of the title, for example, Vivian goes into some detail about the hierarchy of village life and how the warrior class is structured. What could be a sympathetic tale of life in Africa, however, never goes much beyond caricature. The absence of those jaunty ditties, which so enlivened earlier Sir Henry recordings, does nothing to dispel the heavy atmosphere. The music is mournful, largely provided by solo violin and African-sounding drumming and chanting, the one exception being a melody line, which would be later rescued and worked into a more complete autobiographical song for a BBC 2 broadcast, in which appeared the line 'If you had the wit to realize what you could be with your potential'.

Ironically, it was this line that really summed up *N'didi's Kraal*. On the rare occasions that Vivian sings here, it is in the rock'n'roll shouting style of *Men Opening Umbrellas Ahead*, rather than the delicate voicings of *Teddy Boys Don't Knit*, and the production values are so low, it sounds like a kind of demo recording. The album is unwieldy, with a few nuggets of vintage Stanshall wit scattered throughout, but they are far from enough to lift the sombre mood of the recording. The shorter Peel Show stories had skilful pacing and were full of light touches, all the more noticeably absent here, in the longer format of an album.

Vivian's personal situation was not far from the surface. A letter sent by Sir Henry from Africa to his wife Florrie in England seems nothing more than a plea from Vivian in Chertsey to Ki on the *Thekla* for help both material and emotional. Sir Henry admits he's got

himself into a pickle on the expedition. Declaring his great love for his wife, Sir Henry asks her to send him crates of brandy, several hundred roll mops and a mouth organ. Later in the letter, Sir Henry voices what must have been on a lonely Vivian's mind out there among the houseboats of Chertsey, without the succour of a sympathetic mindset to ease his solitary existence. He asserts the natives need to have a regular rendition of 'Jolity Farm'. Complaining that all he hears are drums and banjos every night, Sir Henry grumbles that his crew can't sing the chorus properly. When Sir Henry ends the letter by deciding he would really prefer to have his tuba with him, it seems that Vivian is himself out there on the veldt, waiting in vain for someone with whom he can play an old jazz number. If *Sir Henry at N'didi's Kraal* was hard going for the average listener, the fact that it was issued at all was a matter of huge embarrassment to its narrator.

'Just to set the record straight, this was semi-recorded while Vivian was deeply depressed [and] mind-numbingly drugged,' Ki later wrote. 'The material was never edited, or worked on, or sorted out, or thrown out or redone. Neither he nor I have ever listened to it. I could not bear it and neither could he.'[5] The impetus for the album's release came from Glen Colson. Just as Pete Moss had found it difficult to keep Vivian in line during the recording of *Teddy Boys Don't Knit*, this latest Sir Henry adventure was a similar battleground for Glen.

'Towards the end he went on the piss and I couldn't even talk to him,' says Glen. 'He was in a stupor for months, so I had to edit the record myself.' *N'didi's Kraal* was eventually issued on Demon Records in September 1984. Vivian sounds perfectly coherent throughout his reading of the script, although it lacks the easy humour of earlier outings or a sense of spontaneity. It sounds unfinished, a first draft. The editing process took its toll on Glen, who came under fire from Vivian and his closest circle for the results.

'I took it to him and he couldn't even listen to it, because he was too out of it,' says Glen. 'So I did the deal and put it out and I did it as well as I can. But he had no respect for me as an editor. The only way he liked me was as a kind of old friend, who he was training up. Other people would have to take over making films or records

when Viv went on the piss, about halfway through. And then he'd blame them when he'd sobered up again for finishing it off without him.' If nothing else, *N'didi's Kraal* gives a real sense of how much more work usually went into getting Sir Henry tales right. When the album was finally released, Vivian was hardly up for the publicity rounds. At one radio station, LBC in London, Vivian dozed off before they had even got to talk to him, leaving a furious producer berating Glen as the presenter hastily put on another record. It was the last time Sir Henry would appear on vinyl.

More immediately after recording *N'didi's Kraal*, at the end of the summer of 1983, Vivian was on his own once more. Steve had returned to Islington. For Vivian, the winter of 1983 to 1984 was a tough one, but much harder on poor *Searchlight*, and by March 1984 boat and owner were both exhausted. Vivian was back in hospital and *Searchlight* – complete with all Vivian's possessions, all his treasures, instruments, masks, marvellous clothes and memorabilia – sank to the bottom of the Thames.

The reason seemed clear enough. It was a dilapidated old tub by now, which required more maintenance than Vivian could give it. In Stanshall's circle, however, rumour and stories soon brewed up about the sinking, enough to give the incident mythic status: the electric bilge pumps failed, that was the most likely and prosaic reason, although it was suggested that driftwood struck it. Another explanation was that a callous neighbour wanted Vivian out so he could take the valuable mooring space. According to this sinister theory, the cocks were opened and the moorings cut, and the boat was pushed out. It went down the river, over a weir, and broke up.

No proof was ever found to substantiate this theory, and even if the cause was a malicious person, the boat did not encounter a weir. It sank by the towpath. Other friends looked towards Vivian as the prime, if unwitting, suspect. Houseboats require a great effort to maintain them, and can be quite easily destroyed. Without regular maintenance, rainwater and general water seepage will put paid to the most sturdy vessel. Peter Jackson lost a houseboat in the same area some time before: 'I spent an absolute fortune and was going to put it on the market,' he explains. 'It broke its moorings, went off down

the river and sank. So everybody immediately started saying I had gone for the insurance money. But there was no insurance. You can't get it. It's just the strain put on the ropes when the river is running. These things happen.'

The story that reached Neil Innes was that a rip tide came down carrying a tree trunk, which holed it below the water. 'Everything that happened to Viv was larger than life,' says Neil, who was alarmed by what he had heard, if not surprised. 'And it happened on his birthday, too.'

As those who lived in the area knew, the boat had been leaking like a sieve for ages. Ki, with her intimate knowledge of life on the boat, was – like Neil Innes – not astonished to hear what had happened. 'The boat was always trying to sink,' she says. It didn't even need to be holed. 'All that happened was the water pump gave up one day. All you had to do was be gone for six hours and that was the end of the boat. It would fill up to a crucial point and down it went. You couldn't stop it.' Rather than maintaining the pumps, the captain of *Searchlight* was back in St Peter's hospital in Chertsey after another fall, this time down the stairs of a neighbouring houseboat, where he had once more dislocated his shoulder. A neighbour phoned the hospital and Vivian later told a friend that he was summoned to the director's office where, he said, there were two men in white coats, each armed with a hypodermic.

'Mr Stanshall, I have bad news for you,' began the director. 'Your boat has sunk.' Vivian later said he thought they were talking metaphorically and were rudely suggesting there was no hope for him.

'Nonsense, I'm as fit as a fiddle!' he exclaimed.

'No, no, you don't understand,' the doctors responded. 'Your *boat* has sunk.'

Friends and family rallied around. Monica and Rupert rushed down, and the family contacted Steve Winwood, who allowed a lot of Vivian's stuff to be stored at his place. If there was a positive aspect to the disaster, it was that the Thames was shallow at that point of the river and the boat was not entirely submerged. Everyone worked hard to rescue what they could before all of Vivian's possessions were

completely ruined. Other people in the area helped to get everything moved, including a trumpet player from the London Symphony Orchestra who happened to live nearby. An operation was mounted to clean up what was salvageable, including demo tapes. But for someone like Vivian, whose home was also his creative space, the sinking was catastrophic. A valuation of the loss was impossible – floating around in the filthy canal water at the bottom of the boat was all manner of memorabilia that could never be replaced. The boat itself was raised by enormous, diesel-guzzling pumps which spewed out great fountains of water, full of oozing black slime from the guts of Vivian's home. It was horrible and heartbreaking.

'We went inside and closed all the portholes and watched it come up like a lift,' says Peter Jackson. With money from Steve Winwood, a special rubber cover was put over the hole and the boat was once again on the surface. Vivian was proud of the new accessory, telling friends, 'I'm back aboard and I've got a rubber nappy on the boat!' It was to prove but a temporary reprieve for *Searchlight*, which lasted another six months or so, if indeed it was ever really once again a viable proposition. The dingy, damp boat was now an inviting palace for rats. Taking advantage of the damage caused by the sinking, they made themselves at home on board, causing yet another very real health risk for the boat's owner.

Steve Buckley attempted to get Vivian to abandon the boat entirely, but to no avail. He eventually got him to compromise in taking a trip down to Bristol, and the two took their time meandering back, calling in on the way to see Larry Smith, who was then staying with Whitesnake's Jon Lord near Henley. Finally, Vivian was convinced to come back to Steve's place in Upper Street in Islington for a while, something of a nostalgia trip for Stanshall, a reminder of the early flat-sharing days with Larry. But it did not work out. Steve could tell that Vivian was not happy and, in any case, the sojourn came to a spectacular end after just a few days. The two went to a squat party, at which Steve knew they could find a few musicians and maybe have a jam. There was a session in progress when they arrived, and Vivian soon got into it – an amazing sight.

'He was big time, really big time. The whole body would move,'

says Steve. Vivian started singing along and his legs, his abdomen swayed in time. He completely immersed himself in the music and was the centre of the session, which they left only when Vivian decided it was time to go to the pub. The landlord made it clear he did not like the way Vivian looked, telling him he took exception to his attire, to which Vivian immediately replied, 'But what if I took exception to your bald pate?' Altercation narrowly avoided, the pair returned to the squat. Vivian continued to get on well with the musicians there, which cheered Steve no end, until he found his chum had disappeared along with one of his new acquaintances. Steve rushed outside the house to see the musician in the driving seat of Steve's old BMW. Vivian wanted to be taken to the nearest off licence and pointed the way forward like a commanding officer, 'Drive on!' Whether or not the other musician could actually drive was immaterial; he was certainly not in any condition to be on the roads. Soon after the car turned around the corner, there was, inevitably, a loud crunch. As Steve rounded the corner he saw the remains of his car, embedded into a lamp post which had, with some style, fallen on to the bar of the adjacent Almeida theatre. A vanload of constables soon arrived from a nearby police station and much more explaining had to be done.

With it clear to Steve that the plan to keep Vivian off the boat was not going to work out, he realized his friend was no better off in the heart of the city. That same night he told Vivian he was going to ring Monica and dispatch him over to her place in a cab. Vivian was angry, but Steve made his call to the cab firm, put him in a taxi and did not see him again for ten years. Vivian found his way back to *Searchlight*. He was once more out of action on board the leaky tub, while the crew of the *Thekla* were working towards the July opening date for the Old Profanity Showboat. They had no star, the man who should have been fronting the show seemed at death's door. It was Tony Staveacre who came up with a solution. He had completed his documentary, but was not prepared just to walk off after filming and, by coincidence, his brother Dermot was a counsellor at a drying-out clinic called Clouds House, near Warminster. The likes of Barry Humphries had been treated there and a few of the *Thekla* associates decided to try and nudge Vivian into treatment.

'I suggested Clouds House would be a good place, because it wasn't far from Bristol and Pamela [Ki] and I could both visit him,' says Tony. 'The fact that my brother worked there also gave him some reassurance. So I'm glad that happened, quite soon after we'd filmed him. I think his life might have ended then if he had not gone into treatment in 1984. Of course, the treatment didn't work. Not completely.' Clouds went in for uncompromising treatment, all very tough love. You could not go back to social drinking and each client had to go through a complete process of reassessing his or her life and making choices for the future which might involve rejecting things from the past.

'I think Vivian found that hard,' says Tony. 'I also think he found it humourless and there was not much encouragement to joke. There is a kind of spiritual side to it which Vivian might not have liked. He was such a flamboyant character.' Treatments were based on group therapy, with people sitting around and talking about their lives. It was a rare foray into therapy for Vivian, who 'never saw a regular shrink', according to Ki. 'Only those you find lurking in loony bins – which is to say, he never really saw a shrink. Not in my time. He did see doctors, but only to cadge Valium off them. Fed 'em a brill line or two, and then straight to the pharmacy.' Vivian would naturally dominate any group, as he did with Clouds' therapy, and he was always the centre of attention. In the short term, at least, the treatment did have a great effect on Vivian, providing him with the impetus to complete his first full-length stage production.

Tony visited Vivian in Clouds with Ki. 'She's a great lady and she could really get people going.' Vivian was certainly among those people. It was a family visiting day, when nearest and dearest could be part of the group therapies. Tony and Ki turned up to hear everyone solemnly confess to the awful things they had done to their kin. It was all very organized. After the meeting, visitors took tea with the members and had individual interviews. Some time during the proceedings, Vivian and Ki disappeared and, when they came back, Vivian looked flushed. It was pointed out to them in no uncertain terms that the clinic took a very dim view of people disappearing in the afternoon and coming back looking flushed. 'That showed the

humourless nature of the place. For God's sake – why couldn't they?' exclaims Tony. 'Anyway that was a pretty Vivian-and-Pamela-ish thing to do. Although I don't swallow this idea that alcoholism is a disease and that if you are an alcoholic you *must* stop drinking, it's a philosophy that works. It frightens people and the truth is these treatment centres have an amazing success rate.' Clouds was as good a bet as any – Vivian had certainly tried enough different routes to treat his alcoholism.

'He did go to a hypnotist,' laughs Ki. 'What a hoot. The man's voice carried across half London. *You will relax. Sit down and relax!* Fab.' And then there were the relaxation tapes a well-meaning person gave to him. Vivian simply could not listen to them. 'Listen to this,' he'd sneer. 'Blighter can't pronounce his sibilants.' Ki listened and learned to self-hypnotize – she too had panic attacks, 'especially after a year or two of Vivian', she says. 'But due to his artistic ear, Vivian could make no use of them. Silly bugger.'

If Vivian found temporary solace in Clouds, there was no such reprieve for *Searchlight*. The faithful boat gave up the struggle against the elements. She simply could not continue in her hastily repaired state. In the summer of 1984, months after the first sinking, the nails in the nappy were giving way and the rubber was starting to tear. Steve Buckley took wheelbarrow loads of sodden, ruined clothes down the towpath to put in a convenient wastebin. *Searchlight* sank for the last time.

14
Calypso to Colapso
1984–87

The *Thekla* was the venue for Vivian and Ki's great dream of artistic fulfilment together. The boat was also a permanent home for the family: Ki, Silky and now Vivian. He was out of treatment and on the Bristol boat on a permanent basis, in time for the grand opening in July 1984. He was not yet fit enough to do much and, indeed, the opening production did not feature him at all. Instead, the Reduced Shakespeare Company did a show on the boat, now officially renamed the Old Profanity Showboat. Its unofficial address was given by Vivian in a letter to a friend as 'Old Profanity Bugger Lugger, One Foot In, The Grove, Bristol.'[1]

The lack of Vivian in these opening weeks, even though he was at least recovering, proved to be a telling absence. 'His input would have been wonderful and the place would have been packed,' says Tony Staveacre. 'But he had been in treatment just before they opened and when he came down he could do nothing except paint a few posters. He hadn't got working again and that was a shame.' That was enough to keep him busy – every production or stand-up poet who did a spot was after Vivian to create publicity material. Some of the work he did in this area he later reused himself, including a painting of the out-of-body experiences which had so affected him during the Bonzos' US tour. This artwork was to form the striking cover of a

reissue of *Keynsham*, a fitting choice for the album, which had been largely concerned with fragile states of mind.

Tony Staveacre's 'Omnibus' film was aired not long afterwards, on 30 September 1984. By the time the edit was finished, it had evolved from being a straight documentary about how to set up an arts venue into something rather more peculiar. 'It was really weird,' remembers Tony. 'The truth was the enterprise and the potential of the thing as an arts venue was really overshadowed by the wonderful hilarity of the people involved and the craziness of how they went about things.' There was a lot of positive feedback, although many traditional arts folk wondered whether the film, strictly, should be in the 'Omnibus' strand. At that time the show was introduced by Humphrey Burton and was all very highbrow. Perhaps the Beeb had been too optimistic in thinking that a straightforward, serious documentary about arts funding and the difficulty of setting up new theatres could sit in the same programme as Vivian Stanshall.

'The film was also hilarious, simply because of the eccentricity of the protagonists,' says Tony. 'Here was a wonderful group of funny people – a plumber, a Red Indian authoress and this Bonzo man. You couldn't go wrong really.' Vivian himself did not like the show, telling his friend Virginia Short that he felt he had been sidelined and marginalized and getting her to call up the BBC and complain about the programme. He busied himself promoting a young blues singer from Bristol called Nikki B. With some cheek, having complained about his programme, he rang Tony Staveacre to try and get her on television. Keeping up his collaborative efforts, he worked with Steve Winwood in the latter's studio. Winwood's own solo career had undergone a renaissance and the two wrote 'My Love's Leavin'' for Winwood's highly successful *Back in the High Life* album, released in 1986. Vivian said that there were many more songs that never made it to vinyl.

'Steve and I have written about a hundred more things than have ever been released,' Stanshall told Alan Clayson.[2] 'He might have a melody, and I'll say, "I think this feels like this." This wasn't typical, but I wrote verses about Crazy Horse, chief of the Oglala Sioux. Steve read it through and declared that it was singable – after all, a poem

is meant to be read and a lyric is meant to be sung. Crazy Horse is the only mystic I've ever had total admiration for because, being called an "eccentric" myself, and all other sorts of derogatory versions of that, he stuck it out. After every other Indian was on the reservation and Sitting Bull arrived in Canada, Crazy Horse stuck out and they had to kill him – otherwise they wouldn't have got the railroad through.'

As Vivian's health improved, he was able to turn his full attention to the writing of *Stinkfoot*, his first full-length musical, premiered over Christmas 1985. Ki was delighted, feeling that this was what the Old Profanity was meant for – everyone else involved in it had wanted a go. 'I never knew that all the people who were working for me, all the actors and actresses who came and worked behind the bars and cleaned up shit and vomit in the urinals, thought they were going to have their own star turns,' recalls Ki. 'But there was never any time. We had to make money all the time and keep the bar open.' The Old Profanity simply could not go on in the way it was, she told Vivian. They had to have a big show, and it was going to have music. Sifting through all sorts of musicals turned up nothing suitable and Ki determined that they should write their own. 'We'll showcase everyone we really care about,' she told him.

Stinkfoot was set under a pier and the *dramatis personae* included, as you might expect to find under a pier, singing lobsters. The inspiration for this may well have come, at least in part, from Vivian's summer season playing with the Temperance Seven at Shanklin Pier in the Isle of Wight, back in 1972. 'In the dressing room you could see right through the cracks in the floor and watch the men in wetsuits fishing for lobsters,' Vivian later recalled.[3] More directly, *Stinkfoot* was 'embarrassingly autobiographical', he said, 'and is about a bloke who talks to himself all the time. He is a ventriloquist and he trains two cats, Stinkfoot and Persian Moll, to do his act for him. And because they are both ruthless brutes, they are able to do cold-bloodedly without fear those things a human being – particularly a sensitive artist – could not accomplish. He believes that this is so himself when the cats disappear. He has to fall back on his own resources and finds that he cannot live with himself. I went into a tremendous gloom

because I was naked – I wasn't cocooned and shielded from the outside world for the first time in many years. So that every stimulus was potentiated, the reality was enlarged for me. And what I saw – what I had glanced past hitherto – was very frightening and for the most part extremely depressing. So I concocted this story to pull myself up. I tried to make some sort of prescription for being jolly, and to say that life was actually all right.'[4]

Stinkfoot was adapted from a children's story, written by Ki in America, and concerned the adventures of an alley cat in New York. She soon realized that a wild cat was probably not suitable material for children, and it 'sat around for years until I showed it to Vivian and he adored it and used to read it to Rupert. Only Rupert and Silky know anything about it because Vivian read it to them, doing all the voices. He was very familiar with it.'

Many of the songs which found their home in *Stinkfoot* had never been used before – particularly the ones he had written on the *Searchlight* about Ki disappearing off to Sunderland to work on the *Thekla*. 'He wrote "Made of Stone" and "No Time Like the Future",' says Ki, 'and an incredible song called "Simone", which has never seen the light of day, which he recorded on a little cassette. He wrote all these beautiful love songs and then we had to find a script that would fit these songs, and these people and our stage. God, talk about an idiosyncratic piece.' He also began to compose material specially for the show, songs with such wonderful titles as 'You Can't Confound a Flounder' and 'I Know What My Public Wants – What My Public Wants is Blood'.

Surviving copies of some of the songs show them to be very much in the tradition of rock-opera material, narrative pieces free of much of the wordplay and detailed references that typified his solo material. 'Hear me, won't you listen to me?' ran the song 'No Time Like the Future'. 'Living your life isn't easy, but now's the time.' There were echoes of Mae West to be found in a saucy number sung by slinky feline Persian Moll, aptly entitled 'Come Up and See Me Some Time'. Moll purrs, 'If you want to know all my peccadil-loes/'Bout the bad little things that I've done/If you take the risk, it's a real-life burlesque by the mean-mama minx who loves fun.'

Another standout was 'Only Being Myself', into which Vivian
worked his more personal lyrical touches, giving the song a subtle
lift: 'I was living only me/I was loving only me/I only hope you buy
this switcheroo/Now I've become myself I can love you.' In total,
there were twenty-seven original songs, every one of which was used
in a three-hour show, and that was without the grander plans. Vivian
originally planned a multimedia spectacular. 'I have in mind a chorus
of ship's horns and brass bands, all directed by radio,' he told the
local paper.[5] 'Now wouldn't that be marvellous, with everyone in
the area taking part.'

The final version of *Stinkfoot* has some elements in common with
Sir Henry at Rawlinson End. Both represent aspects of being Vivian,
and of being an artist, through their characters. The main figure in
Stinkfoot was the Great Soliquisto, 'a dignified gentleman *artiste*. A
ventriloquist and puppeteer in the Great Tradition of English Music
Hall.' At first it seems he knows how to make the 'inanimate live', but
we learn his secret is that he 'was once an Artist'. It is up to his
nephew, Buster, to discover the truth. Vivian wrote a song about
Buster's quest to crack his uncle's puzzle, which was also bound up
with the nature of genius, called 'Follow Your Nose'. Ki recalls: 'Oh
God, it was a glorious production.'

Stinkfoot was upbeat and featured what a *Times* review termed a
'highly moral plot', in which 'regeneration triumphs over evil and all
optimists ultimately defeat the pessimists'. Vivian himself saw it as
'contemporary Gilbert and Sullivan; popular, optimistic, enormously
visual.'[6] As ever in Vivian's material, the actual plot was not as impor-
tant as the fun Vivian and the crew had inventing characters, which
included intriguing creations such as an Ocean Liner and a Giant
Squid (played by 'The Desperate Men'). There were Three
Barnacles, a Partly-Cooked Shrimp played by Andy Black (who also
played the Great Soliquisto), a Very Drowned and Putrescent Sailor
(Steve Howe) and a Hoarse, Coarse Coastguard (Pete Coggins). Now
that Vivian was back in the swing of things, people around him
became enthused, as they all had been when the *Thekla* project was
first mooted. Vivian commented: 'All the people involved are doing
it because they trust me and because it will be fun.'[7]

Crew were recruited on an ad hoc basis and included local artist Mark Millmore, who became involved after Vivian wandered into his local art workshop to get etching materials and the two started chatting. Unlike his colleagues, Mark was not fazed by Vivian's intimidating aspect and they quickly became friends. Mark walked Vivian, who was suffering from a bout of agoraphobia, back to the safety of the *Thekla* and was soon asked if he wanted to be a designer. At the time he was working for the BBC and earning a steady £25 or £30 an hour as a scenic artist working on location. Vivian persisted, and Mark agreed to come down to the boat a week later, when the company who would put on *Stinkfoot* were due to start rehearsals.

Sydney, who played a character named Mrs BagBag, remembers the run-up to the show being exciting, if as emotionally fraught as theatrical productions are. Vivian was a hard taskmaster and still a perfectionist. 'He had some interesting ways of doing things,' says Sydney. 'Like he gave us new lines every rehearsal and even when we were performing it before an audience he would make changes.' Putative set designer Mark Millmore turned up for one of the first rehearsals of the Crackpot Theatre Company and was completely carried away by the atmosphere.

'There was this incredible feeling of magical creativity going on,' says Mark. 'I'm sure this is what Vivian for most of his life had been able to create in any given situation. He could walk in and create some sort of magic, where people got together and made something happen. I thought to myself, "Bugger £30 an hour, I want to be involved in this!"' Mark left his job at the BBC 'and became poor!' Over the next few years, he worked with Vivian on a number of projects, retaining his most heartfelt affection for *Stinkfoot*: 'When Vivian was on form he had an extraordinary ability to juggle many different ideas and mediums simultaneously.' *Stinkfoot*'s set-design brief was an unusual one, taking into account the length of the stage within the boat. There were two scenes, one set under the pier, and the other in a theatrical dressing room. Mark created painted waves and suspended them from a bungee cord at intervals all the way to the back of the stage. Because the stage stretched so far back, a good deal of the length of the boat, it was a realistic wave effect, moving up and

down. Characters 'swam' between the waves, under the pier, which was represented by the beams of the boat.

The production came together in just nine weeks, during which time Mark and Vivian's friendship blossomed. Vivian sometimes stayed at Mark's place when he wanted to get off the ship. In Mark's flat they had long, rambling discussions and Stanshall told him how much he admired Salvador Dali and that he was to make a trip to Barcelona to see the museums and exhibitions devoted to the great surrealist. He talked about his influences and heroes, such as Sir Richard Burton, the Victorian explorer: 'He was one of those men in whom nature runs riot,' wrote Alan Moorehead in *The White Nile*, his story of the great river and its explorers, 'she endows him with not one or two but twenty talents, all of them far beyond the average and then withholds the one ingredient that might have brought them to perfection – a sense of balance and direction.' Burton, born in 1821, had been far further than even Vivian suggested in his most outrageous anecdotes of the Merchant Navy. Burton's many expeditions included visiting lost cities and attempting to find the source of the Nile in partnership with John Speke. Sir Richard was also a formidable polyglot, aggressively intellectual, a legendary explorer and a celebrated writer. He translated the *Kama Sutra* and published stories based on *The Arabian Nights*, and his open-mindedness in discussing sex and studying erotica from the Far East drew criticism in Victorian society. He was also famous for writing on swordsmanship and falconry. Vivian's breadth of interests was in turn an inspiration to Mark, dazzling him with knowledge.

'I'd never had a conversation with anyone else like that before,' he remembers. 'He had this wonderful way of expressing himself, this absolute grasp of the English language and at the same time being able to bend and shape the words to create pictures in your mind.' Mark was not afraid of Vivian. Like Pete Moss, Mark would indulge his more outrageous examples of wordplay or let it pass when he was staggeringly rude. Most people on the receiving end were either stunned into silence because they felt they had just been spoken to by a legendary figure or mortified because they had never been so insulted in their life. Vivian would, as a result, quickly become bored.

This friendship with Mark regularly included correspondence in which Vivian demonstrated his regard by writing:

My dear Millmore,

in my opinion; you and all other deviants, pinkos & long-haired self-indulgers, masturbators and so-called-artists (in short, the unemployed and the unemployable!) should be put against the wall and dealt with brutally. But I am a humane man – and would prefer that somebody else acted on my opinion. That is only democracy!

There was a time when an officer was white with black privates – and everybody knew where they stood!

It is mere decency that sways me to give you what you asked for (OOPS application form) and not what you damned-well deserve: an ice-cold shower, a thorough thrashing & 2 years at least in the Armed Forces!

Be that as it may, I shall continue to refuse to shake your hand, will snub you in the street and take all reasonable (or otherwise) measures to avoid you.

Sadly you have yourself to blame, & those noxious indian cigarettes!

Bah! To you,

Vivian.[8]

Tony Staveacre was similarly charmed and found himself part of the team, roped in to provide some musical accompaniment for *Stinkfoot*. 'At some point I let slip to the great man that I was a saxophone player,' says Tony. 'He had this effect on you. When he said, "Come and play in the pit band", you just couldn't say no. He sucked you in. So I dusted off my alto saxophone and played in the orchestra.' The musical arrangements were done by a Bristol man called Pete Watson. Like other musical directors for Stanshall, his role by rights should have won him some kind of Order of Merit medal. Watson's job was to take Vivian's creative ideas and get them into some kind of order for the other musicians.

'He was a very nice fellow who was set this impossible task,' says

Tony. 'Vivian didn't write music. He just sang into tapes and played the ukulele. He gave Pete the demos of the songs and he had to write orchestrations. We would go in there and Viv'd shout and rant at us! And these people were giving him their time for free. Viv would come round in the interval and shout at the band. He was a tough nut. He was very demanding and if you let him down he would give you a hard time, even if you were volunteering. I played the saxophone for him because I loved him, but he would shout, "You're playing too many bloody wrong notes!"' It was only because he invested everything of himself in his work and wanted only the best from everyone around him, who naturally responded in kind to his irresistible enthusiasm. He was bursting with the customary zest he invested in his projects. In early October he wrote to producer Richard Gilbert that he had 'a gorgeous danseuse, a gargantuan chanteuse, a bloke cutting a hole in the hull for a balcony scene, four new lyrics to knock off and comedic dialogue for Brioslian flounder. Also, the Press Johnnys to see off the premises with a fiddle-de-dee in their ears. And a quip.'[9] The mood on board the Old Profanity Showboat was at last good as everyone realized 'an English comic opera in the grand tradition' was being rehearsed. Another member of the Stanshall family pitched up to see what was going on. Mark Stanshall was amused to discover that the venture was costing the backers – a brewery – an absolute fortune.

There were friends of Vivian who thought of the creative partnership of Vivian and Ki as one that lacked balance, Rodney Slater among them. 'She always wound him up. It was just her presence and it was the way he felt about her,' he says. 'He couldn't resist her physically, but she was the last person he wanted to be with in an everyday situation. It was quite complicated, but basically he was jealous of her. She was a writer and quite a successful writer, so that didn't go down too well. I think a lot of the time he was in competition with her. And she held the whip hand, he was completely useless for a lot of the time. He was on her boat and he was living off her. He didn't like that, because he was a proud man.'

Stinkfoot was a chance for Vivian to establish equilibrium. The show ran from 7 to 21 December 1985, a kind of alternative pantomime. It

was packed full of the outrageous costumes, humour and songs which had characterized Vivian's *Sir Henry* work, and this, his first major outing for a while, created huge interest. Stephen Fry, Pete Townshend and Steve Winwood all came to see the show, as did critics from *The Times* and the *Guardian*. That first-night audience even included some American fans, who somehow heard about the show, hired a plane, took a bus from the airport to watch the performance and returned home the same day. The press coverage was overwhelmingly favourable.

The *Guardian* commented: 'The ideas spill out of him: pastiche, the surreal, visual jokes, and new songs by the conveyor belt (several are infinitely better than most of what masquerades as Top 20 material these days). Who are we to complain if the sheer output obscures the narrative and the shape? . . . the marvel is that here is an original, unusual musical, smelling of the salt sea, with Coward, Cagney, and Mae West around to keep us happily buoyant.'[10] It was a great success. They did not make any money, but felt it was appropriate, getting together something worthy of the Old Profanity.

Once *Stinkfoot* finished its run, the enormous amount of energy needed to keep the *Thekla* project alive started to dissipate. It was becoming ever more apparent that further finance was not forthcoming. They tried various ways to make money, mostly by getting in loud bands to attract a crowd, but none of the *Thekla* crew was a commercial promoter type and nor were any of them greatly interested in that side of things. Vivian was still involved with Nikki B, recording five demos of *Stinkfoot* songs at Winwood's studio. When he went off to sell Nikki to various record companies, all the doors were open to him, a measure of how respected he was. The moment he was well enough to present himself, everyone was interested. Far from being a transient pop star, Vivian's fifteen minutes in the spotlight were renewed as many times as he was able to enjoy them, a unique position in the music industry.

Vivian's own career was reigniting; he was getting more offers than Nikki, whose chances were diminished because she did not have her own material. She was a bluesy-voiced diva who injected enthusiasm into some of Vivian's other songs, including a raucous number called

'Mieow Blues', which she performed in April 1986 on the *Thekla*: 'You meet a red tom cat with ju-ju eyes,' she sang, giving Vivian's words a raunchy rock inflection, 'With his ears turned out in an alley fight/When the red tom cat comes out to scratch/Basically stay out of my patch/I can hear my old man howling/With his fishbone cough he can never get enough.' Most of the songs had similarly conventional pop lyrics by comparison with much of Vivian's material, with just the odd lyrical twist. An exception, one of the best numbers, was also one of Vivian's greatest solo pieces, 'I'd Rather Cut My Hands'. That he thought the song was fine was evident in a letter he sent to his friend Richard Gilbert, accompanying a tape of Nikki B in full voice. 'What do you think of "I'd Rather Cut My Hands"?' he wrote in late April 1986. 'All too exciting innit?' Nikki B's rendition was extravagant in its roaring emotion and Vivian himself would perform an intimate version on a BBC show years later. The lyrics touched on Vivian's fiercely possessive attitude to his instruments – 'I'd rather cut my hands than let a stranger play my lead guitar' – and were most powerful at the song's mid-section, a confessional outpouring set against a crescendo from the band: 'Sometimes I get so weak-willed and lonely, frustrated and angry, so wired up and weird, so lonely, so lonely . . . so lonely/I let a complete stranger play around with me.' This version featured some introductory lines, omitted from the later BBC recording, that made it more explicit that the song was about a one-night stand: 'I thought you were shy but you were boring/ I thought that you were bright but you were dull/When I looked across at you the following morning, I prayed don't open your mouth/ Sometimes I want to scream, sometimes I wanna roar, sometimes I wanna grab you by your thick head and shout right down your dopey throat/What the hell am I doing this for?/What the hell am I doing this for?' It was a refrain everyone on the *Thekla* was coming to appreciate. In trying to make the venue work, they got in Andy Roberts, along with his old Liverpool Scene pal, Adrian Henri, by which time the limitations of the venture were as apparent as its brief moment of great success had been.

'That was one of the nightmare nights of our lives,' says Andy. 'It was bloody cold. Viv had booked us and he wanted to dress up and

do something in the show, but he was paralytically drunk when we got there, so we weren't gonna go for that. It was so cold and there was no insulation on this boat at all. It was in the middle of winter and there was condensation running down every surface like a Niagara. It was really unpleasant and the worst surroundings in which to do a show. We got it over with and I remember leaving with the greatest relief. I remember Viv lying in his cabin drunk as a lord. It was not a great memory.' Andy could see the theatre space had potential, but the walls were made of cold steel. 'It would have taken a sensationally large amount of money to make it pleasant for either audience or performer.' But the project was no longer fun for the crew of *Thekla*. The boat began to become a home for an increasingly bizarre collection of hangers-on and unbidden guests, much as Rupert had predicted. One of the residents was the actor David Rappaport, who had achieved fame for his role in the Terry Gilliam film *Time Bandits*.

Ki recalls: 'The ship became a magnet for all sorts of fascinating people. I had to carry it all on my back, so it wasn't so wonderful for me. It was a great *big* ship and Dave Rappaport simply moved on board. We didn't even notice the little bugger! He found himself a berth down below and he slept in there! He also got himself a crate so he could stand by the bar and reach the beer pumps. So we suddenly had him on board. At that time he was making *Robin Hood* nearby with Jason Connery, Sean Connery's son. They were down there all the time, but Rappaport was the only one who had the audacity simply to move on to the ship.' Rappaport was offered a TV show called 'The Whiz' in the US and decided to take it. He had bought a little house in Bristol and offered Vivian and Ki the use of it while he was away. They jumped at the chance. Just six months after *Stinkfoot*, the Showboat closed.

'At the end, the company went spectacularly bust,' says Peter Jackson, 'despite being sponsored by Marstens Brewery, who eventually pulled out. All the theatre plans for the boat went out the window.' And that was it – quite literally, they all abandoned ship. The bar was fully stocked, the cabins full of possessions, the stage and the lights were all working. Ki did not even lock the door. With

timing as exquisitely comic as it was somehow inevitable, 'an old *bum* found the thing', she says. 'Can you imagine the miracle of being a shuffling old bum, wandering around the docks at Bristol and discovering an open ship in which there is a full bar? He finished *all* the beer. And we are talking about kegs of this shit.' Former captain Peter Jackson was approached by the bank that had originally backed the Showboat, relaunched *Thekla* as a music venue and it remains that today. Over at Rappaport's house, Ki had enough to do simply trying to recover some of her strength. In this she was not helped by continual exhortations from Vivian to 'be practical'.

'Well, I was no longer capable of being practical,' says Ki. 'I don't take drugs and I don't do alcohol but I do have panic attacks. I was doing the best I could to cope and I had a kid to bring up. Vivian was expecting my normal stuff, which meant taking care of him.' But it was just not possible; she had to make a break for her own sanity. She realized, finally, that she could not help Vivian any more. Vivian decided to return to north London and he needed help to get there, so he wrote to Rod Slater, who happened to be heading that way and obligingly popped in to see his old chum.

'He was dressed very smart,' remembers Rod. 'Case packed.'

'Give us a lift down to the station, Rod,' said Vivian, and left Bristol.

Initially, he stayed in Rod's old flat in Alexandra Park Road, just off Muswell Hill Broadway and about two miles from Monica in East Finchley, who took him back in again for a while. Finally, he settled into a flat of his own in the heart of Muswell Hill, which Ki helped him find. In the new flat he received state benefit and the visiting officer sent from the Department of Social Security to assess his claim, Jo Garrick, remembers he was 'particularly charming' and seemed well-balanced. He wasn't playing the kind of pranks he carried out in East End Road in the 1970s. Ki felt any games-playing was directed instead towards both her and Monica.

'She was just a very nice lady,' says Ki. 'So basically she's got this monster on her back again. In order to carry this monster, she needed a reason and Vivian gave her the reason.' In fact, Monica had drawn very much her own conclusions on the whole split and Vivian's precipitous return to the capital. 'I wouldn't like to comment on who

drove whom mad,' she says. 'He had a bit of a knife fetish. But he had quite a good time in Bristol because he had a little art gallery, where he was showing other artists' work and he really enjoyed that.' Back in London, Vivian settled down into a routine, at least initially. He used the distance to his advantage: Ki thought he used his new circumstances to play for the sympathy vote. He would often ring her and demand, 'You must come up, I can't bear it any more.'

'So I would make the long trek up to London or he would come down to my place,' says Ki. 'He was just juggling, but I twigged it rather quickly. If this was how he had to live – so what? I loved him and if he needed someone to take care of him, I would. If I had to be the victim, OK, but just don't paint me too black, darling!' Another reason to be back in the capital was that *Stinkfoot* was going to be transferred into an off-West End venue, a move partly financed by his admirer Stephen Fry. Though he had been a huge fan of Stanshall from an early age, the two did not meet until the mid-1980s, when a chance remark brought them into each other's orbits. In 1985, Fry had been recording 'Blackadder II', the Ben Elton and Richard Curtis-scripted show. He was interviewed in the summer for the *Glasgow Herald*.

'This journo, with some insight, asked me whether or not Vivian Stanshall had been an influence,' says Stephen. 'I replied in the affirmative and he set up a meeting about six months later.' It was around the time that *Stinkfoot* was first staged in Bristol that they met, when Fry was known to a far larger audience than Stanshall. Once the starry-eyed boy who had listened with delight to Bonzo recordings, Stephen was now very much in a position to look at his hero as an equal. In the event, says Fry, 'few people I have met have lived up more to the reality I had imagined. I expected in equal measure: sonority, wit, eccentricity, a capacity to embarrass and confuse. I got them all.' When it came to transferring *Stinkfoot* to the West End, Vivian asked if Stephen would be prepared to 'stump up the necessary', which he was delighted to do. He featured in the programme as one of the 'abundantly good guys'. Former Genesis frontman and successful solo performer Peter Gabriel also helped. The show was, remembers Ki, 'absolutely abysmal and a complete embarrassment. That's when I

had a major nervous breakdown. I'd just gotten over my first one and going to help him caused the second one. This show was a fucking cock-up from beginning to end. It was badly conceived, horribly cast, nobody knew what the hell they were in.'

Monica says that Vivian also hated it 'because Pam hated it. It was expensive to hire a theatre and pay for the musicians.' The show was staged at the Bloomsbury theatre near Euston between 12 and 31 December 1988. The characters and nuances were specifically created by Vivian and Ki for the *Thekla* and it proved impossible to translate into the metropolitan setting. The London cast had difficulty in getting to grips with the concept. Only two of the original cast were employed and the Bloomsbury insisted on using their in-house director, who had no idea what Vivian was on about. The director was further confused by Vivian changing his mind and interfering all the time. Practical Pete Moss, the unflappable MD on *Teddy Boys Don't Knit*, was called in to get things working. Even he was stymied by Vivian's insistence on using 'real musicians' in the show.

'What he meant was street buskers,' explains Pete. 'I could have got him some of the best musicians, but he didn't want that. We put adverts in the papers and we had this stream of weird people coming to the Bloomsbury Theatre. We had people coming in with dogs on a string, and even cats and snakes.' Still, Pete did his best to keep Vivian in line, slipping into his patriarchal role. It made a strange impression on the buskers, including a saxophonist who confessed she was convinced that Pete and Vivian were gay. 'Apparently that's what they all thought,' says Pete. 'This girl was certain we were gay and that I was the dominant partner.' The truth was their professional relationship was eroding fast. That Moss was the consummate professional to Stanshall's laid-back bohemian had made for some excellent results in *Teddy Boys Don't Knit*, but now the negative aspects of continual quarrelling began to outweigh the positive. It was games-playing: Vivian had always capitalized on people's perception that his approach to art was free and easy, but 'he wasn't always quite as loose as he wanted to make out', claims Pete Moss. 'He wanted people to think he was confused.' Pete was rapidly tiring of the constant struggle.

The rest of the production was in no better shape than the musical side. Mark Millmore worked on the London sets and found himself giving unofficial coaching lessons to the baffled actors. 'Vivian was getting more and more depressed by all this,' says Mark. 'It was killing him.' The set designer walked off a week before the show opened and Mark remembers painting sets up to the last minute. He finished the final flap just five minutes before the curtain went up on opening night. It seemed as if the whole production was in chaos and in imminent danger of disintegration, with Vivian at the centre. In the frantic rush to complete the set, Mark was struck by how Vivian was capable of coming up with brilliant ideas across a range of artistic fields, effortlessly changing from one medium to another. When Mark was stuck trying to create an effect with one of the flaps, Vivian made a couple of suggestions and solved the problem in minutes.

'He had this ability to juggle three or four different things creatively, simultaneously, and do them all extremely well,' says Mark. 'I can't say I've ever come across anyone like that. I've come across some very clever people in a particular field and some people I'd say are geniuses in a particular field, but he could jump from one medium to another instantly. That I think is extraordinary.'

Once a piece of work became larger-scale, the unique magic evaporated and Vivian became frustrated as he watched others take control. *Stinkfoot*'s opening night was a traumatic affair. The crowds, curious and expectant, poured into the theatre. Among them was Vivian's father, making a rare public appearance, along with Eileen. His father turned up to the Bloomsbury show only because she insisted. She had to travel up by bus and did not want to go on her own. He was unenthusiastic and barely spoke all evening. They all attended the first-night party, which Stephen Fry remembers was 'splendidly chaotic'. The atmosphere of the original show had completely disappeared, and with it went Pete Moss, after one final row. The script was cut, nothing made sense, the show was in pieces. The critics were, not surprisingly, far less impressed with the London show than they had been with the original Bristol version. Stephen Fry recalls that the audience listened in bemused silence.

'Well, the staging was, to put it kindly, a little amateur in terms of

production values, sound quality and so forth,' recalls Stephen. 'Sir Viv was the voice of God and, while he may have felt justifiably let down by the stage management and production, the piece itself was pleasantly baffling, if I can put it that way.' But that was not the only problem that Vivian's fellow-humorist identified. 'There can hardly have been a worse time to mount such a piece,' says Stephen. 'The 1980s were a time when the Jarryesque, the absurdist, the surreal and the non-realistic had never been at so low an ebb in terms of vogue, popularity or understanding. I think, whatever the problems with the mounting of it, it was mistimed. But for all, very timely. Those of us who valued Sir Viv couldn't be more pleased to be involved a) with him and b) with something so out of tune and temper with the age.'

Another more physical problem was simply that a lot of the dramatic effect created by the unique shape and length of the original staging area on board the boat was lost. After the show closed, an exasperated Vivian wrote to Mark Millmore, back in Bristol: 'What a thorough bugger it is about Stinkfoot??? Give my love to my wife. Always yawn sincerely, Vivian.'[11]

It was all horribly reminiscent of the attempt to transfer *Sir Henry* to film. Once out of Vivian's control, his airy creations seemed to evaporate. Nevertheless, Stephen Fry and Vivian kept in contact after the end of *Stinkfoot*, though mainly by telephone. 'He would sometimes call up with a scheme that he would have forgotten about a week later,' says Stephen. 'I took him out to dinner at Anna's Place in Stoke Newington, a Swedish restaurant. He drank a bottle of aquavit and charmed Anna, the eponymous restaurateuse. We returned to my house, where we played duets on the piano together. I had the honour of showing him a diminished seventh (he had asked me to play something and the opening of Beethoven's "Pathétique" sonata was about the only thing I felt confident in hammering out), he was very struck by the sound of the diminished seventh and claimed not to know what it was, but then he was very obscure and contradictory when it came to his musicality which was of an infinitely greater order than mine.' Neil Innes saw the musicologist side of Vivian: 'He took music seriously and got quite scientific about things,' says Neil. 'He would say, "I have learnt a G thirteenth." So? So what, Viv! At times he would

sing totally in the wrong key. So he wasn't a natural musician by any means. But he was a natural performer.'

The end of the *Stinkfoot* run meant a lot of the people involved were suddenly at a loose end. There was not much business for Mark Millmore, who had given up his BBC job to help out on the show in Bristol. With some trepidation, he prepared to go back into art teaching – which he felt was something of a second best. Vivian turned things around for him. When he learned that Mark really did want to be a full-time artist but simply could not get the work, Vivian organized an exhibition, from which came another showing, and Mark was soon exhibiting his work all over the world. He decided to go on an art trip to Africa and planned to have an exhibition. With that he wanted to raise money for the Born Free Foundation for nature. Vivian brought along some of his celebrity chums and the press pitched up too; many of Mark's works were sold and a sizeable amount of money went to the foundation. It was as if all the effort Vivian could not put into furthering his own art, he channelled into helping his friend, at a time when he must have been suffering from the failure of the London *Stinkfoot*. At least he was now back in the heart of the creative industry, in London.

Over the next few years he was to carve out another career for himself in advertising, while continuing with his own work. He claimed now to be better at focusing, saying, 'I've managed to control myself where I no longer do four things at once.' The very physical mode of working he used in the 1970s, when he would rush around on a bike, armed with instruments as well as drawing and writing materials, was behind him, he said, but he was still a perfectionist and unwilling to compromise.

15
Crank
1988–92

Muswell Hill is not far from East Finchley, where Vivian once lived with Monica, and where his son Rupert went to school. It was here, in the top-floor flat of 21 Hillfield Park, that Vivian finally settled, to paint, to draw, to sing and to roar.

Lofty, leafy Muswell Hill is situated between the elegant sophistication of Highgate and the respectability of Finchley. The main street, the Broadway, leads to a busy roundabout, from where cars, buses and bicycles hurtle downhill towards Alexandra Palace or Crouch End. Affectionately known as Muesli Hill, the area was, in the 1970s and 1980s, an intriguing mixture of commuters and social workers, artists and musicians, bohemians and media types. It still boasts its original Art Deco Odeon cinema and opposite that is the branch of Sainsbury's in which Vivian terrified the locals and the staff. Between gaps in the houses straddling the hilly streets, there are fine views over London to the south. Hillfield Park is a short, narrow street, curving down from the Broadway, lined with tall Edwardian houses. Vivian's two top floors were part of a crudely built extension.

From the large bay window, Vivian had a magnificent view over London. He was able to buy the flat outright with a royalty cheque from his work with Steve Winwood. 'Despite his aristocratic airs,' says musician friend Keith Miller, who lived nearby, 'Viv quite liked the fact he was stuck out in a very suburban place like Muswell Hill.

He was like a flower in the desert. He was the village eccentric. That was his role in the community.' Communication from the flat to street level was via an entryphone that he often could not hear. Many visitors shouted greetings from the street below, while pressing the buzzer in the vain hope of attracting his attention.

Says Monica: 'I had a key and two other people had keys, including Rodney Slater. But if you didn't have a key and he wasn't expecting a visitor, you could stand there waiting for hours. So the isolation became more and more intense. He loved people to come. He was so happy to see visitors. He just didn't know they were there.' Vivian was suffering from tinnitus, which meant everything had to be bone-shakingly loud for him to hear. The television set was turned up to distorting volume and the entryphone might as well not have been there. Former Bonzo Roger Spear was also afflicted by the condition, which had been creeping up on Vivian for fifteen years. The symptoms were extraordinarily cruel: a continuous noise in the ears when Vivian wanted to go to sleep or read a book. Music became a form of torture for him. The shockwaves from the explosions in the Bonzo days had caught up with him, those bombs in saxophones and cascading avalanches of 'harmless rubble'. He lost confidence and felt awkward trying to talk to people.

'He couldn't hear what people were saying. If there were more than four people in a room it was just a great blur or buzz. He felt an idiot. A fool,' says Monica. The pair would regularly leave parties early because Vivian could not bear it any more. Everyday tasks became monumental efforts: he would go to the cinema and could not hear the soundtrack. Monica comments: 'Most people describe it as buzzing. He described it as roaring. He thought the word "roaring" was more dramatic. It was obviously interfering with everything.'

A great fan of country music, Vivian found he could get little pleasure from it any more and, as a complete novice when it came to anything technical, he could rarely even tune in to a talk station like Radio 4. He generally worked in absolute silence, writing or painting. 'He said it was all going on in his head,' says Monica. He felt stranded on his own in the flat and was becoming increasingly frail.

In other circumstances his home could have been a comfortable place, beautifully painted in mauves and olive-greens and crammed with Vivian's possessions, from props to ornaments. There was much of his own work, including ashtrays made to look like clasped hands to hold the inevitable roll-ups. In the kitchen, propped up by the sink, were platinum albums from his work with Steve Winwood. There were hand-painted instruments of all kinds fighting for space, of which there was simply not enough for all the belongings. He was forced to cut back on the myriad areas of creativity which were so important to him. Even with some of his gear stored with Steve Winwood, the bedroom was choked by old newspapers, painting materials and left-over takeaway meals.

'It did occur to me and various others, that this was a flammable mixture,' says friend and near neighbour Pete Brown, poet and Cream lyricist. 'He would nod off when he was drunk and anything could happen.' There were also the old aquariums, filled with fish, fierce creatures and decomposing matter. Drapes of material were everywhere and there were canvases, predominantly black, red, yellow and green. The main room, the music room, was pink – 'for Barbara Cartland reasons. And so that I might wear the hats,' Vivian told journalist Robert Chalmers. The atmosphere in the flat was airless and claustrophobic, reinforcing the chaotic impression. 'I know some people are not happy unless everything is neat,' he said. 'That is not my system. But if someone swiped a book I'd realize instantly.' As he wrote to his friend 'Admiral' John Halsey in early 1991: 'My modest yet pleasingly filthy flat is a mountainscape of paper. Minatory concertinas of this & VAT teeter & grumble. I am alpine with demands. But love the slap of lederhosen.'[1] Some of the files were devoted to his work against Valium addiction, a campaign he had been asked to join shortly after *Stinkfoot* finished in London. He answered letters and allowed his name to be used.

Vivian painted, recorded and composed an operetta in his eyrie. The whole flat was an unfinished mass of projects and ideas: 'This place is a trap for me,' he said, likening his home to a scene from *The Pit and the Pendulum*. 'I see the walls closing in with everything writhing and screaming, "Write Me! Finish me! Paint me! Caress me!"

When I watch television I have a book or a musical instrument on my lap. I have never been bored; only frustrated. There's too much to do.' There was no need to feel lonely if he was in good health. He was only a mile or so from where Pete Brown lived in Crouch End; there were plenty of other friends in the Muswell Hill area and opportunities to harass the residents. At the local Sainsbury's, he spotted a sign boasting of the store's fresh meat, called over the manager and, in a sinister tone, asked if they 'did it' on the premises. The nervous manager immediately realized Vivian appeared to be hoping they slaughtered animals in the shop and backed off in horror as Stanshall added, with a low chuckle, 'I haven't heard any noises.' Vivian's friend Keith Miller saw Vivian outside the supermarket. With long hair and a beard, wearing only a short black kimono and sandals and holding a shepherd's crook, Stanshall was 'stumbling along the street shouting abuse and crying out, "You bastards, I despise you all." He was reeling ever closer. Then he spotted me. "Hello, Keith," and carried on shouting and ranting. You wondered sometimes how much he was just winding people up.'

The nearest Vivian came to relaxing was spending hours watching his huge collection of snooker videos. It was something of a refuge up there in Hillfield Park, but he was only too aware that it was not much compared with the rewards earned by some of his peers. Many of the stars of the 1960s lived in mansions in the Cotswolds and had enormous bank accounts. Vivian felt trapped and neglected. When his friends called to cheer him up, they gauged his mood by the answer-phone messages. One informed callers that Vivian could not answer the phone, as he was preoccupied with filling in the Channel Tunnel. Another directed callers: 'If you're going to say anything filthy, please speak *clearly* after the tone.'[2] Roger Wilkes was surprised to find Vivian answering promptly on one occasion: 'Yes, I'm here,' answered Vivian, adding, 'I'm not dead yet.' The two were playing their jazz sessions again, now that Vivian was back in north London. Roger visited the flat and they ran through 'Goodbye Dolly Grey', 'Dinah', 'Bye Bye Blackbird', 'Pasadena Town' and 'When You're Smiling'. One session, Vivian fetched some of his smaller knives and sat on his bed throwing them at the wardrobe. He got quite skilful at

flicking them, casually calling out 'Duck!' to Roger, who was quick to react as the knives whistled over his head.

'You had to think about how much he'd been drinking and whether he was okay to do this,' says Roger. 'Maybe I had a calming effect on him. As soon as I went in there he wanted to play music and he'd pick up his tuba. Some people he wouldn't see at all.' Vivian's relationship with his son was particularly poor. Rupert was now in his early twenties, working as a labourer. He helped Vivian move into the Muswell Hill flat. When he needed some help from his father in return, he felt abandoned. Seriously ill with a muscle-wasting disease, he felt that both his parents simply wanted him out of the way.

'I moved out just after my twenty-first birthday. After that I lost all love for Monica and all respect for Vic as well, because I had given him so much emotionally. He was a selfish bastard. He gave nothing. He just took. He took your attention, he took your love, he took your emotions. He was very demanding. I needed some support myself at that stage. It was good for me to get away from them because I went from strength to strength. The attachment there was just too much.' Rupert clashed with Vivian on his own territory, asserting himself now he had a place of his own. His father visited the new flat, marched in, sat down on the bed with a cigarette on the go and carelessly flicked his ash on the floor. That was it. Rupert was enraged. He picked him up by the scruff of his neck, and threw him out.

'You come into my home and show disrespect,' he yelled at his father. 'Fuck you. Get out!' Rupert would not see his father again until late in 1994. 'He was horrified. Bloody right. He had turned his back on me and then tried to walk back in and his first action is to shit on me. You don't flick ash on people's floors. I don't care who you are. I must admit I wasn't nice to him. But then I knew how to tweak people, having had a master teach me how to do it. It's mind games basically. You then know what hurts and what doesn't.' Vivian himself was given the pattern to follow by his father. He could be that selfish, when he was concentrating on his work or his own problems. Such times were offset by his generosity in helping friends and his love for his family. What he simply did not have was an example of how to relate as a father. The poor state of his relationship with Rupert

affected Vivian deeply, as he later told Rodney Slater. 'He was hurt if Rupert vanished, which he did occasionally, because he couldn't stand it when his father was misbehaving.' Vivian went on to admit that his son had 'got the better' of him. Rupert was confined to his bed for over a year, recovering to take a career route diametrically opposed to that of his father. He set up his own business as a financial adviser.

'It is the complete antithesis of what he did and I seemed very straight in comparison,' laughs Rupert. 'But he knew how to play people. I've learned that. As a salesman you know when to listen, when to speak and when to frighten somebody. With most people – he speaks and immediately he's got the upper hand. He's also got the attitude. Even if he met someone who didn't know who he was, he'd soon have them sorted out.' Rupert's career involved performance and Vivian kept an astute watch on finances when he fancied it. The two were not so different, after all: 'All Vic's old friends say there are similarities – the voice and the sense of humour and the mannerisms.'

Vivian was also finding it difficult to deal with his stormy relationship with Ki. She returned to America following the second *Stinkfoot* production and phone calls with her invariably knocked him off balance. Though she flew over for at least three lengthy stays in the early 1990s, one of which was for six months in 1993, he keenly felt the loss of seeing Silky grow up and she was never far from his thoughts. In a hospital in Chelsea, he made a dancing dress for her as part of his occupational therapy. It was a medieval garment, complete with jangling bells. Vivian never let go of the hope that one day he would have his family around him again.

His return to London coincided with a return to Rawlinson End. Some months before the London run of *Stinkfoot*, in April 1988, Sir Henry made a welcome reappearance on John Peel's show (with further episodes in November 1988 and April 1991). The stories were just as polished, baffling and invigorating as any of those from the 1970s. Some featured reworked material, ever funnier, by turns elegiac and scatological. As before, it was the splashes of colourful detail that made them come alive, adding to the rich mythology of Rawlinson End. It was packed with throwaway lines, the delight of

Sir Henry, loosely knitted together in improbable and lengthy plots which might involve anything up to and including an artefact from a far-off land turning out to be a dinosaur egg which hatches into an endearing, talking diplodocus. There were the mysterious noises in the pipes, tackled by the local plumber, Mrs Giraffe.

The musicians for the sessions included regulars such as Pete Moss, Dave Swarbrick, Danny Thompson, Roger Spear and Rodney Slater. Gone was the memory of *N'didi's Kraal,* as each episode featured tight playing, uplifting and atmospheric tunes, great effects and Vivian narrating at full strength. The shows attracted a new generation of aficionados tuning into late-night Peel for the first time. In total, fifteen episodes of *Sir Henry* were aired on Radio 1 over the years.

Periods of creativity in Muswell Hill were followed by relapses into drinking and stays in clinics. Vivian would be in for a week, all he could afford, by which time he was dry, although he would be weak, shaky and, says Monica, 'not over it. And then go home to exactly the same thing that drove him to drink in the first place. The cycle speeded up and it accelerated to the point where the black bits were shorter than the white bits.' When he came out of treatment, he usually stayed with Monica, who fed him and kept him company. After a few days he was back on the phone. The imperious manner returned. 'I'm very busy! Can't you see I'm busy?' Before long he was ready to go back to his flat. Monica knew the request to go back to the flat really meant a request to be allowed to get on with boozing. 'He wouldn't dare drink in front of me. He did once and I got so angry, he never did it again. Whenever it was time to go back to the flat, I knew that was the beginning of the next binge.'

Towards the end of the 1980s, Vivian's father became seriously ill. He had been suffering from a hernia and, as Mark Stanshall recalls, 'When they opened him up they said, "Gosh, you've got cancer of the liver," and that was the end of that. But eighty was a good innings.' Monica took Vivian to the hospital to see his father as the old man was dying. Vivian desperately wanted him to say that he loved him. He did not. The couple left the hospital with Vivian distraught. There had always been the possibility that the two might come to some understanding, and now even that was gone.

Music journalist Roy Carr asked Vivian to contribute to *The Last Temptation of Elvis* in 1990. This *NME*-sponsored project was a charity album of Elvis Presley movie songs, with cover versions by Bruce Springsteen, Paul McCartney, Tanita Tikaram, Robert Plant, Hall and Oates and Lemmy. Against the serious efforts, Vivian's was welcome light relief, though he was not enthused by Roy's choice of song, '(There's) No Room to Rumba in a Sports Car'. He put together an outfit called Vivian Stanshall and the Big Boys for the recording, dressing up in a Latino shirt to get in the mood at the session while his fellow-musicians recorded the backing tracks. Then panic set in. When the musicians next called for him, they heard the sound of roaring and shouting from the flat and the crashing of vodka bottles being thrown into a dustbin. He had been up all night. When they got to the studio, Roy told him to pop round the corner to a café.

'Have some breakfast and work on your lyrics. We'll pick you up in an hour and do the session.' They went back an hour later and he had vanished, staying out of sight for a full twenty-four hours. He staggered back into the studio and said, 'Punk rock. Let's do it for the kids.' He was quite serious; he now wanted to do the number new-wave style. Roy grew extremely alarmed as the sessions became ever more chaotic – Vivian also had 'flu and was in poor voice. In the midst of the farce was a bemused drummer, a French session man, François Serlau, who injected: 'Who is this man? He is mad.' To which Roy wearily responded, 'Yes. He is. That's quite correct.'

Keyboardist Keith Miller, roped in by Roy for the recording, had some sympathy for Vivian. 'He hadn't recorded in a long time and he was obviously scared about doing this track,' recalls Keith. 'I worked with him on voiceovers for radio, when he'd be absolutely professional. But he was worried because this song was going out under his own name.' The musicians piled in a car to go to a studio in St Anne's Court, just off Wardour Street in Soho, to finish the vocals. Vivian spent the short journey leaning out of the window, leering at passing women and, as ever, somehow managing not to offend.

Safely in the studio, Vivian struggled to complete his part. 'We had

to get a line out of him one at a time – when he could breathe,' says Rob Burns, bassist on the session. In the end, three studios were required to get down Vivian's vocal track. 'He completely changed the words,' recalls Roy. 'Fortunately, nobody from the publishers noticed that he had written his own lyrics.'

Referring to the King's propensity for munching burgers, Vivian begins with, 'I have a need to overfeed . . . and now it's Thursday and I'm bursting full of sesame seed!' and added other lines such as, 'In the mirror where I bend my knees, in the forest where I fell my trees/I'm Raymond Chandler when I'm shelling peas/I eat Big Macs – 'til I climax!/Is this the manly way that normal boys relax? Help me!' A rapid delivery allowed him to get away with much without alerting the original publishers. He suggests there is no room to rumba for the King as: 'I'd need more space and by God's grace/I'll get some grease, I'm too obese – call the police . . .'

The launch party was on a hot day and Vivian turned up 'in a nightshirt and a padded bomber jacket. Then he got up on stage and started singing – and he was absolutely wonderful!' Roy asked Vivian if he would write some notes for the record. 'I asked him to write just 500 words. Then he gave me 15,000 words and said, "Can you pick the bones out of that?" I couldn't! It was just rambling old stuff, which I think he had lying around.' Roy planned to release some of Vivian's own songs on a label which he wanted to start. Just as Roy was getting his project off the ground, however, his sponsors quit during a record company reshuffle. 'Don't worry, poppet, we'll find somebody,' said Vivian, though a couple of years passed before he did. In the meantime, he was spreading himself thinly over any number of other projects, from *Sir Henry* to a book of his poetry to be released by a publisher friend. The plan was for each poem to be accompanied by illustrations from different friends. The project was not completed. There was also a script he was putting together with the Who's Roger Daltrey, for a movie about the life of Keith Moon. Actor John Sessions was mooted to play Keith Moon. 'Not sure about that,' Vivian declared. 'The man's a shirt-lifter.' More of a real risk to the project was that Vivian found it very difficult to remember much about his escapades with Moon. The project was abandoned when Daltrey and

Stanshall fell out and when Vivian returned to prominence it was with a new show of his own material.

A journalist from London's *Evening Standard* visited Vivian at the beginning of April 1991. She found him energetic, dynamic and swamped with work. He was 'in a frightful flap-doodle', he explained to her, threading his way elegantly through the mounds of paper swamping the flat. 'Stanshall is so busy, in fact,' she wrote, 'he has forgotten to get dressed and is conducting this interview, sans underwear, in a short beltless kimono.'[3] The main reason for the flap-doodle was that he was about to play live for the first time in nine years. He proved a genial host, though, as the *Standard*'s Annalena McAfee recorded: '"Would you like to try some menthol coffee?" Stanshall asks, skidding on a sex toy catalogue which lies open on the floor. Glancing down, he remembers. "I really *must* put some knicky-knoodles on."'

The live show in question was *Rawlinson DOG Ends*, which ran for a week in April 1991 at the venue which had hosted *Stinkfoot*, the Bloomsbury Theatre in London. It was to be a musical celebration of his life and, according to the *Evening Standard* journalist, Vivian was now 'a cleaned-up, born-again artist operating from a bohemian eyrie in Muswell Hill', affirming 'anything that interferes with the bonce, apart from a haircut, is abhorrent'.[4] He was well aware that his stage fright would make the show anything but a breeze to do. The prospect terrified him and he welcomed the challenge.

'This is a suicide mission. People who like blood sports will enjoy it. I feel at home in front of a live audience because it's so dangerous. You cannot be as violent with a typewriter, a piano or a sculpture,' he told her, concluding, 'Now . . . I *really* must put some knicky-knoodles on.'[5] The accompanying photograph showed a fully clothed Stanshall looking directly into the camera and the outfit was smart: blue shirt with neat cufflinks, grey waistcoat, abstractly patterned cravat, spy-glass around neck, alarming-yellow octagonal spectacles on head and fag in mouth. It augured well for the gigs.

Glen Colson helped Vivian put the *Rawlinson DOG Ends* concept together with Andrew Sheehan from Charisma. The three of them

booked Leslie Welch, 'the Memory Man', as support. He had appeared with Vivian as part of the promotional show for *Sir Henry at Rawlinson End* and Glen and Vivian were rather saddened to discover that the memory man was now losing his memory. Vivian's own act ranged from songs of the Bonzo Dog period up to Rawlinson End material. A flyer for the event proclaimed that it would be 'an introspective, outrespective, retrospectacular', adding, 'Also on sale in't foyer: The book! The video! The brass rubbing! His own Mother!' The flyer promised three new albums: *The Eating at Rawlinson End*, *The Thing at Rawlinson End* and *DogNeW TrickS*. 'A workaholic – Vivian continues daily to draw and paint, drool and faint . . . All of the above notwithstanding, Vivian Stanshall hopes to squeeze in several nervous breakdowns.'

The concerts were played by a band of 'Ex-Istanshallistes', including Rodney Slater and Roger Spear (saxophones), ex-Cream bassist Jack Bruce, Pete Moss (guitar), John Megginson (piano), Pete Brown (percussion), 'Admiral' John Halsey (drums) and Ollie Halsall, Dave Swarbrick and Susie Honeyman (violins). All the musicians agreed to do the shows for just £50 each, though they would rather have liked to know exactly which 'songs & snatches' promised in the programme he had in mind. Just two days before show time, Vivian let Pete Brown into his plans. He was presented with a list of fifty-five songs with minimal song charts for the band to work from and no MD.

The rest of the band turned up on the morning of the first show with absolutely no idea at all of what was going to be on the set list. They went through a few numbers, guided by Pete Moss, while Vivian stayed downstairs, locked in his dressing room, eating yoghurt and trying to scribble down a list of tunes. It got to lunchtime and nobody was any the wiser. To while away the afternoon, the band ran through a few more things, but there was no sign of Vivian, terrified by the prospect of the gig to come. He briefly popped in to face a barrage of questions and disappeared again. The musicians decided to go to the pub, where they debated the next move with cries of 'What the fuck is going on?' and 'What are we going to do?'

When the audience filed in later that night, they had no idea that

the legend they were about to see had very little idea of what to do that evening apart from try desperately to control his nerves. This was indeed an urban 'blood sport'. Vivian eventually appeared in a particularly outrageous outfit and, almost immediately, vanished from view. 'He missed the stage, because it was in black-out,' says John Megginson. 'He walked down some steps and fell into the orchestra pit. There was no way out. The audience loved it, because he was clawing his way out and of course he couldn't see where he was going.' Back on stage, Vivian started an incoherent monologue and dropped his left hand from above his head, down to his knee. This was the signal! He had not told anyone what it meant. The band sat there and gazed at him. He turned around and did it again. They all looked baffled. 'What?' He murmured over his shoulder, 'Well . . . "Calypso to Colapso",' and the band finally launched into the song, from the album *Teddy Boys Don't Knit*. They played thirty-three songs, including numbers for which there had been not one rehearsal.

'I can't do this any more,' declared Jack Bruce after that first gig. It was for practical rather than musical reasons. 'I didn't have a row with Vivian,' says Jack. 'It's just that he was so out of his brain, nobody knew what was happening. He was so nervous. It was chaotic and, well, yes, a lot of us got a bit annoyed that he put us through that. But it was no big deal.' Pete Moss stepped in on the second day and almost immediately the situation changed. Despite the experience of *Stinkfoot*, the 'Stern One' was back.

'Right, enough of this,' said Moss. 'I don't want Vivian here until five minutes before he's due on stage. The rest will be here at ten o'clock in the morning. I will have a set list and all the arrangements. We will rehearse until five and Vivian – *this* is what you will be performing.' Pete also took over some bass duties and licked a ten-piece orchestra into shape. That second night was better and the show improved all week. The band played several old numbers and some Stanshall had yet to record, including 'I'd Rather Cut My Hands', written on the *Thekla*. Unsure about the quality of the material, Vivian hovered nervously, trying to bully his musicians into making changes. Pete was having none of it. With the worry taken

out of the equation, Vivian visibly relaxed as the week wore on. Hecklers attempted to wind him up but he kept his cool, saying to the audience, 'This is the first time I've done a show straight.' Some wag inevitably yelled back, 'Have a drink, Viv.'

He was just as awkward without the booze. 'You had to get him to a certain level,' says Roger Spear. 'We did some of the shows when he was stone-cold sober, and he was no good at all. He was very uptight and just wasn't letting go.' John Megginson tried to ensure that Vivian did not have a drink and the show became surprisingly slick. At the end of the run, however, Vivian blew it by failing to turn up with the cash for the band, consequently having a huge row with Pete. The two did not talk for months.

Roger Spear did not work with Vivian again. He felt he 'couldn't connect with his really way-out stuff'. He left with fond memories of his friend, completely in his element: 'He wanted to play an old Bonzo song, "We'll All Go to Mary's House",' says Spear. Vivian stamped happily around the stage thumping out notes on his tuba with his back to the audience. It was the last time Roger saw him.

The disagreement about payment – Vivian blatantly did not bring the money on the last day – rankled with the musicians who did so much to make the shows work. Vivian had a mean and thoughtless streak at times, but one which he could turn around and make anyone forgive. John Halsey treasures the letter he received from Hillfield Park, in May 1991, Vivian making amends:

> Following our phone chat & a breakdown, and before I go up the wall again: right!
>
> 1. I want to pay you £560 (being £300 for performance) plus 8 extra helpings at £20 each . . . £160, plus one thrashing session £100.
>
> 2. I've coughed up £411.25 on the night of the final perform-ance.
>
> 3. £560 minus £411.25 = £148.75. Doesn't it? Yes it bloody well does, sweet Jesu! So I enclose my cheque for £148.75.

So now all I need is some codswallop invoice or I'll amend the £620 sent me on 20 May. Whatever you like. But I'll tell you this: I'm posting this bugger before I turn to the medicine cabinet.

Thank Cliff that's over.

Calmer now . . . thanks to Yeastvite . . . & cavalier masturbation.

I'd rather like to hang on to your beaming, glossy pic for my scrap book, if I may. But I hope you enjoy the enclosed drawings made by my mate, Peter Till. Talk to you soon old egg.

Yours & almost myself Vivian.

DOG Ends toured the country, featuring Rod Slater and two musicians from Bristol. Every night was packed. The fans were eager to talk to the legendary figure. 'Mr Stanshall, what's the difference between what you are doing now and what you did with the Bonzos?' enquired one cultured young lady earnestly, to which the star of the show promptly replied in resonant tones, 'There's no minge.' They toured Norwich in the east to Exeter in the south. Vivian's performance was confident and he was looking fit. A support act in Norwich was astonished to see Vivian in the dressing room before the show, bashing away furiously on a typewriter, literally minutes before he was due to go on stage. *DOG Ends* finished on the borders of Scotland during a violent snow storm. Short of money, they were offered a gig for a week in Glasgow. Vivian thought about it and said, 'We just can't afford it.' Rodney offered to pay the band for the duration, but Vivian would not take any money from him.

Among the audiences for the *DOG Ends* London show was BBC producer Mark Cooper, then working on the 'Late Show'. He would go on to produce 'Later with Jools Holland'. The 'Late Show' team had already contemplated doing a fifty-minute documentary on Vivian, and in *DOG Ends*, Mark saw the potential for a good framework. He felt that 'like a lot of his stuff, it was satirical and kind of distancing. But there was a real personal element and thread to some of the songs. Rather than him keeping us at arm's length emotionally, I thought it would be great to do a piece with him, which forced

him not to hide behind a persona. He'd put on a funny voice or enter-
tain us with his wit. I wanted him to own up about himself. I felt that
was always there in his work, but wasn't always brought to the fore.
I can't remember quite how or why I suggested it, but I had this
feeling about his art.' Vivian had met a producer who really under-
stood him and could discipline him sufficiently to get his best work.

'Crank', screened in November 1991, was personal without being
painful, and witty without being distancing. Between a series of
amusing, sensitive songs, backed by a suitably sympathetic band,
Vivian spoke frankly about the man who shaped his attitudes and
character more than any of the artists, writers and explorers he
studied. 'I was terrified of my father, and still am. And he's been dead
for over a year,' said Vivian, fixing his TV audience with an unyielding
stare. This is the only mention that Vivian makes of any feeling
towards his father – one of fear. Similarly, he speaks of his mother
only with simple love and affection and as ever, Mark is not mentioned
at all. The 'Late Show' was appropriately named in Vivian's case. It
was a late flowering in public of all the things he did best, singing,
talking, making wry asides and achieving the kind of intimate commu-
nication that he so desperately needed. It was a fully rounded version
of the kind of confessional that he had been working towards since
Teddy Boys Don't Knit. Mark Cooper had found Vivian just in time.

'I thought he was a wonderful man. I never had any trouble with
him, although obviously I had heard stories about him from other
musicians. I don't remember it being stressful, apart from the fear
that he wouldn't be able to pull it off. He was very insecure at that
period. He had been very damaged by the houseboat sinking and I
had the sense that he was on the verge of collapse. He was a man
nursing himself back to form. Mounting a major piece like this for
television was a lot for him to carry. On the other hand he felt he had
been out of favour and he was excited about the idea of being on tele-
vision, during a vacuum in his career. He wasn't writing songs for
anybody and he didn't have an outlet. So this was a forum for him
and that's why he liked the idea.

'It was such a complete piece and I did find him really scary. I
don't think I had worked with an artist quite so closely before. He

was such an intense and needy guy and he was very demanding. I love working with artists like that. It was a piece about "Who am I?", "Why am I like this?", "Why don't I fit?" Inevitably it was also about a certain kind of English-ness.' Vivian rehearsed with his band at a studio in Crouch End. Rodney Slater played bass saxophone, Danny Thompson bass guitar and Susie Honeyman was again on violin. Vivian talked over his ideas with Mark, which director Sheree Folkson then worked into the show. Inventive and brash, Sheree did not know who Vivian was and so was not scared of him, which always helped in dealing with him. She was free in her shooting technique, which totally suited his style, encouraging the lead cameraman to wander around with a hand-held camera as the group played, to create unusual effects. As one song ends, the camera zooms into the bell of Rodney's sax.

'We shot the music on one day and the spoken pieces over two afternoons,' says Cooper. 'It was transmitted on the night of the second recording, which was pretty crazy, trying to do it that quickly. Being such an intense work schedule, there was always the chance of him hitting the booze or having a nervous breakdown and that didn't happen. He was a true pro. He found it shattering, but he believed in the format.'

The only original props to survive from *Stinkfoot* were used in a song Vivian performed dressed in flowing white robes – one prop was a thunderbolt he brandished in one hand as he sang, 'He's walking on the water, spreading his light', a song he'd performed in *DOG Ends*. At his feet, prop waves were moved backwards and forwards by two people wearing the only other surviving items: large lobster costumes. Like many of his songs, this was littered with subtle references for anyone who wanted to look beyond the holy imagery and omnipresent Stanshall innuendo. Vivian sings: 'When your ship is sinking, he's the bung in your punt/If you can't find your keyhole, hooray for Holman Hunt/He even works at weekends, he is never out to lunch/He is spreading his light all around.'[6] William Holman Hunt, who painted religious themes, was one of the founders of the Pre-Raphaelite art movement. Between 1851 and 1853 he painted 'The Light of the World', a figure with a full beard, long flowing white

robe, holding a lantern which is spreading the light all around the picture. It is an evocative, rich, atmospheric picture and the figure looks startlingly like Vivian.

'We gave him a framework and he came up with many ideas,' says Mark Cooper. 'It was my idea that he should write about his father. But he wrote the piece and knew what he wanted to say. I didn't impose anything on his work. I wanted to shape the programme and get him to do something with a subject and a narrative.' Like many other people who came into Stanshall's orbit, he did not go away unaffected. Years after Vivian's death, his poky BBC office was still dominated by a blown-up photograph of Vivian used as a prop.

Vivian himself was very proud of the 'Late Show' piece, a performance that captured him at his sharpest. 'Television isn't a lasting medium, yet this piece lasted because it was so cohesive,' says Mark. 'A lot of the "Late Show" items consisted of experts telling you what to think. Vivian's piece was showing, not telling. It was someone showing you their life and not *telling* you about Viv Stanshall. You knew Viv after that piece. He was there. He was addressing something in his life in a way that was both honest and artistic. You can feel the anger when he says, "This is what made me who I am." With time, the programme has gained an eerie quality of a final summary – it was made just four years before Vivian's death.

'I don't think he thought he had much left inside him,' says Mark. 'He was getting tired. He'd done the Bonzos and *Sir Henry* and it is hard to make major statements in later life. Easy to say all this, but God knows if he actually thought in that way!' The piece ended with a fine number, 'I'd Rather Cut My Hands', performed by Nikki B on the *Thekla* in the mid-1980s. Where she had been a blues shouter, Vivian imbued the song with a confessional feel and his subtle nuances brought out both its loneliness and wry self-awareness. 'What the hell am I doing this for?' sang Vivian. 'What the hell am I doing this for? For I'd rather cut my hands, than let a stranger play my lead guitar.' It was a powerful end to the programme.

A proposed songwriting partnership with bassist Jack Bruce was less successful. 'He kept in touch,' says Jack, 'and said he wanted to write some songs with me.' After the chaos of *DOG Ends* at the

Bloomsbury, it was a testament to Vivian's reputation and charisma that Bruce thought this sounded like a good idea and even sent a car to take Vivian from Muswell Hill to his place deep in the wilds of the Essex countryside in the summer of 1992. Several hours after he was expected, and only after the cabbie showed great persistence in rousing him and transporting him, Vivian was carried into Bruce's house, completely comatose.

'He sort of came to and I started to play the piano – hoping we'd start to write some songs!' says Jack. 'But he was just gone. I saw that his coat was lined with bottles of booze and Valium and then he collapsed.' Close to panic, Jack phoned a doctor in the nearest village. Events took a turn for the surreal when he explained that he had a friend called Vivian Stanshall and the doctor proclaimed he was a great Bonzo Dog Band fan and became very excited at the prospect of meeting his hero. The doctor diagnosed acute alcohol poisoning and said that had he not been called, Vivian would not have lasted the night. An ambulance was summoned to take Vivian to Colchester General Hospital. Jack, meanwhile, was due to go on tour the next day and had to leave Vivian in the care of the ambulance drivers. Successfully treated in the hospital, Vivian phoned some weeks later.

'Jack, you'll never guess what happened to me,' said Vivian. 'I was on my way to see you and I ended up in a hospital somewhere.' There was no recollection of having got as far as the farmhouse and Jack did not feel he could fill in the details. He just made some non-committal remark about how strange that was. 'And that was the last time I saw him,' says Jack. 'He sent me some amazing postcards and letters, but we never got to write a song together.'

Tom Newman, who had worked with the Bonzos at the Manor studios, tried to get Vivian into the studio to work on *Tubular Bells II*, Mike Oldfield's 1992 follow-up to the hugely successful album which Vivian narrated back in the 1970s. Oldfield wanted him to do the narration on the new version, just as he had before. When the date for recording arrived, Vivian was due in at midday and when he had not shown up two hours later, Mike dispatched Tom to Muswell Hill. Vivian eventually answered the door in his underpants, inexplicably covered in earth. The engineer tried to explain that it was

quite urgent they get to the studio, but Vivian insisted he get his prescription from the chemist first.

On his return, Tom suggested a bath might be in order, given Vivian's condition. He was regarded with genuine astonishment by Stanshall. 'What's the matter, dear boy?' He really had no idea that his hair, his back, his legs, his side – all were covered in dirt. Understanding dawned and he asked Tom to get him a towel. The producer went to the bathroom to find the bath full of earth. Around the bath were shelves with pot plants on them. Vivian had knocked some of these in on himself while getting into the tub. While Vivian got ready, Tom helped out with some washing up. At length, he went into the bedroom to check on Vivian in the bedroom. It was suspiciously quiet.

'Nothing. Not a sound. He was fast asleep again in the bedroom. I shook him again, but he was comatose. He was breathing deeply, but unwakable.' Tom had to report back to Oldfield, who eventually used actor Alan Rickman instead. Vivian claimed he had never wanted the gig in the first place and had sabotaged the session.

Tom recalls: 'He phoned me up one night claiming that the reason he deliberately didn't want to do *Tubular Bells* was because he'd been cheated. Somehow he managed to turn it all around. He reckoned he'd got a bad deal on the first one. He had no idea that it was going to be such a monster hit. People probably told him it was only a hit because of his narration. He would have invented that story for himself, anyway. So he felt cheated and bent my ear for an hour one night on the phone about how he was going to sort out Mike Oldfield. "*He made all that money on the back of my voice.*" All that sort of thing.'

Vivian made a memorable appearance in Oldfield's stunning video for *Tubular Bells II*, something of a recompense. Though it was not apparent to fans who watched him in fine form on screen, his friends were aware of how Vivian's powers of resilience were fading now he was approaching his half century. 'His letters were always jolly and spikingly funny,' says Neil Innes, 'but the moments of fun and clarity were getting shorter and the sogginess was getting longer.' At least Vivian and Neil did manage to complete some work together, on a

new Bonzos song, 'No Matter Who You Vote for the Government Always Gets In (Heigh Ho)'. Elections were perhaps not the wisest of subject matter, since it meant writing for a deadline, never a Bonzo strong point. The track did actually come out in time for the 1992 election, but only because it had actually been recorded with the 1987 poll in mind. It was kept back when they missed the time slot in trying to find a record company. They originally hoped to go with Virgin.

'When we made the single, Viv wasn't well enough to promote it,' says Neil. 'We did BBC TV's "Pebble Mill", but we couldn't get a major record company interested. They all said anything political was no fun at all. People might laugh at it, but they wouldn't buy it.' The 1992 version was to come out on China Records under the Bonzo Dog Doo Dah Band name, and Larry Smith added some vocals. Old hand Gus Dudgeon was back on production duties. The song failed to hit the charts.

Somehow, politics and the Bonzos did not sit well together. In the early 1980s, Vivian himself claimed he voted only once, and then for the Sense and Order Society. 'I think the chap's name was Mr Stern,' he told an interviewer.[7] With the Bonzos unlikely to make any more money than they had before, Vivian would instead look to more commercial ways of earning a living.

16
The Land Where the Hoppity Oats

1992–94

Vivian used the language of advertising as a rich source of material for satire and parody. 'Wrestle poodles and win!' was one of his favourite spoof slogans. Making radio and TV commercials for real was lucrative and infinitely less stressful than risking the uncertainties of live concerts. It was a smartly attired, alert Stanshall who was lured towards the commercialism he once professed to despise.

He worked in ads intermittently for years, mainly voiceovers for radio commercials for the likes of Amplex and Burtons. His second career was more prominent in the early 1990s. 'He got into beer commercials based on *Sir Henry* the movie,' says his friend Philippa Clare. 'He was terribly well behaved and earned a lot of money too. He couldn't believe that voiceovers could earn that amount of money. Vivian sold out with the best of 'em. It's called earning a living.'

Vivian's reassuring voice could sell the most unlikely products and he soon found himself in huge demand. He wrote in the promotional flyer for *Rawlinson DOG Ends*, 'With no patronage whatsoever, like Orson Welles, he supports his uncompromising, unadulterated indulgences with voices and music for radio and TV commercials.' Those same thirty-second bursts of creative selling were also well suited as a framework for Vivian. As Neil Innes put it, Vivian's 'soggy' periods were lengthening and the limited amount of material needed to fill a short advert was ideal for him. He welcomed the discipline of a

focused brief. 'I like taking orders,' he said, 'and I particularly like doing voiceovers because it is so very exacting and often you'll have three people in the box telling you to put a particular inflection on this or to speed this up or slow that down.'[1] In the 1960s, many of the bright young things of advertising quickly warmed to the invention of the Bonzos. Among them was Fay Weldon, who went on to find fame as a novelist. She never forgot the band. In one of the many round-up, end-of-the-millennium polls in 1999, she nominated the Bonzos as one of the most important exponents of late-twentieth-century culture. Such was Vivian's reputation, he did not even need to go out hunting for work, as advertising creatives came knocking at his door – not that he always answered it.

Armed with an agent and a show reel, Stanshall built up a portfolio of work. In 1987 he wrote a Tennent's Pilsner lager TV advertisement, based on the Bonzo gangster spoof 'Big Shot'. 'Lou . . . Lou Tennent's the name. I was between cases, so I stopped off at the Sink Inn. The place was swimming over. I asked the barman for a Tennent's Pilsner. The cool taste was music inside me, so I asked for another. Ann introduced me to her sister . . .' The old Bonzo routines, with their catchy tunes, were perfect for jingles, appealing to advertising executives with fond memories of their student years. Vivian recorded advertisements for Cadbury's Crème Eggs, a riff on the Bonzos' 'Mr Slater's Parrot': 'When Mr Cadbury's parrot goes berserk/A geezer just can't get on with his work,' sings Vivian. 'Be careful, coz wherever you may go/You'll hear that parrot say, "Hello".'

Volkswagen asked Vivian to do what was a painfully straight instruction voiceover for mechanics, unintentionally as funny as many a comic routine. He also conducted a promotional interview in 1989 for a young singer Glen Colson was managing, John Wesley Harding. 'You've been listening to just a sample from John Wesley Harding's forthcoming album,' he begins. 'I'm Vivian Stanshall, but it's always sensible to have a urine test.' Harding went to record at the Muswell Hill flat, free-associating with Vivian for some time. They came up with a hilarious, loose evocation of the influences and thoughts of the pair. It was original and unusual. The record company hated it.

Vivian tried again. Ever the painstaking perfectionist, he scripted

a structured ten-minute version. The recording sounds spontaneous, Vivian introducing Wesley to the fans: 'a young man without a pusil-lanimous notion in his noddle . . . We're having a cup of char and a cosy promotional chat.' Vivian put no little effort into the enterprise and exercised his skill with language purely as a favour to Glen and Wesley. Just as he had helped artist Mark Millmore out, or bullied friends and colleagues into creating, Vivian always seemed concerned that those around him should be fulfilled. The Harding interview was an atypical example of Vivian's voiceover work. More usually it was routine stuff, such as an advert for Hill Samuel Investment Services International, which paid well, when Vivian remembered to cash the cheques.

'The point was he was always pleading poverty,' says Pete Moss. He went to sort out all the rubbish lying on Vivian's bed and there was a pile of unopened letters. Some of them contained cheques of up to £8,000. 'He was a crafty old bugger. I don't think he was partic-ularly rich, but he certainly had more money than he led people to believe. He was always off down to the building society.'

When Vivian lapsed and failed to turn up for a session to the studio, the ad men would send minders and cabs to get him. He made a small fortune. 'As soon as he came out of one of his bad periods,' says Pete Brown, 'and put his head above the parapet, he would be deluged with offers of work. He wouldn't know where to turn. Whenever he surfaced people would wave gigs at him. I used to feel slight pangs of envy!' When sober, Vivian worked hard and was conscientious. Vivian earnestly told young Wesley Harding a story he had heard about Peter Gabriel damaging his voice through using the wrong kind of throat medicine, and Vivian was keen to impress on the singer how vital it was to look after your voice. It was unfortunate he was incapable of following for himself the advice he gave others. If anything, Vivian was becoming more reckless in his own life.

In 1992, he discovered that great deals could be had for trips to Sicily, rather unsurprisingly, as Mount Etna was about to erupt and there was nobody there. Vivian told Monica that he was going in order to conquer his fear of flying, and because he hated warm weather, he went in January when the weather was pleasantly cool.

He stayed in a small town where he got on well with his hotel's proprietor. Kids on the street were not so friendly, and he was abused for his long hair and exotic clothes. Not long after he arrived, he was mugged.

'He fought these guys off and even hurt one of them,' says Pete Brown. 'But they got his wallet and dislocated his arm. He went back to the hotel and they let him stay on, even though the muggers had stolen his credit cards.' According to Vivian, word of the attack on the distinguished gentleman soon spread. Four classic Sicilian heavies appeared at the hotel, wearing sober jackets and dark glasses. They apologized profusely for what had happened and wanted to make amends. They got on so well with Vivian they wanted him to become a member of their fellowship, which was apparently a kind of 'self-help' organization.

Pete says: 'So they became blood brothers. After cutting him, they gave him a ceremonial Mafia knife. It became apparent that the poor guys who had mugged him had been dealt with. The local Mafia didn't want the place to get a bad name.' The saga was redolent of Vivian's Merchant Navy tales. Whatever actually happened in Sicily, Monica confirms that he returned to London with some terrible scars: 'Whether he had really been in a street fight or an initiation ceremony, I have no idea.' Vivian no longer had the resilience of youth to rely on in recovering from his exploits, and each new experience weighed him down with grief. His formidable powers of description meant that when Ki and her family read letters from Sicily, they found them funny and engaging. In England, Rodney Slater immediately saw how low Vivian was on his return from his trip and believed his equanimity never really returned.

A few months later, on 29 May, musician, collaborator and friend Ollie Halsall died in Madrid of a heart attack. He played guitar and other instruments on *Teddy Boys Don't Knit* and the two had reunited only the year before for the *DOG Ends* shows. The effect was pronounced on Vivian. He was 'floored', says Ki. Born in 1949, Halsall was six years younger than Vivian, had been battling personal problems, and the death came at a time when Vivian was struggling with his own mortality. He cried for Ollie, for himself, for days.

These twin body blows wiped Vivian out, and only over time did he recover sufficient strength to return to songwriting and present new material to his old friend Rob Dickins, by then chairman of Warner Bros. Since the late 1980s Vivian had been in the habit of popping along to Rob's offices for a social chat, just as he had done in the 1970s. With a hugely successful record corporation to run, Rob sat enraptured for anything up to two hours as Vivian talked about his formative years in his spellbinding way and very important people indeed sat outside his office waiting for delayed meetings. As an East End lad, born in East Ham, and in some awe of Vivian's voice, Rob was astonished to discover that they shared a similar background in London. Occasionally, one of Rob's staff might poke his or her head around the door in a vain effort to break the charm. When Vivian got back into songwriting, their relationship ratcheted up a gear to a professional level and he played some of his new efforts.

Rob was not sure about their suitability for Warners. He believed Vivian to be a great lyric writer and an accomplished melody-line composer. There simply was not the audience for Vivian's songs. They were diverse, some humorous, some more straightforward, and it was not until Vivian started the new set of 'Rawlinson End' stories for the BBC that Rob thought of a better way forward, that Warners would be perfect for a *Sir Henry* album. Vivian countered with a suggestion that they do half songs and half story, a compromise discussed at length from the early 1990s right up until Vivian's death.

'Vivian thought it would be the last one and therefore it was very important to him,' says Monica Stanshall. 'I don't think he would have continued to write music.' His hearing problems meant he simply could not do it any more. He wanted to concentrate on painting.

'He went in and out of being creative and in and out of wanting to do it,' says Rob Dickins. 'He is one of the most complicated people I have ever come across. And as funny and brilliant as he could be, he could also be dark. Whichever Viv you got at the time, you had to live with.' Rob met with Tom Newman, the engineer and producer who had tried to get Vivian to appear on Tubular Bells II. They discussed how they might best help Vivian without awakening what Sir Henry called 'the Beasht inside'.

'The ball was in Vivian's court and he did try,' says Tom. 'In order to get the record deal he was as straight as he could be. When he was like that he became this overbearing, very efficient, bright and breezy chap who got up at six in the morning and got on the phone to you and woke you up deliberately in order to show you that he was on the ball and that nothing was going to stop him. He wanted to ensure that the news got back that he was sober.'

When they next met, Rob said he did not want to see the 'other' Vivian. 'Don't worry, mate,' responded Stanshall, 'I don't like him either.' Once the contract was signed and the first part of the advance paid, it was all back to square one again. 'There must be joy,' he would tell his friends. One day in 1992, Roy Carr spotted Vivian at East Finchley station, bowling along and looking very dapper.

'Hello, poppet, wonderful day isn't it? I've just been round and ripped off Warner Bros,' he boomed. Roy's idea to issue Vivian's material on his own label was forgotten. Ebullient, Vivian wanted to share some of his good fortune with his pal. 'Do you think we should celebrate? Shall we go and crack open a schooner of sherry?' Getting the deal was a cause for celebration, a major coup for Vivian at a time when labels were not looking at older artists. He recorded a staggering eighty-eight tracks, more than thirty hours of material. There was enough for several decent albums, giving Vivian the space to get back to his painting. Pete Brown agreed to help him sort out the songs.

'It was a nightmare,' says Pete. 'A lot of the stuff had no lead vocals.' Brown himself played on a track which reunited Vivian with Dave Swarbrick and Danny Thompson. Once again, the other musicians were left completely in the dark. 'I didn't know where the structure was,' says Pete, 'I just couldn't hear it.' Editing proceeded at a crawl. Vivian was panicked by the thought of not getting it right for Rob. Just as there were two Vivians, he felt there were two Robs, one the friend and one the chairman of Warner Bros, the corporate boss.

'Sometimes he couldn't believe that I was taking him seriously,' says Rob. 'There was a need not to disappoint. He would have felt there was less pressure if the relationship had been anonymous, if someone just gave him money to make a record. I wanted it to be a

special record, not just a Viv Stanshall record for the sake of it. We had a good relationship, but it was always really professional.'

Pete Moss and John Megginson could never rely on three clear weeks of concerted activity. Vivian changed direction several times and could drop out of sight for months at a time. Production dragged on from months into years. Rob was enthused about the project again when he saw a photo of Vivian in one of the broadsheet papers, looking magnificent, like a medieval scholar with a velvet cap and a quill pen. Here, he thought, was the cover image, and he renewed his attempts to push the album through. Suspecting that Vivian was considered within Warner Bros to be the 'chairman's folly', Rob was undeterred. When any of his staff asked why they were bothering, he told them it simply had to be done.

With the Warner Bros album in the background, Vivian continued with his ad work. Ruddles went to him in 1993 to devise a campaign for their beer. Stanshall was not a great drinker of real ale, but was perfectly suited to the brief, which was to come up with something quintessentially English and timeless. This, it was felt, summed up the very traditional taste of Ruddles beer. The agency, BST, came up with a concept based on the Sir Henry stories. Creative director Paul Lees and account director Tim Nicholls were shown *Sir Henry at Rawlinson End*. Both were of the opinion that it was so brilliantly witty, so well done, that they could not do anything half as good. Vivian was the man and, aware of his often fragile condition, Tim Nicholls went to Muswell Hill to call on him personally. Tim did not know much about Vivian, and had only childhood memories of the Bonzos. He was greeted in Hillfield Park by Vivian wearing just ill-fitting boxer shorts, presenting a 'spooky, freaked-out' figure, says Tim. As soon as he played tapes recorded as roughs by the agency, Vivian was animated and enlivened.

'I can write better than this,' he declared. It was the beginning of an extraordinarily tight-knit working relationship that quickly spilled over the professional boundaries to become an intense friendship. Tim had been in the ad business for many years and quickly saw Vivian was the most creative person he had ever worked with.

'If he spoke coherently for thirty seconds even,' says Tim, 'he was

charming and hugely intelligent. He was fascinating and definitively unconventional.' Tim and Paul Lees even went to visit Vivian when he was staying with his mother in Leigh-on-Sea. Everyone at the agency took Vivian under their wing and the dapper Vivian was soon back, every inch the dandy. Ki came to stay with him in the Muswell Hill flat for a few months and remembers him being on top form.

'He was great,' confirms advertising account manager Leslie Murray. 'When I had to go into hospital for an operation, he called me every day to see if I was okay. He was just a good guy and his career was starting to pick up.' He was doing a lot of the writing, which was very rare in an advertising campaign. One of the pieces is pure *Sir Henry*, although Vivian baulked at fully naming 'Old Scrotum, the wrinkled retainer' for the delicate ears of a potential consumer audience, instead coyly referring to him as 'Old S.'. In one example, Sir Henry is heard holding forth on his favourite subjects, Empire, subjugation and booze: 'Y'see, the natives had it riveted in their noddles that if a chap's soul were pure, then the snake bite wouldn't harm him. Well, poor old Hargreaves died almost immediately, horrible agony. I suppose I could have saved him with a drop of Ruddles, but y'see I was down to just the fourteen barrels by then and there we were; stuck in the Dark Incontinent and still had to locate the lost tribe and make sure that they understood the deeply compassionate concept of Empire. Three or four merciful executions, a bag or two of beads and sequins-allsorts. Failing that, a sip of Ruddles normally does the trick. Explain that whatever they'd been up to for the last ten thousand years or what-have-you was wrong. Unless it was British, as British as, well, this foaming tankard. It was tough, a man's decision, but you can see why I had to take it.' And then the tagline: 'Ruddles. It unmuddles it.' The ad agency thought it was almost perfect.

'At the same time we had to make sure it was commercial,' says Leslie. 'He wrote with the team and they had to turn it into something that would last thirty seconds. They made it into a commercial, instead of being a piece of art.' As Vivian worked on the ads, Leslie, like many who had worked with him, saw that underneath a lot of his bluster he was simply deeply shy, and if ever he was put

into a demanding social situation, he'd freeze and then kick off. 'With Vivian it was either all or nothing.'

He was fifty and had not mellowed or relaxed with his hard-won reputation. Those around him saw with sadness that he did not feel any more confident, or find it easier to deal with people. As Monica observes, 'He just didn't know how to respond. He didn't reject people. He just found it very difficult to show affection. He was certainly suspicious of what people call schmoozing in the record business. He hated it.' Disappointed, he would come back from yet another showbiz do and remark that yet another person had met him and promised to get something together which never happened. 'If they are standing in front of me, they are all terribly excited and want to know me,' he complained. 'But out of sight, out of mind.' He was actually getting an enormous amount of work by the usual standards of the entertainment business. Able to imprint anything he worked on with his unique signature, his ability to see things in a completely surprising way was a crucial factor in the success of the Ruddles campaign.

The team needed a Sir Henry figure to replace Trevor Howard, the formidable Rawlinson in the 1980 movie. He had died in 1988 and the agency knew they needed someone who could play the part with similar skill. Vivian suggested Dawn French, the comedian who was then enjoying so much success with partner Jennifer Saunders. Dawn was fascinated by Vivian when they met. She was a rare favourite for him among the new wave of comedians who had come to prominence in the early 1980s. For the most part, with his love of music hall and his own training on the northern club circuit, Vivian preferred more traditional comedy. She made an interesting Sir Henry and her presence added to the atmosphere of the adverts, a sequence of dreamlike scenes around the Rawlinson dinner table over which Vivian recited a poem that was a mix of the kind of lines he had once written for Silky and the nonsense verse of Victorian poet Edward Lear: 'Malcolm the porcupine went to see/If a moon with green cheese would float./He exhaled a spray of, "Will you go away?"/To the land where the hoppity oats./He brewed humpty of Ruddles/Which he dumpty in puddles/And licked up whenever it snowed.' Much like

the owl and the pussy-cat in Lear's famous poem, Vivian's advertising work ensured that, for a while at least, he had 'some honey, and plenty of money,/Wrapped up in a five-pound note'.[2] Dawn French's husband, Lenny Henry, came down for the shoot, as did many other younger comedians. The attention was a source of discomfort for Vivian.

Vivian and Ki went for a meal towards the end of production. He soon called over the waitress. 'A glass of red wine, please,' he requested. He and Ki exchanged glances. They both knew what that meant. Once again, Vivian was unable to finish his work. For a while the agency was understanding. On recording days, the company kept their fingers crossed that he would be dressed and ready to go. If he was, it was going to be a good day. If he was not, they had to cancel and start again the next day, but they had luck with them in that the clients were Stanshall fans and were prepared to wait for him. The ad was finished without much more input from him. By the end of the Ruddles campaign, Tim Nicholls had become very close to Vivian. In some ways, he feels, looking back on it, perhaps too close. 'He kind of began to lean on me a bit,' says Tim.

After Ruddles, advertising work continued to come in from Toshiba (with a version of 'Terry Keeps His Clips On'). As the sessions continued, Vivian began to drop out again, partly through problems with contracts, but also for more familiar causes: 'So people just stopped hiring him,' says Rodney. 'He could never really take on board that he wasn't getting work because he was unreliable. He thought it was all some big plot. In his mind the world had turned against him.' The *Tubular Bells II* débâcle had led him to the same conclusion. If it was not Mike Oldfield's fault, it was his agent's. Slater heard the tail end of a revealing conversation when he was at Vivian's flat. The phone was wired into speakers and it was hard not to hear Vivian bawling out his agent in the next room: 'You never get me any work!' he shouted.

'Do you ever think it's got anything to do with you?' his agent asked him. 'Do you ever think it's because you are unreliable? So don't give me all this shit.' Rodney was embarrassed on Vivian's behalf, but his friend was clearly not in a mood to take any of this on board: 'And so the next thing is . . . enter Sir Henry,' says Rod. 'He

wasn't going to accept the idea that he was to blame. I think he could, but he wasn't going to because it was a game for him. I think even he realized it in the end.'

He did blame himself for not being an artist. That old frustration grew stronger with every passing year. Ki recalls an evening during her stay in 1993 when the two went to the gallery in Highgate owned by Vivian's Polish friend, Jan. Vivian had some wine at the viewing. On their return, the pair stayed up all night and Vivian wept, telling Ki he had failed and missed his vocation. When he was working on a piece of art, everything else faded into the background, music included. 'Therapeutically, the painting was really working,' says Rob Dickins, 'and he didn't want to go back to something else while it was.' By the end of the year, Vivian's now infrequent live appearances drew to a close. He made his last stage appearance at the Malt Room, Kendal, on 20 December 1993 and concentrated on the projected Warner Bros album.

'He always operated out of complete chaos,' says Keith Miller. 'He much preferred to have absolute freedom to make it up as he went along, hopefully with everyone else on his wavelength. But that is the kiss of death as far as record companies are concerned. At least with the adverts he was harnessed in some way, without being shackled.' He was writing bits and pieces of more *Sir Henry* material, for an album with the working title of *Plastered in Paris*, featuring Sir Henry and Hitler, and he was thinking about the possibilities of a second film. John Megginson was waiting in the wings to help with the new album, following Vivian's busy schedule.

'He'd take the money he got from Ruddles, meant for recording TV ads, to fund stuff he was recording for Warner Bros. When he got the cheque off Warners there was nothing to shell out. Sufficient demos had been done on Ruddles money. He enjoyed all that. He was playing games with them. He was pleading poverty to Ruddles by saying he had to have an advance, as he'd spent £50,000 on recordings for *them*.'

Vivian was invited to contribute to *Mojo* magazine, launched in late 1993 by Mark Ellen. They never received a piece from him. Which was not to say that he did not entertain from the moment Ellen got

in contact: 'Thus began a bizarre correspondence that lasted until his death,' he wrote later. '"Give me a subject and I'll deviate from it with all speed!" Vivian would send me ridiculous postcards from godforsaken seaside resorts in his flowery italic script, and I'd collect suitably dreadful pictures to send back to him. Then he'd ring me to off-load his thoughts and anxieties – "Wotcher, cock! Hello, mate!" – about his mother, maddening dreams about his father, the drugs, the drink, the mounting mail ("from the chappies at The Inland Revenge, dear boy. Venom Added Tax and all that kind of carry-on"), records, plays he'd seen.'[3]

With such anxiety in daily life, there had to be a very good reason for Vivian to overcome his fear of flying. When Vivian made a final trip out of the country, in June 1994, it was to appear in a film by Marcus Thompson called *The Changeling*, based on a Jacobean drama, which was being shot in Spain. Vivian was looking forward to the shoot mainly because singer Ian Dury was involved, who had been with him in the same year at Central School of Art. Despite a touch of rivalry, they were friends. Dury explained it would be a bit of fun, just a pleasant fortnight's filming in Alicante. Vivian had been in good shape for about three months prior to departure. He invited his friend John Megginson to come out with him. The idea was they could work on material for Vivian's solo album when they were not filming. There were only two or three days' shooting at the front end of the fortnight and some shots at the end. In between the pair could do some work on the songs. It was another great opportunity for fun and creativity. For the first three days, Vivian was fine, right up until he suggested that he and John go and see some paintings in Barcelona. He had arranged to meet a writer from the *Independent* newspaper and, in a hired car, they drove to find a nice hotel. For a day or two they spent time pleasantly enough, drinking the odd cold beer and writing. Vivian went out to buy some instruments for his collection and learned how to ask for one more beer in Spanish. He was glowing and beaming. John was delighted. 'This was the old Vic that we all loved.' John knew that, as long as Vivian steered clear of brandy, he would be all right.

One Sunday evening, they went to dinner in a local restaurant and

John began to fret when they walked in and Stanshall took his jacket off to reveal nothing on underneath. And then the brakes really came off. The next day he was having cold beers for breakfast and drank all day. He ended up yelling at people in pavement cafés. 'And that's the way it went,' says John. 'As soon as he started shouting at people, you knew the head was going.'

Vivian latched on to a couple of German people who had no idea what he was trying to say to them. Pretty soon he started bellowing and calling them Nazis, 'the usual stuff', says John. 'Making very good gags, of course, but they didn't understand this was "Viv from the Bonzos". It just got worse. On the Monday we went off for a meal and the brandy started again. Because he'd been eating, he didn't get a hit off the beer any more. It was hopeless.' On their return to Alicante, Megginson tried to find the rest of the team. Because Vivian kept going off to fetch more beer, they kept missing the film crew. Megginson was put in the position of being little more than the latest in the line of minders, 'but we were both a pair of wimps. So we booked into this nice little hotel and I put my passport beside the bed. Big mistake. Wake up the next morning. No Viv. No passport. He'd disappeared. He'd gone on a bender. He ended up two days later in Ian Dury's hotel room.' Somehow, like a homing pigeon, Vivian had found a haven down on the seafront in Alicante. When John finally caught up with him, Vivian was lying on the floor, unrecognizable. His face was bloated and he looked like a heart-attack victim. His eyes were puffed up.

'What could you do? I took him back to a villa, where he rested up. We tried to create windows of opportunity to get the film shots done. Marcus Thompson kept moving the shots around and Vivian missed them every time. It was a non-starter.' The idea was that Stanshall should drive a Harley Davidson motorbike down the promenade. Vivian had never learned to drive and could not hold it together for the shots. The film was completed with another actor in Vivian's role. With two days left before they were due to come back home, Megginson knew the director was still trying to get shots of Stanshall, who was trying to avoid the pressure by drinking brandy. After breakfast the faithful Megginson decided even he had had enough and left.

Vivian made up for the loss of his minder by flagging down a local farmer and begging him to take him to a village where he could buy a couple of bottles. The upshot was that the film crew lost the window of opportunity. Vivian blamed the Spanish brandy: 'This foreign muck doesn't agree with me.'

By the time he returned to England, his symptoms had reappeared: the agoraphobia, the nerves, the terror. 'He couldn't stand the tiniest hint of insanity creeping in,' says John Megginson, 'because he had such a brilliant command of any situation. His intellect was so sharp. And once a bender was over, within a couple of months he'd be fine.' In the second half of 1994, the benders were ever more severe.

'The last days were bad,' says Pete Brown. 'He used to call me up in the middle of the night. He was lonely and it would seem whenever he and Ki spoke on the phone, it would spark a tremendous reaction. He would fall off the waggon and go into a black depression and stay there. Unfortunately, she had that kind of effect on him.' Brown believes that the mixture of success, the legendary status, the drugs and alcohol broke any structure in his life to pieces. 'These things cannot exist together. It's very hard when you have to travel to find the work and you have to be – how you are – in order to create. For Vivian there were these enormous pressures of addiction added to his fantastic imagination. He was into knowledge of all kinds. He was into different cultures, as he tried to understand how the world was put together. Vivian was basically a working-class guy with this incredible intelligence. He was a self-made intellectual.' For those awaiting new material, the reasons for Vivian's prevarication were no help. He was not under financial pressure to work. A cheque had come in for £60,000-worth of royalties. Three big budget advertising campaigns had earned him so much he was able to disappear from view and drink to his heart's content. The effect of money without responsibility would be catastrophic.

John Megginson: 'In those last years, from 1993 to 1994, he wasn't fun any more. Not once the brandy started. It was absolutely heart-breaking. You would go to see him and he'd be literally out of his mind. He'd be rambling and repeating himself. I'd try to make him go out and eat something, if it was only a kebab. Anything. But it

would only pick him up enough to reach out for the bottle again. I think he liked the adventure of being completely pissed.' He was getting into fights on the street as well. 'It was masochistic in a way,' says engineer Tom Newman. 'He almost dared people to beat him up.'

As old friends did their best to help, younger fans wanted to give Vivian a more prominent platform. It was an unwell-looking Vivian who made an appearance in a video by Pulp. Their frontman was Jarvis Cocker, whose lanky frame and effete stage manner gave more than a nod to Vivian's Bonzo image. The year before they broke through in 1995, Pulp made a film which featured various celebrities' recollections of losing their virginity. Vivian was among the guests in 'Do You Remember the First Time?' One of the key questions was what did stars think when they had lost their cherry?

'Hooray!' replied Vivian.

17
The Clocks are Baring Their Teeth

Vivian Stanshall's favourite cry was a rousing 'Let there be joy!' By the mid-1990s, it was heard infrequently. He was lonely and tired. He stood before the grim twin prospects of premature old age and rapidly collapsing physical strength. During the worst periods, when he was overcome by fear and night terrors, there remained a few friends ready to listen or try to offer comfort and advice. When Vivian was found causing trouble in the streets, shouting and attracting the attention of the police, his oldest friend Rodney Slater stepped in. 'He wouldn't be eating. He'd just be living on vodka and orange. He was in a terrible state.' Rod turned up to find Vivian laid out. He got him out of bed, marched him to the car and drove him to the Priory, the large and expensive drying-out institution which had a reputation for helping celebrities and showbiz stars.

Rodney says: 'I thought he was going to be dead unless someone did something. He stayed for three days and then discharged himself.'

'Thank you, Mr Slater,' Vivian said curtly. 'You've cost me another thousand pounds.'

'So fucking what,' was Rod's terse rejoinder. 'Somebody has got to do something about you!' Star friends from the 1960s anonymously contributed to the cost of his treatment. He was three or four times in the Priory and also the Charter Nightingale in Lissom Grove. Monica accompanied him on many trips to these hospitals and

remembers one fruitless treatment at Friern Barnet hospital. Monica insisted on seeing the psychiatrist with Vivian.

'So the three of us sat in this cream-and-green-painted cell with a window right up on the ceiling. It was just like a prison. The young psychiatrist was obviously terrified. We got nowhere at all. He started by asking Vivian, "What do you remember of your childhood?" Vivian told him that his mother had said he was singing when he was still in the womb! That slightly threw the psychiatrist. According to Vivian and his mother, he was incredibly precocious as a baby. But singing in the womb? When you hear that, you begin to question the whole story.'

Vivian and his mother retold the tale together on a radio show about his childhood. It was a focused Vivian Stanshall who resurfaced on the BBC Radio 4 programme, 'From Essex Teenager to Renaissance Man', broadcast in November 1994. He was a revelation. Given his poor state of health, his clear tones and vintage form must have been drawn from somewhere deep inside. 'From Essex Teenager . . .' was written and narrated by Vivian. The programme was produced by Martin Buckley and continued with the autobiographical theme first established in *DOG Ends* and the 'Late Show'. The guest of honour responded brilliantly to the challenge. Once again Brainwashing House brought out the best in him. He took his crew down to Leigh-on-Sea and Southend to revisit the scenes and meet the people from his childhood. Vivian was relaxed and at ease, as he conducted interviews and conversations with old friends and acquaintances. He even revisited the Kursaal funfair. Eileen Stanshall took part in the conversation without a trace of self-consciousness. Vivian broke into chuckles of laughter at her anecdotes and the closeness of the two was apparent.

The programme was very much Vivian's construct of an idyll by the sea. As was usual in Vivian's version of his life, his brother Mark was simply not mentioned and, instead, old school chums were reunited to reminisce over pranks at school. Blinkered teachers popped up to show themselves as obligingly unreformed and all very 'My Pink Half of the Drainpipe'. Vivian's first job, as a bingo caller at the Kursaal, was brought to life with a number in which Vivian

calls the balls, with all the rhyming slang, over a smoky jazz backing. As Vivian himself says in the programme, the show was packed with fond memories 'tinged with a rosy *tristesse*'. Outside the snug world of Radio 4, the realities of late-1994 Britain were cold, as a threatening group gathered around Vivian.

John Megginson guessed during the recording of 'Essex Teenager' that Vivian was beginning another period back on the booze. It was always a threat. Ironically, a more immediate danger was waiting on the actual route he took to buy alcohol. To get to the nearest off licence, Vivian had to walk past an old church where a group of street drinkers habitually gathered. They got talking; the gang were friendly enough and one of the regulars there was a guitar player. Vivian eventually invited them back to the flat. In return, they very kindly offered to get his drink orders in. These new friends soon began to take advantage of Vivian. Some began surreptitiously and systematically stealing his possessions, from gold discs to his treasured instruments.

Vivian told his mother, Eileen, about the encounters he had. 'He was walking home late one night and he met this couple. He brought them back to the flat with him. There was plenty of room and they spun him a yarn that they couldn't find anywhere to stay.' Vivian gave them some sheets and blankets and left them to it. They slept on the floor in the lounge. He got up the next day and, as he told his mother later, 'I went into the lounge and never saw such a mess in all my life.' They had scattered food everywhere and trampled it into the carpet.

'He told them to clear it up,' says Eileen. 'They didn't. But they came back again the next night. He thought they looked like a respectable couple. He felt sorry for them.' The couple left two or three days later, taking half his belongings with them. 'I thought they were going up and downstairs a lot,' Vivian confessed to his mother.

'There wasn't much I could do to help him, when he wasn't feeling well,' says Eileen, 'except he could come and stay at home with me, which he did for a couple of months. When someone is ill, they don't tell you all the ins and outs. So you don't know what to do for the best.' Vivian reported the theft to the police, who told him he should not have let them in. Glen Colson talked to some members of the group himself when they, ominously, answered Vivian's phone instead

of him. One was a young alcoholic girl of fifteen who had run away from home. When Glen asked to speak to his friend, she said: 'He's asleep in the other room. To be honest with you, he's passed out and we're all just sitting around here.'

'Well, who are you?' demanded Glen, to which she answered, vaguely, 'We're just mates of his from up the road.' Vivian's real friends and family felt uncomfortable about the new crowd and were baffled by his motives in letting them in.

'In some of his obituaries, people described him as a humanitarian by taking these kids into his house,' says Ki. 'That was a load of codswallop. He was no humanitarian. He would never have taken these kids into his house under ordinary circumstances.' At least in hanging out with the drinkers he did not have to admit to his friends how bad things were in his life.

'He was embarrassed. He was out of shape. And he was on the run from Rob Dickins,' says John Megginson. Vivian was still anxious about the Warner Bros material. 'If Rob called, he always knew what was going on. If he was capable of speech, Viv would still be talking in his plummy elocution mode. But of course the speed of delivery had gone down. These street guys were on the same level as him. It was like a derelict with the derelicts. At least he had some company, because he was terrified of being alone. He was living in that flat on his own. That was why he spent so much time at Monica's place when he was straight.' Stanshall knew that Monica would not tolerate him when he was drinking, and neither would friends like Neil Innes. They all knew what Vivian was up to.

'It was really just attention-seeking,' says Neil. 'I think he was desperately lonely. But rather like a battleship that was sinking, he was firing on his rescuers. I tried to help him for over ten years. It got to the point where I would only talk to him when he was lucid. When he wasn't, I wouldn't. I felt that was the best thing I could do.'

Rupert saw his father again that autumn, for the first time in years. In November, Rupert and Vivian got together again over a game of snooker. Vivian was a huge snooker fan.

'He spent no end of time in snooker halls,' says Rodney. 'And he used to cheat like fuck! You dared not look round. The balls would

always be in a different place, when you came back from the loo! I was much better than him. I could play tactically and Viv never could. If you tried to play safety shots, he'd get so angry.' Vivian just loved to wade in and hit the balls as hard as possible, delighting in hearing the deafening crack of a good whack. If he could, he would hit a ball so hard that it would go over the pocket and down the other end of the hall. The game with Rupert was highly charged, a battleground for the two generations of Stanshall.

'It was the first time we had seen each other for about three years,' says Rupert, 'and the last time as well.' They headed down to the Archway snooker club in Holloway Road. The match was a battle of wills, of psyching out and intimidation. But now Rupert was old enough to hold his own.

'People talk about his presence,' says Rupert. 'His presence used to get to me. Now, the thing about snooker is, it's not about skill, it's about beating your opponent's mind and fucking him up. You are gonna beat him. I'm terribly competitive like that and he was as well. He always whipped me at snooker. Always. But after six years I had been away and grown up. So I pulled off some shots which were outrageous. I was playing his game. Blasé all the way through.' Rupert thwarted him at every turn. When Vivian went off to the bar, having offered to buy 'coffee', alarm bells rang in Rupert's mind and he followed him. Father was downing a swift shot of vodka. Rupert crept up behind him while he was ordering another and quietly asked, 'What are you doing?' It was, he says, like finding a little boy caught with his hand in the sweet jar, all flustered and 'Oh! Oh!' The balance of power had finally altered between the two of them. 'I beat him. At long last. And that was great, man-to-man stuff. And now, having beaten him at snooker, I could say, "I can battle with you, old man."'

Steve Buckley came back into Vivian's orbit that autumn as well. He had not been in contact since the night in 1984 when his car had been wrecked in Islington. He phoned Vivian to tell him that Larry Smith's father was ill, knowing that Vivian had always liked Alec Smith and would want to visit him. It was a good excuse to get back in touch. He got no reply when he visited the flat. He pressed the entryphone button, again and again. Half an hour passed. Steve

phoned the police, who said, 'Oh, if it's Mr Stanshall, we're not going to bother. Forget it.' Just as he was about to give up, the door buzzed open. Another, steeper set of stairs led straight up from the inside doorway and although Vivian was not standing there, Steve glimpsed a shadow, Nosferatu-like, disappearing around the corner at the top. The sight did nothing to relieve his nerves. Vivian was in the bedroom when he arrived, clad only in the same cut-off loon trousers that had been a staple in *Searchlight* days. 'Good man, Buckley! Good man!' he boomed and collapsed on the bed. This was the Vivian that Steve had grown used to seeing, but looking around the bedroom he saw evidence of the other Stanshall. Visible through the half-opened wardrobe door were beautiful suits hanging up, silk shirts and hand-made clothes.

'What happened to you?' There was no answer. To break up the gloomy atmosphere he picked up a nearby guitar and started playing the Sam and Dave classic 'Soul Man'. Vivian immediately leapt into life, keeping time with extravagant stamps of his foot and bellowing, 'I'm a soul man! Oo! I'm a soul man!' When he was in an animated mood, says Steve, Vivian was not just larger than life, he was 'larger than an epoch'. Steve ran him a hot bath and on the way in, Vivian knocked all his plants into the bath, a scene that would have been familiar to Tom Newman. Dressed in a black suit with a red shirt, Vivian stood poised at the top of the steep stairs. Steve was ready to help him and asked should he go first or second? 'That's no problem,' replied Vivian, and promptly fell all the way down the stairs, landing heavily and with a crunch, hitting his head on the wall. Steve stared at the body in absolute horror. He had not seen his friend for a decade and now he had managed to kill him within a couple of hours. With real panic and fear, he shouted Vivian's name at the top of his voice. To his relief, Vivian faintly replied, 'I'm all right.' They did not visit Alec Smith that day and instead Vivian stayed at Steve's house in Ladbroke Grove for a week or two. During the latter part of 1994, he often spent time there, playing music with Steve, away from the unpleasant influence of the street drinkers near his flat.

Vivian was still entertaining company recalls Steve. 'One night he just sang six songs off the top of his head, which he'd made up there

and then to the chords I was playing.' Vivian got along with the various other people who passed through Ladbroke Grove, including a friend of Steve's called Mary Chater, whom he immediately propositioned with his usual directness. Though she turned him down, she was none the less charmed by his manner. Steve also helped Vivian through another drying-out session and it was a cheerful and focused Stanshall he next telephoned, around the time of 'Essex Teenager . . .'. Vivian popped in the next day for a cup of tea, well groomed, wearing a new suit and twirling a smart walking stick from his collection. Steve was keen to get Vivian back working, maybe on stage for a show or two.

'He'd agreed with me that he should do a proper live gig,' says Steve. They went to see a theatre nearby, small enough for Vivian to do a show without the aid of amplification, which always aggravated his tinnitus. Vivian did a few vocal exercises on the stage, just to try it out, and liked the venue. Something positive at last, Steve felt, and Vivian returned to Muswell Hill.

Once on his own again, the panic attacks returned and he was back to calling friends for help. Pete Brown, down in Crouch End, fielded a few of the late-night telephone calls. 'These didn't go down that great because I was living with partner and child,' he says, 'but I answered the call as often as I could. I tried to get it into his head that though he was lonely because he wasn't very easy to live with, many people loved him, more people than most are loved by, and that he wasn't really alone, just physically, at that moment. There were still glimmers of light.'

Steve's friend Mary Chater popped over to the flat in order to cook him some decent food. Vivian was anxious to get in shape and eat properly when he was free of the toxins of alcohol. 'I cooked him squid, and chicken breasts in white wine and lemon,' she says. 'Very plain, but nourishing food that was not difficult to digest. I sensed that physically his insides were . . . not flowing.' The kitchen was as cramped and cluttered as anywhere else in the flat, boasting a tiny area where Mary chopped up food as required, turning around to drop it on to the stove. This *Alice in Wonderland* domestic scene was complemented by the tall, gaunt figure of Vivian himself. He could

barely fit in the kitchen at all. His cooking arrangements were much like the conditions in which he worked. Nothing was tucked away, it was all scattered all over the place. Mary also helped Vivian's song-writing efforts, accompanying him on his home keyboard. She visited a number of times at the turn of the year and on each occasion it seemed as if he was seeing her for the first time. The visits were not even separated by more than a few days: 'He always knew that I was coming,' she says, 'but every single time I'd ring the doorbell, he always seemed surprised and not quite sure who I was.'

Part of his absent-mindedness was probably down to the continuing attentions of the gang of drinkers. 'I'm in high anxiety,' he told writer friend Chris Newby. 'I was burgled at Christmas, but they took nothing of intrinsic value, only things like my Grandmother's crucifix.' In fact, the gang stripped the flat of many of his most cherished possessions. Just before Christmas in 1994, Steve Buckley received a message, this time from Monica. Steve had not seen or spoken to her since he first met Vivian on the boat and that alone made him worried. Vivian was back on the drink again and now even the resourceful Monica was at the end of her tether. Steve and his girlfriend went to the flat and managed to get Vivian into a clinic for a few days.

'He was absolutely clear but extremely depressed,' says Monica. 'It was Boxing Day when I picked him up from the hospital. Every time he went in, they said he should stay for more than six weeks. But where was that money going to come from? How could he possibly afford that?' A few weeks into 1995, Vivian called Steve directly. He was in a state of fear and shock. 'There are men at the door with hammers,' he told him. By the time Steve and some friends arrived, there was no sign of anyone hanging around. Steve noticed that there were more valuable items missing from the walls. Back at Steve's house, they settled down for the night. Vivian was not forthcoming about what happened in Muswell Hill. From what Steve could piece together, it seemed as if Vivian had some months earlier questioned the group who hung out by the church to find out who was taking his stuff and where they were. He actually got an address out of them – it was somewhere in Neasden, where Vivian went in a taxi to demand his property back. He had negotiated some price for it,

he said, and the men at the door with hammers could have been those responsible. It was all very vague. Vivian stayed with Buckley for two nights and then decided to return to Muswell Hill.

Thousands of miles away in Vermont, USA, Ki had a completely misleading version of events from him. Vivian left out most of the worst details. The way he was telling it to her in February, the two of them were going to get together again. He could not have been unaware that his terribly poor condition made this a remote possibility at best.

'On some level, he bloody well did know,' says Ki. 'But he didn't consciously allow himself to know this. Even if he did survive, he was going to be an invalid from alcoholism. But I didn't know he was so sick. If I had known, I would have been over there and then. I would then have been witness to what he did not want me to see. So he never told me.' The two of them talked seriously about where they might buy a place. All that needed to be arranged were the practicalities. 'I knew he couldn't come to the States because he couldn't get on a plane. I knew I had to come back.' Vivian would sell his place in Muswell Hill and Ki would leave the beautiful surroundings of Vermont for London. Just about the only area of London they could think of to compare to that leafy American state was the literary enclave of Hampstead.

'All I ever wanted was to put together his energy and my energy, which we did once in the triumph of *Stinkfoot*. He wanted to do it again,' says Ki. 'I don't mean another *Stinkfoot*, I mean a home with my daughter Silky, who loved him desperately. He adored her. You only have to listen to "The Tube". This was a hope that he was holding on to. It was just a dream. But I thought it was real and I was making plans.'

At the end of February, Vivian phoned Steve Buckley. Having been ill himself over the course of that winter, it was the first time Steve had heard from Vivian for a while. 'Steve, I want you to come over. I want to buy you fish and chips,' said Vivian rather wistfully. This gave Buckley pause for thought; it was a treat reserved for a select few.

'Hold on a minute, this is real, love, innit?' he replied. 'You only

buy Glen Colson fish and chips.' He promised to come, either the next day or at the weekend. Before he had a chance to get over there, he had a disquieting premonition, and he was not the first. That February, Ki dreamt she was in Holborn in London and a man came up to her with a small box in which he said he had Vivian. He wanted her to find a place for him.

Over in Toronto was former *Melody Maker* photographer Barrie Wentzell, who could usually be relied on to lift Vivian's spirits. As February ended, Wentzell received a 3 a.m. phone call: 'He was in a terrible state,' says Barrie. 'He seemed to be full of self-loathing and he said things like, "I hate myself."' Barrie, roused from his bed and thoroughly alarmed, did his best to calm him down. 'I tried to say to him: "You are a genius and everybody loves you. But you are going crazy. You've *got* to stop drinking." I was the only photographer he ever wanted to take his pictures. He once asked me over from Toronto to visit him in London for a session. I think he wanted the photos for a record sleeve. I travelled 3,000 miles to this awful flat in Muswell Hill. There wasn't enough room to take the pictures and we went down into the basement, where he started putting on a funny hat. Then he suddenly said: "We should stop doing this. I'm too old for all this silliness." He realized he had become a parody of himself. I told him he should try to take himself more seriously.'

On Sunday, 5 March, back in England, Steve Buckley went for a walk to a church he often visited, not that far from Muswell Hill, in Belsize Park. He kept seeing a solitary magpie flying overhead, which brought to his mind the line from the children's song about the bird: 'One for sorrow, two for joy'. When he got home, he rang Monica. The lone magpie had been the harbinger of the worst news. Monica had received a phone call from the police that morning. Did she, an impersonal voice enquired, know a 'male person' named Vivian Stanshall? Monica found the casual indifference of the officer almost as hard to bear as the news he brought. At some time around 6 a.m. that Sunday, the policeman informed her, a fire had broken out in the top flat of 21 Hillfield Park. Vivian Stanshall died in the blaze, which destroyed his bedroom.

The news spread quickly around the tight-knit circle of family and

friends. John Megginson was among the first on the scene, meeting Monica at Hillfield Park. Vivian's bedroom was totally consumed, but the bedroom door was shut and this contained the flames. The adjacent bathroom was only heat-damaged. The cause was likely to have been a bedside table lamp falling over while Vivian was asleep. It scorched the myriad papers around him. They began smouldering and set light to his video cassettes. Both smoke inhalation and toxic fumes from burning plastic knocked him out.

'How it hadn't happened before, I don't know,' says John Megginson. Back on the *Searchlight* in the 1980s, Vivian had twice set fire to himself and a tragedy like this seemed inevitable. Some of those close to Vivian raised suspicions about the role the gang of drinkers played in the Muswell Hill fire. A police enquiry established only that they had been there earlier in the evening, getting Vivian to buy a huge amount of alcohol.

Days passed before Steve Buckley could bring himself to visit the scene. He drove past the front of the house, which looked untouched. Around the back was a car park, from which it was possible to see the gutted bedroom. The roof was covered with a tarpaulin and Steve was immediately touched by the sensation that the scene was a mirror image of the one in Chertsey, when *Searchlight* sank and was then refloated with the rubber nappy. Only this time, it was the roof of Vivian's home that needed protection.

Monica and John Megginson spent two weeks in the flat, sorting through the remains of Vivian's property. As the fire did not spread beyond the bedroom, what survived and what was destroyed split into two categories. All Vivian's personal possessions and work-in-progress were destroyed. Paintings and instruments survived in the other room. Many of them had been stolen by the gang and sold back to Vivian, who had not put any of the artwork back on the shelves or walls. It was this precise split between the burnt and the salvaged that led Ki to think that it almost resembled a plan. It was as if Vivian had wanted the gang to take his work from him.

'In the last couple of years of his life, the only thing keeping him alive was his art. The only way to let go of life was to let go of the work. He took them into his house for a specific reason,' she says.

'He took them into his house because they then removed from his house, his work. They stole it, piece by piece. They took his musical instruments and they took his paintings. They took his jewellery. They took the accoutrements that made Vivian in terms of style. They stripped him bare and took away the last things he needed. He could not have done that himself. I'm not extrapolating this and becoming terribly romantic. I think it's true. He was going out the way he intended to go. I consider it a triumph because I see it as an artistic creation by Vivian to go out beautifully.' For Ki, this made sense of the way he had been destroying himself with drink. Nobody had to view his body as a result of the fire and, she says, 'he stage-managed a fabulous production. It was very personal and only a few people could know what it meant. I don't believe in this "tragic death" crap. He had been trying to kill himself for years and he was doing it so slowly and so publicly.'

This is a view Rupert Stanshall shares: 'He was drinking for months on end and my feelings were this was his painless way of ending it – a feeble attempt at killing himself. His situation at the time was not at all pleasant. He did ask for help, but as I said to him at the time, he had to sort himself out with me first before I could start solving his problems for him.' The prospect of ending his days dying slowly in a hospital bed was too terrible to contemplate. Rodney Slater saw the considerable physical change in Vivian over the last few months of his life. 'He was a big bloke. Yet at the end of his life, despite his height, he weighed less than me and we could wear each other's jackets.'

Mark Stanshall adds that he was always 'fearfully thin' and that 'he wasn't awfully robust towards the end. He looked very red-faced and red-veined. I never visited him at Muswell Hill because I hadn't spoken to him for a number of years prior to his death. It was a shame he went so young, but it was just waiting to happen really. It was all part and parcel of the tortured-genius syndrome.' At his lowest, Vivian freely admitted he did not see his continued survival as a positive thing at all. 'I've been cursed with a body which seems to survive anything,' he told Robert Chalmers late in 1994.[1]

'It's funny because he's always had a beard and been *old* and I've

always called him the old man,' remembers Rupert. 'He has been immortalized now. Nobody has got to see him in a wheelchair or hobbling down the road – or unable to shake a large cane and bellow at somebody! For those who believe in spiritual release . . . well, then he is now far too busy to talk to any of us.'

Ki thinks the manner of his death was a significant part of his desire not to go out as an invalid. 'When he burned the bedroom down he gave himself a Viking funeral,' she says. Steve Buckley agrees, believing that Vivian went 'like a Celtic warrior on his own funeral pyre. Terrible. But it's the only way he could have gone. He was never going to just drink himself to death. He was not going to go like anyone else.' Vivian himself used similar terms to describe destroying his possessions when he split from Monica and had often spoken to Ki about wanting to be put on a boat and set alight at sea after his death.

'He deserved a heroic ending,' says Rupert Stanshall. 'He loved that film with Kirk Douglas, *The Vikings*. He thought it was great. And that's the way the old man went, in a kind of Viking funeral fire with all his possessions. There is a lot of power in that image. He went up with his clothes, his ukulele, his baccy . . . it's weird. Everything that was in that room was really him. All his little bits and pieces he needed to hand and all his creativity, they all went up with him. As he went up, first of all he was out of his head and secondly he would have been dreaming. This might sound like an awful thing to say, but the fact that he went the way he did in a fire, meant he must have gone in one of the most amazing hallucinogenic trips of his life. And because he was such a coward – what a way to go! Any consciousness he would have had would have been colours and sounds. It was an *awful* thing to happen. But that's how I see it, as a Viking funeral. That's how I can cope with it.'

The date of his death was an extraordinary coincidence. There had been more than one real Sir Henry Rawlinson and one had been a Victorian – Sir Henry Creswicke Rawlinson – who, the *Dictionary of National Biography* for 1896 records, died on 5 March 1895 – one hundred years to the day before Vivian. Sir Henry's entry in the *Dictionary* reads like an extract from one of Vivian's stories. A noted

Assyriologist, he had military experience, and 'quickly distanced all competitors in the acquisition of Persian and the Indian vernaculars', becoming an interpreter. Sir Henry was brave and well-travelled out in India. One paragraph in the lengthy entry seems peculiarly suited for Vivian: 'Personally, Rawlinson was a fine specimen of the old school of Anglo-Indian officials, a survival of a great tradition – soldier, scholar, and man of the world. To strangers he was in manner somewhat imperious and abrupt; to his friends he was large-hearted and generous.'

Vivian's passing stirred enormous interest in the media. In those final years, when his work was produced sporadically and the painful periods between it were so great, it was easy to forget what huge respect he commanded in the arts. All the broadsheet papers carried obituaries, and it was front-page news in the *Telegraph*. In America, *Rolling Stone* said, 'He leaves behind an adult son, a daughter and a multi-media legacy of inspired silliness and serrated invention.'[2] John Peel introduced a special television tribute on BBC2 and showed clips from early Bonzo videos and the 'Late Show' piece. 'He was one of the few people I actually wanted to be,' said John Peel. 'Back in the 1960s, I used to think I'd give anything to be as cool and funny as him.'

The inquest into Vivian's death opened on 7 March 1995 and immediately adjourned until 13 June, when the north London coroner found the cause was a 'non-suspicious fire situated mainly in the bedroom'. The verdict was accidental death.

Ki had flown in from Vermont shortly after the death, with Silky, leaving Sydney back on the farm. She too visited the flat in Muswell Hill: 'He had a wall in his flat which he called his "family wall",' she says. 'On it he hung paintings and photos of his family. There was his granddad in his fireman's hat. His mum. His dad . . . though off to the side. There was a tiny one of himself and Rupert when Rupert was a wee lad. And there were several of Silky. Of me. It was the wall he looked at when he wrote. Seeing it in the aftermath of his last hellish days it almost broke my heart. What was left of it.'

Rupert was surprised to find within him strong echoes of the protective instincts that Vivian always had towards his possessions.

'When my sister and I were going through his things after he died, she was all over the instruments and I still had the same in-built thing where I had to say, "Stop it!" She was only a kid and she was picking them up and bashing them about. It was like, "No, I can't believe I'm watching this." He would have not even let her sniff at them. As a little 'un, I wasn't allowed anywhere near them. Crawling inside the tuba case was just about all right.'

Monica and Ki arranged the details of the funeral and memorial service. Inevitably, some friends and colleagues felt that more could have been done for him before he died. Gerry Bron, who had been the Bonzos' second manager, says that it was only in the last few years of Vivian's life, when the two got back in contact again, that he realized the full extent of the difficulties that Stanshall had faced. 'I think he had a natural talent, but he was never very professional because he would never do anything consistently,' says Gerry, adding, 'I felt later that it was my fault. I should have realized there was a problem and tried to nurture him in other ways.'

The funeral was at Golders Green Crematorium, on St Patrick's Day, 17 March 1995. The crematorium is just off the main road into Golders Green, Finchley Road, on a small street called Hoop Lane. When Ki saw it, she was immediately reminded of the dream she had had in February, of being in Holborn and meeting a man who asked her what he should do with Vivian. 'Only it wasn't Holborn – it was Hoop Lane. So Monica was the little figure in the suit who appeared in my dream.' Rodney Slater was the only former member of the Bonzo Dog Band to attend the funeral. Neil Innes felt it was a family occasion and Roger Spear's invitation was never sent out. It was a beautiful spring day, early on in what was shaping up to be a blisteringly hot summer. Rodney walked the four or five miles from Muswell Hill to join his fellow-mourners in Golders Green, only to find they were all apparently at the funeral of someone else.

'He was buried under another name. It was terribly funny,' says Rupert. 'They used a different name, so that nobody would know it was him, because Monica didn't want the press there. He was given the name of St John Danvers.' This was one of the names he had used when sending off for bizarre or amusing things from magazine adverts.

Just contemplating this idea is enough to summon memories of Vivian's delight in the absurd and his wheezing, choking, deep-throated bursts of laughter. There was a strained atmosphere at the funeral as the two sides of Vivian's family met. Says Rodney: 'Ki and Monica didn't like each other and, of course, they had one child each by Vivian, Rupert and Silky, and they were all at the funeral.' There was some resentment over how the arrangements for invitations and seating had been made. Ki realized that, personal differences aside, Monica had done a lot for Vivian. 'Monica took care of him so well towards the end of his life. She was there for him. He was hiding all the stuff that was happening from me.' But the funeral was not the time for reconciliation. To add to the tension, Rupert and Monica had not spoken for some time and were angry with each other. 'I was furious with her for what happened when I was ill,' says Rupert.

The memorial service at St Patrick's Church in Soho, on 21 March, was a straightforward, joyous celebration of Vivian's life and work. It was a sunny, fresh spring morning as people gathered at the church on the eastern side of Soho Square. Among them was Derek Taylor, the former Warner Bros record-company executive and legendary Beatles press secretary. John Walters represented the BBC and Mark Ellen came from *Mojo*. Many musicians attended, including Steve Winwood and former members of Scaffold, Zoot Money and Ian Dury. Eileen Stanshall was taken aback by the strength of feeling. 'I was amazed! I wasn't well myself as I'd had every tooth in my head taken out a couple of days before. Mark drove me up. I never knew Anthony had so many friends and some of them were quite well-known!' Mark Stanshall, then working at the Chelsea Arts Club, escorted his mother into the church: 'As we walked into the church in Soho Square, I recognized ten members of the club. For some strange reason everybody sat on one side of the church, leaving the other side empty. I said, "Hello" and you could see them wondering "Why is the club doorman here with an old woman?" And then the penny dropped, which I thought was quite funny.'

When Larry Smith arrived, it was in true 'Legs' style – with a cameraman: 'I was involved with a documentary maker at the time and we filmed the memorial service,' he explains. 'Nobody knew about

it, but we had a camera up in one of the balconies.' This had not actually gone unnoticed.

'I could have punched him,' says Ki. 'Everything is a photo opportunity for Larry. It was supposed to be private, not a media event. Larry has a TV camera crew and then he starts talking about "projects" and I'm thinking – what are you talking about?' Neil Innes paid a moving tribute to his old friend and an ensemble of musicians, Tom Newman, John Megginson, Steve Winwood, Suzy Honeyman and Pete Moss, gave a poignant rendition of 'Aunt Florrie's Waltz', the theme from *Sir Henry*, at the end of the service. The poet Roger McGough, veteran of Scaffold and Grimms, read a poem about Vivian 'walking the tightrope with the safety net firmly nailed to the floor'. That went to the centre of his life, Monica thought.

'There wasn't much safety in his life and that was the thing that ran all the way through his work,' she says. 'He took enormous risks with what he was doing. He did care about other people's opinions. He cared enormously. I wouldn't say he wanted to please, but he certainly cared about what people thought. He wanted people to be amused or shaken, but the most important thing was that they listened.'

When Steve Winwood sang 'Arc of a Diver', the song he had written with Vivian, in the hushed church, his performance brought many of the mourners to tears. Monica was especially delighted that Winwood sang for Vivian. 'Steve helped him in a great way by asking him to collaborate on his music.' She had earlier asked him if he would do something as a tribute. There was a long pause. At length, Steve simply said, 'I'll think about it,' and he entranced everyone when he turned up and sang. This was, of course, all captured by Larry: 'We had Steve Winwood playing his song and he was interviewed afterwards.'

The presence of so many people pouring into the church to pay their respects raised uncomfortable questions in Monica's mind. Barrie Wentzell remembers her asking, 'Where were all these people when he needed them?' Vivian never let anyone near enough to help him and he knew it. The impossible position in which he had put his first wife weighed heavily. 'In many ways he carried a tremendous

burden of guilt about Monica,' says Rod. 'He had given her hell, but she took him back in, as a friend. There was always a room and a bed for him and he stayed with her a lot. They were in love with each other, to the end.'

For most people, there was never the chance to help. 'He had such talent, and yet he really was a tortured genius,' says Barrie Wentzell. 'He was tortured by his intelligence and he just couldn't stop thinking of ideas. He once told me, "It's all in my head and I hate it."'

With no specific plans for a wake, various groups splintered off after the service and found their way to bars and clubs around Soho and Chelsea. Some went to Toucans in Carlisle Street and then adjourned to the Groucho Club, where Glen Colson and actor Keith Allen toasted Vivian's memory with champagne. Others went to the Chelsea Arts Club. The family went to a legendary artists' club in Soho, the Colony Rooms.

'There was a bunch of awful painters there, slobbering all over the place,' says Ki, who arrived in the club with a plastic shopping bag. When Pete Moss went to take the cumbersome bag from her she said, 'Well, be careful of him.' It was Vivian's ashes. 'So I thought we'd put him somewhere safe and stuck him on the piano,' says Pete. Soon after, Monica came over to talk to him. 'I'm so glad Vivian's not here. He hated loud noise,' she said.

'It was so funny, just the sort of situation Vivian would have loved,' says Pete. 'I said to her, "He's looking at you!"' Philippa Clare was not so sure Vivian would have approved. She certainly did not. 'There was no party set up afterwards,' she remembers. 'I wanted to arrange something but I kept out of the way. Ki came up to the club and she carried the urn with his ashes. And she was slinging them around.' There was something appropriate about the improvised chaos of it all and the deep affection which everyone felt for Vivian was heartfelt. Monica shared a taxi back to north London with Pete Moss, who was convinced that Vivian's mischievous spirit was very much with them. They hailed a chatty cab driver who eyed the sombre party in his driving mirror and said, 'Cheer up. It looks like you've been to a funeral,' and, when informed that this was precisely where they'd been, blithely continued: 'Oh. My mistake. Don't worry about it

though. Good job you haven't got him with you, I'd be charging you extra.' Pete looked at the bag containing Vivian's ashes and could not help but smile.

Vivian's will left everything to his children. That Mark Stanshall was not one of the beneficiaries was only to be expected. Mark viewed his brother's death with phlegmatic calm. He did not even have any idea about what the estate might have been. 'I really don't know because I thought he was one of the meanest bastards in the world. He still owes me two hundred quid!' The Stanshall legacy was also in the form of the songs he had been recording for Warners, still locked away in the record company vaults somewhere and the subject of a long-running legal dispute over ownership. Friends continue to spend time trying to get the clearances to get the material finished and released.

Vivian's sudden death was especially difficult for the children. Silky was angry that she was denied the chance to get to know him. She was a teenager when he died and was still dealing with it into her twenties, says Ki. 'She was taking music lessons and she's second-generation Vivian. Strong personality. Lots of balls, very theatrical, full of talent. She's a stand-up comic, plays different instruments and sings.' Ki's older daughter, Sydney, says she has become the painter that Vivian himself always wanted to become.

'Although he felt he was a failed painter,' says Ki, 'he *did* paint and there is a body of work. And he did spend time when Sydney was young teaching her to draw and how to write songs.' She learned a lot from Vivian and rejected the idea that an artist has to suffer. Sydney was enthused by 'his lack of compromise when it comes to your personal trust in your own aesthetic'.

Silky remembers her father with awe and affection. She 'has lots of dreams about Vivian', says Ki. 'She has a dream where she is facing a canvas and wondering what to do and he comes up behind her, holds her arm and wrist and paints from behind, saying, "Be bold!"'

His son deeply regrets the lost opportunity for a mature relationship with his father: 'Now I am a businessman with a wife and a child, living in our own house,' he says, 'I am pissed that we didn't get that opportunity to link up properly and to be able to share my successes,

because it was always his successes. So he was in the West End with a show? Well, I was in the West End too. "Where are you playing? See you after work!"'

As time passed after Vivian's death, friends and colleagues were able better to quantify their feelings about him. 'I'm not with the guy twenty-four hours a day any more,' says Rodney Slater. 'But for me, he lives on. He did so much and as soon as I met the guy, he was talking my language. I couldn't find a way to get it out. He did that for me. He was being what I was thinking. He was a genuine, real friend. And we were both teddy boys.' In 1997, Rodney had an odd reminder of his friend and the *Searchlight*. He was playing a gig when a huge man lumbered across to him, wearing glasses with windscreen wipers. He said, 'Have you ever seen these before? I was the man who raised the boat and I found these glasses.' The guy had a shaven head and was covered in tattoos. 'A real river man,' remembers Rodney. 'So he had Viv's glasses. But he wouldn't give 'em to me!'

Vivian's output was hardly prolific and everyone who knew him would have wanted his creative processes to have been easier for him. Stephen Fry questions both that it could have been different and indeed that it should have been any different: 'It's very easy, and I think, wrong, misleading and impertinent to regret what people were not,' says Stephen. 'It's true that whenever Johns Peel and Walters managed to get him to do something when no one else would touch him one felt a great surge of joy that an under-used genius was being appreciated, but on the other hand who am I to say that his life was one of under-achievement or failure? He didn't live by the terms or rules most of us follow, but that's what made him what and who he was. He left the party earlier than one would have wished, but that's our problem.' All his friends and colleagues wished his dedication to living by his own code could have been less painful for him and many were struck with feelings of guilt in the immediate aftermath of his death.

Six years after his death, Monica Stanshall is still coming to terms with the loss of his presence. 'It's only in the years since he's gone I realize how much fun he was,' she says. 'He had a quirky slant on everything.'

Vivian gave Sir Henry some characteristically unprententious views on how he would like to be remembered: 'I don't give a toss what you do with me when I've shrugged off me mortal coil. Shove a bit of flex up me back passage, stick a lightbulb in me mouth and stand me in the hall. Mind you,' he continues with a wheezy laugh, 'if you're using electricity, you'll have to dry me out first.' The creation of Sir Henry was enough to ensure an enduring reputation for Vivian. *Rawlinson End* is so well crafted, such a delicate balance of the comic grotesque and the absurd, it is out of time and timeless. At once it is an England that never existed and the essence of Englishness.

Vivian's post-Bonzo work impressed for its range as much as anything. From radio shows to light jazz numbers, via film and television, there were few media he could not make his own: 'I could never think of anything to say when I'd played one of his pieces on the radio,' said John Peel, 'and would end up, rather feebly, with something along the lines of "I fear that a single one of Viv's thoughts would blow my damn brains out."'[3]

Threads of optimism and indefatigable humour run across all Vivian's music and writing. 'Essex Teenager to Renaissance Man', his last piece, recorded only months before his death, was as sharply witty as anything he had performed at the very beginning of his career with the Bonzos. He concludes the show with a brief tribute to Rodney Slater and signs off by urging his fans, much as he had throughout his life: 'Do have an unusual day – toodle-oo.'[4]

Discography

Solo

Singles

The Sean Head Showband (featuring Eric Clapton):
 'Labio Dental Fricative'/'Paper Round' (Liberty) 1970
Vivian Stanshall and his Gargantuan Chums:
 'Suspicion'/'Blind Date' (Fly) 1970
Vivian Stanshall:
 'Lakonga'/'Baba Tunde' (Warner Brothers) 1974
 'Trail of the Lonesome Pine'/'Terry Keeps His Clips On' (unreleased) 1975
Vivian Stanshall and Kilgaron:
 'The Young Ones'/'Are You Havin' Any Fun?'/'The Question' (Harvest) 1976
Vivian Stanshall:
 'Terry Keeps His Clips On'/'King Kripple' (Charisma) 1980
 'Calypso to Colapso'/'Smoke Signals at Night' (Charisma) 1981

Albums/CDs

Men Opening Umbrellas Ahead (Warner Brothers) 1974

Sir Henry at Rawlinson End (Charisma LP/Virgin CD) 1978
Teddy Boys Don't Knit (Charisma LP/Virgin CD) 1981
Sir Henry at Ndidi's Kraal (Demon Records LP and CD) 1983

Film

Sir Henry at Rawlinson End (Island video); Vivian co-wrote the screenplay with Steve Roberts, wrote the music and appears as Hubert.

Radio and Television

Radio 1: 'Top Gear' (with BiG GRunt) March 1970, 'Cyborg Signal'/'Blind Date'/'Eleven Moustachioed Daughters'/'The Strain'
'Radio Flashes' (August 1971, featuring Keith Moon)
'John Peel Show' October 1975, 'Trail of the Lonesome Pine'/'The Unbridled Suite'/'In the Final Analysis, Aunt Florrie Remembers'
Sir Henry at Rawlinson End: 'Christmas at Rawlinson End', Christmas 1975; Part 34, April 1977; Part 35, May 1977; 'The Road to Unreason', Part 37, December 1977; 'Florrie's Waltz'/'Fool and Bladder'/ 'Interlewd'/'Smeeton', April 1978; 'Ginger Geezer'/'Socks'/'Stripe Me a Pinky'/'Fresh Faced Boys'/'Aunt Florrie'/'Piece in Toto', July 1978; 'Gooseflesh', Part 1, December 1979; 'The Crackpot at the End of the Rainbow', April 1988; 'The Eating at Rawlinson End', November 1988; 'Cackling Gas Capers'/'Octavio'/'Tour de Farce'/'Achmedillo'/'Peristaltic Waves', April 1991

Radio 4: 'Start the Week', 1971–72; 'Jack De Manio Precisely' (reuse of Stanshall's features from 'Start the Week'); 'If It's Wednesday, It Must be . . .', 1972–74; 'Yellow' (pilot, never broadcast), 1982; 'From Essex Teenager to Renaissance Man', November 1994

BBC 2: 'Up Sunday' (1972–73); 'One Man's Week' (1974); 'The Bristol Showboat Saga' ('Omnibus', 1984: Vivian is interviewed for this); 'Late Show' special: variously called 'Crank' and 'Diamond Geezer' (1991)

Adverts: Vivian appeared in a range of commercials, most notably the Ruddles campaign of the early 1990s, Cadbury's 'Mr Cadbury's Parrot'

series in the late 1980s, as well as providing corporate production voiceovers

Collaborations/guest appearances:

John Entwistle – *Smash Your Head Against the Wall* (Decca LP/Repertoire CD) 1971; Vivian and Neil Innes play percussion

Mike Hart – *Basher, Chalky, Pongo and Me* (Polydor) 1972; Vivian contributed vocals and recorders

Pete Brown – *The 'Not Forgotten' Association* (Deram) 1973; Vivian plays tuba

Mike Oldfield – *Tubular Bells* (Virgin LP/EMI CD) 1973; Vivian narrates (and also recorded at the same time a spoken piece over traditional instrumental 'The Sailor's Hornpipe', which can be found on Oldfield compilations, such as *Boxed* (Virgin, 1976), credited to Mike Oldfield)

Robert Calvert – *Captain Lockheed and the Starfighters* (United Artists LP/Beat Goes On Records CD) 1974; Vivian plays sketch characters

Jim Capaldi – *Whale Meat Again* (Island LP/Edsel CD) 1974; fellow-collaborators Steve Winwood and Gaspar Lawal also appear

Traffic – *When the Eagle Flies* (Island LP/Polygram) 1974; Vivian co-wrote 'Dream Gerrard'

Peter and the Wolf (RSO) 1975; Vivian narrates

Steve Winwood – *Steve Winwood* (Island LP/Mobile Fidelity CD) 1977; Vivian co-wrote 'Vacant Chair'

Steve Winwood – *Arc of a Diver* (Island LP/Mobile Fidelity CD) 1980; Vivian co-wrote the title track

The Damned – 'Lovely Money'/'I Think I'm Wonderful'/'Lovely Money' (disco mix) (Bronze) 1982; Vivian provides spoken word background on 'Lovely Money'

John Wesley Harding – *God Made Me Do It: The Xmas EP* (Sire/Reprise 1989); Vivian conducts a promotional interview for Harding's first album

Pulp – *Do You Remember the First Time?* (1994); Vivian interviewed for this short film

Compilation appearances:

That'll be the Day soundtrack (Ronco) 1973; Vivian contributes previously unreleased track 'Real Leather Jacket'

Masterpieces (Charisma) 1980; Vivian contributes 'King Kripple', originally on *Teddy Boys Don't Knit*

The Last Temptation of Elvis (NME) 1990; Vivian Stanshall and the Big Boys contribute '(There's No) Room to Rhumba in a Sports Car'

Famous Charisma Box Set (Charisma) 1994; Vivian contributes 'Hoopoe's Tales'/'Terry Keeps His Clips On'/'Window City'/'Sir Henry at Rawlinson End'

Charisma Poser (Charisma) 1994; Vivian contributes 'Eulogy'

Play

Stinkfoot by Vivian and Ki Stanshall, Sea Urchin Press, November 2002

The Bonzo Dog Band

(There were also many reissues and US-specific releases, but the original albums are still currently available in CD format)

Singles

'My Brother Makes the Noises for the Talkies'/'I'm Going to Bring a Watermelon to My Girl Tonight' (Parlophone) 1966 (April)

'Alley Oop'/'Button up Your Overcoat' (Parlophone) 1966 (October)

'Equestrian Statue'/'The Intro and the Outro' (Liberty)1967

'I'm the Urban Spaceman'/'The Canyons of Your Mind' (Liberty) 1968

'Mr Apollo'/'Ready Mades' (Liberty) 1969 (July)

'I Want to be with You'/'We were Wrong' (Liberty) 1969 (November)

'No Matter Who You Vote for the Government Always Gets In (Heigh Ho)'/'I'm the Urban Spaceman'/'The Intro and the Outro'/'Them' (China) 1992

Albums

Gorilla (Liberty) 1967

The Doughnut in Granny's Greenhouse (Liberty) 1968

Tadpoles (Liberty) 1969 (August)
Keynsham (Liberty) 1969 (November)
Let's Make Up and be Friendly (United Artists) 1972
Peel Sessions (Strange Fruit) 1987
The Bonzo Dog Doo-Dah Band Unpeeled (Strange Fruit) 1995
Anthropology (DJC Records)1999 (a mixture of unreleased, demo, perform-
 ance and alternative versions, contact: DJC Records, 104 Constitution
 Hill, Norwich, NR3 3BB)

Compilations

The Alberts, the Bonzos, the Temperance Seven (1971)
*The Alberts, the Bonzos, the Temperance Seven, Spike Milligan and Peter
 Sellers By Jingo, It's British Rubbish* (Hux Records) 1999 (includes
 previously unreleased Bonzo track: 'On Her Doorstep Last Night')

Television

'Do Not Adjust Your Set' (twenty-six episodes ran in two series from January
 1968 to March 1968 and February 1969 to May 1969, with two
 Christmas specials, on Boxing Day 1967 and Christmas Day 1968)
'Colour Me Pop' (1967)

Notes

All interviews conducted by authors, unless indicated below.

1. Teddy Boys Don't Knit

1. Vivian Stanshall, 'Late Show' special, 'Crank', BBC 2, 1991.
2. Ibid.
3. 'Essex Teenager to Renaissance Man', Radio 4, 1994.
4. Ibid.
5. Charles Alverson, *Let's Make Up and be Friendly*, press kit, 1972.
6. 'Essex Teenager', 1994.
7. Ibid.
8. Ibid.
9. Gill Pyrah, radio interview, Christmas 1988, transcribed in *Mojo*, June 1999, p.68.
10. 'Essex Teenager', 1994.
11. Neil Norman, *The FACE*, December 1981.
12. Alverson, *Let's Make Up*, 1972.
13. Pyrah radio interview, 1988.
14. Norman, *FACE*, 1981.
15. 'Essex Teenager', 1994.
16. Jonathan Green, *Friends*, 31 January 1970.
17. Neil Innes, liner notes to *By Jingo It's . . . British Rubbish*, Hux Records, Hux 015, 1999.
18. 'Essex Teenager', 1994.

19. Green, *Friends*, 1970.
20. *Melody Maker*, 21 December 1968.
21. Richard Gilbert interview, 'Nightcap', CBC Radio, Canada, 1978.
22. 'Essex Teenager', 1994.

2. So the Boys Got Together and Formed a Band . . .

1. Neil Norman, *The FACE*, December 1981.
2. Charles Alverson, *Let's Make Up and be Friendly,* press kit, 1972.
3. Robert Chalmers, *Observer Life*, 23 April 1995, p.23.
4. Bill Kates, interview for 'Perspective', WBCN, Boston, 1980.
5. Ibid.
6. Ibid.
7. Interview with Chris Welch, 1976.

3. The Dopal Show Will Appear in Person as Themselves

1. 'The Bride Stripped Bare by "Bachelors"', Stanshall/Innes, *Keynsham*, EMI, 1969.
2. Ibid.
3. Ibid.
4. Ibid.
5. Ibid.
6. Ibid.
7. Ibid.
8. John Platt, *Comstock Lode*, Winter, 1979.
9. Ibid.

4. 'Is *Mrs* Penguin at Home?'

1. *Melody Maker*, 21 December 1968, p.29.
2. Charles Alverson, *Let's Make Up and be Friendly*, press kit, 1972.
3. *Melody Maker,* 21 December 1968.
4. Ibid.

5. Do Not Adjust Your Set

1. Richard Gilbert interview, 'Nightcap', CBC Radio, Canada, 1978.
2. *Melody Maker*, 4 November 1967.
3. *Melody Maker*, 21 December 1968, p.29.
4. John Platt, *Comstock Lode*, Winter, 1979.
5. *Q* Magazine, January 1989.
6. 'Do Not Adjust Your Set', 1969.

6. I'm Singing Just for You . . . Covered in Sequins

1. *Melody Maker*, 21 December 1968, p.29.
2. Jonathan Green, *Friends*, 31 January 1970.
3. *Melody Maker*, 5 October 1968, 'Blind Date with Frank Zappa', p.13.
4. *Melody Maker*, 21 December 1968, p.29.
5. Richard Gilbert interview, 'Nightcap', CBC Radio, Canada, 1978.
6. John Platt, *Comstock Lode*, Winter, 1979.
7. Jonathan Green, *Friends*, 31 January 1970.
8. Band interview, Paradiso Club, Amsterdam, 25 August 1969.
9. Ibid.
10. Green, *Friends*, 1970.
11. *Melody Maker*, 19 December 1970, p.28.
12. Ibid.
13. Vic King, Mike Plumbley and Pete Turner, *Isle of Wight Rock* (Isle of Wight Rock Archives, out of print, pp.141–2).

7. Can Blue Men Sing the Whites?

1. Jonathan Green, *Friends*, 31 January 1970.
2. Ibid.
3. Neil Norman, *The FACE*, December 1981.
4. Ibid.
5. *Melody Maker*, 19 December 1970, p.28.
6. Gill Pyrah radio interview, Christmas 1988, transcribed in *Mojo*, June 1999, p.66.
7. Green, *Friends*, 1970.

8. Stephen Fry, *Moab is My Washpot* (Arrow, 1998).

9. Vivian Stanshall, 'Busted', *Keynsham*, EMI, 1969.

10. Green, *Friends*, 1970.

11. Charles Alverson, *Let's Make Up and be Friendly*, press kit, 1972.

12. Green, *Friends*, 1970.

13. Richard Gilbert interview, 'Nightcap', CBC Radio, Canada, 1978.

8. A Festival of Vulgarity

1. *Melody Maker*, 19 December 1970, p.28.

2. Vivian Stanshall, 'Blind Date', Fly, 1970.

3. Alan Clayson, *Record Collector*, 1995, p.105.

4. Chris Welch, *Melody Maker*, 21 February 1970, p.16.

5. Charles Alverson, *Let's Make Up and be Friendly*, press kit, 1972.

6. Ibid.

7. Ibid.

8. Bill Kates, interview for 'Perspective', WBCN, 1980.

9. *Melody Maker*, 19 December 1970, p.28.

10. Kates, 'Perspective', 1980.

11. Ibid.

12. Ibid.

13. Ibid.

14. Ibid.

15. *Melody Maker*, 19 December 1970, p.28.

16. Kates, 'Perspective', 1980.

17. Charles Alverson, *Rolling Stone*, 2 December 1970.

18. Interview with Chris Welch, 1976.

19. Alverson, *Let's Make Up . . .*, 1972.

20. Ibid.

9. The Crackpot at the End of the Rainbow

1. Vivian Stanshall, *Mike Oldfield Boxed*, Virgin, 1976.

2. 'Start the Week', Radio 4, 1972.

3. Vic King, Mike Plumbley and Pete Turner, *Isle of Wight Rock* (Isle of Wight Rock Archives, out of print, pp.141–2).

4. Ibid.

5. Steve Peacock, *Sounds*, 24 February 1973, p.33.

6. John Platt, *Comstock Lode*, Winter, 1979.

7. King, Plumbley and Turner, *Isle of Wight Rock*, pp.141–2.

8. Ibid.

9. Vivian Stanshall, 'Real Leather Jacket', *That'll be the Day*, Warner Bros Music Ltd, Ronco, 1973.

10. Mark Ellen, *Mojo,* May 1995, p.64.

11. Alan Clayson, *Record Collector*, 1995, p.106.

12. Stanshall/Winwood, 'Dream Gerrard', *When the Eagle Flies*, Traffic, Asylum, 1974.

13. Promotional interview with John Wesley Harding, *God Made Me Do It – The Christmas EP*, 1989.

14. Robert Calvert website: http://www.thing.de/projekte/future/welcome.htm

15. *Captain Lockheed and the Starfighters*, Robert Calvert, BGO Records, BG0CD5, originally United Artists, 1974.

16. Ibid.

17. Ibid.

18. Interview with Chris Welch, 1976.

19. King, Plumbley and Turner, *Isle of Wight Rock*, pp.141-2.

20. Platt, *Comstock Lode*, 1979.

21. Ibid.

22. Ibid.

23. Vivian Stanshall, 'Yelp, Bellow, Rasp et Cetera', *Men Opening Umbrellas Ahead*, Warner Brothers, 1974.

24. Ibid.

25. Vivian Stanshall, 'How the Zebra Got His Spots', *Men Opening Umbrellas Ahead*, Warner Brothers, 1974.

26. Vivian Stanshall, 'Dwarf Succulents', *Men Opening Umbrellas Ahead*, Warner Brothers, 1974.

27. Vivian Stanshall, 'Strange Tongues', *Men Opening Umbrellas Ahead*, Warner Brothers, 1974.

28. Platt, *Comstock Lode*, 1979.

10. I Don't Know What I Want – but I Want It Now

1. Interview with Chris Welch, 1976.
2. Richard Gilbert interview, 'Nightcap', CBC Radio, Canada, 1978.
3. Vivian Stanshall, 'The Road to Unreason Part 37', BBC Radio 1, December 1977.
4. Ibid.
5. Gilbert, 'Nightcap', 1978.
6. Vivian Stanshall, *Sir Henry at Rawlinson End*, Charisma, 1978.
7. Interview with Chris Welch, 1976.
8. Stanshall, *Sir Henry at Rawlinson End*, 1978.
9. Stephen Fry, *Moab is My Washpot* (Arrow, 1998).
10. Interview with Chris Welch, 1976.
11. Ibid.
12. Ibid.
13. Ibid.
14. Ibid.
15. Ibid.
16. Ibid.
17. Bill Kates, interview for 'Perspective', WBCN, 1980.

11. The Fur-tongued Horror of a Kiss

1. Ki Longfellow Stanshall, extracted from www.gingergeezer.net
2. Ibid.
3. Gill Pyrah, radio interview, Christmas 1988, transcribed in *Mojo*, June 1999, p.69.
4. Vivian Stanshall, *Sir Henry at Rawlinson End*, Charisma, 1978.
5. 'Yellow', unbroadcast pilot for BBC Radio 4, 1982.
6. Alan Clayson, *Record Collector*, 1995, p.106.
7. Vivian Stanshall/Steve Winwood, 'Vacant Chair', *Steve Winwood*, Island, 1977.
8. Interview with Michael Watts, 25 October 1980.
9. Richard Gilbert interview, 'Nightcap', CBC Radio, Canada, 1978.
10. Charisma press release, 6 October 1978.
11. Gilbert, 'Nightcap', 1978.
12. Ibid.

13. Ibid.
14. Ibid.
15. Ibid.
16. Ibid.
17. *Melody Maker*, 26 April 1979.
18. Ibid.
19. 'Yellow', 1982.
20. Jonathan Green, *Friends*, 31 January 1970.
21. Interview with David Hancock, 1977.
22. Pyrah radio interview, 1999.

12. Some Geezer, an Ooly Ginger Geezer

1. Interview with Michael Watts, 25 October 1980.
2. Ibid.
3. *Radio Times*, March 1997.
4. Neil Norman, *The FACE*, December 1981.
5. Alan Clayson, *Record Collector*, 1995, p.106.
6. Mark Ellen, *Mojo*, May 1995, p.61.
7. Clayson, *Record Collector*.
8. Vivian Stanshall, 'The Cracks are Showing', *Teddy Boys Don't Knit*, Charisma Records, 1981.
9. Patrick Humphries, *Melody Maker*, 15 August 1981.
10. Gill Pyrah radio interview, Christmas 1988, transcribed in *Mojo*, June 1999, p.66.

13. Boy in Darkness

1. 'Bristol Showboat Saga', 'Omnibus', BBC 2, 1984.
2. 'Essex Teenager to Renaissance Man', Radio 4, 1994.
3. 'Bristol Showboat Saga', 1984.
4. Ibid.
5. Ki Longfellow Stanshall, www.gingergeezer.net

14. Calypso to Colapso

1. Letter from Vivian to Mark Millmore, 30 August 1985.
2. Alan Clayson, *Record Collector*, 1995, p.106.
3. Vic King, Mike Plumbley and Pete Turner, *Isle of Wight Rock* (Isle of Wight Rock Archives, out of print, pp.141–142).
4. Gill Pyrah radio interview, Christmas 1988, transcribed in *Mojo*, June 1999, p.66.
5. *Bristol Evening Post*, 10 October 1985.
6. Ibid.
7. Ibid.
8. Letter from Vivian to Mark Millmore, 30 August 1985.
9. Letter from Vivian to Richard Gilbert, 10 October 1986.
10. *Guardian* review taken from www.gingergeezer.net site.
11. Letter from Vivian to Mark Millmore, 27 January 1988.

15. Crank

1. Letter from Vivian to John Halsey, 6 January 1991.
2. Robert Chalmers, *Observer Life*, 23 April 1995, p.23.
3. Annalena McAfee, *Evening Standard*, 4 April 1991, p.26.
4. Ibid.
5. Ibid.
6. Vivian Stanshall, 'Late Show', BBC2, 1991.
7. Interview with Michael Watts, 25 October 1980.

16. The Land Where the Hoppity Oats

1. Gill Pyrah radio interview, Christmas 1988, transcribed in *Mojo*, June 1999, p.68.
2. Edward Lear, 'The Owl and the Pussy-Cat'.
3. Mark Ellen, *Mojo*, May 1995, p.62.

17. The Clocks are Baring Their Teeth

1. Robert Chalmers, *Observer Life*, 23 April 1995, p.23.
2. *Rolling Stone*, 20 April 1995.
3. John Peel, *Mojo* tribute, May 1995 p.61.
4. 'Essex Teenager to Renaissance Man', Radio 4, 1994.

(Main sources: Vivian solo discography in *Record Collector*; www.amg.com; Ken Garner, *In Session Tonight*, BBC Books)

Key websites:
Ki Longfellow Stanshall's site: www.gingergeezer.net
Superlative Bonzos site:
http://bridge.anglia.ac.uk/~systimk/Music/Bonzos/index.html
Isle of Wight Rock Archives: www.iowrock.demon.co.uk

Permissions

The White Nile, Alan Moorehead, Penguin UK: Reproduced by permission of Lawrence Pollinger Limited and the Estate of Alan Moorehead.

'Yelp', 'Bellow', 'Rasp Electra', 'Dwarf Succelents', 'Strange Tongues': all songs Words and Music by Vivian Stanshall © 1974 Warner Bros. Music Ltd, Warner/Chappell Music Ltd, London W6 8BS. Reproduced by permission of International Music Publications Ltd. All Rights Reserved. 'How The Zebra Got His Spots': Words and Music by Vivian Stanshall © 1973 Warner Bros. Music Ltd. Warner/Chappell Music Ltd, London W6 8BS. Reproduced by Permission of International Music Publications Ltd. All Rights Reserved. 'Sir Henry at Rawlinson End': Words and Music by Vivian Stanshall © 1981 Warner Bros. Music Ltd. Warner/Chappell Music Ltd, London W8 6BS. Reproduced by permission of International Music Publications Ltd. All Rights Reserved.

'Dream Gerrard': Words and Music by Steve Winwood and Vivian Stanshall © 1974 Warner Bros. Music Ltd and Fantasy Songs Ltd, USA. Warner/Chappell Music Ltd, London W8 6BS. Reproduced by permission of International Music Publications Ltd. All Rights Reserved. 'Vacant Chair': Words and Music by Steve Winwood and Vivian Stanshall © 1975 Warner Bros. Music Ltd and Fantasy Songs Ltd, USA. Warner/Chappell Music Ltd, London W8 6BS. Reproduced by permission of International Music Publications Ltd. All Rights Reserved.

Index